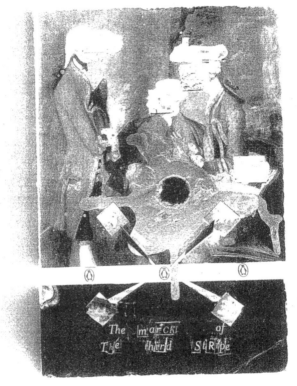

The Marque of the Third Stripe
(2007) by Alexandre Singh

THE MARQUE OF THE THIRD STRIPE

TRANSLATED INTO MODERN ENGLISH BY *Alexandre Singh*

ESSAYS BY *Stefano Collicelli Cagol, Jonathan Griffin,
Geoffrey Lee, Luca Lo Pinto, Luca Martinazzoli, Colin Perry,
Filipa Ramos, Alexander Waterman*

INTRODUCTION BY *Kate Stancliffe*

MONITOR
GALLERY

The earliest antiquity lies buried in silence and oblivion, excepting the remains we have of it in sacred writ. This silence was succeeded by poetical fables, and these, at length, by the writings we now enjoy: so that the concealed and secret learning of the ancients seems separated from the history and knowledge of the following ages by a veil, or partition wall of fables, interposing between the things that are lost and those that remain.

FRANCIS BACON

Edited by Ella Christopherson

Designed by Emily Lessard

Published 2008 by Monitor Gallery, Rome & Preromanbritain, New York

The format of this book is based on an original idea by Luca Lo Pinto &
Alexandre Singh

Translation and dictionary copyright © 2008 Alexandre Singh

Printed in the United States of America by Print Craft Inc., St. Paul, Minnesota
Special thanks to Larry Lewis

Set in Nexus, a typeface designed by Martin Majoor, and Doulos

PRB005

ISBN 978-0-9821395-0-9

CONTENTS

On The Marque of the Third Stripe

From Wikipedia, the free encyclopedia

Contents [hide]

> *Lines, stripes, never crossing, never diverging, always parallel.*
> *Parallel lines that will never ever cross though they burrow forever*
> *deeper and deeper and deeper and deeper and deeper and deeper*
> *into the core of the earth…*[1]

In a minor province, deep in the heart of the Alps, an imposing castle casts a shadow over a small town. Its exterior is ancient, rough and irregular; a Gothic ruin to all appearances, hewn from the rock that rises up from behind its shady environs and disappears into the enveloping, sinking mists of the mountains. The building's structural core, however, defies such a Romantic description, for it is Modernist in design, the crypts and under-passages cast in concrete, its interior walls icy cold to the touch. The building's internal structure seems to be controlled by a hidden yet inescapable gravitational force: it is composed of rigorously geometrical forms, all 90° angles and parallel lines stretching down toward the bowels of the earth, forming room after room after room. The nerve centre of the revered Adidas running shoe, this eerie palace of production is where

sports shoes of the highest calibre are manufactured, providing employment for—and controlling the activity of—an entire town's working population, each inhabitant labouring to support its infinite manufacturing operation.

Modern Antiquity [edit]

Alexandre Singh's multilayered project *The Marque of the Third Stripe* (2007/08) appropriates its title from the ubiquitous three-stripe branding of the renowned global sportswear corporation Adidas. So far, it has

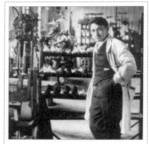
Adi Dassler in his workshop

taken the form of four site-specific installations,[2] each one emerging from and responding to an intricately composed tale written by Singh. The six-part tale interlaces contemporary culture and late capitalism with ancient mythologies and rituals in its dark account of the birth of the sporting empire Adidas—the brainchild of Adolf Dassler—and the terrifying and disabling power it holds over those who become slaves to its product and manufacture. The tale employs the devices of the nineteenth-century gothic horror literary genre but is set in a timeless age where elements from a bygone era meet unmistakably modern-day references. This is a world where merchants trade in plastics instead of ore; where halogen "fires" illuminate gloomy catacombs; and where the enemy of man—that ubiquitous gothic motif—is cast as the anthropomorphic personification of gravity, an enemy that grounds aeroplanes, battles against architecture and sculpture, and ruins the efforts of athletes. The tale itself appears in a number of different formats within each installation both as a reproduced text, usually in fanzine form, and as the narrative to a video of the same title.

Narrative Structure [edit]

The tale's narrative structure references the composition of seminal nineteenth-century gothic texts such as Charles Maturin's *Melmoth the Wanderer* (1820)—an account of an individual's pact with the devil—through what Singh calls a "Russian doll" narrative structure. Tales are told within tales, a popular trick in gothic literature that can be confusing for the reader but enables the story to comment on itself, demonstrating knowledge of its own subjectivity and even questioning its own veracity. Beginning with "The Medician" and ending with "The Statue," the narrative weaves through prophetic dreams, letters, reveries, and accounts, each narrative nestling within the previous one. Singh pushes this structure

Charles Maturin's *Melmoth the Wanderer,* 1820

to its extreme when the very last narrator insinuates that the first story (which, of course, contains his own) is the one he is about to tell. The linear narrative folds into itself like a Möbius strip and the entire story becomes a paradox, with no clear beginning or end.

The Gothic Tradition [edit]

The Gothic is an escapist form that retreats into distant landscapes and lost eras, refusing the constraints of space and time. *The Marque of the Third Stripe* is imbued with gothic references not only through its narrative form and literary style, but also in its approach to the concept of time and its implicit relationship to the past. Recognising that the gothic novel was the first literary medium to fetishise history, Singh deliberately plays with the discrepancy between his modern take on the genre and the originals of the eighteenth and nineteenth centuries. He regards the first gothic novels as fetishisations of the period's not-too-

distant past, namely the Dark Ages, drawing their characters from medieval Europe into sinister tales grounded in monasteries and castles in order to represent the irrational, the unknowable, and the occult. Rather than following suit, Singh inverts history: the contemporary becomes the neolithic, the recent past the medieval, and the furthest reaches of man's ancestral knowledge high Modernism.

Installations [edit]

Singh's installations are visually reserved in stark contrast to the lucid complexity and extreme detail described in the tale itself. On first glance, the works are minimal albeit large-scale constructions composed to a rigorous geometrical form. They are structurally slight but immersive; conceptually dense and extravagant in size yet ironically lo-fi in their construction and use of materials. The first realisation of the project at White Columns gallery in New York was less an installation than a series of components or clues referencing the most telling aspects of the tale: a fog-filled vitrine partly concealing a primitive statue dripped with white paint, crudely evoking the Romantic landscape paintings of Caspar David Friedrich; an inverted collage of Adi Dassler holding a shoe with his head turned to the floor, apparently melting under the perceived gravitational pressure imbued in the athletic article. Singh's museological approach to the

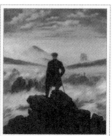

The Wanderer Above the Sea of Clouds, Caspar David Friedrich, 1818

display of the Adidas trainer is consistent in each of the installations. The shoes are exhibited: Placed in pristine Perspex vitrines and thus elevated to the status of artefact—yet still too low budget for a museum or a slick corporate showroom—they are displayed within wayward geometric structures. Each pair is worn out, encapsulating a life on the run, the three-stripe logo preserved for posterity.

The three large-scale installations of *The Marque of the Third Stripe* range in their references to architecture and the history of design. Delineated by repetitive, partially completed grid-like walls, each installation is framed by a series of walkways, antechambers, and rooms. Singh's first realisation evoked the geometric crypts of the Dassler underworld, the sinister epi-centre of this eerie tale; the second venerated the Adidas legend through a space that was simultaneously a museum, church, and pilgrimage site, to be circumnavigated as if honouring the shoe itself; and the most re-cent incarnation featured a Modernist lounge equipped with a TV screen and an appropriately angular, uncomfortable MDF interpretation of a Bauhaus couch. In each instance, the spaces are barely illuminated except for the incandescent glow of the vitrines and the flickering glare of the video projection.

Video: Signs and Signifiers [edit]

As with the installations, the video of *The Marque of the Third Stripe* com-bines conceptual intricacy with visual simplicity due to its seemingly ba-nal imagery. Six Portuguese women narrate the story; their voices are slow and monotonous, hypnotic yet at odds with the style and content of the gothic tale. (Portuguese is a romantic and mysterious language, hard to place when applied to spoken English.) Visually, the film presents a series of black-and-white computer-generated patterns that correspond to key words in the tale and change accordingly as it is read aloud. At times, the patterns mimic the words they represent: the hieroglyph for "castle," for example, looks like a digitised version of a rook in a game of chess. Ideas such as "tempter," "treacherous," "enemy," "sanitarium," and "pre-historic" are treated as variations of one another on large fields of white and black. Words that are conceptually related—"brick," "construction," and "plaster," for example—have very similar symbols, while the patterns for oppositional concepts are often the negative or inverted arrangement of their respective antonym. This heightened level of detail underlies the

video's seeming visual naïvety: Over one thousand words, even the smallest articles, are attributed a form.

The Power of the Grid [edit]

The hypnotic combination of the video's visual and aural facets knowingly attempts to simulate the "heightened state of being" experienced by athletes at the climax of their "severe sporting," as described in the tale. It is in this trancelike state that Singh's athletes feel they are passing

> *...from this world into an endless grid, both infinitely large and infinitely regressed. The grid appeared to be made up of black-and-white squares constantly fluctuating and forming patterns in an eerie synchronisation with the athletes' own mental processes. The whole of* existence *translated itself into a* visual language *through which their mental processes created a symbiotic schema."*[3]

Within the installations, the grid motif both references and triggers the terrifying and destructive state of "synchronisation" that extends out from the Adidas empire. The grid is omnipresent, down to the most careful detail. A small waffle, pinned and camouflaged against a wooden frame, references the account given by the Priest, who is third in line to tell his tale. This consumable item, despite its commonality in the everyday culture of the "Grand Americas," is (according to the Priest) freed of its lowly origins and imbued with the entire history of the tale, both physically embodying and formally symbolising the grid-like structure described in the athlete's hallucinations. *The Marque of the Third Stripe* points us towards the occult via such banal objects whilst simultaneously acknowledging their lack of any mystical aura. At the dark heart of Singh's work lies a tale close in tone to the writings of H. P. Lovecraft, where a belief in magic and witchcraft is to be questioned—ridiculed, even. Human progress is futile, locked in a capitalist regime within a

universe that is merely a furtive arrangement of particles, devoid of mystery and heading towards chaos.

KATE STANCLIFFE

Notes [edit]

1. "The Priest," *The Marque of the Third Stripe*, p.136.
2. "Alexandre Singh: White Room," White Columns, New York; "East*International*," 2007, Norwich Gallery, Norwich; "Of this tale I cannot guarantee a single word," Royal College of Art, London; Monitor Gallery, Rome.
3. "The Medician," *The Marque of the Third Stripe*, pp.126-7.

On H. P. Lovecraft

From Wikipedia, the free encyclopedia

Contents [hide]

> *This book is for the very few.*
> *Perhaps none of them are even alive yet...*
> *My day won't come till the day after tomorrow.*
> *Some people are born posthumously.*

FRIEDRICH NIETZSCHE, *The Antichrist*

Howard Phillips Lovecraft (1890-1937) wrote pulp fiction of a most extra-ordinary nature. Writing in relative obscurity until his death, his "weird stories" are an abrasive fusion of traditional woodsy gothic and his own original, vertiginous futurism; it was a style that gave no quarter to public taste, and the public rejected it. Worse still, because his work was published solely in the more obscure rags and fanzines of his day, his reputation and writings seemed condemned to the silent obscurity of the public archives, the memory of aged fans and a few glassy-eyed acolytes.

'60s Renaissance [edit]

Yet his freakish works did survive, against all odds, to become holy texts for a

later generation. From the early 1960s, the science fiction writer August Derleth was fleshing out Lovecraft's more outré mythologies,[1] both publicising and plagiarising the master's dark vision. Meanwhile, publishers of graphic comics such as EC Comics' *Vault of Horror* and Marvel Comics' *Masters of Terror*[2] were giving Lovecraft's world a lurid pictorial existence[3] aimed directly at teenage boys. Emerging in parallel with this Lovecraftian renaissance were the West Coast underground comics of Harvey Kurtzman and Robert Crumb, which sketched a visual language for the emergent

Masters of Terror, Marvel Comics

counterculture. Crumb, who by his own admittance was heavily influenced by LSD,[4] would walk along San Francisco's streets pedalling his comics from a baby stroller, providing hippies with a stream of subversive, psychedelic graphic art.

By an accident of history, it seems, Lovecraft was taken up by the hippies as an avatar of tripped-out otherworldliness. Before the decade was out, a flowering of psychedelic recordings had paid tribute to the master of obscure visions: the acid rock group H. P. Lovecraft—who gigged alongside Procol Harum, Pink Floyd, and Donovan—were obvious devotees. Lovecraft's fiction fits oddly into this counterculture, but his imagery is undeniably psychedelic, its gothic imponderables an accurate description of a very bad trip:

> Johansen and his men landed at a sloping bank on this monstrous Acropolis, and clambered slipperily up over titan oozing blocks which could have been no mortal staircase… twisted menace and suspense lurked leeringly in those crazily elusive angles of carven rock where a second glance shewed concavity after the first shewed convexity.[5]

As the trips turned ugly, pioneer heavy metal rockers Blue Öyster Cult[6]

and Black Sabbath found solace in Lovecraft, metronomically intoning a world bereft of protective gods. In its early days during the late '60s and early '70s, heavy metal provided the truest manifestation of Lovecraft's writing:

Chill and numbs from head to toe
Icy sun with frosty glow
Why'd you go reaching your sorrow?
Why'd you go read no tomorrow?[7]

Schlock Horror [edit]

Not simply dark, however, Lovecraft's writing is also brilliantly tasteless. Overblown and out of this world, his alien apparitions are drawn in schlock-horror detail—their tentacle limbs and fishlike heads, their arcane cultures and infinite cities, their wonderfully daft names: Yog Sothoth, Cthulhu, and "unmentionable" Azathoth. Where Edgar Allan Poe and Algernon Blackwood—horror writers of a classical bent—edge around the mouth of the abyss, Lovecraft descends straight down, dredging the horrors and examining the residue in lurid detail. Here's an alien autopsy from "At The Mountains of Madness:"

Objects are eight feet long all over. Six-foot five-ridged barrel torso 3.5 feet central diameter, 1 foot end diameters. Dark grey, flexible, infinitely tough. Seven foot membranous wings of same colour...yellowish five-pointed star-shaped apparent head... Cannot yet assign positively to animal or vegetable kingdom.[8]

Lovecraft and the "Other" [edit]

Understandably, theorists and commentators see such fantasies as paradigms of "otherness."[9] Teenagers learn, via the metaphor of alien difference, to empathise with peoples of different nations, races, and sexuality.

This is a very optimistic concept: to misquote philosopher Emmanuel Lévinas, any literature that "infinitely overflows the bounds of knowledge"[10] has the capacity to present alterity. Only "the Transcendent" can, therefore, see off normative prejudices. Lovecraft certainly presents a vocalisation that can quite literally shake the foundations of our universe. The voice of an alien from "At The Mountains of Madness" does just that:

> *A voice from other epochs belongs in the graveyard of other epochs.*
> *As it was, however, the noise shattered all our profoundly seated*
> *judgments...*[11]

But Lovecraft is fundamentally at odds with Lévinas' yearning for a brotherhood of peoples. His fiction was actively inspired by a pathological hatred of others,[12] and if he presents images of otherness he also happily illustrates the most stereotyped and vile prejudices of an outright bigot. Worse than merely intolerant, Lovecraft was a malicious racist. His poem "On The Creation Of Niggers" must stand as a nadir in his reputation (its title reveals the general direction of the attack— he viewed black people as biologically inferior to white). Yet there was something that struck Lovecraft as far worse than the mere coëxistence of races: he was appalled by the idea of miscegenation. Lovecraft's ultimate horror is impure blood, and he

Howard Phillips Lovecraft

repeatedly stresses his disgust at the hybrid. In "The Shadow Over Innsmouth" the forsaken town is a parable of a populous city whose inhabitants are degenerate half-breeds—humans who have wedded with alien dæmon-fish and are doomed to devolve into seagoing monsters. "The Shadow Over Innsmouth," like many of his other works,

involves a protagonist who discovers his blood is infected with alien or dæmonic lineage: Lovecraft's recurrent trope could be accurately described as a DNA of doom.

Lovecraft was driven to verbal delirium by his bodily revulsion to the city. He reeled in disgust from New York's swarming crowds, describing it as a "babel of sound and filth."[13] As Walter Benjamin points out, "Fear, revulsion, and horror were the emotions which the big-city crowd aroused in those who first saw it."[14] Charles Baudelaire, the poet and flaneur of Paris, described himself as a "botanist of the sidewalk," picking up its "sickly flowers." For Lovecraft, however, the sidewalk was less a garden of evil than a carnival of doom:

> … I saw that the moonlit waters between the reef and the shore
> were far from empty. They were alive with a teeming horde of shapes
> swimming inward toward the town; and even in my vast distance
> and in my single moment of perception I could tell that the bobbing
> heads and flailing arms were alien and aberrant in a way scarcely
> to be expressed or consciously formulated.[15]

Indeed, his vision of hatred was oddly prescient. Compare Lovecraft's nauseating modern crowd of the 1930s with Jean Baudrillard's promiscuous postmodern one of the early 1990s:

> In the lamp of the headlamps, a huge, dense crowd, shrouded in
> the mist rising from the ocean, a contorted mass of bodies and faces.
> The men, who were hidden away out of the heat, reappear around
> strings of slaughtered chickens, steaming entrails and charcoal fires as
> night falls… The language guttural, the poverty visceral, and a seething
> which is that of epidemics. Everything… is potentially violent obeying
> primitive injunctions…[16]

Against the ideology of his own time, Lovecraft viewed modern science's faith in advancement as actively dangerous:

> The sciences... will open up such terrifying vistas of reality...
> that we shall go mad from the revelation or flee from the deadly light
> into the peace and safety of a new dark age.[17]

Here, once more, he is oddly in tune with the counterculture of the 1960s. When Rachel Carson published *Silent Spring* in 1962, its critique of pesticides unleashed a storm of ecological activism. *Silent Spring* reads like science fiction turned fact:

> ... the short-lived triumphs now strongly support the alarming view
> that the insect enemy has been made actually stronger by our efforts.
> Even worse, we may have destroyed our very means of fighting.[18]

Lovecraft the Leftist? [edit]

In Lovecraft, conservatism and radicalism come full circle. His anti-modern reactions—his hatred of the city, of progress, of democracy—were all levers with which to prise open the sealed box of 1920s and '30s high modernism. As Nietzsche puts it, "A hatred full of shudders, caution, depth, far-sightedness—it is the most profound hatred there is."[19]

Despite himself, Lovecraft's tropes of escapism, otherness, and ecology all anticipated nascent left-wing ideals. What would he have made of it all? Perhaps he would have given a thin, vindicated smile. He has, after all these years, finally attained a degree of respectability, largely through the accolades of high-profile devotees including Jorge Luis Borges, Michel Houellebecq, and (of course) Stephen King. Indeed, Lovecraft's cynical, hard-bitten analysis of the human condition seems, in retrospect, not so very different to that of the twentieth century's literary canon—from Dashiell Hammett and Albert Camus to William S. Burroughs and Thomas Pynchon. Artists, musicians, filmmakers, and theorists continue to flock to his side, and the volume of Lovecraftian literature and commentary increases day by day—the present text included.

Legacy [edit]

His gravestone in Providence, New England is a place of pilgrimage—its epitaph grandly proclaims, "I AM PROVIDENCE." Of course, Lovecraft presides over a far greater realm than his native Rhode Island—he stands awk-

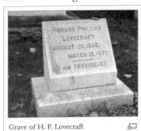

Grave of H. P. Lovecraft

wardly over this entire postmodern era, a visionary of a civilisation hooked on a psychedelia of images and texts. Which leads to the inevitable question: If this post 9/11 world is the crash-and-burn of a postmodern comedown, what can Lovecraft's antimodern works do for us today? Can his charnel house of visions shed fresh light on our "new dark age?"

COLIN PERRY

Notes [edit]

1. Derleth's "collaborative" works were written between 1945 and 1974. http://en.wikipedia.org/wiki/August_Derleth

2. http://www.hplovecraft.com/popcult/comics.asp

3. http://blog.wfmu.org/freeform/2006/01/hp_lovecraft_an.html

4. http://archive.salon.com/people/bc/2000/05/02/crumb/index.html

5. H. P. Lovecraft, "The Call of Cthulhu," in *The Call of Cthulhu and Other Weird Stories*, Penguin, 1999, p.166.

6. http://members.aol.com/bocfaqman/boc_faq.html

7. Lyrics to "Behind The Wall of Sleep," Black Sabbath, on the album *Black Sabbath*, 1969.

8. "At The Mountains Of Madness," in *The Thing at the Doorstep*, Penguin, 2001, p.262.

9. http://www.geocities.com/fantasticreviews/science_fiction.htm

10. Emmanuel Lévinas, "Transcendence and Height," 1962, in *Basic Philosophical Writings*, Indiana University Press, 1996, p.12.

11. Ibid.

12. Michel Houllebeqc, 'Racial Hatred', *H. P. Lovecraft, Against The World Against Life*, Weidenfeld & Nicholson, p.105.

13. Ibid, p.220.

14. Walter Benjamin, *Illuminations*, Fontana Press, 1992, p.170.

15. "The Shadow over Innsmouth," *The Call of Cthulhu and Other Weird Tales*, Penguin, 1999, p.320.

16. Jean Baudrillard, *Cool Memories*, Polity Press, 1996, p.3.

17. H. P. Lovecraft, "The Call of Cthulhu," *The Call of Cthulhu and Other Weird Tales*, Penguin, 1999, p.139.

18. Rachel Carson, *Silent Spring*, 1962.

19. Friedrich Nietzsche, *Twilight of the Idols*, Cambridge University Press, 2005, p.202

On the Lindow Man

From Wikipedia, the free encyclopedia

Contents [hide]

Lindow Man is the name given to the naturally preserved bog body of an Iron Age man, discovered in a peat bog at Lindow Moss near Cheshire, northwest England on May 13, 1984 by two runners. The body has been freeze-dried for preservation and is on display in Gallery 50 of the British Museum, London.

Archaeological interpretation [edit]

The Lindow Man has been carbon-14 dated to some time between 2BCE and 119CE. This particular bog body is notable for the "triple death" or "threefold death" he suffered. The cause of death is thought to have been three blows to the head followed by an incision to the throat. Lastly, a knotted cord was twisted tightly three times around the neck. These details are suggestive of a ritual slaying because triplism is key to Celtic religious iconography. He was found with

the rope still around his neck, face down in an already mature bog at Lindow Moss.

Discovery [edit]

The Lindow Man was discovered at dawn by two runners who were training for the London Marathon. Andy Mould and Stephen Dooley were warming up on the peat bog when one of them stumbled over what appeared to be a piece of wood. After removing some of the peat still attached to it, they discovered it was a human femur bone and contacted the police. Over the next few years more parts of the Lindow Man's body would be discovered.

The bog's natural acidity had preserved the contents of the Lindow Man's stomach. His last meal consisted largely of burned cereal grains, wheat, bran, barley, and mistletoe. The presence of mistletoe leaves in the victim's stomach is highly indicative of a sacrificial offering given its many druidical associations.

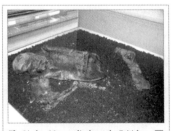

The Lindow Man on display at the British Museum

The "threefold death" was a common sacrificial ritual among Indo-European and Pre-Roman British populations. Archaeologist Dr. Anne Ross has suggested that the Lindow Man was himself a druid as this would explain the lack of physical evidence of a life of hard labor; she has also proposed that he was sacrificed, possibly during Beltane, the Celtic May Day festival. An alternative view is championed by the writer John Grigsby, who suggests that the Lindow Man met his death enacting the role of a dying—and resurrecting—fertility god.

The Lord of Glauberg [edit]

Dr. Peter Marsh has developed a fascinating theory, drawing comparisons between the Lindow Man and the sculpture of the Lord of Glauberg at the ancient German settlement and burial site of the same name. The sculpture depicts a three-headed warrior with three lines carved in the center of his forehead, extending at 45° angles from one another. Unfortunately, the stat-

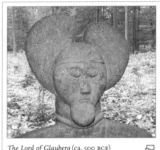

The Lord of Glauberg (ca. 500 BCE)

ue's feet are missing. The shape of the statue's three heads recalls the form of a mistletoe leaf—a plant sacred in Celtic culture, known for its hallucinatory effects. (As previously noted, mistletoe leaves were found in the Lindow Man's stomach.) The Lord of Glauberg has been identified as a funereal ornament, probably produced in the later Celtic period by which point sculptures had been substituted for actual human sacrifice.

The Cult of Lugus [edit]

It cannot be mere chance that the three marks on the forehead of the Lord of Glauberg recall the threefold death of the Lindow Man, and that both subjects are linked with mistletoe leaves. Such an insisted presence leads to Lugus, the most revered of the Celtic gods, commonly represented with three faces. Lugus was the patron of trades and commerce and protector of the arts and crafts. As well as triplism and mistletoe, shoes are an important motif in the cult of Lugus' iconography: One of the dedications to the *Lugoves* was made by a shoemakers' guild, and Lugus's Welsh counterpart Lleu (or Llew) Llaw Gyffes is described in the Welsh Triads as one of the "three golden shoemakers of the island of Britain." So while the Lord of Glauberg's sculpture stands in for a

human sacrifice to Lugus, perhaps the Lindow Man is the actual human sacrifice dedicated to the cult of this god.

Beltane [edit]

Dr. Ross has speculated that the Lindow Man was sacrificed as part of Beltane, a festival in early to mid May celebrating the arrival of summer. The Celts considered the Otherworld closer to our reality than usual during Beltane and thus enacted rituals to contact the gods, or even cross over to their dimension, during the festival. This, it is thought, was the ultimate aim of the threefold human sacrifice. Each of the three steps in the ceremony—the smashing of the head three times, the slitting of the jugular, and the use of a triple garrote—had a precise meaning. The head smashed three times recalled the three heads of Lugus and his sovereign power; the blood drained from the jugular was meant to draw all the vital energies out of the human body and transfer them to the earth; and the strangulation with a thrice-knotted sinew cord was to squeeze out, and separate once and for all, the spirit from the body, enabling it to move away from the body and, after death was finally reached, break free of the gravitational

Image of a tricephalic god identified as Lugus

pull of its earthbound prison. The desire to reach the Otherworld, a place without time and space, was common in Celtic culture. The Otherworld is commonly described as a country where there is no sickness, no old age or death, where happiness lasts forever, and where one hundred years is as one day.

Passage to the Otherworld [edit]

According to accounts, the cult of Lugus believed the Otherworld was not the only dimension that could be accessed. A passage by Plinius the Elder helps us understand what kind of belief system could cause someone to willingly submit themselves to the "threefold death:"

> *Reports were circulating of druids pushing their bodies to hazardous thresholds at which they would experience, for the briefest of moments, a heightened state of being. It is believed that through the rite of the threefold death, it is possible to pass from this world into an endless grid, both infinitely large and infinitely regressed.*

Plinius specifies the importance of ingesting mistletoe leaves at the very beginning of the ritual, probably due to its hallucinatory effects. It seems that the details and inferences of this celebration were passed down through the centuries by an ancient intelligence, perhaps in collusion with a dark, unknown side to the cult of Lugus, whose ambiguities are succinctly represented by his three heads. With the passing of time, this brutal ritual was abandoned and different means of reaching the mythical dimension described by Plinius were pursued. The secret of Lugus's cult seems to be nestled within those enigmatic three leaves of mistletoe disposed at 45° degrees from one another, a trefoil logo that, stylised, looks out at us in silence from the forehead of a statue that lost its shoes and a bog man forever imprisoned in the dry ice of a museum vitrine.

STEFANO COLLICELLI CAGOL

See also [edit]

Bog body
Celts and human sacrifice
Haraldskær Woman
Lindow Woman

Ötzi the Iceman
Tollund Man

References [edit]

1. Grigsby, John, *Warriors of the Wasteland*, Watkins Publishing, 2005.
2. A controversial book on the Grail legends that seeks to fit the death of the Lindow Man into a reconstructed Ancient British Mystery cult akin to that celebrated by the Greeks at Eleusis. Not a major book on the Lindow Man as such but one that suggests a possible framework in which his death can be viewed.
3. Ross, Anne and Don Robins, *The Life and Death of a Druid Prince*. New York: Simon and Schuster, 1989. ISBN 0-671-74122-5
4. Presenting the historical and archaeological reasoning for the ideas of the Lindow Man's social status and suspected reasons for death. While not an exhaustive overview of the archaeological procedures used in the uncovering of the peat bog body, Ross and Robins attempt to provide insights to the Celtic and Druidic worlds of the Lindow Man's age.
5. Stead, Bourke, and Brothwell (ed.), *Lindow Man: The Body in the Bog*. London, 1986. ISBN 0-7141-1386-7 The British Museum. See pp. 90-114 for information regarding diet.
6. A collection of essays regarding the results of examinations of the Lindow Man. Anatomical features, forensic studies, diet and environment, artefacts, and theories regarding his death are but a few of the topics covered in this extensive collection written by experts in their fields. Does not focus on druid rituals, just facts.
7. P.12 shows a site plan of where he was found, along with the Lindow Woman, and p.16 the origins of the bog body known as "Pete Marsh."

External links [edit]

Lindow Man
Picture of site where found

On Adidas

From Wikipedia, the free encyclopedia

Run DMC: Brand Identity Trailblazers [edit]

June 1986. Run DMC, the legendary American hip-hop group then at the peak of its success, plays Philadelphia. After the first few songs they strike up their hit "My Adidas," written that same year:

> I wore my sneakers, but I'm not a sneak
> My Adidas cuts the sand of a foreign land
> with mic in hand
> I could take command
> My Adidas and me both askin' P
> We make a good team my Adidas and me
> We get around together, rhyme forever and we
> won't be mad
> When worn in bad weather.

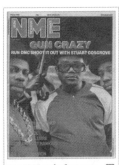

Run DMC on the front cover of the NME, 1986

During the song Joseph "Run" Simmons and Darryl "DMC" McDaniels encourage the audience to take off their Adidas shoes and hold them above their heads—a quasi-religious image in iconological terms. Out of the 20,000 people in the crowd, some 5,000 respond. It doesn't take the German sports brand long to twig that this trio could be the perfect celebrity endorsement for their products.

The Birth of a Brand [edit]

1924. Sixty-two years prior to the Run DMC concert, deep in the German countryside—at Herzogenaurach in Bavaria, to be precise—Adolf Dassler (1900–1978), who has been making sports shoes since the end of the First World War, decides to start his own business. The name is a combination of his nickname, Adi, and his surname, Dassler. (It was popular practice in those days to use one's own name within a brand name.)

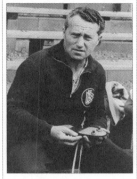

Adolf "Adi" Dassler

And thus one of the world's largest sports multinationals comes into being. The initial idea is simple: provide each athlete with the best possible footwear for his or her discipline. The first protoypes are made using canvas and rubber repurposed from fuel tanks. A year after the company opens Adi registers his legendary three-stripe logo. Could Raymond Pettibon have been thinking of it when he created the four-stripe logo for seminal '80s hardcore band Black Flag?

Sport as Life [edit]

The firm grows fast, playing a prominent role in major sporting events, particularly athletics. 1954 proves to be the turning point, however, when Fritz Walter's West Germany football team beats Hungary—the favourites under the captaincy of magical striker Ferenc Puskas—at the World Cup finals. The German team is wearing Adidas shoes, and the event is heralded as the Miracle of Bern. Over the years Dassler expands into producing sports clothing. For his advertising campaigns he invites the greatest athletes of the moment to pose dressed in Adidas: athlete Jesse Owens, boxers

Mohammad Ali and Max Schmeling, footballers Sepp Herberger and Franz Beckenbauer. In 1963, Adidas begins manufacturing footballs. (Adidas has been the official supplier of balls for all major football events since 1970.) When Dassler dies in 1978, at the age of seventy-eight, a new era opens up for the firm, culminating in the brand becoming a joint stock company two years after the death of its founder. Adidas' marketing strategies also change as the company diversifies from sports clothing to the "lifestyle" market. In early 2000, the Japanese designer Yohji Yamamoto is appointed creative director of the Sport Style department. The collaboration is celebrated with the creation of a new label, Y3—the "Y" for Yamamoto and the "3" for the stripes of the Adidas logo. By now Adidas is firmly established as a lifestyle brand. In 2007 the firm declares a turnover of over ten billion euros.

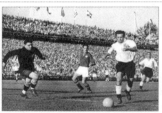

The Miracle of Bern: West Germany triumph at the 1954 World Cup Final

Core Demographic [edit]

Should you be sitting on the tube or on a bus, take a moment to look down at the shoes of your fellow passengers. Of those that are trainers, a surprisingly large majority will be either Adidas or Nike. Statistically speaking, forty-five percent will be Adidas, the same number will be Nike, and the remaining ten percent other brands (Puma, New Balance, et al).

Adidas and Nike are two quite different brands, however. With its bold italic font, the Nike logo is typical of 1970s design, while the Adidas logo is sleek, modernist, rational, geometric, German.

Now raise your gaze and observe the people wearing the shoes. You will notice the brand differences extend also to the wearer. Besides their logos, the main differential between these two brands is their market reference

target. The Nike Swoosh logo has only occasionally broken into the world of fashion and has remained confined to sport and the mainstream American hip-hop scene, where Nikes are a must. Adidas, however, has always been considered more sophisticated, more "casual chic," and is favoured by a more alternative audience to Nike. The three stripes have always encountered the favour of artists, musicians, and notably the 1990s rave scene.

LUCA LO PINTO

On Shop Architecture

From Wikipedia, the free encyclopedia

Contents [hide]

Shoe Shops [edit]

The traditional shoe shop has two distinct sections, one used for displaying goods and the other for storing stock. The shop floor is usually walled with shelves displaying shoes surrounding seats for customers to sit on while they try on their potential purchases. If you feel like trying on a pair you browse the selection on display and request your desired style and size from a salesperson. They go off to fetch your request from the stock room and bring it back to you to try on. Some large outlet stores have maximised the available space (and minimised staffing costs) by stacking all available sizes and styles in their boxes next to a display shoe, in effect combining the two traditionally demarcated areas and allowing the customer to review the available

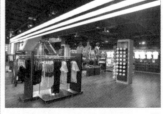

Adidas shop in the Real Madrid Santiago Bernabéu Stadium

stock without the aid of a salesperson—self-service shoe shopping. In past decades, shoe shops were conceptualised from a purely pragmatic point of view. The customer entered the store only to buy a pair of shoes, and

the management's major preoccupations were maximising the number of shoes on display and most efficiently sorting shoes rejected by clients. Nowadays, however, many people enter shoe shops expecting not just a pair of shoes but an *experience*. Shoe stores are not just selling shoes: they're selling a way of life.

Coolhunting [edit]

In March 1997, *The New Yorker* ran a piece by Malcom Gladwell[1] on coolhunters—professional observers of youth culture, particularly in urban areas, who sell their consumer trend projections to corporate clients.[2] They pick the bones of what Sharon Zukin termed "urban lifestyle."[3] All they are, in fact, doing is interpreting the vernacular of popular culture so that multinationals can market it as a product. The piece was circulated widely in marketing offices and design schools.[4] By the time William Gibson's novel *Pattern Recognition* was published in 2003—the protagonist of which is a female coolhunter negotiating her way through a brandscape quagmire— being a coolhunter had acquired status value, and architects had come to understand the close interconnectivity between store architecture and con-

Malcolm Gladwell

sumer behaviour. Thomas Davenport and John Beck's 2002 volume, *The Attention Economy*, explains how the contemporary economy works within the constraints of the public's short attention span. Given that the public's attention is hard to get, it is thus the most valuable commodity. In turn, the value of an item of merchandise can be determined by how

long it can hold our attention. This applies not only to the products we buy but the places where we buy them—just as it is true of shoes, it is true of architecture and interior design. In the past decade, brands have had to radically reevaluate their identities. They are no longer competing simply in terms of their product: they, and the lifestyle they represent, *are* the product.

"I feel like shopping" [edit]

Rem Koolhaas has argued that architects have snubbed shopping for far too long given that it is now one of the main pastimes in urban areas. (The odd sociologist has even expounded the city as a large-scale entertainment zone.⁵) Cities are certainly morphing from once-public spaces to predominantly privately owned zones, largely dominated by shopping malls. A recent example of this is The Grove, a large privately owned "boutique outdoor commercial centre" in downtown Los Angeles camouflaged as a public area. Thousands of square metres devoted to consumption and managed by a single developer, Rick Caruso, have been grafted to the urban tissue and credited with revitalising downtown L.A.

In 2001 Rem Koolhaas and a research team from the Harvard Design School published a paper titled *The Harvard Design School Guide to Shopping,* placing consumer trends under the microscope and effectively opening the door for architects to enter the boundless universe of shopping and fashion. Indeed, it is this very universe that has provided architecture firms with the resources to realise their more experimental projects in recent years. Herzog & de Meuron's 2003 Tokyo "epicentre" for Prada is a six-storey, five-sided glass crystal with diamond-shaped glass panes which vary between flat, concave, and convex "bubbles," its interior all smooth curves throughout despite its sharp exterior angles. For some architects, the potential for creative innovation (and unlimited funds) typified by shopping spaces now embodies the ideal medium in which to forge one's symbolical legacy.

Dozens of pairs of sports shoes clinically arranged side by side on identical shelves.[6] The photograph—taken in 1997 by German photographer Andreas Gursky, the same year that Gladwell's piece was published—illustrates how the modernist taste for minimalism has spread to mass consumerism. The shopping space is now on a par with the art gallery. Writing about New York City's newly opened Prada store for *The New York Times* in December 2001, Herbert Mushamp's title declared, "Forget the Shoes, Prada's New Store Stocks Ideas."[7] Rem Koolhaas' OMA design team arranged the shelves within a large amphitheatre-like basin that puts both the clothes and the clientele on display. With its own calendar of cultural activities, the store aims to function as a public arts venue, thus imbuing the Prada brand with cultural cache. The traditional preoccupation with maximising the goods on display is now secondary to

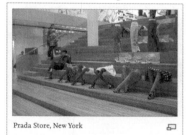

Prada Store, New York

creating a memorable environment using architectural innovation and lavish technology. And the trend for lifestyle branding extends well beyond the luxury goods market: Skating store Supreme has fitted its Los Angeles store with a skate bowl. As more and more architects have received commissions to redesign shopping areas it would appear that fashion, rather than architecture, has come out on top. Or rather, architectural concerns have been subsumed by the dynamics of shopping, reducing form to obsolescent content.

Shoes [edit]

Back to the point: shoes. For the most part they are still sold in traditional stores that smack of air conditioning and suburbia. Foot Locker remains the world's leading sports shoe retailer, its walls literally lined

floor-to-ceiling with shoes. Dressed in their black-and-white-striped uniforms, Foot Locker sales staff fetch your requested size while you sit and wait. But in 2008 it closed one hundred and forty branches in the United States[8]—consumption and shopping are still firmly conditioned by the economy. Architecture has intervened, boosting the symbolic value of certain brands, but it has not yet changed the way people shop. It has simply become another cog in the brand communication machine. Certain architects have exploited the fashion world for self-publicity but without using the shopping space to develop any radically innovative, expressive language. In the general mayhem of marketing strategies, Storefront for Art and Architecture—an American non-profit gallery—has followed in the footsteps of many well-known brands by opening up pop-up stores, only reinforcing the idea of shopping as an event. What could be further from architecture?

LUCA MARTINAZZOLI

Notes [edit]

1. http://www.gladwell.com/1997/1997_03_17_a_cool.htm

2. http://www.look-look.com

3. Sharon Zukin, "Urban Lifestyle: diversity and standardisazion in spaces of consumption."

4. http://varnelis.net/articles/couture

5. Terry Clark, *The City as an Entertainment Machine*, Amsterdam, Netherlands; Boston, MA: Jai/Elsevier, 2004.

6. Andreas Gursky, *Untitled V*, 1997, 185.4 x 443.2 cm, http://www.its.caltech.edu/~squires/gursky/gursky_5.html

7. http://query.nytimes.com/gst/fullpage.html?res=9C0CEEDB113FF935A25751C1A9679C8B63

8. http://www.prnewswire.com/cgi-bin/stories.pl?ACCT=104&STORY=/www/story/03-10-2008/0004771180&EDATE=|

On Synæsthesia

From Wikipedia, the free encyclopedia

Contents [hide]

Synæsthesia (also spelled synaesthesia or synesthesia, plural synaesthesiae or synesthesiae) is a neurologically-based phenomenon in which stimulation of one sensory or cognitive pathway leads to automatic, involuntary experiences in a second sensory or cognitive pathway.

Synæsthesia can occur between nearly any two senses or perceptual modes. In one example of synæsthesia, known as grapheme→colour synæsthesia, letters or numbers are perceived as inherently coloured, while in ordinal linguistic personification numbers, days of the week, and months of the year evoke personalities.

Telekinetic Synæsthesia [edit]

An interpersonal form of synæsthesia known as "Telekinetic Synæsthesia" or "TS" also sometimes occurs between individuals. An experience

of a particular colour or sound in one individual causes a second individual to have an involuntary sensation in a different sensory modality (often a sensation of being tickled). The existence of TS has been acknowledged by people in Haiti for centuries, and pairs of TS "senders" and "receivers" are often used in Voodoo ceremonies. The use of TS in voodoo is the likely source of the widely believed myth that practitioners of voodoo use so-called "voodoo dolls" to harm their enemies.

Effet Fuidique by Edouard 🖾 Isidore-Buguet

Early Origins [edit]

Synæsthesia was known to the ancient Greeks and was discussed by Aristotle in *De Anima*. Aristotle postulated that synæsthesia occurs when the form of the soul becomes dented and can no longer keep impressions of different kinds separated from one another.

A particularly common form of synæsthesia occurs with exposure to photographs of celebrities. Julianne et al. (2005) showed an image of celebrity "it girl" Paris Hilton to a group of subjects, forty percent of whom reported spontaneously feeling a strange sensation of nausea combined with sexual arousal. One subject vomited onto the experimenter's lap.

Research history [edit]

Although there were previous mentions of synæsthesia, the phenomenon was first brought to the attention of the scientific community in the 1880s by Francis Galton. Following these initial observations, research into synæsthesia proceeded briskly, with researchers from England, Germany, France, and the United States all investigating the phenomenon. However, due to the difficulties in assessing and measuring subjective internal

experiences and the rise of behaviourism in psychology, which banished any mention of internal experiences, the study of synæsthesia gradually waned during the 1930s.

Prevalence and genetic basis [edit]

Estimates of the prevalence of synæsthesia have varied widely (from 1 in 20 to 1 in 20,000). However, these studies all suffered from the methodological shortcoming of relying on self-selected samples—that is, the only people included in the studies were those who reported their experiences to the experimenter. Simner et al. (2006) conducted the first random population study, arriving at a prevalence of 1 in 23. Recent data suggests that grapheme →colour, and days of the week→colour variants are most common.

Almost every study that has investigated the topic has suggested that synæsthesia clusters within families, consistent with a genetic origin for the condition. The earliest references to the familial component of synæsthesia date to the 1880s, when Francis Galton first described the condition in *Nature*. Since then, other studies have supported this conclusion. However,

The red cape or *muleta* of the torero

early studies which claimed a much higher prevalence in women than in men (up to 6:1) most likely suffered from a sampling bias due to the fact that women are more likely to self-disclose than men. More recent studies, using random samples find a sex ratio of 1.1:1.

Freudian Forms of Synæsthesia [edit]

Certain forms of synæsthesia may be caused by traumatic incidents in early childhood. An often-cited case is that of "K," a patient studied by the Swiss neuroscientist Zakka Rafran (1927). On viewing the colour pink,

K would instantly hallucinate a deafeningly loud noise and become sexually aroused. Through the techniques of regressive hypnosis and post-coital suggestion, Rafran was able to ascertain that on his sixth birthday K had been chased through the streets of Prague for four days by a man in a pink suit carrying a foghorn, an event he subsequently repressed.

Public Perception of Synæsthesia [edit]

Synæsthesia is the mental disorder ranked most desirable by members of the public, according a 1993 survey carried out by Dartmouth college undergraduates. Asked to rank forty mental disorders on a scale of 1 to 10 based on how awesome they would be to have, members of the public ranked synæsthesia top with an average score of 8.2.

Synæsthesia in Animals [edit]

Not only does synæsthesia occur in human beings, it is also found in animals as diverse as elephants, cats, and dolphins.

A study by Jerdan and Cockrich (2006) revealed evidence that the violent reaction of bulls to the colour red could be linked with synæsthesia. FMRI images taken of a bull's brain while it was shown fabrics of different colours showed that exposure to the colour red caused activity not only in visual but also auditory and tactile areas.

In 1983, blind former polo champion Wolfgang Herrdrer was run over by a tram when his synæsthetic guide dog Bobby heard his command to stop as the smell of meat wafting from across the street. The incident was ranked fifth in the *Chicago Tribune*'s list of the twenty most tragic events of 1983.

Synæsthesia in Literature [edit]

The Bible contains forty-three references to synæsthesia. An interesting

case is the technicolour dreamcoat described as belonging to Joseph in the book of Genesis. "Wearing a dreamcoat" was, in fact, an idiomatic Hebrew expression for having a severe mental illness. In the case of Joseph, it has been speculated by some biblical scholars that he had a rare visual form of synæsthesia that causes the sufferer to experience a shimmering, kaleidoscopic rainbow effect on the surfaces of human bodies.

Dame Mary Barbara Hamilton Cartland

In the 1971 Barbara Cartland novel *The Colour of Love* psychic stable boy Aaron Finch uses his powers as a telekinetic synæsthete to eroginate Lydia, the beautiful daughter of sinister Duke Ballingford. The couple come together when Lydia falls off her horse during a telekinetically-induced orgasm and Aaron rescues her from being trampled. In a memorable final scene, the couple ride naked on horseback through the Duke's country house while inducing a wild array of psychedelic imagery in each other (it turns out that Lydia has TS abilities, too). The book ends with both the couple and horse simultaneously orgasming as they jump from a third floor window.

Synæsthesia and Psychedelic Drug Use [edit]

Synæsthesia may arise through "disinhibited feedback" or a reduction in the amount of inhibition along feedback pathways. Normally, the balance of excitation and inhibition are maintained. However, if normal feedback is not adequately inhibited, then signals coming from later multi-sensory stages of processing might influence earlier stages of processing, so aural tones would activate visual cortical areas in synæsthetes more than in non-synæsthetes. This might explain why some users of psychedelic drugs such as LSD or mescaline report synæsthetic experiences while under the influence of the drug.

My friend Simon and I once took some really amazing mushrooms at a folk festival in Maine. We were walking past a sausage truck when Simon stopped to buy some water. It was getting dark, and I started staring at this guy's T-shirt who was waiting in line to buy a sausage. The T-shirt was old and faded and had an image of a spiral surrounding a woman's face on the front. It appeared to me as if the woman was opening and shutting her mouth in time to the music coming from a nearby clothing stand. The spiral started pulsing and undulating to the beat of the music, and the woman's face suddenly turned menacing. I looked away and noticed that Simon had bought his water and was ready to go somewhere else.

Synæsthesia Self-Test [edit]

Look at this square for five minutes. What did you feel? Did you hear any unusual sounds or hear music playing? Did you taste ice cream or feel like you were being stroked? Did you hear the voice of someone that sounds like you but the voice is angry and it's coming from inside you? Do you

sometimes feel a burning sensation in your heart and mind when you wonder why you're here, what are we all doing, why the fuck am I sitting here doing this just staring at a square like I fucking care about this why am I wasting my time looking at this I'm always looking at a screen why fucking why?

GEOFFREY LEE

A blue square

On Quipu

From Wikipedia, the free encyclopedia

Notation: Reading with both hands [edit]

One of the essential functions of a musical composition and its notation is to instruct the musician *how* to execute the musical ideas of the composer. These directions have a range of sociopolitical implications, often including the musician's collaboration in the process of music-making and even a piece's structural composition. When notations act like logographic or pictographic language, they need to become another sign in order to become meaningful.

St. Jerome, who is said to have written with both hands, can serve as a historical analogue to the musician who literally "reads with both hands" when performing. The reading and, by extension, *manipulation* of material not only references the musician/interpreter's manual labor on his/her

instrument, but also the act of translating the coded musical sign into another meaningful sign.

To borrow philosopher C. S. Peirce's definition, "a sign is not a sign unless it translates itself into another sign in which it is more fully developed." Translating musical or semantically encoded signs is a different type of labor to that performed by the person writing the original signs. The written sign is returned in a different form, as the "read" sign, and yet again returned as meaningful thought, utterance, or performed action.

C. S. Peirce on Signs and Semiotics [edit]

Peirce's studies of logic and mathematics and his development of Pragmatism alongside the philosophers William James and John Dewey have been of critical importance to linguists and semioticians as well as one of the foremost scholars of Incan quipu, Gary Urton. To quote Peirce:

> In intercommunication, likenesses are quite indispensable. Imagine two men who know no common speech, thrown together, remote from the rest of the race. They must communicate; but how are they to do so? By imitative sounds, by imitative gestures, and by pictures. These are three kinds of likenesses. It is true that they will also use other signs, finger-pointings, and the like. But, after all, the likenesses will be the only means of describing the qualities of the things and actions which they have in mind. Rudimentary language, when men first began to talk together, must have largely consisted either in directly imitative words, or in conventional names which they attached to pictures.

Peirce presents us with three sign categories: icons (or "likenesses," which convey ideas of the things they represent by imitating them), indices (which show something about things due to their physical connection with them, such as a guidepost which points down the road to be taken, or a relative pronoun which is placed just after the name of the thing intended to be denoted), and symbols (or "general signs," which have

become associated with their meanings by usage such as most words and phrases). Upon establishing his logic of signs, Peirce is quick to remind us that icons, or likenesses, are deceptive—especially if they are pictorial. They cannot *convey* information as such. We need a further level of mediation and, more particularly, we need more *indications*.

Inca quipu [edit]

An illustration from
The Indian Chronicler by
Felipe Guaman Poma
de Ayala, 1615

Quipu or khipu (sometimes called talking knots) are recording devices used by the Inca Empire and its predecessor societies in the Andean region. A quipu, usually made of coloured spun and plied thread or strings from llama or alpaca hair, consists of cotton cords on which numeric and other values are encoded by knots in a base ten (i.e. decimal) positional system. Quipus may have just a few strands, but some have up to two thousand.

The strings of Incan quipu were not calculating devices or compilers like an abacus—they were used primarily as storage devices. In order to decipher the information stored on them, the reader had to use a set of stones to make the calculations, translating the original sign (knotted string) into another meaningful sign (the numbers compiled by the stones).

The Encoding System [edit]

Quipu scholars Marcia and Robert Ascher, after analysing several hundred quipus, have shown that most of the information on the quipu is numeric, and these numbers can be read. The number, size, position, distance apart, and colour of the knots on the quipu all have particular significance. Each cluster of knots represents a digit, and there are three main types of knots: simple overhand knots; "long knots" consisting of an overhand knot with one or more additional turns; and figure-of-eight knots. Powers of ten are

indicated by the knots' positioning on the string, and this positioning is aligned between successive strands.

Quipucamayocs [edit]

Quipucamayocs, the accountants of Tawantinsuyu, created and deciphered the quipu knots. Quipucamayocs were capable of performing simple mathematical operations such as adding, subtracting, multiplying, and dividing, keeping track of taxation, labor, economic output, and census information for the indigenous people. The system was also used to keep track of the calendar. According to indigenous Peruvian chronicler Guaman Poma (ca. 1550–1616), quipucamayocs could "read" the quipu with their eyes closed.

Conquest [edit]

Quipucamayocs were not the only members of Incan society to use the quipu. Incan historians used the quipu when telling the Spanish about Tawantinsuyu history (whether they recorded important numbers or contained the actual story itself is unknown). Members of the ruling class were usually taught to read the quipu as part of their education.

Some historians believe only the quipucamayoc that made the specific quipu could read it. If this is true it cannot be considered a form of writing but rather a mnemonic device.

Quipu storage capacity [edit]

In terms of raw information storage capacity, Urton explains how the quipu's seven-bit knots are created through their intricate tying:

Six bits are accounted for by the binary construction of the knots themselves. Strings are moved from right to left (2 x 2).

Over or under one another (2 x 2).

To the front or to the back of other strings—recto and verso knots (2 x 2).

Telephone wires in Vietnam

The seventh bit is compiled from the colour combinations of the strings, of which there are twenty-four variations.

Ergo, if six bits equals a binary to the 6th degree (2 to the 6th = 64) and if this is multiplied by 24, we get 64 x 24 = 1536 information units.

This large storage capacity rivals Linear B, Cherokee, and modern Chinese (which uses around 1000 characters in daily use and an average of 2400 out of approximately 5000 for most written language).

Towards a narratology of the quipu [edit]

Over two-thirds of the six hundred or so extant quipus in the world are thought to have been used for accounting purposes, but there exists an anomalous group of quipu that seem to communicate much more than the accounting of materials, people, and taxation. In his book *Signs of the Inka Khipu* (2003), Urton demonstrates the possibility that the knots could be read as a conventionalised representation in the form of a diagrammatic icon. The knots function on the dual level of icon and index; should it be that the quipu do indeed function in a narrative manner, they could also have further symbolic significatory capabilities as well.

Urton argues that an understanding of the knot clusters' binary oppositions can be aided by the linguistic concept markedness theory, the oppositional theory first explored by Roman Jakobson. In this light, Urton expands the possible significance of the seemingly standard binaries' relationships to include not only sociopolitical and cultural values, but also indexically meaningful relations which thus start to function in not

only logographic but also potentially phonographic ways. Urton suggests that the quipu might one day be decoded so we can read the narratives that they might contain.

Quipu binary opposition [edit]

The wider Incan notion of binary opposition is interesting to note here. In Quechua, the language of the Incans (still spoken in modern-day Peru and other parts of northern South America), odd and even numbers represent two related social states—*Ch'ulla* (odd; alone) and *ch'ullantin* (even; pair; the odd one together with its natural partner). This mode of pairing is similar to what we find in ACSII binary code: 3 is grouped with 4, 30 with 40 etc., 0 and 1 makes a pair etc. This relationship, defined by specified absence rather than polar opposition, is closer to the idea of A/non~A than to A/B.

The couplings found in the knots are echoed in the semantic couplings found in Quechuan poetry. In the example below, we can imagine that this poem is a key to the larger cipher of the quipu:

Intiqa	Sun
Kilaqa	Moon
P'unchawqa	Day
Tutaqa	Night
Puquyqa	the season of ripeness
Chirawqa	the season of freshness
Manam yanqachu	do not simply exist
Kamachisqam purin	[but] are ordered

(Cited in Mannheim 1998:245) [1]

The quipu's parallelism essentially relies upon the relationship of the binary pairs encoded on the string to act like the semantic couplets above, or at the very least like binary elements that determine meaning when

combined. The relationship between the quipu and the stones empha-sises that parallelism was essential to their understanding. The re-coding of the stored information on the stones constituted a convention of rep-resentation that necessitated the knots and stones be combined in order to result in the message being recited.[2]

Quipu and musical composition [edit]

Starting from the idea that quipu are storage devices, the analogue be-tween them and a musical score is easy to imagine even though one is a two-dimensional surface with marks and the other is a three-dimensional object composed of manifold self-enclosing moves. A score must be made up of signs requiring translation; it must be read with two hands; and it should include a type of parallelism that allows it to be meaningful to both itself and to its reader. Quipu easily meets these basic prerequisites of a notational device. The knots are mainly indexical and rely more upon reaction than either feeling or thought: In this sense they suggest a more mediate language such as that of gesture. If this were the case, what kind of gestures would be implied? And where in time and space would they happen? What is the musical duration of the quipu?

Should we start from the basic informational capabilities of the seven-bit system and try to make sense of musical time from there, or rather should the indicator be the primary cord upon which all the other cords and knots are tied? Would the primary cord be a key (as Urton has suggested) or perhaps a typology that could be applied to the other cords?

Cords to Chords [edit]

The complexity of the quipus' seventh bit of storage capacity and signifi-cation, namely their colour coding, is where the subtleties of music would most likely reside. Musical composition can be divided into four main

structural categories: pitch, duration, dynamics, and timbre. Both pitch and duration can be represented numerically as twentieth-century serialist composers, change-ringing notation, and even Rousseau's suggestions for numerical notation (later to become *jianpu* or "simplified notation") have demonstrated. The seventh bit could provide the subtle differentiations needed to represent the degrees of dynamics (amplitude and quality thereof) and timbre (variations in the sonic quality of the pitch e.g., plucked, bowed, overblown, mixed with other effects). A combination of the first six bits (primarily used for pitch and duration) with the seventh could provide chords, harmony, rhythm, and expression. Finally, the visual form of the quipu—with its hierarchised knots and colour coding— could be extremely useful in analysing the musical structure of the work without performing it.

Quipu are not only the key to many of our accounts of everyday Incan life, but could also be redeveloped as compositional and storage musical devices. Resuscitating a dead media could bring this incredible system of notation into use and practice once more.

ALEXANDER WATERMAN

Notes [edit]

1. Gary Urton, *Signs of the Inka Khipu*, Austin, University of Texas Press; 2003. This poem was cited on page p.157.

2. Ibid.

On the Portuguese Accent

From Wikipedia, the free encyclopedia

Contents [hide]

Pronunciation [edit]

This article is not about the **Portuguese accent**. It *is* the Portuguese accent in and of itself, and should be read respecting the strict rules of its pronunciation: don't aspirate the H's (read *'ell* instead of *hell* and *tree* instead of *three*); put a slight emphasis on the final accent of each word (read *going'e* and not *goin'*); and do not make a distinction between a double E or an I (*sheep* should sound like *ship*).

Truth and Meaning [edit]

Reading with a Portuguese accent is not an easy task, as Holly Golightly demonstrates in Truman Capote's novel *Breakfast at Tiffany's* and the film of the same name:

> *[SPEAKING PORTUGUESE]*
> *[RECORD STOPS]*
> HOLLY: *Really, darling, I can't tell you how divinely happy I am!*
> PAUL: *What is that, anyhow?*
> HOLLY: *Portuguese—a very complicated language. 4000 irregular verbs.*
> *[SPEAKING PORTUGUESE]*
> PAUL: *Hmm. Very impressive. What's it mean?*

HOLLY: "*I believe you are in love with the butcher.*"
PAUL: *Holly, what's this about?*

Paul has no idea what Golightly is talking about because he doesn't understand Portuguese. He can neither appreciate the beauty of the language—only to be shared by those who speak it—nor understand what Golightly is saying (even if such a silly sentence only proves her weak knowledge of the idiom). Paul is thus unable to communicate as he cannot establish a direct connection between words and images. In this short scene, he manifests the validity

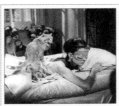

Audrey Hepburn in *Breakfast at Tiffany's,* 1961

of one of Wittgenstein's early crucial points: language is the only means by which we can picture the world. Not knowing Portuguese, Paul is lost and cannot decipher meaning. He cannot tell truth from fiction—Golightly could say anything and he would have no way of telling whether her explanation was correct. Truth and fiction need to be attested by a linguistic system that validates them, as lies only exist when they are contextualized within a system that demonstrates their lack of truth.

A Visual Translation [edit]

In the installation *The Marque of the Third Stripe*, artist Alexandre Singh's gothic horror story of the same name is read aloud by six female Portuguese narrators. It is the soundtrack to a mesmerizing video of over one thousand black-and-white geometric hieroglyphs designed by Singh, each of which represents key words in the tale and appear onscreen at the exact moment a corresponding word is recited.

Still following Wittgenstein's thread, "Pictures are often used instead of words, or to illustrate words." Singh could easily have abused the viewer's ignorance of his self-coded visual language, creating a cause-effect

connection between what the viewer sees and hears and automatically establishing a misleading, fictitious association. In this light, *The Marque of the Third Stripe* can never be true or false. It simply suggests a possibility of occurrence that cannot be proved.

As a mode of communication pictures are subservient to words, exemplified by the relationship between the words recited by the six Portuguese narrators and Singh's hieroglyphs. One never finds out whether these women actually understand English or are just reading aloud unfamiliar words without comprehending what they are saying (as happens in Gary Hill's video *Remarks on Color* [1994], in which the artist's daughter recites a chapter of Wittgenstein's eponymous book with no clue as to what she's talking about). Without knowledge of the whole system and structure of Singh's hieroglyphs, the viewer can never be sure if there is, in fact, any relation between the words and images. Did Singh, in fact, create a whole new grammar to organize his signs? Or are they as aleatory and absurd as The Fiery Furnaces' "My Egyptian Grammar," in which the indie rock band makes bizarre associations between facts and symbols?

> *I consulted my Egyptian Grammar.*
> *On page 333 was the hieroglyph for a motorcycle helmet.*
> *I combined this with a leatherback's shell as I felt I was instructed.*
> *I xeroxed it and posted it down by the bike lock-ups at the Oriental Institute.*
> *Maybe a netherworld entity would see it and pass it on to those responsible.*
> *That kind of thing must happen sometimes.*
> *Now that clearly didn't happen. I consulted my Egyptian Grammar.*
> *On page 428 was the hieroglyph for French Canal boat...*

The Fiery Furnaces' Egyptian grammar has no use or function than to provide nonsense content to accompany a melody. Does Singh's grammar have any other meaning or utility than contributing to the fruition of his work? And how does his use of the Portuguese accent change the implications of the spoken text? What is a Portuguese accent, anyway?

Defining the Indefinable [edit]

The *Oxford American Writer's Thesaurus* provides the words brogue, burr, drawl, and twang as synonyms of "accent." These onomatopoeic, guttural vocables only attest to the difficulty of describing the term. An accent refers to a distinctive mode of pronunciation of a language, generally associated with a specific nation (she speaks English with a Portuguese accent), location (her accent is clearly from the north of Portugal), or even social class (she has a posh accent). What do we infer from the pronunciation of a woman who speaks with a posh accent, who is from Porto in the North of Portugal, and who speaks English with a Portuguese accent? How many nuances can one identify in a single accent? How many accents can a person have?

Being Portuguese, you would think that I speak English with a Portuguese accent. However, people in the UK tend to think I am a posh Australian. In Portugal, people take me for a foreigner who speaks very good Portuguese. Spaniards almost always swear I am Italian. In Italy, I am often asked if I am from the Marche, a north Italian region where the locals tend to drop the double consonants.

The Portuguese accent is a fraudulent notion—a human attempt to classify the unclassifiable. It does not exist as a single entity because it is always multifaceted, plural, impossible to grasp in a single observation. It changes constantly according to the context in which it is expressed. Thus the Portuguese accent should be regarded as a curious fiction—rather like *The Marque of the Third Stripe.*

Reading this story with a Portuguese accent is in itself a tautology and a pleonasm, narrating a fictional story in an indefinable manner, and underpinning one unreality with another. However, if my poor knowledge of logic is not wrong, isn't a double negative a positive statement?

FILIPA RAMOS

On Waffles

From Wikipedia, the free encyclopedia

The Heart-Shaped Waffle [edit]

The Heart-shaped waffle (as opposed to the more usual round or square waffle) was a popular dish in early nintheenth-century Pennsylvania. Its shape derived from its significance at "Waffle Frolics," dances at which waffles were given as mementos by young suitors to their sweethearts at the end of the evening. The phrase "heart-shaped waffle" is still used in some parts of the country, meaning something is light and frivolous but nevertheless sincerely felt (particularly a gift). It can also refer to a statement or pronouncement that is willingly

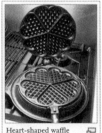

Heart-shaped waffle maker

taken at face value despite being privately understood as likely grounded in no basis of truth.

History [edit]

The technique of cooking a doughy mixture between two heated metal plates was first developed in ancient Greece, but was also employed during the Middle Ages in Europe. At some point between the thirteenth and sixteenth centuries, blacksmiths began making gridded irons specifically designed for the purpose of cooking waffles. By putting a greater surface area of the dough in direct contact with the heat the biscuits cook more quickly, and the resulting waffle provides a sturdier base for sauces or stews. This technique was first introduced to America by Dutch settlers in the northeastern part of the country. While the dish has been modified by various cultures to produce quite different results, the metal grid used in the cooking process has remained the constant in all the waffle's incarnations.

Etymology [edit]

The Middle English word *wafre,* or *wafer,* was first recorded in 1377. It is unclear whether it derived from the Low Germanic word *wâfel,* meaning woven, or the French word *gaufre,* meaning honeycomb, both of which may have referred to the wafer's gridded form.

Dogs [edit]

While in contemporary English language the sound a dog makes is articulated as a "woof," in the seventeenth century it was represented (more accurately) as a "waff." The verb "to waffle" (to bark like a dog) later came to be applied to humans—meaning to chatter senselessly or to gossip.

Frolics [edit]

At this point the word's usage splits and "waffle"—perhaps because of its closeness to the Germanic *wâfel*—started being used in reference to the heart-shaped love wafers given out at the end of dances. The first recorded use of the term "waffle frolic" can be found in an 1855 edition of *Harper's New Monthly Magazine*.[1] The lightness and sweetness of the dish suited the levity of the occasions, at which suitors often gave out large numbers of waffles to young ladies. (It is not coincidental that the heart-shaped waffle iron produces five or six waffles at a time, depending on the design.)

Recipes [edit]

While modern American waffles are made using baking powder, the original waffles eaten at dances in the eighteenth century were made using yeast, as is still the case with Belgian waffles today.

Belgian Waffles [edit]

What we now know of as Belgian waffles are made using yeast and egg whites, producing a lighter and fluffier waffle than both its modern and eighteenth-century counterparts. There are, in fact, two distinct types of Belgian waffle:

The Brussels Waffle [edit]

The Brussels waffle is currently the most popular form of Belgian waffle. It is larger than most other waffles and often has deeper ridges (depending on the type of iron used). The batter is made with yeast, into which stiffly beaten egg whites are gently folded. The entire mixture is then left overnight (if the waffles are to be eaten for breakfast) in order for the dough to rise.

The Liège Waffle [edit]

This waffle is smaller, denser, and sweeter than the Brussels waffle. The egg whites are not beaten separately and nib sugar (or pearl sugar—a large-grain variety of sugar) is added once the dough has risen to give the cooked waffle a caramelised surface. It is thought this was invented by a chef of the Prince-Bishop of Liège in the eighteenth century.

The Prince-Bishopric of Liège [edit]

The Prince-Bishopric of Liège was a small state of the Holy Roman Empire that existed between the tenth and the eighteenth centuries. It controlled a scattered and disparate territory of provinces in what is now Belgium and the Netherlands, first acquiring its secular powers in around 980. The Prince-Bishop de Velbruck, whose cook developed the Liège waffle, was a proponent of the ideas of the French *Encyclopédistes*. It was shortly after the end of de Velbruck's reign that the Prince-Bishopric of Liège was invaded and conquered by France.

The Encyclopédistes [edit]

Part of the group of French intellectuals known as the *philosophes*, the *Encyclopédistes* were dedicated to the compilation of the *Encyclopédie*, the cornerstone and social manifestation of their belief in the redemptive power of human knowledge, reason, and debate. Led by Denis Diderot, the group was bound to the ideas of the French Enlightenment, which led eventually to revolution in France and also the fall of the Prince-Bishopric of Liège.

Title page of the *Encyclopédie*

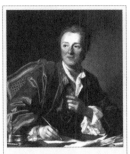

Portrait of Diderot by Louis-Michel van Loo, 1767

Denis Diderot [edit]

Denis Diderot (October 5, 1713–July 31, 1784) was a French philosopher and writer. He became a key figure of the *Encyclopédistes*, leading the quest to create the first French encyclopedia (begun as a simple translation of Ephraim Chambers' *Cyclopædia* of 1728). He is thought to have written about a fifth of the encyclopedia's entries, but as editor he exercised a considerable amount of creative and subjective control over the material at his disposal. He not only embellished certain entries pertaining to otherwise uninteresting subject matter, but also wove deliberate untruths into his entries so he might detect plagiarists subsequently passing off his research as their own. In certain cases his secreted falsehoods were actually adopted as common practice. One notorious example of this phenomenon is the North American folk custom of exchanging heart-shaped waffles at the end of dances, a practice that, despite apparently being invented by Diderot for the reasons explained above, was enthusiastically adopted by young people at the start of the nineteenth century when a translation of the *Encyclopédie* reached America.

JONATHAN GRIFFIN

Notes [edit]

1. *Harper's New Monthly Magazine*, volume 42, issue 252, 1855.

ON THE MARQUE OF THE THIRD STRIPE
http://en.wikipedia.org/wiki/Alps
http://en.wikipedia.org/wiki/Gothic
http://en.wikipedia.org/wiki/Gothic_architecture
http://en.wikipedia.org/wiki/Modernism
http://en.wikipedia.org/wiki/Geometry
http://en.wikipedia.org/wiki/Adidas
http://en.wikipedia.org/wiki/Alexandre_Singh
http://en.wikipedia.org/wiki/Installation_art
http://en.wikipedia.org/wiki/Adidas
http://en.wikipedia.org/wiki/Singh
http://en.wikipedia.org/wiki/Adi_Dassler
http://en.wikipedia.org/wiki/Nineteenth_century
http://en.wikipedia.org/wiki/Gothic_horror
http://en.wikipedia.org/wiki/Halogen
http://en.wikipedia.org/wiki/Gravity
http://en.wikipedia.org/wiki/Sportsperson
http://en.wikipedia.org/wiki/Charles_Maturin
http://en.wikipedia.org/wiki/Melmoth_the_wanderer
http://en.wikipedia.org/wiki/Russian_doll
http://en.wikipedia.org/wiki/Möbius_strip
http://en.wikipedia.org/wiki/Paradox
http://en.wikipedia.org/wiki/Gothic_horror
http://en.wikipedia.org/wiki/Eighteenth_century
http://en.wikipedia.org/wiki/Nineteenth_century
http://en.wikipedia.org/wiki/Dark_ages
http://en.wikipedia.org/wiki/Medieval
http://en.wikipedia.org/wiki/Europe
http://en.wikipedia.org/wiki/Occult
http://en.wikipedia.org/wiki/Neolithic
http://en.wikipedia.org/wiki/Minimalism
http://en.wikipedia.org/wiki/White_Columns
http://en.wikipedia.org/wiki/Smoke_machine
http://en.wikipedia.org/wiki/Romanticism
http://en.wikipedia.org/wiki/
　　Caspar_David_Friedrich

http://en.wikipedia.org/wiki/Primitivism
http://en.wikipedia.org/wiki/Perspex
http://en.wikipedia.org/wiki/Geometry
http://en.wikipedia.org/wiki/Crypt
http://en.wikipedia.org/wiki/Underworld
http://en.wikipedia.org/wiki/Adidas
http://en.wikipedia.org/wiki/Modernist
http://en.wikipedia.org/wiki/Tv
http://en.wikipedia.org/wiki/Medium-
　　density_fibreboard
http://en.wikipedia.org/wiki/Bauhaus
http://en.wikipedia.org/wiki/Video_projection
http://en.wikipedia.org/wiki/Portuguese_people
http://en.wikipedia.org/wiki/Women
http://en.wikipedia.org/wiki/Hypnotism
http://en.wikipedia.org/wiki/Portuguese_language
http://en.wikipedia.org/wiki/English_language
http://en.wikipedia.org/wiki/Black
http://en.wikipedia.org/wiki/White
http://en.wikipedia.org/wiki/Rook_(chess)
http://en.wikipedia.org/wiki/Chess
http://en.wikipedia.org/wiki/Snake
http://en.wikipedia.org/wiki/Betrayal
http://en.wikipedia.org/wiki/Satan
http://en.wikipedia.org/wiki/Sanatorium
http://en.wikipedia.org/wiki/Prehistory
http://en.wikipedia.org/wiki/Brick
http://en.wikipedia.org/wiki/Plaster
http://en.wikipedia.org/wiki/Symbol
http://en.wikipedia.org/wiki/Antonym
http://en.wikipedia.org/wiki/Hypnosis
http://en.wikipedia.org/wiki/Trance
http://en.wikipedia.org/wiki/Grid
http://en.wikipedia.org/wiki/Infinite
http://en.wikipedia.org/wiki/Synchronisation
http://en.wikipedia.org/wiki/Sportsperson

HYPERLINKS

http://en.wikipedia.org/wiki/Existence
http://en.wikipedia.org/wiki/Visual_language
http://en.wikipedia.org/wiki/Waffle
http://en.wikipedia.org/wiki/Priest
http://en.wikipedia.org/wiki/Hallucination
http://en.wikipedia.org/wiki/Occult
http://en.wikipedia.org/wiki/Hp_lovecraft
http://en.wikipedia.org/wiki/Magic_(paranormal)
http://en.wikipedia.org/wiki/Witchcraft
http://en.wikipedia.org/wiki/Capitalism
http://en.wikipedia.org/wiki/Universe
http://en.wikipedia.org/wiki/Chaos

ON H. P. LOVECRAFT

http://en.wikipedia.org/wiki/Nietzsche
http://en.wikipedia.org/wiki/The_Antichrist_(book)
http://en.wikipedia.org/wiki/Lovecraft
http://en.wikipedia.org/wiki/Pulp_magazine
http://en.wikipedia.org/wiki/Gothic_fiction
http://en.wikipedia.org/wiki/Futurism
http://en.wikipedia.org/wiki/1960s
http://en.wikipedia.org/wiki/Science_fiction
http://en.wikipedia.org/wiki/August_Derleth
http://en.wikipedia.org/wiki/EC_Comics
http://en.wikipedia.org/wiki/Vault_of_Horror
http://en.wikipedia.org/wiki/Marvel_comics
http://en.wikipedia.org/wiki/Masters_of_Terror
http://en.wikipedia.org/wiki/Harvey_Kurtzman
http://en.wikipedia.org/wiki/Robert_Crumb
http://en.wikipedia.org/wiki/Counterculture
http://en.wikipedia.org/wiki/LSD
http://en.wikipedia.org/wiki/San_francisco
http://en.wikipedia.org/wiki/Psychedelic_art
http://en.wikipedia.org/wiki/Hippies
http://en.wikipedia.org/wiki/Psychedelic_music
http://en.wikipedia.org/wiki/Acid_rock

http://en.wikipedia.org/wiki/H._P._Lovecraft_(band)
http://en.wikipedia.org/wiki/Procol_harum
http://en.wikipedia.org/wiki/Pink_floyd
http://en.wikipedia.org/wiki/Donovan
http://en.wikipedia.org/wiki/Heavy_metal
http://en.wikipedia.org/wiki/Blue_oyster_cult
http://en.wikipedia.org/wiki/Black_sabbath
http://en.wikipedia.org/wiki/1960s
http://en.wikipedia.org/wiki/1970s
http://en.wikipedia.org/wiki/Lovecraft
http://en.wikipedia.org/wiki/Yog_Sothoth
http://en.wikipedia.org/wiki/Cthulu
http://en.wikipedia.org/wiki/Azathoth
http://en.wikipedia.org/wiki/Edgar_allen_poe
http://en.wikipedia.org/wiki/Algernon_Blackwood
http://en.wikipedia.org/wiki/Horror_fiction
http://en.wikipedia.org/wiki/Alien_autopsy
http://en.wikipedia.org/wiki/
 At_the_mountains_of_madness
http://en.wikipedia.org/wiki/Emmanuel_Levinas
http://en.wikipedia.org/wiki/Racism
http://en.wikipedia.org/wiki/Miscegenation
http://en.wikipedia.org/wiki/
 The_Shadow_Over_Innsmouth
http://en.wikipedia.org/wiki/Monster
http://en.wikipedia.org/wiki/Extraterrestrial_life
http://en.wikipedia.org/wiki/Demon
http://en.wikipedia.org/wiki/DNA
http://en.wikipedia.org/wiki/New_york
http://en.wikipedia.org/wiki/Walter_Benjamin
http://en.wikipedia.org/wiki/Paris
http://en.wikipedia.org/wiki/1930s
http://en.wikipedia.org/wiki/Baudrillard
http://en.wikipedia.org/wiki/Postmodern
http://en.wikipedia.org/wiki/1990s
http://en.wikipedia.org/wiki/Rachel_carson

http://en.wikipedia.org/wiki/Silent_Spring
http://en.wikipedia.org/wiki/1962
http://en.wikipedia.org/wiki/Pesticides
http://en.wikipedia.org/wiki/Conservatism
http://en.wikipedia.org/wiki/Radicalism_(historical)
http://en.wikipedia.org/wiki/Escapism
http://en.wikipedia.org/wiki/Alterity
http://en.wikipedia.org/wiki/Ecology
http://en.wikipedia.org/wiki/Borges
http://en.wikipedia.org/wiki/Houellebecq
http://en.wikipedia.org/wiki/Stephen_king
http://en.wikipedia.org/wiki/Dashiell_Hammett
http://en.wikipedia.org/wiki/Albert_Camus
http://en.wikipedia.org/wiki/William_Burroughs
http://en.wikipedia.org/wiki/Thomas_Pynchon
http://en.wikipedia.org/wiki/Cthulhu_Mythos
http://en.wikipedia.org/wiki/Providence
http://en.wikipedia.org/wiki/New_England
http://en.wikipedia.org/wiki/Rhode_island
http://en.wikipedia.org/wiki/9/11

ON THE LINDOW MAN

http://en.wikipedia.org/wiki/Lindow_man
http://en.wikipedia.org/wiki/Bog_body
http://en.wikipedia.org/wiki/iron_age
http://en.wikipedia.org/wiki/bog
http://en.wikipedia.org/wiki/cheshire
http://en.wikipedia.org/wiki/may_13
http://en.wikipedia.org/wiki/1984
http://en.wikipedia.org/wiki/freeze_dried
http://en.wikipedia.org/wiki/british_museum
http://en.wikipedia.org/wiki/carbon-14
http://en.wikipedia.org/wiki/2_BC
http://en.wikipedia.org/wiki/119_AD
http://en.wikipedia.org/wiki/garotte
http://en.wikipedia.org/wiki/Lindow_Moss

http://en.wikipedia.org/wiki/Celts
http://en.wikipedia.org/wiki/Triplism
http://en.wikipedia.org/wiki/London_marathon
http://en.wikipedia.org/wiki/Acid
http://en.wikipedia.org/wiki/Cereal
http://en.wikipedia.org/wiki/Mistletoe
http://en.wikipedia.org/wiki/Druid
http://en.wikipedia.org/wiki/Archaeology
http://en.wikipedia.org/wiki/Beltane
http://en.wikipedia.org/wiki/May_day
http://en.wikipedia.org/wiki/Glauberg
http://en.wikipedia.org/wiki/Germany
http://en.wikipedia.org/wiki/Hallucination
http://en.wikipedia.org/wiki/Human_sacrifice
http://en.wikipedia.org/wiki/Lugus
http://en.wikipedia.org/wiki/Wales
http://en.wikipedia.org/wiki/Shoemaking
http://en.wikipedia.org/wiki/Guild
http://en.wikipedia.org/wiki/Welsh_Triads
http://en.wikipedia.org/wiki/Otherworld
http://en.wikipedia.org/wiki/Jugular_vein
http://en.wikipedia.org/wiki/Garrote
http://en.wikipedia.org/wiki/Spirit
http://en.wikipedia.org/wiki
 Gravitational_pull#Earth.27s_gravity
http://en.wikipedia.org/wiki/Prophecy
http://en.wikipedia.org/wiki/Pliny_the_Elder
http://en.wikipedia.org/wiki/Mistletoe
http://en.wikipedia.org/wiki/Adidas
http://en.wikipedia.org/wiki/Dry_ice

ON ADIDAS

http://en.wikipedia.org/wiki/1986
http://en.wikipedia.org/wiki/Run_dmc
http://en.wikipedia.org/wiki/Hip_hop_music
http://en.wikipedia.org/wiki/Philadelphia

http://en.wikipedia.org/wiki/Run_dmc#Singles
http://en.wikipedia.org/wiki/Joseph_Simmons
http://en.wikipedia.org/wiki/Darryl_McDaniels
http://en.wikipedia.org/wiki/Adidas
http://en.wikipedia.org/wiki/1924
http://en.wikipedia.org/wiki/Herzogenaurach
http://en.wikipedia.org/wiki/Bavaria
http://en.wikipedia.org/wiki/Adolf_Dassler
http://en.wikipedia.org/wiki/Multinational_
corporation
http://en.wikipedia.org/wiki/Sportsperson
http://en.wikipedia.org/wiki/Athletic_shoe
http://en.wikipedia.org/wiki/Raymond_Pettibon
http://en.wikipedia.org/wiki/'80s
http://en.wikipedia.org/wiki/Hardcore_punk
http://en.wikipedia.org/wiki/Black_Flag_(band)
http://en.wikipedia.org/wiki/Track_and_field_
athletics
http://en.wikipedia.org/wiki/1954
http://en.wikipedia.org/wiki/Fritz_Walter
http://en.wikipedia.org/wiki/
Football_in_germany#FIFA_World_Cup_1954
http://en.wikipedia.org/wiki/
Hungary_national_football_team
http://en.wikipedia.org/wiki/Ferenc_Puskas
http://en.wikipedia.org/wiki/FIFA_World_Cup
http://en.wikipedia.org/wiki/1954_World_Cup_Final
http://en.wikipedia.org/wiki/Jesse_Owens
http://en.wikipedia.org/wiki/Mohammad_Ali
http://en.wikipedia.org/wiki/Max_Schmeling
http://en.wikipedia.org/wiki/Sepp_Herberger
http://en.wikipedia.org/wiki/Franz_Beckenbauer
http://en.wikipedia.org/wiki/1963
http://en.wikipedia.org/wiki/Football_(ball)
http://en.wikipedia.org/wiki/1970
http://en.wikipedia.org/wiki/1978

http://en.wikipedia.org/wiki/Joint_stock_company
http://en.wikipedia.org/wiki/2000
http://en.wikipedia.org/wiki/Yohji_Yamamoto
http://en.wikipedia.org/wiki/Adidas
http://en.wikipedia.org/wiki/Nike,_Inc.
http://en.wikipedia.org/wiki/Puma_AG
http://en.wikipedia.org/wiki/New_Balance
http://en.wikipedia.org/wiki/Nike_logo
http://en.wikipedia.org/wiki/1970s
http://en.wikipedia.org/wiki/Rave

ON SHOP ARCHITECTURE
http://en.wikipedia.org/wiki/Shoe
http://en.wikipedia.org/wiki/Retailing#Retail_types
http://en.wikipedia.org/wiki/Customer
http://en.wikipedia.org/wiki/Inventory
http://en.wikipedia.org/wiki/Outlet_store
http://en.wikipedia.org/wiki/
Salesperson#Sales_agents
http://en.wikipedia.org/wiki/Shopping
http://en.wikipedia.org/wiki/Management
http://en.wikipedia.org/wiki/Subjective_experience
http://en.wikipedia.org/wiki/Lifestyle
http://en.wikipedia.org/wiki/March_1997
http://en.wikipedia.org/wiki/The_New_Yorker
http://en.wikipedia.org/wiki/Malcom_Gladwell
http://en.wikipedia.org/wiki/Coolhunting
http://en.wikipedia.org/wiki/List_of_subcultures
http://en.wikipedia.org/wiki/Urban_area
http://en.wikipedia.org/wiki/Corporation
http://en.wikipedia.org/wiki/Sharon_Zukin
http://en.wikipedia.org/wiki/Vernacular
http://en.wikipedia.org/wiki/Popular_culture
http://en.wikipedia.org/wiki/Multinationals
http://en.wikipedia.org/wiki/William_Gibson
http://en.wikipedia.org/wiki/

Pattern_Recognition_(novel)
http://en.wikipedia.org/wiki/2003
http://en.wikipedia.org/wiki/Architect
http://en.wikipedia.org/wiki/Architecture
http://en.wikipedia.org/wiki/Thomas_H._Davenport
http://en.wikipedia.org/wiki/2002
http://en.wikipedia.org/wiki/Attention_economy
http://en.wikipedia.org/wiki/Economy
http://en.wikipedia.org/wiki/Commodity
http://en.wikipedia.org/wiki/Interior_design
http://en.wikipedia.org/wiki/Brand#Brand_identity
http://en.wikipedia.org/wiki/Rem_Koolhaas
http://en.wikipedia.org/wiki/Leisure
http://en.wikipedia.org/wiki/Sociology
http://en.wikipedia.org/wiki/Public_space
http://en.wikipedia.org/wiki/Shopping_mall
http://en.wikipedia.org/wiki/
 The_Grove_at_Farmers_Market
http://en.wikipedia.org/wiki/
 Downtown_Los_Angeles
http://en.wikipedia.org/wiki/2001
http://en.wikipedia.org/wiki/
 Harvard_Graduate_School_of_Design
http://en.wikipedia.org/wiki/Fashion
http://en.wikipedia.org/wiki/1997
http://en.wikipedia.org/wiki/Germans
http://en.wikipedia.org/wiki/Photographer
http://en.wikipedia.org/wiki/Andreas_Gursky
http://en.wikipedia.org/wiki/Minimalism
http://en.wikipedia.org/wiki/Consumerism
http://en.wikipedia.org/wiki/New_York_City
http://en.wikipedia.org/wiki/Prada
http://en.wikipedia.org/wiki/New_York_Times
http://en.wikipedia.org/wiki/December_2001
http://en.wikipedia.org/wiki/
 Office_for_Metropolitan_Architecture

http://en.wikipedia.org/wiki/Amphitheatre
http://en.wikipedia.org/wiki/Luxury_goods
http://en.wikipedia.org/wiki/Skateboarding
http://en.wikipedia.org/wiki/Skatepark
http://en.wikipedia.org/wiki/Air_conditioning
http://en.wikipedia.org/wiki/Suburbia#Suburbia
http://en.wikipedia.org/wiki/Foot_Locker
http://en.wikipedia.org/wiki/Black_and_white
http://en.wikipedia.org/wiki/2008
http://en.wikipedia.org/wiki/United_States
http://en.wikipedia.org/wiki/
 Business_communication
http://en.wikipedia.org/wiki/
 Storefront_for_Art_and_Architecture
http://en.wikipedia.org/wiki/Non-profit

ON SYNÆSTHESIA

http://en.wikipedia.org/wiki/Synæsthesia
http://en.wikipedia.org/wiki/Neurology
http://en.wikipedia.org/wiki/Phenomena_
 (philosophy)
http://en.wikipedia.org/wiki/Sense
http://en.wikipedia.org/wiki/Perception
http://en.wikipedia.org/wiki/Telekinesis
http://en.wikipedia.org/wiki/Tickle
http://en.wikipedia.org/wiki/Haiti
http://en.wikipedia.org/wiki/Haitian_Vodou
http://en.wikipedia.org/wiki/Voodoo_doll#
 Myths_and_misconceptions
http://en.wikipedia.org/wiki/Ancient_Greece
http://en.wikipedia.org/wiki/Aristotle
http://en.wikipedia.org/wiki/De_Anima
http://en.wikipedia.org/wiki/Soul
http://en.wikipedia.org/wiki/Photographs
http://en.wikipedia.org/wiki/Celebrities
http://en.wikipedia.org/wiki/It_girl

http://en.wikipedia.org/wiki/Paris_Hilton
http://en.wikipedia.org/wiki/Nausea
http://en.wikipedia.org/wiki/Tumescence
http://en.wikipedia.org/wiki/Vomit
http://en.wikipedia.org/wiki/1880s
http://en.wikipedia.org/wiki/Francis_Galton
http://en.wikipedia.org/wiki/Behaviorism
http://en.wikipedia.org/wiki/Psychology
http://en.wikipedia.org/wiki/1930s
http://en.wikipedia.org/wiki/Self-selection
http://en.wikipedia.org/wiki/Nature_(journal)
http://en.wikipedia.org/wiki/Biased_sample
http://en.wikipedia.org/wiki/Swiss
http://en.wikipedia.org/wiki/Neuroscience
http://en.wikipedia.org/wiki/Zakka_Rafran
http://en.wikipedia.org/wiki/Pink
http://en.wikipedia.org/wiki/Hallucination
http://en.wikipedia.org/wiki/Hypnosis
http://en.wikipedia.org/wiki/Prague
http://en.wikipedia.org/wiki/Foghorn
http://en.wikipedia.org/wiki/Mental_disorder
http://en.wikipedia.org/wiki/1993
http://en.wikipedia.org/wiki/Dartmouth_College
http://en.wikipedia.org/wiki/Undergraduate
http://en.wikipedia.org/wiki/Elephants
http://en.wikipedia.org/wiki/Cats
http://en.wikipedia.org/wiki/Dolphins
http://en.wikipedia.org/wiki/Harold_Jerdan
http://en.wikipedia.org/wiki/Eleanor_Cockrich
http://en.wikipedia.org/wiki/Bullfight
http://en.wikipedia.org/wiki/Red
http://en.wikipedia.org/wiki/FMRI
http://en.wikipedia.org/wiki/Brain
http://en.wikipedia.org/wiki/1983
http://en.wikipedia.org/wiki/Blindness
http://en.wikipedia.org/wiki/Polo

http://en.wikipedia.org/wiki/Wolfgang_Herrdrer
http://en.wikipedia.org/wiki/Tram
http://en.wikipedia.org/wiki/Guide_dog
http://en.wikipedia.org/wiki/Chicago_Tribune
http://en.wikipedia.org/wiki/Bible
http://en.wikipedia.org/wiki/
 Joseph_(Hebrew_Bible)
http://en.wikipedia.org/wiki/Genesis
http://en.wikipedia.org/wiki/Idiom
http://en.wikipedia.org/wiki/Hebrew
http://en.wikipedia.org/wiki/Kaleidoscope
http://en.wikipedia.org/wiki/Rainbow
http://en.wikipedia.org/wiki/1971
http://en.wikipedia.org/wiki/Barbara_Cartland
http://en.wikipedia.org/wiki/Barbara
 Cartland#Novels
http://en.wikipedia.org/wiki/Horse
http://en.wikipedia.org/wiki/Orgasm
http://en.wikipedia.org/wiki/Psychedelia
http://en.wikipedia.org/wiki/
 Neural_basis_of_synesthesia
http://en.wikipedia.org/wiki/Visual_cortex
http://en.wikipedia.org/wiki/Psychedelics,_
 dissociatives_and_deliriants
http://en.wikipedia.org/wiki/LSD
http://en.wikipedia.org/wiki/Mescaline
http://en.wikipedia.org/wiki/Simon_says
http://en.wikipedia.org/wiki/Mushrooms
http://en.wikipedia.org/wiki/Folk_festival
http://en.wikipedia.org/wiki/Maine
http://en.wikipedia.org/wiki/Hot_dog
http://en.wikipedia.org/wiki/Dasani
http://en.wikipedia.org/wiki/Spiral
http://en.wikipedia.org/wiki/Square_(geometry)
http://en.wikipedia.org/wiki/Ice_cream
http://en.wikipedia.org/wiki/Anger

http://en.wikipedia.org/wiki/Internal_monologue
http://en.wikipedia.org/wiki/Computer_screen

ON QUIPU

http://en.wikipedia.org/wiki/Musical_composition
http://en.wikipedia.org/wiki/Musical_notation
http://en.wikipedia.org/wiki/Musician
http://en.wikipedia.org/wiki/Musical_composer
http://en.wikipedia.org/wiki/Logographic
http://en.wikipedia.org/wiki/Pictographic
http://en.wikipedia.org/wiki/Sign
http://en.wikipedia.org/wiki/St._Jerome
http://en.wikipedia.org/wiki/
Eye_movement_in_music_reading
http://en.wikipedia.org/wiki/Philosopher
http://en.wikipedia.org/wiki/C.S._Peirce
http://en.wikipedia.org/wiki/Logic
http://en.wikipedia.org/wiki/Mathematics
http://en.wikipedia.org/wiki/Pragmatism
http://en.wikipedia.org/wiki/William_James
http://en.wikipedia.org/wiki/John_Dewey
http://en.wikipedia.org/wiki/Linguistics
http://en.wikipedia.org/wiki/Semiotics
http://en.wikipedia.org/wiki/Inca_Empire
http://en.wikipedia.org/wiki/Quipu
http://en.wikipedia.org/wiki/Gary_Urton
http://en.wikipedia.org/wiki/Icon
http://en.wikipedia.org/wiki/Index
http://en.wikipedia.org/wiki/Symbol
http://en.wikipedia.org/wiki/Image
http://en.wikipedia.org/wiki/Quipu
http://en.wikipedia.org/wiki/Inca_Empire
http://en.wikipedia.org/wiki/
Cultural_periods_of_Peru
http://en.wikipedia.org/wiki/Andes
http://en.wikipedia.org/wiki/Llama

http://en.wikipedia.org/wiki/Alpaca
http://en.wikipedia.org/wiki/Hair
http://en.wikipedia.org/wiki/Cotton
http://en.wikipedia.org/wiki/Base_(mathematics)
http://en.wikipedia.org/wiki/10_(number)
http://en.wikipedia.org/wiki/Decimal
http://en.wikipedia.org/wiki/Image:Yupana_1.GIF
http://en.wikipedia.org/wiki/Abacus
http://en.wikipedia.org/wiki/Information_storage
http://en.wikipedia.org/wiki/Number
http://en.wikipedia.org/wiki/Knot
http://en.wikipedia.org/wiki/Numerical_digit
http://en.wikipedia.org/wiki/Overhand_knot
http://en.wikipedia.org/wiki/Figure-of-eight_knot
http://en.wikipedia.org/wiki/Accountant
http://en.wikipedia.org/wiki/Tawantinsuyu
http://en.wikipedia.org/wiki/Mathematics
http://en.wikipedia.org/wiki/Addition
http://en.wikipedia.org/wiki/Subtraction
http://en.wikipedia.org/wiki/Multiplication
http://en.wikipedia.org/wiki/
Division_(mathematics)
http://en.wikipedia.org/wiki/Taxation
http://en.wikipedia.org/wiki/Labour_(economics)
http://en.wikipedia.org/wiki/Economic_output
http://en.wikipedia.org/wiki/Census
http://en.wikipedia.org/wiki/Indigenous_peoples
http://en.wikipedia.org/wiki/Calendar
http://en.wikipedia.org/wiki/Guaman_Poma
http://en.wikipedia.org/wiki/Historian
http://en.wikipedia.org/wiki/Spanish_conquest
http://en.wikipedia.org/wiki/Mnemonic
http://en.wikipedia.org/wiki/Seven
http://en.wikipedia.org/wiki/Bit
http://en.wikipedia.org/wiki/
Binary_numeral_system

http://en.wikipedia.org/wiki/Linear_B
http://en.wikipedia.org/wiki/Cherokee_language
http://en.wikipedia.org/wiki/Chinese_language
http://en.wikipedia.org/wiki/Gary_Urton
http://en.wikipedia.org/wiki/Markedness
http://en.wikipedia.org/wiki/Roman_Jakobson
http://en.wikipedia.org/wiki/Narrative
http://en.wikipedia.org/wiki/Binary_opposition
http://en.wikipedia.org/wiki/Quechua
http://en.wikipedia.org/wiki/Peru
http://en.wikipedia.org/wiki/South_America
http://en.wikipedia.org/wiki/Parity_(mathematics)
http://en.wikipedia.org/wiki/Ascii
http://en.wikipedia.org/wiki/Binary_code
http://en.wikipedia.org/wiki/Poetry
http://en.wikipedia.org/wiki/Sheet_music
http://en.wikipedia.org/wiki/Dimension
http://en.wikipedia.org/wiki/Height
http://en.wikipedia.org/wiki/Manifold
http://en.wikipedia.org/wiki/Gesture
http://en.wikipedia.org/wiki/Time_(musical)
http://en.wikipedia.org/wiki/Serialism
http://en.wikipedia.org/wiki/Change-ringing
http://en.wikipedia.org/wiki/Numerical_notation
http://en.wikipedia.org/wiki/Amplitude
http://en.wikipedia.org/wiki/Timbre
http://en.wikipedia.org/wiki/Pitch_(music)
http://en.wikipedia.org/wiki/Time
http://en.wikipedia.org/wiki/Chord_(music)
http://en.wikipedia.org/wiki/Harmony
http://en.wikipedia.org/wiki/Rhythm
http://en.wikipedia.org/wiki/Dead_media

ON THE PORTUGUESE ACCENT
http://en.wikipedia.org/wiki/Portuguese_language
http://en.wikipedia.org/wiki/Accent_(linguistics)

http://en.wikipedia.org/wiki/H
http://en.wikipedia.org/wiki/Syllable
http://en.wikipedia.org/wiki/Glottal_stop
http://en.wikipedia.org/wiki/E
http://en.wikipedia.org/wiki/I
http://en.wikipedia.org/wiki/Holly_Golightly
http://en.wikipedia.org/wiki/Truman_Capote
http://en.wikipedia.org/wiki/Breakfast_at_Tiffany's
http://en.wikipedia.org/wiki/
 John_%22Hannibal%22_Smith
http://en.wikipedia.org/wiki/Language
http://en.wikipedia.org/wiki/Idiom
http://en.wikipedia.org/wiki/Wittgenstein
http://en.wikipedia.org/wiki/Truth
http://en.wikipedia.org/wiki/Fiction
http://en.wikipedia.org/wiki/Alexandre_Singh
http://en.wikipedia.org/wiki/Cause
http://en.wikipedia.org/wiki/Association_of_Ideas
http://en.wikipedia.org/wiki/Geometry
http://en.wikipedia.org/wiki/Hieroglyph
http://en.wikipedia.org/wiki/Logogram
http://en.wikipedia.org/wiki/Computer_screen
http://en.wikipedia.org/wiki/English_language
http://en.wikipedia.org/wiki/Gary_Hill
http://en.wikipedia.org/wiki/Daughter
http://en.wikipedia.org/wiki/Eponym
http://en.wikipedia.org/wiki/Singh
http://en.wikipedia.org/wiki/Grammar
http://en.wikipedia.org/wiki/Sign_(semiotics)
http://en.wikipedia.org/wiki/Absurdism
http://en.wikipedia.org/wiki/The_Fiery_Furnaces
http://en.wikipedia.org/wiki/Egypt
http://en.wikipedia.org/wiki/Indie_rock
http://en.wikipedia.org/wiki/Nonsense
http://en.wikipedia.org/wiki/Melody
http://en.wikipedia.org/wiki/North_of_Portugal

http://en.wikipedia.org/wiki/Social_class
http://en.wikipedia.org/wiki/
 Port_Out,_Starboard_Home
http://en.wikipedia.org/wiki/Porto
http://en.wikipedia.org/wiki/UK
http://en.wikipedia.org/wiki/Australia
http://en.wikipedia.org/wiki/Alien_(law)
http://en.wikipedia.org/wiki/Spaniards
http://en.wikipedia.org/wiki/Italians
http://en.wikipedia.org/wiki/Italy
http://en.wikipedia.org/wiki/Marche
http://en.wikipedia.org/wiki/Brogue
http://en.wikipedia.org/wiki/Guttural_R
http://en.wikipedia.org/wiki/Drawl
http://en.wikipedia.org/wiki/
 Southern_American_English
http://en.wikipedia.org/wiki/Synonym
http://en.wikipedia.org/wiki/Onomatopoeia
http://en.wikipedia.org/wiki/Vocable
http://en.wikipedia.org/wiki/Tautology_(rhetoric)
http://en.wikipedia.org/wiki/Pleonasm
http://en.wikipedia.org/wiki/Logic
http://en.wikipedia.org/wiki/Double_negative

ON WAFFLES

http://en.wikipedia.org/wiki/Waffle
http://en.wikipedia.org/wiki/19th_century
http://en.wikipedia.org/wiki/Pennsylvania
http://en.wikipedia.org/wiki/Dance
http://en.wikipedia.org/wiki/Courtship
http://en.wikipedia.org/wiki/Truth
http://en.wikipedia.org/wiki/Dough
http://en.wikipedia.org/wiki/Ancient_greece
http://en.wikipedia.org/wiki/Middle_ages
http://en.wikipedia.org/wiki/13th_century
http://en.wikipedia.org/wiki/16_century

http://en.wikipedia.org/wiki/Blacksmith
http://en.wikipedia.org/wiki/Biscuit
http://en.wikipedia.org/wiki/United_States
http://en.wikipedia.org/wiki/Dutch_empire
http://en.wikipedia.org/wiki/Middle_english
http://en.wikipedia.org/wiki/1377
http://en.wikipedia.org/wiki/Low_German
http://en.wikipedia.org/wiki/French_language
http://en.wikipedia.org/wiki/English_language
http://en.wikipedia.org/wiki/
 Bark_%28dog%29#Representation
http://en.wikipedia.org/wiki/17_century
http://en.wikipedia.org/wiki/1855
http://en.wikipedia.org/wiki/Harper%27s_Magazine
http://en.wikipedia.org/wiki/Baking_powder
http://en.wikipedia.org/wiki/18th_century
http://en.wikipedia.org/wiki/Yeast
http://en.wikipedia.org/wiki/Belgian
http://en.wikipedia.org/wiki/Albumen
http://en.wikipedia.org/wiki/Brussels
http://en.wikipedia.org/wiki/
 Proofing_%28baking_technique%29
http://en.wikipedia.org/wiki/Nib_sugar
http://en.wikipedia.org/wiki/Caramelization
http://en.wikipedia.org/wiki/Chef
http://en.wikipedia.org/wiki/Bishopric_of_Liège
http://en.wikipedia.org/wiki/Holy_Roman_Empire
http://en.wikipedia.org/wiki/10th_century
http://en.wikipedia.org/wiki/18th_century
http://en.wikipedia.org/wiki/Belgium
http://en.wikipedia.org/wiki/Netherlands
http://en.wikipedia.org/wiki/Secularity
http://en.wikipedia.org/wiki/980
http://en.wikipedia.org/wiki/Encyclopedistes
http://en.wikipedia.org/wiki/Revolution_Liégeoise
http://en.wikipedia.org/wiki/Rive_gauche

http://en.wikipedia.org/wiki/Philosophes
http://en.wikipedia.org/wiki/Encyclopedie
http://en.wikipedia.org/wiki/Diderot
http://en.wikipedia.org/wiki/Age_of_Enlightenment
http://en.wikipedia.org/wiki/French_revolution
http://en.wikipedia.org/wiki/Diderot
http://en.wikipedia.org/wiki/Ephraim_Chambers
http://en.wikipedia.org/wiki/Cyclopaedia,_or_
 Universal_Dictionary_of_Arts_and_Sciences
http://en.wikipedia.org/wiki/1728
http://en.wikipedia.org/wiki/American_Folk_Art

THE MARQUE OF THE THIRD STRIPE

FACSIMILE PLATES

*The following thirty-four plates are an accurate reproduction
of the original imprint. Any marks, names, colophons,
logos, or other symbols or identifiers that appear on or in this book
are used only for historical reference and accuracy.*

Make yourself grow to a greatness beyond measure, by a bound free yourself from the body; raise yourself above all time, become Eternity; then you will understand God. Believe that for you, impossible is nothing, think yourself immortal and capable of understanding all, all arts, all sciences, the nature of every living being. Mount higher than the highest height; descend lower than the lowest depth.... [Imagine] that you are everywhere, on earth, in the sea, in the sky, that you are not yet born, in the maternal womb, adolescent, old, dead, beyond death. If you embrace in your thoughts all things at once, times, places, substances, qualities, quantities, you may understand God.

HERMES TRISMEGISTUS

NUMBER ONE
THE MEDICIAN

"OF THIS TALE I simply cannot guarantee a single word. It was muttered to me on the breath of a dying man. The delusions that gripped him at the threshold of death may have appeared exotic to say the least. Yet they are a little less remarkable when tempered with the extravagances uttered by his lips in life. I speak of the gentleman Adolf Dassler, known as Adi.

How I came to know Adi Dassler is a story well worth recounting, though it pains me to do so. Thinking now over the events of those last years I am overcome with a queer feeling—or as it is described in my profession, a nausea of the psyche.

I was then, as I am now, the principal Doctor of this little town. Herzogenaurach nestles in a region of folded valleys towered over by the alarming spectre of the northern Alps. You may have heard unpleasant tales told of the inhabitants of this particular province. Be assured that to this day I still do not share the unnatural countenance of these people. I suppose it may have something to do with the spending of one's formative years in the region; perhaps as a consequence of the unusual flora and fauna. Just what exactly it is about this populace that disturbs me so I find hard to put into words. Do I imagine that their sullen reticence hides decayed occult practices? Or am I right in my concern that the accursed prehistoric rituals that modern city folk laugh at and decry as old wives' tales are indeed alive and thriving in the dark backwater hamlets of these mountains? In my time here I have witnessed peoples and events that would have chilled the most fervoured sceptics. You may amuse yourself to imagine me as feeble and superstitious as these rustic peoples, yet I was educated in the finest rational and scientific traditions of our age. Indeed, my roots lie not in this new

untested world but back in the grand old Americas.

I studied at the great medical school of Providence for seven years before earning my doctorate. There I learned the most contemporary chemical and biological knowledge, all that there is to do with the human temperament—the flesh, the humours, even the conscious mind. Though I did later come to wish that I had paid a great more attention to the latter and in particular to its most abnormal divergences.

After completing my studies, I decided to try for a life in this new world. My wife was pregnant with our first child and I had been offered passage *gratis*, acting in the capacity of the ship's doctor. Arriving in the port of Amsterdam in the land of the low people, the Savage Dutch, we made our way inland on treacherous roads into Germania and finally on to the small town of Herzogenaurach.

The town is nestled in a valley towered over by three huge peaks. The ancient Alps lie only a little southwards. In the summer months fiery sunsets and evening fogs shroud the peaks in eldritch colours and auroras. The weather varies in great magnitude, from those torpid summers of unbearable humidity to the harshest winters. I suspected that this peculiar climate had a direct relation to the unnatural bearing of these people. From the first snows, even up to the vernal equinox, most of the roads are impassable. The small communities surrounding the township are cut off for long periods of many months. In this time of isolation, stories and legends long forgotten are retold around log fires. Practices deemed heretical by the mother church simmer in pockets in the hills. From time to time, once the snows and ice have melted, travellers tell of coming across whole hamlets whose residents have entirely vanished. Curiously, there are no signs of departure. Whole pots of food lie uncooked on stoves, baths that have been drawn stand untaken and beds lie unmade. Local legend has it that the disappearances are a terrible sacrifice made to the Winter, and that as he slips away with the snow the villages too melt out of our existence.

III

When I first arrived, the town was still made up in large part by the early frontiersmen, the descendants of the explorers that first pushed inland, braving the fierce European winters and breaching the barrier of the great Rhine. At that time, very few of the autochthonous peoples had been civilized enough to cohabit with

us in the settlements. Yet, by the end of my stay, a fair few were working there, some engaged in the trade routes, but most working as artisans and builders.

Now this town of Herzogenaurach was organised in an unusual manner that I should describe in further detail. To the casual observer—an immigrant making his way east, stopping for a night of respite at the inn—it would appear like any other lively frontier town, as it did indeed to us upon our first arrival. While we searched urgently for more permanent accommodation, we resided in the hotel at the centre of town for a number of weeks. I did not find it the most agreeable of environments and was very glad when we finally left it. The very night of our first arrival I remember that I slept very badly. In the centre of the night, I was struck by the most curious and frightening dream.

I found myself to be a savage European, a primitive being from the deepest mountains of the Alps. I was chained with a gang of my own kind, labouring in a vault far below the ground on a structure that I did not recognise. It was an edifice of white, unbroken rock shaped in curious angles of 90°. In the vision, I succumbed to fatigue brought about by narcotic intoxication and fell into a deep stupor. I, the primitive at that moment, dreamt that I was a modern man. I was a doctor residing in a hotel in an unknown settlement. In the vision within the vision I saw myself, eyes closed, about to enter a reverie. I perceived this primitive man, dressed in these modern clothes, flat on his back. There was a presence at the door. I could feel it there, expectant. I felt a great dread come over me. All of a sudden there was a tremendous knocking and I started awake. My hand lashed out and knocked over my thermometer that I always keep by my bedside table. It crashed to the ground, cracking open and spilling mercury on to the floor. The liquid seeped quickly into the cracks of the pitted floorboards. I know that it was dark and that I was exhausted, but in that moment when I saw the element slipping into the gaps in the floor it seemed to me that it had a purpose in the way that it moved. It was as if it was seeking a passage down. Or possibly that some force was drawing it below.

The crash woke my wife. Upon my insistence she rose and checked to see if there was anyone at the door. The corridor was dark and utterly empty. My mood upon waking that night developed into a disturbing sentiment that I was unable to shake off for

weeks. My wife consoled me, ascribing the vision to the unusual sounds and odours of the foreign town and to my weakness from the long voyage. I eventually convinced myself that it was indeed the interminable noise and bustle of the town that affected me so and later, as we moved into our current abode on Fog Street, my uneasiness passed and the episode slipped from my thoughts.

The constant activity of the town was something that one inevitably became used to. All the shops, smitheries, tanneries, hypothecaries and so on were open all day and all night churning out goods. Carts arrived daily from faraway ports bringing supplies of strange materials, rubbers, oils and malodorous chemicals, the slightest whiff of which would bring bile to the throat. None of these carts, however, stopped for very long in the town. All of their deliveries were intended for the factory high up on the promontory. The factory of Adolf Dassler. And if a visitor were to make more inquiries, he would learn that the tools the smith was forging were for the benefit of the factory, the bread of the bakers the same. In fact, the entire activity of the town had but one single purpose—to provide for the continuous operation of that castle upon the hill.

Now I spoke of how little we saw the savage man in town. Curiously, despite the scarcity of indigenous labour, not one of the labourers at the Adi Dassler factory was a colonist. Every single one was a European barbarian. Adi claimed that their craftsmanship and productivity were unsurpassed, yet the idle talk of the town was that he was more interested in their primitive rituals. I myself suspected that it had more to do with the sullen and uncommunicative nature of those peoples. If there were strange goings on, the townsfolk were unlikely to hear of it from the savages.

At the time that I arrived, Adi's power was at its peak. The sporting goods produced at the factory, primarily the new vulcanized shoes, were responsible for a veritable callisthenic revolution. All over the known world, human endurance limits were the subject of furious scientific inquiry. Competitive sports were *de rigueur* in all fashionable society and the Adi Dassler shoes were by far the most popular of the day. As a physician I had naturally become aware of the most notorious experiments in severe sporting. Reports were circulating of athletes pushing their bodies to hazardous thresholds at which they would experience, for the briefest of moments, a heightened state of being. They described passing from this world into an endless grid, both infinitely large and infinitely regressed.

The grid appeared to be made up of black and white squares constantly fluctuating and forming patterns in an eerie synchronisation with the athletes' own mental processes. The whole of existence translated itself into a visual language through which the inductees' mental processes created a new symbiotic schema. Those sportsmen who survived the experience—and we are only speaking of a third at best—describe, in the last moments of this trance, feeling behind the syncopated patterns the weight of an ancient intelligence, a being seeking and probing their thoughts in an oppressive manner. There are not many who have survived who enjoy elaborating on this last revelation. However, those who do speak of a mind not entirely benign or maleficious, simply heavy with the burden of eons closing in, enveloping them like a dark fog, whispering of the dawn of time and, before that, the decays of the universe that preceded it. Those willing to speak of the experience never continue these callisthenic experiences. Indeed, they are lucky if they can continue their lives as normal. Quite often an abnormal psychology develops and they end up in the Sanitarium, raving of some malign being. A Saturnian creature desperate to cling to its children. So fearful is it of their escape, that it ceaselessly seeks to draw them down, deep into the depths of its stomach.

III

It came to pass that I was asked by a neighbour to enquire on the health of her daughter. She, like many of the time, had succumbed to this same sporting obsession. It was something that she seemed unwilling or unable to communicate to her family. Gradually, little by little, she had begun to withdraw from their lives, becoming like a character acting in the background—quiet, indistinct, never vocal. Eventually she had quit her employment. And yet it had been so long since she had begun this retreat from her life that her absence at her post was not even commented upon.

Her mother told me that she would catch sight of her on rarer and rarer occasions, perhaps rising from a troubled dream in the small hours when the night bleeds into the morning. Looking out from her window just before the break of dawn, she would see the girl slipping past the garden gate and into the fields to begin her regime. She sometimes wondered if perhaps, rather than seeing her leave, she had in fact glimpsed the wretched creature returning from a whole night of running and chasing, silently jogging away from the rising sun.

And every time this happened she was conscious it might be the last occasion that she would see her daughter's back disappearing around the country lane. For once the decline had begun, they all seemed to disappear quite quickly. Within months, their runs would increase in number and length till one day they would simply never return.

On that day that I visited, the daughter was laid out in a specially-made bed up in the attic. I asked her mother why she wasn't down below with the rest of her family. She explained that her daughter had developed a great fear of being in close proximity to the ground. "Don't ask me why, Doctor," she said, huffing as she climbed the steep stairs. "I'd much rather she was downstairs where I could keep an eye on her. We tried moving her there but then she starts with a great thrashing and screaming. It's a queer thing. We would hardly see her—her running around the woods at all hours, she was. And then one day they found her stuck up a tree, like a frightened cat. Couldn't coax her down for nothing. She clung onto that branch like it were the only thing left in the world. Eventually they had to cut the tree to bring her down. Daft little girl."

She paused at the landing to grab her breath, looked up the stairs furtively, and then whispered to me, "I should warn you, sir, to not trust anything she says, though. She's been telling harebrained stories again, trying to frighten us all." She gave me a dark look and then continued up the stairs.

The room was stuffy and sombre. A heavy sack covered the only small window. The yellow light that filtered through didn't provide much illumination with which to make an examination of the patient. The mother left and I sat down with the curled-up shape under the covers. I pulled open my case of instruments and heard a soft voice. It was indistinct. I asked her to repeat herself.

"My confession?" she said, her voice becoming a little clearer. "Have you come for my confession?" I answered that I had not, that I was in fact a medician. "I thought not," she said, sitting up in the bed, her pale face framed by the cushions. "After all, how could you? How could you be him? Our priest, he's gone. Disappeared. He went up into the mountains, to the castle. I think he's not coming back." Before I could interject, she shushed me. I was surprised. This girl so young had the comportment of one much older. There was a strength and age to her that was eerie.

"Listen, before my mother returns, there is something I must tell you. My confession, if you will. You must hear it now. Please, whilst I still can." I calmly put away the instruments and let her begin, feeling that there could be no harm in letting the patient discharge some of her delusions.

NUMBER TWO
THE ATHLETE

"YOU MUST KNOW, DEAR DOCTOR, that you are not the first that I have confessed to. There was a man before you, the Priest. He was a kind soul. He had always kept an eye out for me since I were young, been a guardian when there was none at home. And in confession I always had an open heart for him. It was when I first started these exercises, started wearing these shoes, that he became concerned. I couldn't fathom why but he grew dark and withdrawn whenever I would come to mention this passion. It was only after a great deal of prompting that I finally had him reveal to me why. He believed that there was a link between these shoes and certain activities of Mr. Dassler's carried out up there in that factory. These were activities that were somehow unnatural, unwholesome. The Priest had been making inquiries, in secret as it were and he'd been and confided in me that he had kept a journal. I wasn't to read it unless for some reason anything happened to him. You look perturbed, Doctor, but this is not half of the matter. As a stranger to this town you may not be acquainted with the life of our most esteemed citizen, Mr. Dassler. Perhaps you ought to know a little more about that story before you judge what I've found.

It was in the years before my birth when Adi's father made his way over the ocean to the new world with his family. Upon settling here in Herzogenaurach, the elder Dassler applied himself to the family trade, abstract painting. With the opening of new trade routes all the way to the East—even up to the Urals—modern painting was in great demand. The European tribesmen had a great affection for geometric painting. Indeed, in every longhouse on the continent one would be guaranteed to find if not in the great dining hall, then in the chieftain's private quarter, a very fine

example of experimental canvas.

Together with his wife, who was also a fine painter in her own right, the elder Dassler plied the plastic art, setting up a small studio at the edge of the town by the north bridge. From a young age Adi's time was divided between there and the schoolhouse where he learned of knowledge both contemporary and ancient, The Wisdom of the Moderns.

At home the young Dassler was initiated into the craft of the brushes. He was a quick learner—indeed, a child prodigy. Quickly moving through the flattening of pictorial space, by the age of eleven young Adi was regaling the court with virtuous abstract works composed entirely blindfolded. His works of this time are noted for their iridescent brilliance. Their surfaces seemed inconceivably close and tactile, and yet at the same time infinitely vast and remote. Indeed, his works conjured up such consistently sublime experiences that rumours began to circulate of an unnatural influence on the child, perhaps of iniquitous origin. It was during his eighteenth summer that a messenger arrived seeking the young boy. The stranger, dressed in a dark blue cloak with red highlights and riding a magnificent white charger, asked for the whereabouts of the Dassler house. By the time he left their residence a sizeable crowd had gathered outside, eager to hear the reason for a visit by a FedEx man of the Church. The delivery man had come with a message all the way over the seas directly from the hand of the new Pope in Memphis. Somehow word had come to him of the precocious young man and his gift, and he desired to commission a great mural by him.

The pontiff was breaking ground on a great new basilica, the largest and most splendid ever attempted. The young Dassler was to come at once to Memphis and plan out a great colour field painting to lie directly above the altar. As preparations were undertaken for his departure, it was noted that a change had come over the boy's demeanour. Previously diffident and introverted, every day seemed to bring greater and greater confidences. The apprentice was emerging into a young master of the craft.

Unfortunately, events at that moment were conspiring against him. A tragedy struck the new pontiff in Memphis. Dining on exotic shellfish in his White Castle one evening, he was struck by a terrible fever. An influential poison secreted by the animals left him fighting for his life for a whole fortnight. He was finally

roused from his bed by the new moon, but the illness had already taken its toll. Till the end of his days he would be completely blind, reliant on the ingenuous descriptions of others in his navigation of the world.

Though the new Pope was still nominally in charge, a new guard rapidly took the helm of the apparatus of Memphis. These cardinals constituted a new arm of the church allied not to the nobility but to the newly affluent mercantile classes. There were notable differences in their philosophies, especially when it came to the aesthetic direction of the church. They found contemporary abstraction to be antiquated and were determined that the new church would embrace the latest fashion, pictorial representation. So the basilica project was interrupted and word was sent to Herzogenaurach of these new developments. It was, however, too late. Adi had already arrived in the colony of Le Havre and was waiting for the arrival of the St. Augustine to take passage to the Americas. Unfortunately, a great storm settled over northern Europe that summer. Most rivers flooded, bursting their banks. The great inundations made of the surest roads muddy quagmires. The FedEx men were unable to reach Le Havre and Adi before he set sail.

The young man inevitably arrived in Memphis with hope, pride and expectations of wealth, only to be quickly scorned and sent back by the new clergy. One can only guess of his mood on that journey home. He gained passage back to our barbaric lands on a vapour boat. I don't know, dear Doctor, if you are aware that in that year there was a terrible volcanic eruption in Indonesia. Well, it sent a huge volume of dark matter into the atmosphere, causing a great perturbation of our climate. Here in Herzogenaurach there was no summer and the great storm that had delayed the Fedex men of the church flooded our town. Adi Dassler's mother and father were both caught in the rising waters and perished. The same meteorological event that overcame Dassler's parents struck his returning ship in mid-Atlantic. When the boat failed to came back to port, search parties were launched. But they came back without finding any evidence of the wreck. There were no survivors, no life boats—in fact, no evidence at all of the ship's existence. Naturally it was assumed that Adi had perished too.

Many years passed and gradually the events of that summer were forgotten. The town grew and prospered. New houses were

built over the remains of those destroyed in the inundations. Our Priest, who had been a young man at the time, had become grey and distinguished. The tragedy had entirely passed from his mind until one day he heard in the market the most curious rumour. On the edge of town had arrived a young man accompanied by a large baggage train carrying exotic ores, rubbers and materials. It was a great wealth rarely seen in the New World. He was accompanied by a number of European Indians—savages that never worked freely in the employ of any American man without the necessary coercions of shackles and the nine-tails.

Most curiously of all, this young man was claiming to be Adolf Dassler, the son of the painter thought lost in a shipwreck. The Priest hurried over to where the Dassler house had once stood and where the crowd had gathered. It is one of the first instances that he describes in this manuscript. I know, dear Doctor, it is tattered and smudged, almost unreadable, but I have had the time to peruse it at length. There are passages contained that you may not wish to hear, those passages that have affected me so. I guess I shall have to decide whether to omit them when we come to them. But this incident of Adi Dassler's arrival is one of the first that I have been able to decipher in detail. Let me read it to you now.

NUMBER THREE
THE PRIEST

"AS I STOOD THERE at the edge of the crowd I caught a glimpse of the young man between the many figures of onlookers. He was standing still over the ground where the house had stood, silent. He turned and gazed over the crowd of onlookers, and past them up to the tallest of the great peaks. There amidst the swirling fogs stood a grey shadow, the crumbling remains of the town's castle— long uninhabited, decayed and unlived. He barked orders to the heathen workers and the baggage train began to lumber into movement. The people parted and watched them as they slowly proceeded out of town, around the craggy road, and up to the dilapidated fortress. As he left I heard the mutterings of the people, most of them young or newly arrived to the settlement. They passed to each other fragments of the tragic story of Dassler's parents and the young man long gone. Fragments of truths, misremembered details and, of course, as is the nature of these crowds, complete and utter fabrications. There were ruminations over the source of his great wealth and the origin of his taciturn savages. And yet as I stood there and listened, I was struck that not one person talked of what, to me, was the most singular aspect of his return. That the face of Adi Dassler was identical in its features to that of this young man was irrefutable. But if in these many intervening years that had passed we all had grown old, fat, feeble and generally aged, how had this apparition that claimed to be Adi Dassler remained exactly the same? He was completely and utterly unaged.

The castle of which he made a new home stands on a promontory overlooking the town. It is a queer structure. Its architectural style is a *mélange* completely unknown to the area. The highest structures of the exterior are fashioned in the contemporary barbaric style, typical

of the region. These walls of unhewn rock lie on even older gothic walls and structures. The fortress is, however, known to have been in existence even before that time. The few scholars who've had the opportunity to examine it before Adi Dassler's recent tenure agreed that the ancient red brick foundations indicate its construction dates from the very latest days of the Industrial Revolution.

The real foundations, though, the deepest underground crypts and garages, are from an antediluvian modernism. Deep within the structure, walls of poured concrete defy gravity and logic. There are windows as large as a man hewn from single sheets of glass. There is all about this diabolical architecture a constant reference to that most disagreeable of angles, 90°.

The Square Plane worshipped by the High Priests of Modernity.

The ancient castle had stood there for the best part of a thousand years. The native tribes expressed a reluctance to discuss its origins or histories, though one night I did overhear an interesting tale from the mouth of one of the savages that had assisted its reconstruction.

III

I was taking my supper, as I did every evening after my confessions, at the famous Waffle House on the corner of Centre and Main Streets. Sadly, that building is no longer standing. It was a spectacular structure, the interior walls spanning heights of twenty to thirty feet. Every surface was covered in a lattice-work of ancient waffles. The square pockets of each waffle were filled with paint, chocolate, salt, and many other materials, forming a diagrammatic structure. In the dark depths of the ceiling, flickering in the dim candlelight, were the history and mysteries of this land encoded into a codex of black-and-white chocolate pixels.

That night as so often, I found myself digesting the effects of a hearty meal staring up at these primeval waffle patterns. I was disturbed by the conversation of the next table over. There sat a white Indian and another native European savage. Both were much the worse for the imbibing of their moonshine. Their argument was furious and yet carried out in carefully hushed tones. I must impart, though, that I have always been blessed with a particularly sensitive pair of ears. As a child it was I who would listen out for the arrival of the professor to class whilst my peers chalked Latinised obscenities on the blackboard. Hence I was able to follow their conversation quite closely.

It transpired that the first of the savages had worked on the construction of the castle on the promontory in the capacity of a carpenter. From the very beginning an unnatural series of events had plagued the project—events that his companion was arguing that he did not wish to remember.

He described how, in the centre of the night, walls of white sheet rock would appear where none had been before. A hewn stone wall would mysteriously transform itself into an immaculate surface of flatness without a single worker laying a hand upon it. Halogen lights burned all day and night deep in the catacombs, halogen fires that seared their eyes as they worked. During the nights a small dark figure would appear dressed in the garbs of a runner. Limping as she paced around the site, she would direct Adi in the reconstruction of the palace. She would direct the placement of doors and hallways as if recalling a pre-planned structure, somewhere that she had inhabited. The terrible figure never spoke to anyone. It was even unclear how she communicated her wishes to Adi, although he always seemed to be at pains to appease her.

At times their own construction materials would betray them. Many was the time when a back was turned and, upon the resumption of gaze, a pile of lumber or stone would have metamorphosed into sheets of cold white plaster. These same sheets lined the tunnels that delved the deepest into the mountain, three tunnels that penetrated the ground to a destination none of them even wanted to contemplate. An icy cold hell lined with squares and angles. Lines, stripes, never crossing, never diverging, always parallel. Parallel lines that will never ever cross though they burrow forever deeper and deeper and deeper and deeper and deeper and deeper into the core of the earth.

The Indian recalled that it did not take long for the fearful workers to turn to drink in the town's bars. Tongues loosened by alcohol precipitated rumours that ebbed and flowed around the streets and shops and homes. What made matters worse was the frequent disappearances of the labourers that worked in the very deepest structures under the castle. Somehow word seemed to get back to the Dassler camp of the growing unease in the town, and overnight his demeanour changed completely. Gone was the reclusive bearded hermit enclosed in his laboratory of potions and bubbling vials. The young man made sure to show his freshly-shaved face at every dinner and banquet, dressed in the most current

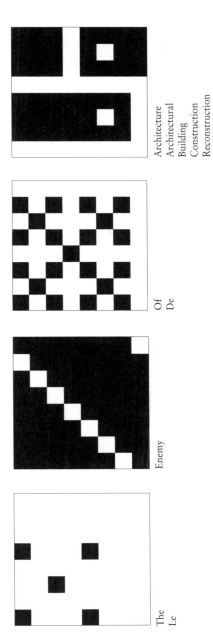

The · Le · Enemy · Of · De · Architecture · Architectural · Building · Construction · Reconstruction

fig. 1 The Enemy of Architecture

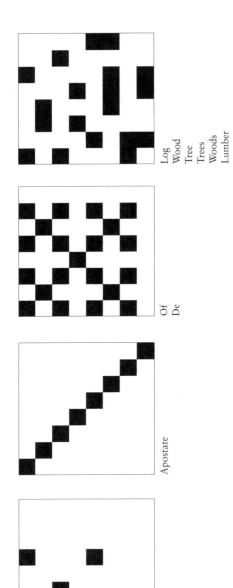

fig. ii *The Apostate of Trees*

fashions. He freely gave to charity and acquired a reputation as a noted philanthropist. Nobody ever questioned the source of his great wealth. After all, his enterprise was a boon for the town, generating a thriving trade. And no one—at least openly—commented upon the fact that no locals were ever employed in his factory ever again. Only the savage European was left engaged in the unknown machinations of the factory.

It was at this point that the savage German, speech slurring and eyes drooping, began to murmur a song that I did not recognise. I was surprised when all the other native labourers in the bar began to join him, lending their doleful tones to his forming a haunting harmony.

They sang–

They say that Adi Dassler owns one half of this whole town,
With political connections to spread his wealth around.
Born into society, a painter's only child,
He had everything a man could want: power, grace, and style.

But we work in his factory
And we curse the life we're living
And we curse our poverty
And we wish that we could be,
Oh, we wish that we could be,
Oh, we wish that we could be,
Adi Dassler.

The papers print his picture almost everywhere he goes:
Adi Dassler at the opera, Adi Dassler at a show.
And the rumors of his parties and the orgies on his yacht!
Oh, he surely must be happy with everything that he has got.

But we work in his factory
And we curse the life we're living
And we curse our poverty
And we wish that we could be,
Oh, we wish that we could be,
Oh, we wish that we could be,
Adi Dassler.

He freely gave to charity, he had the common touch,
And they were grateful for his patronage and thanked him very much,
So our minds were filled with wonder when the evening headlines read:
Adi Dassler went home last night and has yet to leave his bed.

As the song died away, the first German, his eyes drooping, his speech already slurred, turned to his companion. His voice seemed to change, and as he spoke his tongue began to modulate his words in an eerie manner. The speech had a strange cadence, here slower than usual, here faster. It was so entirely unnatural that I had to close my eyes and concentrate to follow the tale he told.

NUMBER FOUR
THE SAVAGE

"HAVE I EVER TOLD YOU of the dream I have every single night? It is a vision of a vision, as when two mirrors are held in front of each other and start to echo their love for one another into the infinite. Every night I dream that I am this man. A man of the old world, a man from beyond the oceans. I am a doctor, trained in a village named Providence. I find myself on a ship bearing me over the sea to the land of the Dutch. I travel for many days on land till I arrive in this town. In Herzogenaurch. And I find myself in the hotel behind this tavern.

Upon the first night of my arrival, I am lying asleep on a bed in the hotel. I am woken by a loud knocking at the door. I rush to it and fling it open to find a Priest standing there. His face is familiar, though not to the doctor of this dream. I don't know if he is a man of this town but I feel that I know him in some way. The Priest speaks in a grave tone and orders me to quickly pack my medical instruments and to follow him. I hesitate, but his familiar features rouse a great curiosity in me and so I grab my instruments and throw them in a case. He takes me up a rocky path along the edge of the tallest peak to the castle over the town, the castle of Mr. Dassler. He leads me through rooms and corridors filled with suits of armour, tapestries, and glass cases full of geometrical aberrations. There are shoes upon shoes, arranged in stacks and rows and piles. The hallways are cluttered with canvasses and photographs and statues, objects that leer their newness out of the shadows as the Priest leads me by.

We come to a set of doors framed in matte metals and plastics. The Priest takes my leave and I pass through the entrance. The room is stuffy and sombre. A heavy curtain covers the only small

141

window. The yellow light that filters through doesn't provide much illumination with which to make an examination of the patient. He is lying on his back in an enormous bed in the centre of the room. The blankets are piled over him, forming a small heap that all but obscures his face. His eyes are closed. He looks entirely lifeless. I pass my hand to touch his brow when I hear a croaky whisper from behind my ear. "My confession?" he says, his eyes springing open. "Have you come for my confession?" Startled, I stumble back and a dark cackle comes from the figure in the bed that ends in a mixture of laughter and coughing.

The patient presents a range of symptoms that I find difficult to diagnose. He suffers from low blood pressure, a weak pulse. His pupils barely react when I pass an electric torch over them. This young man has to me an entirely necrotic aspect, and so I am surprised that he can summon the energy to rebuke my questions and appraisals of his health with a dark sarcasm. He smirks and tells me that he knows full well about everything that goes on in that town. He knows what the fishwives say about him when they are packing ice in the market. He knows what they whisper to their husbands at night when they think no one can hear.

"And you, dear Doctor," he says, his gaze fixed on mine. "I have seen you in the town. I have seen you in the inn, in the tavern. I have seen you conversing with the Indians. I have seen you talking with that girl in the attic. I would not hold too dear what she tells you. Her path was one borne in weakness. She was not ready to see the things as they are, to see beyond the vale." With that he laughs and his mirth quickly descends to into an uncontrollable fit of coughing. Finally it passes, and as I wipe the bloody phlegm from the corner of his mouth he whispers to me.

NUMBER FIVE
THE ARTIST

"BUT YOU, DEAR DOCTOR, you are a learned man such as I—whatever one may mean by learned, though. I no longer give much credence to that word. You are no doubt as intimately familiar as I with the structures and methods taught to us as scientific doctrine. I will tell you a secret. For a metaphysical madness is what it is. I have discovered what none of them dared even imagine, that which concerns the passage of our soul through the cosmos. It is a knowledge that contravenes the suppositions of those braggards Newton and Copernicus. They who fight by the book of Arithmetic... Well, they never came close to understanding it. For it is a knowledge of the total unity of the universe. Music, mathematics, painting—these things only hint at the underlying structure, the vibrations of the universe, the spheres. Kircher and Bruno never knew how right they were. For I tell you, Doctor, that all phenomena, from those as mundane as tastes and preferences to those as cosmic as the drifts of the galaxies, are governed by the forces of these three stripes here. Three straight parallel lines that extend from the infinite to the finite, from the end of time to time eternal. They converge and diverge and they cross and they intertwine and knot. And yet they are at the same time always parallel, forever unchanged, constantly undivided, endlessly unmultiplied. Always.

These stripes are the *lingua franca* of all creation. It is they that govern friendship, love, sympathy, hatred. It is they that govern all of the chemical reactions, the planetary action, plants heliotropic, selenitropic, and medicinal. The wind, hydraulics, the tides, musical harmony—even, my friend, the nature of what you would call God himself. Though I wonder, Doctor... If you knew as did I his nature as a geometrical conceit, as a set of forms and planes, if you

would be so eager still to pay him homage as all these fools do. For he is as an infant who molds from his dung an image of himself and calls it by his name. He persists in his idiocy, eating and regurgitating his dung to form trees and plants and mountains. He is as empty and innocent as the waves on the ocean. As the pattern of snow on the rocks. As the swirls of fog in the vitrines of The Museum. For it is his mindlessness that is his divinity. But what is that to worship? What is that to venerate, I ask you? How can that protect you from those that seek to harm you?

My discoveries are derived from iniquitous inquiries that I have pursued in the creation of my shoes. You may not know it, Doctor, but it is in that most lowly of garments that one can find our deepest concrete truths. It is the foot that physically, psychically and statically speaking, grounds us to the Great Mother Earth as she spins through the cosmos. The passage of all bodies in spaces and times is relative. Though we exist as distinct entities, our trajectory and velocity are always constant and relative to each other. Hence our understanding of this reality is forever predicated on our shared inhabitation of this instance in the textile of space and time.

There is only one factor that prevents the unshrinking student of life to explore other realms and ages: His anchoring to this world and all those other souls that spin on its surface towards the next day, the next year, the next eon. The most divine act is to run. Though inefficacious in surface, it is a ritualistic act that enables the spirit to conceive of movement away from the body politic and to, after death, possibly gain traction and leave the gravitational pull of our earth-bound prison.

The foot should be venerated as the link of our communion. It is the portentous tool of our soul's departure. However, there is a great maleficious power that coïnhabits this moment of ours. A tenebrous being that inhabits the centre of the earth. This dark lord pulls heavily at every living being on the planet. Every rock, every stream, every ocean, every mountain obeys his unswaying commands. From the iron core miles under the planetary crust he sends out his constant desire for us. And every day his weight pulls at us, prevents us from escaping the bounds of the earth. He makes our feet heavy to lift so that by the end of the day we lie exhausted in our beds. He pulls the moisture from the air so that it thunders down on our crops in a ruinous rain. As men seek to commune with the heavens in ingenious balloons and other flying

vehicles his clutch is never released and, inevitably, those same engines will always be returned to the ground in a celebratory inferno of crushed metal and burning gasoline.

His love, his desire for us sucks us to earth's surface. He simply cannot let got of his children.

He is The Enemy of Architecture, The Apostate of Trees, The Great Attractor. The Indians, too, have a word for him—though not one they would ever acknowledge aloud for fear of garnering his attention lest he takes a morbid interest in us, these little beings that scuttle over his skin, that make holes through his pores, that build fragile towers of glass and steel on the membrane of his eyelids. For one day the savages say he will wake. And on that day he will brush us off his carapace and into the blackest voids of space.

Do not look so wary, my friend. Believe what you will. I have not asked for you to come here so that you can listen to me spout my wild and unhinged theories. Nor is it for the attentions of my health. There is no power that you possess that could help me in that regard. No, my corse is held in sway now by an influence beyond the potency of any mortal man. No, I have asked for you here as I feel that I must leave the world an account of my tale. It may be that I will not be here much longer and mankind must know these truths of existence.

There is a chapter of my life that is completely unknown to anyone. It concerns my journey back from the Americas. There would have been a time when I would have dreaded the consequences of me revealing this to anyone, when through fright or, perhaps, vain arrogance... Well, Doctor, you as much as anyone would understand the desire to feel oneself master of his own fate. Could there be no greater fear than to lose the mastery of our own actions, to become the passenger of the mind whilst another has the controls? I have long hesitated to confess this to anyone, but I believe that there is little left of me now on which to affect a coërcion.

We had left port in a vessel clad in sheets of iron, the kind of ship propelled by artifices that was still current back then. From her midsection rose a mast a hundred-foot high that held no sails but poured an oily thick smoke. It billowed out into the clear sky leaving an inky trail of our passage in the heavens. I don't know, my Medician, friend if you remember that summer. The eruption of that volcano on Sumbawa had ejected massive amounts of particulate matter into the atmosphere. The sunsets we experienced

on that trip were indescribable, the sky became a myriad of colours all bleeding into each other. It was as if a painter's palette had been smeared across the firmament and bisected by the dark line of our ship's plume.

It was a sunset as I've described to you that had brought the whole ship out onto the deck that evening. I mingled with crew and passengers, a varied bunch mostly made up of emigrants. As the twilight approached the ship slowed and came to a complete stop. The steady vibrations of the engine had ceased and a silence descended over the ship. I noticed that there was no breeze. It was an utter calm, the air was hot and stagnant. The wick of the candles burned straight up, not at all disturbed. There was a problem with the boiler and they were unsure how long it might take to repair. As the hours passed, the stilted heat became more and more unbearable and, seeking to evade the sweltering confines of the lower decks, the passengers congregated outside. They laid themselves out on blankets, fanned themselves with newspapers, and passed round the diminishing supplies of water in an effort to cool themselves.

The night was moonless and all around the ship a darkness enveloped and crushed us. I felt uneasy and asked the captain if it may be a sign of a simoom or some other such phenomena. He laughed and told me not to worry for his ship was very old and could withstand any tempest. Besides, the satellite watchers in the sky had seen no storms in the region. Later, I went down to my cabin to fetch a book and was halfway down the ladder when I heard a terrible wrenching sound. A huge foamy wash had broken over the bow and drenched me as I clung to the rungs. Scuttling up to the deck, I found it utterly deserted. All souls had been washed overboard. And all around me the ocean was in wrath. Huge slate mountains of water were rising and falling, making peaks and troughs that rose three of four times the height of the mast. As I watched, the ship was caught in such a movement and began to slide down a sheer precipice. Our vessel was pitched to an angle of 90° and I found myself hanging by a rail, staring down at the pit that was opening up beneath me. In this moment I believed myself already dead. I felt there was nothing that I could possibly do to extricate myself from an immediate oblivion. And so came to me the most unusual calm. I began to take a pleasure in observing myself and this situation in a detached scientific manner.

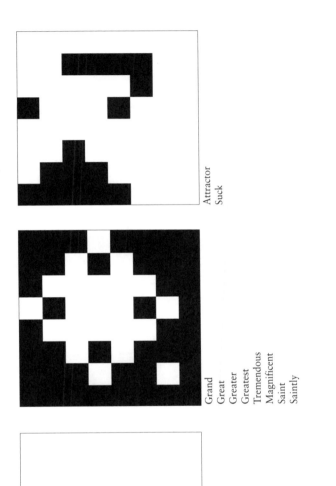

The
Le

Grand
Great
Greater
Greatest
Tremendous
Magnificent
Saint
Saintly

Attractor
Suck

fig. iii The Great Attractor

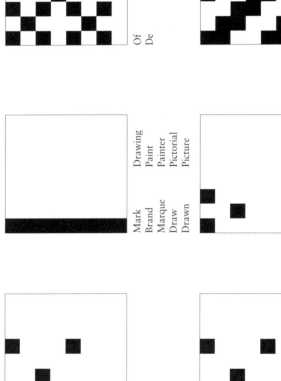

fig. iv The Marque of the Third Stripe

And it was with wonder that I saw the mountains part to form a well that descended into the depths of the ocean. The scale was cyclopean. The water was roaring around in a circular pattern, forming a giant depression in the surface of the ocean. As the maelstrom began to sink further and further down the ship followed, till in a matter of minutes the sky above was framed by massive walls of black and green. I wondered how long this could last as I measured the diminishing surface of sky. The giant whirlpool was stressing and pulling the ship. It rumbled and cracked beneath my feet and in an instant broke apart. The vessel splintered into a hundred shards that were sucked immediately into the vortex. I took hold of a rail but realised too late that it was no longer attached to the rest of the deck and I tumbled into the air of the void, tumbling down and down into the swirling core that kept on descending.

I closed my eyes and fell into a black pit of unconsciousness. I don't know for how long I could have fallen or what could have broken my fall from such a height but I awoke in a wet, fetid field. I wondered if this was some form of reverie? Had I imagined my voyage on that ship or our naufrage? From my prone position I could not see much of where I was lying. My first impression was that I was in a desert at night. The sand was littered with peculiarly shaped rocks and remains of plant matter. Yet the ground was wet and held the impression of many footsteps. All the footsteps were from one man. Judging from their indentations, he must have been a man of substantial height and weight for they fell deep into the sand. And then I was struck by a great dread. For I realised in an instant revelation that the horizon I had taken simply to be the night sky had a surface to it, a certain solidity. In it I saw flecks of white, streaking. It was the walls of the maelstrom. What I had taken to be the moon up above me was, in reality, a tiny disk of the day framed by the towering mountains of ocean. I had not even escaped from the catastrophe in death. I was being tortured in the greatest and most imaginative ways.

My artificial moon gave me a dim light with which to examine my surroundings. It was a beach of calm, perhaps a kilometre in diameter, surrounded on all sides by the incomprehensible volume of the Atlantic. In the centre of the clearing stood an outcrop of rocks. As I approached it I could see that there was a statue emanating from them. What hand had carved it I could not begin to imagine. It certainly could not have been the product of any human agency

of which I know. It was of a figure, a humanoid man, yet made entirely from polygons. It was a mathematical being, all angles and planes. What gave it such an unearthly character I couldn't begin to communicate to you, dear Doctor. Suffice to say that as I came closer and as I changed my angle of approach it appeared to change its shape, not behaving by the conventions of geometry as you and I know it. And the closer and closer that I came to it, the more and more it began to resolve itself into the shape of a man. And finally, upon traversing the fetid desert and coming as close to it as I dared, its features finally resolved into the ones that I was above all most familiar with. My own. I was staring into a reflection of myself. And then the statue spoke. Its mouth opened and his voice reached my ears. Its sounded exactly as I did, without any deviation or mistake. But it was not the uncanny voice of the self, not that noise which we capture to tape or circular platter and then play back to one's own ear for amusement or for distress. No, it was a replication more perfect and complete than such a simple trick as that. For it was the voice one hears constantly but to which you would never think to listen. For the statue spoke to me in the voice that emanates in my own throat and that still echoes in my own skull.

NUMBER SIX
THE STATUE

"HOW MANY TIMES are we to meet like this, Adi? How many times have we met before? I can only tell you the latter, though it is perhaps best that you do not comprehend the tedious eons for which we have now been playing this game. And because you can never remember, you will never know how much He tires of this constant disappointment. Oh, if only you knew that, dear Adi! Then you would cease this vain exercise! Every time you attempt to divulge our secret, our agreement, every time you attempt to dissolve a contract that can never be broken.

Perhaps it is to be expected from creatures such as you. The very weakness that tempted you and corrupted you has now again and again manifested itself in foolish arrogance. Adi, you cannot ever renege on your promise—though you will believe you can try forever. We will always meet here on the ocean floor, closest place to His dwelling. And, again and again, you will always seek to tempt the Temptor. Save your breath, dear Adi. Know that I will forever lie here amongst the rotting leaves of the ocean floor. And watch ships fall from the surface. And count the shoals as they pass. And watch the crabs migrate back and forth. And wait for you. I will always be waiting.

And know that again and again I will tell you the secrets that no human mind was ever meant to comprehend—the knowledge of time and space and our sacred geometry. And you will go up to the surface and do His bidding and do what it is that He asks. Though you will try again and again to subvert His will. He has more patience than any human soul. And one time you will fail to slip up. You will do your duty and keep our secrets. And then our exercise will not have been in vain.

Now listen to me, child, that I can give you the information you seek. That secret of the void. That which you have heard in the mutterings on the breath of every dying man. The vectors of souls along their passages in the cosmos. The straight parallel lines that connect the necrotic dimensions... Listen closely to what I am about to tell you... Listen now, Adi... Listen to the Numbers...

THE MARQUE OF THE THIRD STRIPE

RECORD OF INSTALLATIONS

*The following eighteen plates are a faithful record of the public
exhibitions of The Marque of the Third Stripe from
June, 2007 to May, 2008 in the cities of New York, Norwich,
London, and Rome.*

I. VIEW OF "ALEXANDRE SINGH: WHITE ROOM," WHITE COLUMNS, NEW YORK, 2007.

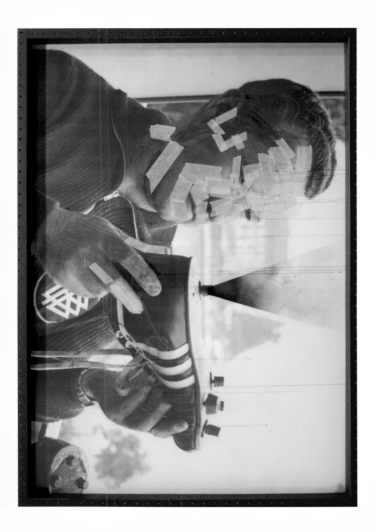

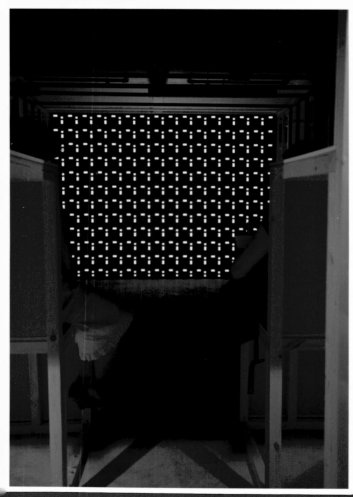

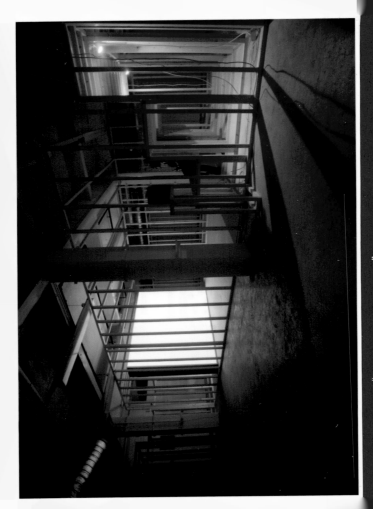

V. VIEW OF "EASTINTERNATIONAL 17," NORWICH GALLERY, NORWICH, 2007.

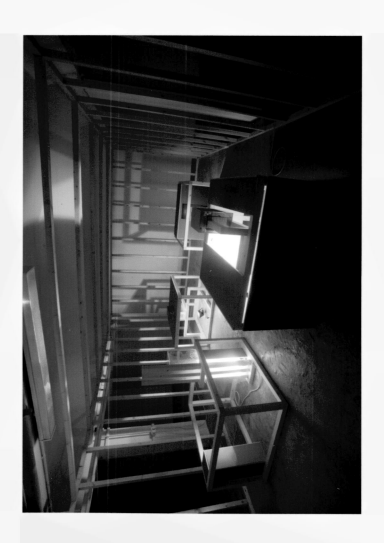

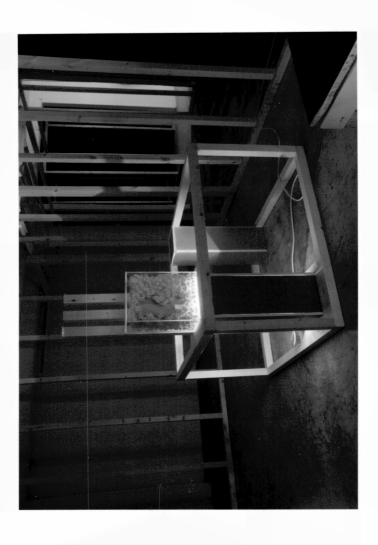

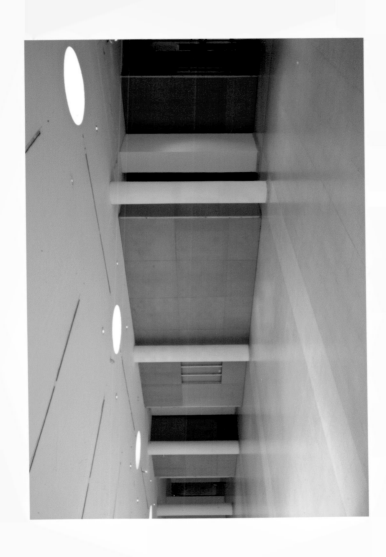

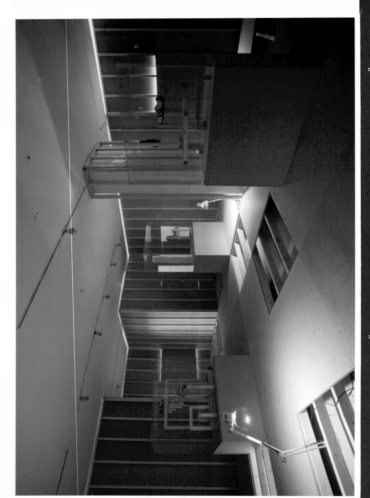

IX. INTERIOR VIEW OF "OF THIS TALE, I CANNOT GUARANTEE A SINGLE WORD...,"
THE ROYAL COLLEGE OF ART, LONDON, 2008.

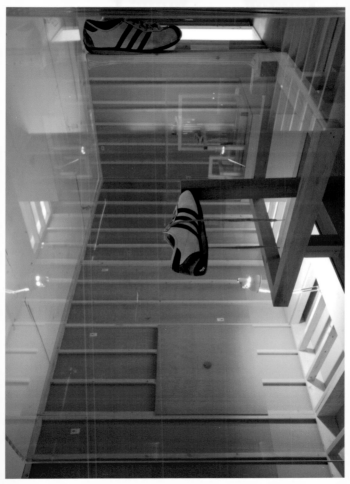

X. VIEW OF "OF THIS TALE, I CANNOT GUARANTEE A SINGLE WORD...," THE ROYAL COLLEGE OF ART, LONDON, 2008.

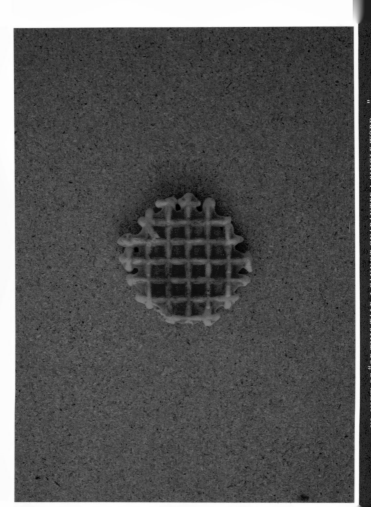

XI. VIEW OF "OF THIS TALE, I CANNOT GUARANTEE A SINGLE WORD...,"
THE ROYAL COLLEGE OF ART, LONDON, 2008.

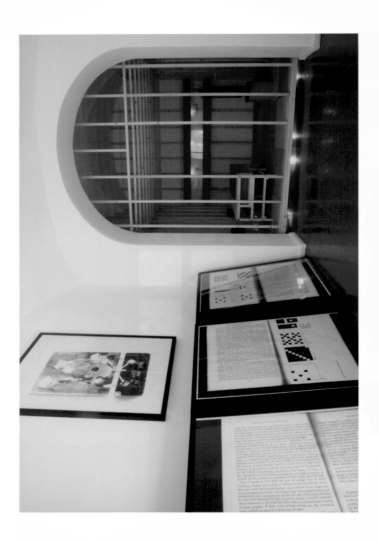

It transpired that the first of the savages had worked on the construction of the castle on the promontory in the capacity of a carpenter. From the very beginning an unnatural series of events had plagued the project—events that his companion was arguing that he did not wish to remember.

He described how, in the centre of the night, walls of white sheet rock would appear where none had been before. A hewn stone wall would mysteriously transform itself into an immaculate surface of flatness without a single worker laying a hand upon it. Halogen lights burned all day and night deep in the catacombs. During the nights a small dark figure would appear dressed in the garbs of a runner. Limping as she paced around the site, she would direct Adi in the reconstruction of the palace. The terrible figure never spoke to anyone. It was even unclear how she communicated her wishes to Adi, although he always seemed to be at pains to appease her.

At times their own construction materials would betray them. Many was the time when a back was turned and, upon the resumption of gaze, a pile of lumber or stone would have metamorphosed into sheets of cold white plaster. These same sheets lined the tunnels that delved the deepest into the mountain, three tunnels that penetrated the ground to a destination none of them even wanted to contemplate. An icy cold tell lined with squares and angles. Lines, stripes, never crossing, never diverging, always parallel. Parallel lines that will never ever cross though they burrow forever deeper and deeper and deeper and deeper and deeper and deeper into the core of the earth.

The Indian recalled that it did not take long for the fearful workers to turn to drink in the town's bars. Tongues loosened by alcohol precipitated rumours that ebbed and flowed around the streets and shops and homes. What made matters worse was the frequent disappearance of the labourers that worked in the very deepest structures under the castle. Somehow word seemed to get back to the Dassler camp of the growing unease in the town, and overnight his demeanour changed completely. Gone was the reclusive bearded hermit enclosed in his laboratory of potions and bubbling vials. The young man made sure to show his freshly-shaved face at every dinner and banquet, dressed in the most current

136

Architecture
Architectural
Building
Construction
Reconstruction

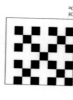

Of
De

Enemy

The
Le

fig. 1 The Enemy of Architecture

XVI. PAGES 136-137, 2008, INKJET PRINT, 108 × 138CM.

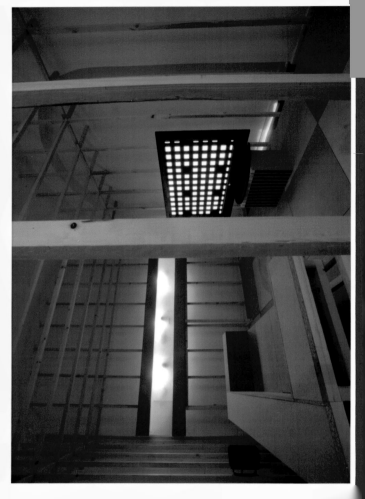

1a	1b	1c	1d	1e	1f	1g	1h
2a	2b	2c	2d	2e	2f	2g	2h
3a	3b	3c	3d	3e	3f	3g	3h
4a	4b	4c	4d	4e	4f	4g	4h
5a	5b	5c	5d	5e	5f	5g	5h
6a	6b	6c	6d	6e	6f	6g	6h
7a	7b	7c	7d	7e	7f	7g	7h
8a	8b	8c	8d	8e	8f	8g	8h

|ˈdɪkʃ(ə)n(ə)ri|

A description of the visual significance of the sign or symbol within the language, culture, and belief system.

part of speech

The linguistic meaning or, where appropriate, combined meanings of the symbol within common usage.

|ə| |eɪ|

[the indefinite article]

adjective

Indicating indefiniteness. In a more definite sense: one, a certain, a particular; the same, one and the same. In its most defined sense indicating desires of objecthood on behalf of groups of numbers, words, names, ratios, proportions, and purportions. The five-square cross related to the definite article. (SEE ⠒ |ðə|.)

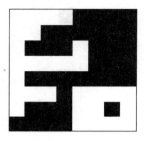

|abəˈreɪʃ(ə)n|

The black square divorced from the larger mass.

noun

The action of wandering away or straying; the state of error or irregularity thence resulting. A gradual moving away, a straying; a deviation or divergence from the earth's gravitational field. A deviation or divergence from a direct, prescribed, or orthodox course or mode of action. A wandering from the path of rectitude, or standard of morality; moral irregularity, profane supernaturalism. A wandering of the intellect, an abnormal state of any intellectual faculty; deficiency or partial alienation of reason. A nausea of the psyche. Deviation from the ordinary or normal type of natural production; statue, painting, or monolith.

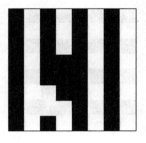

|əbˈnɔːm(ə)l|

A broken field of stripes.

adjective

Deviating from the ordinary rule or type; contrary to rule or system; irregular, unusual, aberrant.

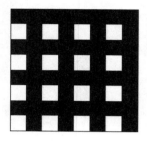

|ə'baʊt|

preposition

On the subject of; with regard to. Used to indicate movement within a particular grid but not position. Used to indicate position in a grid but not movement. (SEE 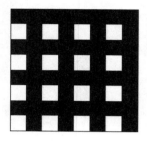 |ʌn'sɔːt(ə)nti 'prɪnsɪp(ə)l|.)

adverb

Circularly, in a round, to come around.

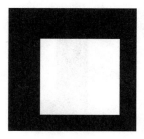

|ˈabstrakt|

The blank space in cluttered pictoriality. The ideal form.

participle and adjective

Withdrawn or separated from matter, from material embodiment, from practice, or from particular examples. Abstruse.

verb [trans.]

To withdraw in thought. To derive. To consider something theoretical or theological separately. To make a written summary of an article, book, or language.

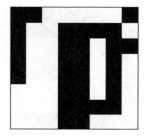

|əkɒmə'deɪʃ(ə)n|

noun

Provision of conveniences. A lodging; room and board. A conven-ient settlement or arrangement. Adaptation of the eyes to seeing objects at multiple distances. Adaptation of words, persons, or things to different circumstances.

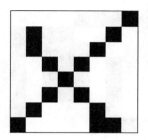

|ə'kaʊnt|

The addition of points to the full diagonal stripe.

noun

The rendering of a reckoning. A computation of debts or expenses. An arrangement for one party to hold the funds or services of another. A computation of ideas and characters. A story fictional or perhaps true. A reckoning.

verb [trans.]

To esteem; to reckon; to count; to give a satisfactory answer; to recount a wonderful tale.

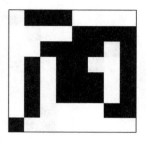

|əkˈnɒlɪdʒ|

verb [reporting & trans.]

To own the knowledge of; to confess to; to recognize the truth of; to show recognition of.

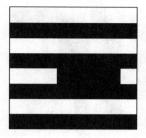

|əˈkrɒs|

*The traversing of a space or field of stripes by a bridge
or segment of squares.*

adverb

Placed transversely or to 180°. Crossing the length of.

preposition

Motion from side to side. To move from one part of a body to another. On the other side.

a

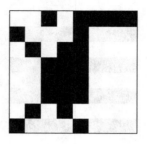

|akt| |akts| |aktɪŋ| |ˈakʃ(ə)ns|
|ˈeɪdʒ(ə)nsi| |bɪˈheɪvjə(r)| |bɪˈheɪvɪŋ|

The stick-figure man who, with his arm held aloft,
strikes and fabricates. The agent.

noun

Something done; a deed. Manner of conducting oneself in the external relations of life; demeanour, deportment, bearing, manners. A fictional role. Working as a means to an end.

verb [trans. & intrans.]

To do something. Not to rest. To produce effects on some passive subject. To assume a role. To conduct oneself in a specific way, esp. toward others.

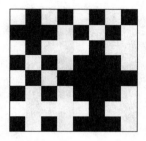

|akˈtɪvɪti| |ˈaktɪv| |ˈakʃ(ə)n|
|ɒpəˈreɪʃ(ə)n| |akˈtɪvɪtiːz|

adjective

That which acts as opposed to being passive.

noun

The condition in which things are happening or being done. A thing done, an act. The condition of being active. A medical procedure performed upon a being.

|ˈadɪ| |adəˈlf|

noun

The unadulterated vertical stripe pattern. Popular name in German-speaking countries.

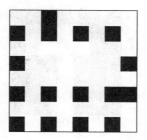

|ə'fɛkt| |ə'fɛktd|

verb [trans.]

To disrupt an even field. To act upon, to produce effects upon other things. To assume a false appearance, to counterfeit. To assume artificial airs.

|ə'fɛkʃ(ə)n| |lʌv|

noun

The joining of the individual's mass to a separate and distinct consciousness. Strong predilection to devotion (to something or someone), kindness. Romantic attachment, sexual attraction. Sexual desire or lust. Amatory relationships.

verb [trans. & intrans.]

To have or feel toward a person or thing the above.

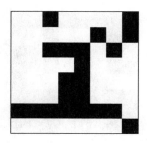

|ˈɑːftə| |sɪns|

preposition, conjunction & adverb

Following in place. Following an event. Next to in order of importance. Immediately following. Thereafter. Because. For the reason that. Ago.

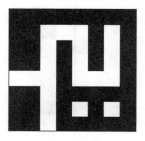

|əˈgɛn| |rɪˈpiːt|

The snake delineates the path of time or action, upon which two white squares of instances are replicated.

adverb, preposition & conjunction

A second time, once more. In reaction or reciprocal action.

verb [reporting, trans. & intrans.]

To say or utter once more. To reiterate. To do something a number of times.

|ə'gɛnst| |dɪ'fʌɪ| |dɪsə'griːəb(ə)l| |'kɒntrə'viːn|

The individual or unit acts in opposition to the other.
The two characters are noted for their dissimilarity.

preposition

In opposition to any person or cultural force.

verb [trans.]

To openly refuse to obey, to start hostilities, to resist.

adjective

Characterised by incongruity. Unpleasant taste, behaviour, humour, or ideological position. To violate a law or prohibition. To run counter to. To contradict.

|ə'griː| |ə'griːd|

The near-symmetrical arrangement of the two powers.

verb [intrans.]

To be in concord, to hold the same opinion. To consent. To be pleased of, to suit the humour of. To settle.

|εː|

The bubble that delineates the formless content.
To be contrasted with the ▪ |vɔɪd|.

noun

The element encompassing the terraqueous globe. An atmosphere.
The gaseous element to which animal life is addicted.

|əˈlɑːm| |əˈlɑːmɪŋ|

*The disturbance in the web. The signal that the fly
is caught disrupts the slumber of the spider.*

noun

The call to arms. The awareness of danger.

verb [trans.]

To call to arms. To cause the feeling of fright, of danger.

| ˈalkəhɒl |

The pixel code indicates a complex organic compound.
The regularity of the pattern induces numbness, euphoria, and coma.

noun

A highly rectified dephlegmated spirit of wine or any organic substance, i.e., grain, cactus, blood, spit. Intoxicating colourless liquid, highly flammable. Originally a powder derived from distillation, applied upon the eyelids. Quintessence itself. The spirit in physical form.

ɔ

|ɔːl| |ˈɛvri| |ˈɛvrɪθɪŋ| |ˈtəʊt(ə)l|

*The completeness of the imaginable. The set that contains
the entire number of other sets. The left and bottom margins indicate
the universe with the four squares as materiality.*

predeterminer, adjective, pronoun & noun

The whole number. Without exception. Including the complete
set of constituent parts. The collective nature. Pertaining to the
absolute parts of existence.

|ə'laʊ| |lɛt| |lɛtɪŋ| |ɪn'eɪb(ə)lz|

verb [trans.]

To admit, to justify, to leave. To give the necessary time to. To permit an event to take place. Not prevent, not forbid. To suffer.

a

|alps|

The origin of the now more universal |ˈmaʊntɪn|.

noun

A single heap or large mountain, always covered in a snowy cap. The great range of mountains of central Europe. The summit of the world. The home of the European gods.

|ˈɔːltə|

*The spiritual table. The surface floats above the support to
show the separation of essence from substance.*

noun

The place where offerings to the deities of the firmament or of
the underground are laid. A table or surface where sacrifices
are made. Where the Eucharist is performed. (SEE |ˈstʌmək|;
|kəˈmjuːnjən|.)

27

ˈɔːlweɪz		ˈkɒnst(ə)nt		ˈkɒnst(ə)ntlɪ		
kənˈtɪnjʊəʊ		ˈɛndlɪs		kənˈtɪnjuːd		ˈsiːslɪslɪ
kənˈsɪst(ə)ntlɪ		ˈɛvə		fəˈrɛvə		ɪˈtəːn(ə)l

One of the most fundamental concepts. The unending.
A variation of the simple grid. The predominantly luminous field
indicates the primarily positive associations of this belief.

adverb

For all times up to the present. Perpetually. For all future time.

adjective

Occurring unchangingly over a period of time. A period of time
without limit. Without end or beginning. Abiding.

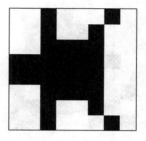

|əˈmerɪkəs|

The figure on her back. The fertile landmass.

noun

Collective western continents. The Old World. Seat of culture, home of the Pope. (SEE 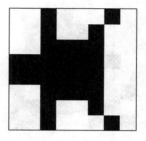 |pəʊp|.) Example of convergent linguistic evolution in Old French it is derived from the word "bitter."

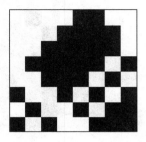

|ə'mʌŋ| |ə'mʌŋst|

The principal object finds itself in the chaotic mud of smaller things.

preposition

Mingled with, joined with others. In the relation of anything in the local group to its surrounding group. In the equivalent class as other nominal members of same group.

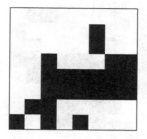

|ˈamstəˈdam|

noun

The capital city of the savage nation of the 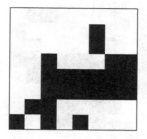 |dʌtʃ|. European port noted as a principal trading post with the Americas. A place where civilized men may abandon their own culture in lieu of a seductive barbarism.

ə'

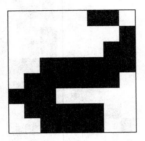

|ə'mjuːz| |ə'mjuːzm(ə)nt| |geɪm|

verb [trans.]

To entertain with tranquillity. To cause interest or good humour in another.

noun

The state of finding something funny or enjoyable. A divergent enterprise governed by rules that the participants or players should abide by. A contest. (SEE 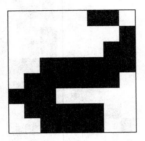 |fʌɪtɪŋ|.)

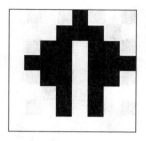

|ˈaŋkə| |ˈaŋkəɪŋ|

*The spiked form that arrests a body. The heavy weight
that binds physical and psychic entities to the earth or ocean.*
(SEE ▮ |weɪt|; ▓ |ˈiːv(ə)l|.)

noun

A heavy object usually iron that holds a ship or airship or fixes
something to the ground. A spiritual block.

verb [trans.]

To moor or fix a vessel, object, person, idea, or ideological conceit.

33

ə

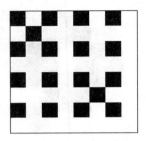

|ənd| |bəʊθ| |ˈɔːlsəʊ|

Togetherness. Visual construction relates to the principal, the definite and indefinite articles. The repeated five-square pattern.

conjunction

The particle by which sentences or terms are joined together. As well.

adjective & pronoun

Two people or things.

adverb

In the same manner, likewise. In addition to.

|ˈaŋɡ(ə)l| |ˈaŋɡ(ə)lz| |ˈaŋɡ(ə)ld| |stiːp|

The nook of all objects. The two ells nestle in each other's arms.
All objects in the Euclidian universe have limits and thus points of
completion that are so measured.

noun

The space intercepted between two lines intersecting or meeting,
usually measured in degrees (SEE |dɪˈɡriːs|.) A way of approach-
ing a problem, situation, or opportunity.

verb [intrans.]

To seek a desire via some artifices. To approach in a cunning manner.

adjective

Rising or falling sharply. At a great incline. Extending to a great
height, elevated, lofty.

35

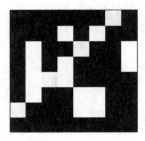

|ˈaŋgə| |ˈaŋgri| |reɪvɪŋ| |rɒθ|

The disrupted chaos. Belonging to the family of dark signs.

noun

A strong feeling of displeasure, uneasiness, or discomposure. An extreme vehemence or indignation. The default emotion of the orthodox and of deities.

verb [trans.]

To be provoked with a feeling of vexation.

verb [intrans.]

To talk wildly as if delirious or insane. To relay the messages of dæmons. To write without sense, or with great enthusiasm, esp. ebullient criticisms of formalist artworks.

|ˈanɪm(ə)lz|

The corporeal sign.
Derived from the horns of domesticated beasts and the inverted A.

noun

A living being, or higher being that consumes organic matter. A being that ingests and excretes mass. In opposition and contrast with |plɑːnts|. The set that includes man. Said of men that are base or primitive, or sophisticated and immoral.

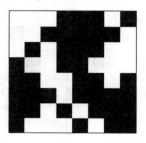

|ə'nʌðə|

adjective & pronoun

A person or thing in addition or similar to the one previously mentioned. A different person or thing from the one previously mentioned. A differing concept.

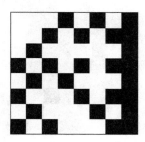

|ˈɛni| |ˈɛnɪwʌn|

*An indefinite thingness measured against
the totality of the right-hand side.*

adjective & pronoun

To refer to one or many things; an indefinite number of things
within a given set or sets. Whosoever. Whatsoever. Whatever per-
sonage. Used in contrast with ▪ |nʌn|.

39

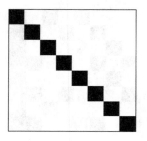

|ˈapəsteɪt|

The foe. The Demiurge. The pure diagonal transversal.
(SEE 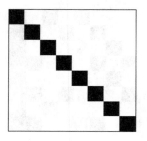 |ˈɛnəmi|; OPPOSED TO 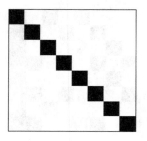 |ˈnɒlɪdʒ|.)

noun

One that has forsaken his calling, moral allegiance, or faith. A
perversion. A renegade. Unfaithful. An idealized figure. (SEE ⬚
|səˈtəːnɪən|.)

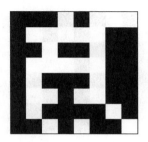

|apəˈreɪtəs|

noun

Means to a certain trade. A tool of the trade. A complex structure, organisation, or system. (SEE 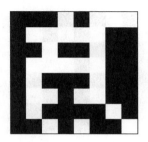 |ˈkɛmɪk(ə)l|.)

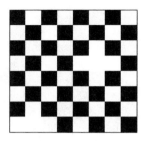

|ə'pɪə| |ə'pɪəd| |siːmd| |'vɪʒjʊəl| |glɪm(p)sd|
|iːs'θɛtɪk| |geɪzd|

*Is there any greater faculty than that which we realize from
the scatterings of particles of light? The disruption
in the even cosmic field is perceived by the brain and understood as
reality. Verbal acuity is illusory. Only the observed is always true.
Thus tricks related to the perception of light are not illusory but also
true. Hence the material truthfulness of the* ▓ |driːm|.

verb [trans. & intrans.]

To comprehend the universe through the two orifices in the centre of the head. To come into sight; to be made visible; to be made clear by evidence; to come into being. To give the impression of having a particular quality. To cast a passing glance. To see or briefly perceive. To look steadily and intently.

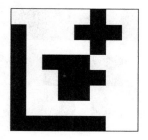

|ə'piːz|

To reunite the separated masses in relation to the ell of the ground.

verb [trans.]

To quiet; to still; to placate; to pacify; to give in to demands; to manipulate aggression.

42 ▨ |ə'pɪə|

adjective

Of or related to seeing and sight. (SEE ▦ |siː|.) Concerned with beauty, the appreciation of or the illusion of beauty.

|əˈplʌɪ| |əˈplʌɪd|

Two manipulators bring surface into contact with surface.
(SEE ![hand icon] *|hand|.)*

verb [trans. & intrans.]

To put one thing to another. To place objects over surface or surfaces against each other. To be relevant. To make formal requests of position or influence.

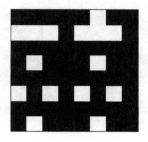

|ə'preɪz| |ə'preɪz(ə)l|

Compare and contrast the two states.
Yes, one is a deviation from the other.

verb [trans.]

To set a value or price upon.

noun

The act of asserting value or qualities upon things and persons.
Also truth, divinity, and likelihood.

45

ə'

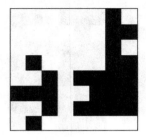

|əˈprəʊtʃ|

An arrow of movement arrives at another state.

verb [trans.]

The act of drawing near. To begin to engage with a subject.

noun

The way of dealing with a subject. The action of coming close.

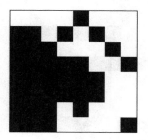

|ˈɑːgjuː| |ˈɑːgjʊm(ə)nt|

verb [trans. & intrans.]

To reason; to persuade. To express divergent views. To exchange verbal attacks.

noun

An exchange of opinions. A reason or set of reasons. Proof. Evidence. Manifestation of thought.

47

|ˈɑːmə|

The geometrical encasement of the life force.
(SEE T̈ |ˈanɪm(ə)lz|*.)*

noun

Defensive arms. A protective covering usually fashioned from plastics, matte metals, and other ancient materials.

verb [trans.]

To provide physical or metaphysical protection to a person or thing.

|əˈraʊnd| |səˈraʊnd| |səˈraʊndɪŋ|

Circumlating the objects of the centre.

adverb

About. In the environs of.

verb [trans.]

To be encompassed on all sides. To be beset my many things, i.e., foes.

noun

The action of being encompassed. The area outside of which the subject is enclosed.

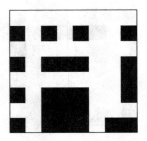

|əˈrʌɪv| |əˈrʌɪvɪŋ| |əˈrʌɪvd| |əˈrʌɪv(ə)l|

verb [intrans.]

To come to any place. To reach the end or stage of a journey, physical or conceptual. To land or port.

noun

The act of reaching a place. The exact moment of finish in a race or journey.

|ˈarəg(ə)nt| |ˈɛrəgəns| |ˈbragət|

The wandering continent divorces itself from the landmass of humility.
To claim separate virtues from the totality.

adjective

The quality of taking much upon oneself. Proud, haughty. An exaggerated sense of one's virtues, importance, or possibilities.

noun

A vain boaster. One who is boastful.

a

|ɑːt| |ˈɑːtɪst| |ˈɑːtɪsts|

*The kernel of inspiration. A fruit with three pips drifts
into the material plane (the left-sided ell).*

noun

The power of doing something not taught by nature. Speculation.
Creative imagination transmuted from the virtual into the corpo-
real. The act of physicalizing abstract pictorial images or texts. A
human being that performs creative acts. A maker of things ele-
vated above an artisan or craftsman. (SEE ▦ |meɪd|; ◼ |ˈabstrakt|;
▦ |ˈdʒɪəˈmetrɪk|; ☐ |drɔː|.)

|ɑːtɪˈzans|

noun

Those who are employed in the mechanical arts. Craftsmen.

a

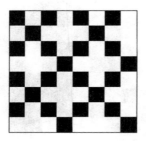

|az|

In relation with the definite and indefinite articles.
A complication of comparison.

adverb

Used in comparison of degree of quality.

conjunction

Because. Since. To indicate that something is happening during an activity. Even though.

preposition

During the time of being. To refer to function or character or social position that a subject has. To indicate capacity or title that one is working in.

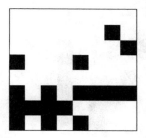

|ə'skrʌɪbɪŋ|

verb [trans.]

To attribute to a cause or quality. To write into, to add writing to. To enter into account.

a

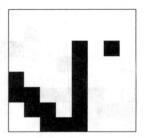

ɑːsk		ɑːskɪŋ		ɑːskd		ɪnˈkwʌɪə
ɪnˈkwʌɪris		dɪˈmɑːnd		kəˈmɪʃ(ə)n		
ˈkwɛstʃ(ə)n		ˈkwɛstʃ(ə)nd				

A satellite comes into contact with the unknown body.
It probes the subject with investigative apparatuses.

verb [trans.]

To elicit information. To say something in order to obtain enlightenment. To request. To express doubt. To seek knowledge. To look for information in. To consult an oracle. To express a desire for something imperiously. To employ someone to perform a task or mission. To retain the services of someone.

noun

The act of the above. A sentence that elicits information. That which is discussed or debated.

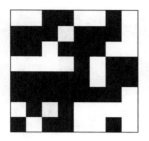

|ˈaspɛkt| |ˈfiːtʃəs|

noun

Way of looking. A particular attribute. The point at which one perceives an object or side of an object. A quality of a subject.

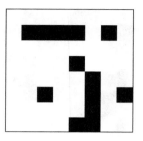

|ə'sjuːm|

verb [trans.]

To suppose something without proof or knowledge of. To take control of an office or position. To claim without asking. To take upon oneself.

|əˈʃʊə| |əˈʃʊəd| |ʃʊəɪst| |ˈʃʊəli|

The interlocking parts fit without doubt.

adverb

In a confident manner. Without danger of risk, loss, injury, or annihilation. With no caveats for security. Certainly.

adjective

Confident in one's knowledge or abilities. Reliable. Trustworthy.

verb [trans. & reporting]

To be made to believe in the likelihood of success. Compare with ▓ |daʊt|. To dispel doubts in a person.

ə

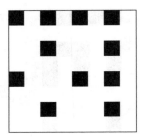

|ət|

The space in the cross. The very location of Locality.

preposition

The general localization of space, the relation of a thing to a point in space that it encounters with touch or has ideological placement. Defining the instance in the axis of time where actions or objects were located. Engagement, occupation, or condition of subjects. Position in a graduated scale. Time, order, and consequence. Point in a causal chain.

|at'lantɪk|

The great masses separated by the yet more massive form.

noun

A sea, ocean, body of water that divides a New World from an Old World. The physical barrier between |'jʊərəp| and the |ə'merɪkəs|.

|əˈtatʃ| |əˈtatʃd|

verb [trans.]

To fix to one's own interest. To arrest; to fasten; to join.

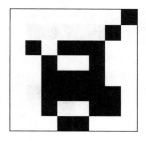

|ə'tɛnʃ(ə)n|

noun

The action of taking heed; regarding someone or something. The act of placing mental faculties upon a subject.

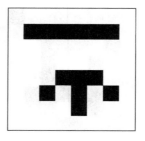

|ˈatɪk| |ˈhɛv(ə)ns| |ˈhɛv(ə)nli|

*The arrow of intent moves inexorably to a distant
plane out of reach of mortal souls.*

noun

A space or room below the roof or conclusion of a building. The
space of stars and planetary bodies. The firmament and night sky.
Paradise. The afterlife. A wonderful place or state. The residence of
positive deities.

adjective

Pertaining to the paradise, afterlife. Full of religious sanctity.
Delightful. Unearthly.

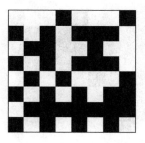

|ɔːˈrɔːrəs|

noun [pl.]

Electrical phenomena appearing in the North and South Poles. Colourations and animations of the night sky. The tendrils of the dawn.

ə'

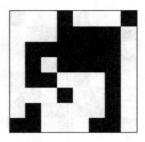

|əˈweɪk| |əˈwəʊk| |weɪk| |wəʊk|
|weɪkɪŋ| |raʊzd|

*The two forces—night and day, sleep and dream,
reality and illusion—intertwine.*

noun

The state of being not asleep. Everyday reality.

verb [trans. & intrans.]

To rouse from a dream, delusion, or rest. To rise from a state of
inaction, death, indifference. To become active, dangerous. Con-
versely to move from the illusory nature of reality to the actuality
of the dream world. (SEE ▓ |driːm|.)

|bak| |rɪˈgrɛsd| |rɪˈtriːt| |rɪˈtəːnd| |rɪˈtəːns| |rɪˈtəːnɪŋ| |wɪðˈdrɔː|

The dark water recedes from the sand.

verb [trans. & intrans.]

To the place where one came from. To come again to the place where once came from. To withdraw. To recede. To decline, decrease, or disappear. To remove oneself. To devolve. To degenerate.

adverb

Toward the rear. Coming again to a previous state.

noun

The state of action of above.

|ˈbakwɔːtə| |ˈbakgraʊnd|

The character of action comes to see a place behind other places.

noun

The area behind that of chief contemplation. Opposed to the ▨ |frʌnt|. The cultural history or knowledge of a subject. A stagnant area of water, ill frequented and unexplored.

| 'bagɪdʒ |

noun

The personal belongings and effects one takes on a journey. The emotional and psychological history of a person. Supplies and ammunition of an army plus the men guarding it. Derogatory; an old woman.

'b

|ˈbeɪkə| |ˈbeɪkəz|

In the warm cavity, space and matter expand.
The stars rise and push at the hard, crusty envelope that contains them.

noun

A craftsmen of bread. One who heats and hardens foodstuffs in an oven.

|ˈbaŋkwɪt|

At the head of the long table, the chieftain commands the feast.

noun

A sumptuous meal often ceremonial in nature, followed by speeches. A feast. A decadent entertainment of food and drink.

b

|bɑː| |bɑːs| |ˈtav(ə)n|

The somnolent drinker's head rests upon the cool mass of the table.

noun

An establishment where alcohols, barley broth, and food may be sold and consumed.

|bɑːk| |bɑːkd|

verb [trans. & intrans.]

To emit the noise of a dog. To emit an explosive shout. To command or question aggressively.

|ˈbarɪə| |ˈfrʌntɪə|

From the eye of the bird or airborne vessel, the civilized lands appear as
a geometrical painting broken into neat fields, roads, and hedges.

noun

The separator of two distinct spaces or thoughts. The dividing
line. The extreme limit of an area or sphere of knowledge.

|beɪs| |beɪsd| |ˈprɛdɪkətd|

The pillar that supports forms.

noun

The bottom of any thing. The pedestal of a statue. The support of a subject.

verb [trans.]

To found something upon a structure. To lay a foundation for. To create a logical basis for.

b

|bəˈsɪlɪkə|

noun

A royal palace, oblong building, or hall with double colonnades.
A building of worship. A magnificent church. (SEE ⊞ |tʃəːtʃ|.)

|bɑːðz|

The container of water.

noun [pl.]

Either hot or cold, either artificial or of nature, restorative treatments of water. Containers of water, salted or natural, in which the body is inserted. Establishment of a remedial remit.

b

|biː| |biːɪŋ| |biːɪŋs| |ˈkriːtʃəs|

The sign of essence. The absolute quality from which all others are permutations. Essentiality.

verb

To have or to take place in the world of fact. To have or to take place in the world of fiction. To occur, exist, happen. To enter or remain in existence.

noun

Those subjects that are in existence, esp. living or supernatural. Living essences that have been created by accident or deific agency. Persons. Animals. Plants. Rocks.

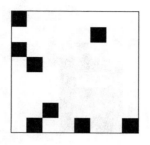

|biːtʃ|

noun

The shore of a sea or river. A sandy or pebbly strip of land next to a body of water. An area upon which waves are broken.

b

|bɪəd| |bɪədɪd|

The mask behind which the emotions of the face are hidden.
The penitential sacrifice of vanity to a supernatural spirit.

noun

An outcrop of hair grown on the face of adult men. A growth or tuft
of hair on the face of an animal, i.e., goat, lion, seal.

|ˈbɛrɪŋ|

noun

A person's standing, comportment, or demeanour.

b

|bɪˈkɒz| |kɔːzɪŋ|

conjunction

For this reason that; since. With the purpose to.

verb [trans.]

Giving rise to an action. Forming chains of effect. i.e., from A to B. Making occur as instances.

|bɛd| |bɛds| |ˈbɛdsʌɪd|

noun

A piece of furniture or object upon which one sleeps. The area next to and around such objects. Haunted by the contemplative, idle, and lustful.

b

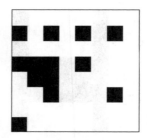

|bɪˈfɔː| |prɪˈsiːd| |ˈprɪviəsli|

prefix, preposition, conjunction & adverb

In front of in time or place. In advance. Anterior to the time in question. At the beginning.

verb [trans.]

To happen or exist earlier.

|bɪˈhʌɪnd|

The object surprises the subject approaching from his unawareness.

preposition

At the back of. Remaining after departure. On the far side of. In support of.

b

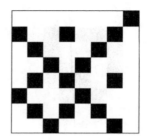

|brˈliːf| |brˈliːvd| |əbˈsɛʃ(ə)n| |trʌst| |ˈkriːd(ə)ns|

noun

Theological faith in. Reliance on the truth of a thing. Expectation or hope of something. An idea or image that continuously troubles the mind.

verb [trans.]

To be confident in the reality of a statement. To accept something as true, sometimes irrationally.

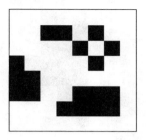

|bɪˈnʌɪn| |ˈhɑːmlɪs|

adjective

Free from or not able to cause loss, injury, death, grief, suffering, or ill. Not malefic.

b

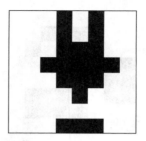

|bɛst|

The greater force above the plain, unadorned baseline.

adjective

The superlative form of 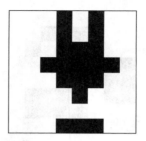 |gʊd|. Excelling all others in quality.

adverb

The utmost power. The highest degree.

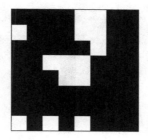

|bɪˈtreɪ|

verb [trans.]

To give into the hands of enemies by treachery. To be false, to lead astray, to deceive. To reveal information that was guarded, vital.

b

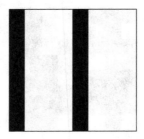

|bɪdɪŋ|

The two invisible lines that control the movement of a compass,
the patterns of iron filings, and the wills of human wretches.

noun

The action pressing an individual to an order, summons, or control.

|bʌɪl|

*The organic fluid envelops and entropically transmutes
the ingested material of the external world.*

noun

Choler. One of the four humours. A bitter brownish, yellowish, or greenish fluid secreted by the liver as an aid to digestion. A transformative fluid.

| 'bɪləʊ | | 'bɪləʊd |

verb [intrans.]

To swell and flow outward, esp. of fabric, smoke, or water vapour and steam. (SEE |klaʊd|.)

|bʌɪə(ʊ)ˈlɒdʒɪk(ə)l|

The regulated logic of the base matter made complex and irregular.

adjective

Of or relating to living systems, the science of organic forms. Cyclic and rhythmic activities of an adaptive and self-propagating nature, as opposed to |məˈʃiːns|.

b

|bə:θ| |bɔːn|

The vessel is launched into the vacuum from the Mother.
The separation of a single being into multiple ones.

noun

The act of coming into life. The bearing of offspring or concepts.
Nativity. The exit from the womb. The coalescing of concept into
materiality.

past participle

To have been brought forth. To have been brought into existence.

adjective

Nated.

|ˈblakbɔːd|

Marks of information drawn over a void.

noun

A large, dark surface of slate or painted wood found in schools, universities, and the atelier of chemists. A board to write upon with chalk that can be erased. A flat plane inscribed with temporary information. (SEE ▢ |drɔː|.)

|'blaŋkɪt|

Layers of two-dimensional planes create intercostal spaces filled with warmth. The skin man has fashioned for himself.

noun

A woollen spread commonly upon a bed. A covering for warmth. A plane of soft material draped over objects for protection or concealment.

|blɛs| |blɛsd|

Holy crosses fall like snow over the spiritual wound,
protecting and enchanting.

verb [trans.]

To anoint with blood. To consecrate through sacrifice or magic rite. To make sacred, hallow. To protect from evil influences. To support. To praise.

b

|blʌɪnd| |ˈblʌɪn(d)fəʊldɪd|

The incomplete structure deprives knowledge and vision.

adjective

Deprived of the sense of seeing. Lacking perception, intellectual darkness. Physical darkness affecting sight. Unseen. Lacking foresight. Not easily discernible, obscure. Unknowing. Concealed or closed off. To perceive a bright light that confuses the faculties.

verb [trans.]

To deprive someone of sight or vision often through injury or application of cloth material around the head to cover the eyes. To pierce someone's eyes. To be unsighted by an opponent.

noun [pl.]

Those who lack the ability to see.

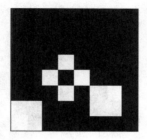

|blʌd| |'blʌdi| |bliːds| |bliːdɪŋ|

*From the individual spills an opaque block of life,
more potent than the vessel in which it is contained.*

noun

One of the four humours associated with a confident and optimistic temperament. The basis of sacrificial rites. A red liquor contained in the bodies of human beings and higher animals. A liquid circulating in political bodies and institutions. The life force.

verb [trans. & intrans.]

To let out the liquid of the veins and arteries. To cut deeply a higher animal.

adjective

Covered, smeared, or running with said liquid. Obscene profanity with reference to the internal composition and death of the prophet of the 🔳 |tʃəːtʃ|.

b

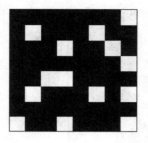

|blu:|

adjective

One of seven principal colours. The colour of the sky, the sea, and great abstract painting. Between green and violet in a scale. The colour of the dead and the unbreathing. The colour of smoke, vapour, veins, and pale distant hills. A melancholic feeling inspired by the sight of the above.

|'bɒdi| |'bɒdːs| |kɔːps| |hɛlθ|

The symbol of the prison of man. On the right side is the Vehicle.
On the left the Material World that enchants it.

noun

The material substance of a man or animal. The structure of bones, flesh, and organs known as a person. The vessel of the soul. A person. The form of a living creature. The form of a dead creature. The corporeal. The main part of a thing. A group of people. To be free from injury or disease. Condition in which all duties are discharged efficiently.

|ˈbɔɪlə|

noun

A fire-burning apparatus for heating water or driving engines with steam. (SEE |klaʊd|.) A vessel in which water or liquids are agitated into an excited state. A man or creature who performs the above function.

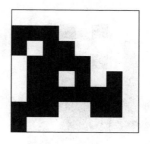

|buːn| |ˈbɛnɪfɪt|

noun

A gift or grant. An advantage or profit gained. A payment or gift. A favour or request for favour.

b

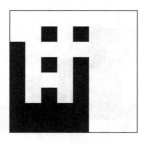

|bəʊ|

noun

The fore-end of a ship. From the sides where the planks arch inward, and terminating where they close, at the rabbet of the stern or prow. That which the ship presents going forward.

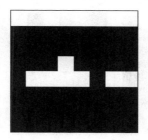

|breɪv| |breɪvɪŋ| |dɛː| |dɛːd|

*The single soul prepares to confront an apparently
impossible task or obstacle.*

adjective

Courageous; bold; intrepid; stout-hearted; high spirited. Ready to
endure hardships, pain, injury, danger, death, humiliation, or failure.

verb [trans.]

To not be afraid. To challenge or defy. To undergo hardships. To
be bold.

b

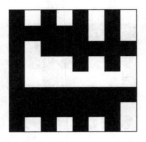

|briːtʃɪŋ|

The waters overflow the barrier.

verb [trans.]

Breaking through a barrier, wall, or dam. Failing to observe a code of conduct. Achieving a breakthrough of historic importance.

|brɛd|

A vessel for nourishment.

noun

A foodstuff made of corn or grains, water, and yeast. Made by |'beɪkəs|. The food of life. That which is eaten in churches in place of the corpses of prophets. (SEE |məʊld|; |'wɒf(ə)l|.)

b

|brɛθ| |briːð| |hʌfɪŋ| |wɪnd| |wɪnds| |briːz|

*The mixing gases flow around the earth and in and out
of creatures and plants, each one adding and subtracting to its
composition until its formula is completely reversed.*

noun

The air drawn in and out by living animals. The circulation of the
air in the sky. Exhalation or inhalation. The movement of air, esp.
to fly kites or push the sails of ships. The creative force of deities
used to imbue forms with life.

verb [intrans.]

To respire. To inspire air into one's body and then eject it. To
acquire oxygen and lose carbon dioxide. To imbue a narcotic sub-
stance via the lungs. To blow air in a vigorous way. To behave in an
irresponsible or light hearted manner.

|brɪk| |wɔːl| |ˈmjʊər(ə)l|

In the bowels of the earth, wood becomes blocks of coal.
In the hands of men, earth becomes squared.
Mountains are made by men; inside they contemplate the
pattern of mortise that bonds their world.

noun

Hardened and burned earth formed into blocks. Used instead of stone. Clay left in the sun or placed in ovens. (SEE |ˈbeɪkə|.) Commonly used to build fortifications, industrial and residential building. Of definite size and shape, rectangular, reproducible. Stone and cement carried upward. The exterior of a building or interior partitions. A fortification or part of. A division of land that is impenetrable. A painting or drawing placed upon a vertical plane, esp. artificial edifice.

b

|brɪdʒ|

The line diverges over another unseen force.

noun

A building raised upon water for the convenience of passage. A structure carrying a road, railway, or information system over water, great heights, and injurious threats.

verb [trans.]

To build said structure. To join together different or oppositional tendencies.

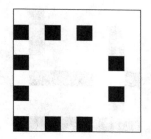

| ˈbrɪlj(ə)nt | | ˈbrɪlj(ə)ns |

noun

Shine, sparkle, lustre. An intense radiance or splendour. Of a great mind or work of man.

b

|brɪŋ| |brɔːt| |brɪŋɪŋ| |dɪˈlɪvə|
|dɪˈlɪv(ə)ri| |dɪˈlɪv(ə)ris|

verb [trans.]

To fetch from one place to another. To convey in one's hands. To create. To cause to come along with oneself. To introduce. To lead, conduct, propel. To place in circumstances. To conduct to a place. To have happen. To conjure up. To cause to arrive. To give, yield, offer, surrender. Of music or literature, to perform; to raise from notation to high art. Utterance, speech, childbirth.

noun

The conveyance of a substance from one place to another, often on a regular or planned routine.

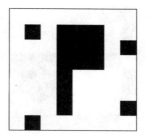

|brʌʃ|

One of the major tools. The pusher of liquids and powders.
A delineator of shape, information, writing, and makeup.

noun

An instrument used by painters to draw liquids into patterns. A handle of wood holding hairs or bristles. A long pole with hair or wires on the end used to clean streets, rooms, and floors by sweeping dust and debris to another location. Device of many lines held in place to form a block of volume.

verb [trans.]

To wield such an instrument. To remove dust or dirt. To lightly carry away. To move a thing without great effort.

|ˈbʌb(ə)l| |ˈbʌb(ə)lɪŋ| |bəˈluːns| |fəʊm| |ˈfoʊmi|

noun

A film of water filled with wind, a globular or hemispherical shape of liquid containing air or other gas. A ball of air or aberration in a solidified liquid, glass, plastic. Something that lacks solidity or firmness. A ball or spherical object used in games or divertissements, inflated or hollow. A large amount of spherical film as produced by the mouth, waves, the gesticulation of water and soap.

verbal noun

To produce such effects.

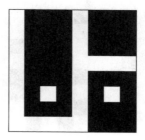

|bɪldɪŋ| |kənˈstrʌkʃ(ə)n| |ˈɑrkəˈtɛk(t)ʃ(ə)rəl| |riːkənˈstrʌkʃ(ə)n|

The lines of space demarcate the boundaries in which people and goods are protected from nature. (SEE 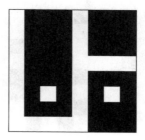 |brɪk|.)

noun

An edifice, form, or structure created by man or lower organism, i.e., termite, bee, spider. A container of men and goods protected from the elements by raised walls or roof. The science of devising, drawing, formulating, erecting, putting together a structure, home, factory, bridge, powerstation, dock, or other such complex unnatural form. The repair, renovation, renewal of a dilapidated or destroyed place or structure. The manner in which things are artificially organised, esp. men, society, ideas, religion.

verb [trans.]

To erect or form a structure, machine, unit, road, concept, or sculpture.

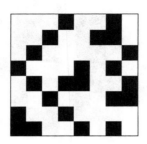

|ˈbɪzi| |ˈbʌs(ə)l|

adjective

To be employed with earnestness. Occupied, engaged, engrossed with attention.

noun

A hurry, a tumult, a confusion. Said of many men and cattle on a market day.

verb [intrans.]

Moving in an energetic or noisy manner. To be full of activity.

adjective

Related to this science of structuralizing.

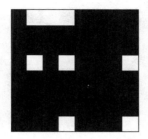

|bʌt|

One of the negators of language. Sign of the equivocator.

preposition, adverb & conjunction

Except. Yet. However. Nevertheless. Only. Nothing more than. Albeit. A particle meaning that the foregoing sentence is constrained by boundary or possibility or veracity. With objection. An argument against something. Used to introduce contrast with something already said. Used to express anger.

b

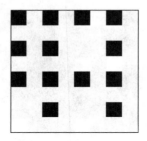

|baɪ| |θruː|

preposition & adverb

Near, at a small distance. Beside, at the edge, vicinity of. In the presence of. Traversing with the means of. From end to end of. Using transmission. In the means of. Utilising; appropriating; using.

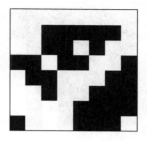

| ˈkak(ə) |

verb [intrans.]

To laugh, to giggle. To make a noise as of a goose, hen, or disturbing bird. To talk glibly, loquaciously, to prate in a maleficious manner.

noun

The laughter of a bird.

k

|kɑːm| |kɑ(l)mli|

The controlled conclusion of two lines.
The resolution of oppositional forces. Lack of conflict.

adjective

Quiet, serene, not tempestuous.

noun

A serenity, freedom from agitation. A want of wind on the seas. The portent of a great storm.

verb [trans.]

To pacify, soothe, satisfy anger. To remove ill humours. To allay fear.

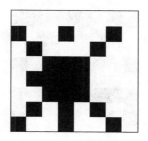

|kamp|

noun

A party or group of men. A temporary accommodation, esp. armies and hunters. Supporters of a doctrine or discipline.

verb [intrans.]

To pitch tents or reside in fields. To play at soldiers.

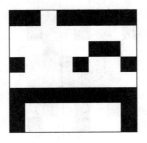

|kan| |kʊd| |ˈeɪb(ə)l|

From the material base rises a possibility of action at the top.
In the horizontal plane lies obstacle.

verb (modal)

The power to. The license to. To have the potential to do something. An active ability. The possibility of, in contrast with the permission to.

noun

The power of possibility.

|ˈkand(ə)l| |ˈkand(ə)llʌɪt|

The mass that illuminates the white field.
A separator of vision from the occlusion of the night.
(SEE ▦ *|blʌɪnd|.)*

noun

An implement to create light. A stick of wax or tallow with a cotton or flax thread that is burnt. (SEE ▬· |wɪk|.) The light thrown off by such instruments, a light that is weak, insubstantial, esp. compared with the sun. The weak flame of humanity in an ocean of cold, darkness, the vacuum of space.

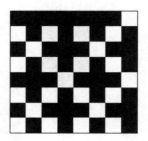

|ˈkanɒt| |ʌnˈeɪb(ə)l| |ˈkʊd(ə)nt|

adjective, adverb & verb

Lacking the skill, means, or opportunity to. Lacking the possibility of. Being blocked in one's intentions. Weak, impotent.

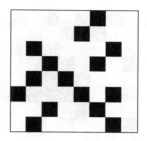

|'kanvəs|

*The speckle of impurity on the plane points the artist
in the direction of absolute flatness.*

noun

A strong coarse fabric of hemp, flax, cotton, or other such suitable materials. From the derivation of cannabis, hemp, narcotic. Cannibus Lat. Used to move men on ships by use of sails. Used to billet men in cloth houses. (SEE |kamp|.) Used to construct paintings. (SEE ☐ |drɔː|.) The field of view, the understanding of a political situation. Vantage point.

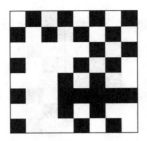

|kəˈpasɪti|

noun

The power of holding or containing something or someone. The force or power of the mind. Power, ability. The role, function, or office of a profession, e.g., that of carpenter, artisan, priest, doctor, king, assassin, burglar, burgher. (SEE 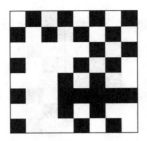 |prəˈfɛʃ(ə)n|.)

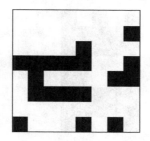

|ˈkaptɪn|

noun

A chief commander. A commander of a company in a regiment. A commander of a ship or maritime vessel. A commander of an airborne vehicle. A master of transport, industry, or enterprise.

|ˈkaptʃə| |ˈkaptʃəd| |ˈkaptʃəɪŋ|

*The sticky field absorbs and impedes the passage
of transient individuals and flies.*

verb [trans.]

To take and hold a thing, esp. warfare or hunting. To take control of a town, city, position. To have possession of affections. To represent well in the medium of writing, poetry, sculpture, or painting. To control the corporeal form of a thing.

|'karəpeɪs|

A house upon another house. The body carries its own roof.
(SEE ▯ *|'ɑːmə|.)*

noun

The hard upper shell of tortoises and crustaceans. The protective formation of soldiers with shields held above their heads in an interlocking pattern. The surface of the earth, ground. (SEE ▯ |sə'təːnɪən|.)

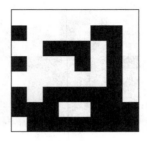

|ˈkɑːd(ɪ)n(ə)l| |ˈkɑːd(ɪ)n(ə)lz| |ˈklɔːdʒi|
|seɪnt ɔːˈɡʌstɪn| |ˈwəːʃɪp|

noun

The body of men set apart as labourers in the service of the Church, as opposed to the laity. Those ordained in religious service. One of the chief administrators of the Church of whom the 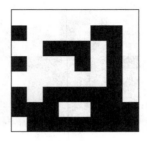 |pəʊp| is elected. One of the seventy ecclesiastical princes. |seɪnt ɔːˈɡʌstɪn| of Hippo (353–430 CE), doctor of the Church, Bishop of North Africa. The concept of the immediate efficacy of grace and absolute pre-destination. The act of adoration, religious reverence.

verb [trans.]

To honour or revere a supernatural being or power. To venerate an icon, fetish, sculpture, or work of art. To place undue honours on an animal, horse, dog, or cat as is done in foreign lands.

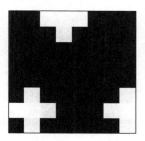

|kɛː| |ˈkɛ(ə)rf(ə)li|

The tentative caresses of the edge of hyperbolic space
reveal the hand doing the caressing.

noun

The application of consideration or attention. A trouble or pertuba-
tion. A caution or regard for.

adverb

In a heedful, circumspect, attentive, or cautious manner.

verb [intrans.]

To be anxious. To be affected by something. To pay serious atten-
tion to. To avoid a particular outcome. To be tentative.

131

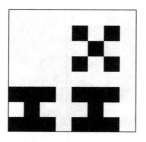

| ˈkɑːp(ə)ntə |

Two forms fashioned by the sharp.
Soft material abrased into useful shapes.

noun

An artificer in wood. An artisan or lesser artist. A builder of houses, furniture, ships from timber.

|kɑːts|

The two large wheels pulled by a horse's head.

noun [pl.]

Carriages of two or four wheels. Open vehicles used for carrying loads pulled by horse, ass, donkey, oxen or mythic beast. Chariots or cars. Strong wagons. (SEE |dɪˈlɪvə|.)

k

|keɪs| |keɪsɪz|

noun

A thing fitted to enclose or contain another thing. A box, chest, bag. The outer part of a thing, often protective. A device to carry tools of a trade, esp. philosophy or medicine.

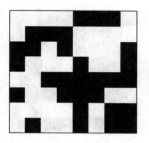

| 'kaʒʊəl |

adjective

Not predetermined. Arriving from chance or accident. Incidental. Relaxed or unconcerned. Not regular, permanent, or timed. Informal, unmannered. Not following dictum or protocol.

k

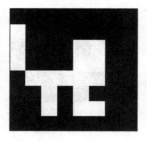

|kat|

The ghost of the capricious reborn as an animal.
The symbol of the Trickster. His bushy tail on the left distracts the eye
in the manner of the magician's wand, while on the right side
his paw purloins the white rabbit.

noun

A small furry carnivorous quadruped. Domesticated animal wor-
shipped by the ancient Tennesseans of Memphis. A predator of
mice, spiders, and toes.

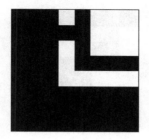

|katʃ| |kɔːt|

The dark ell sandwiched between two pale planes.

verb [trans.]

To intercept. To lay a hand on. To prevent from flying or remove from the air. To receive suddenly. To come upon. To seize suddenly. To ensnare. (SEE 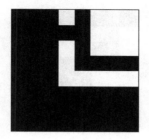 |ˈkaptʃə|.)

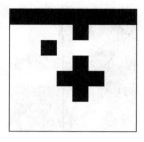

|ˈsiːlɪŋ|

The souls drift up to the barrier of heaven.

noun

The inner roof. The upper interior surface of a room. The limit of potentiality of amount. (SEE ▪▮ |ˈfəːməm(ə)nt|; ⊤ |ˈhɛv(ə)n|.)

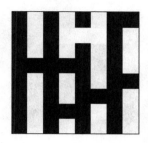

|ˈsɛlɪbreɪt| |ˈsɛləbrəˈtɔri|

verb [trans.]

To praise, to commend. To perform rites solemnly. To mark a significant occasion through rejoicing, merriment, and narcotic intoxication.

adjective

Serving to honour a person or occasion.

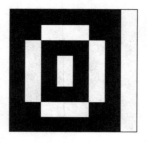

|ˈsɛntə| |ˈmɪd(ə)l| |kɔː|

The heavens and planets, all creatures and rock are held
in sway to the initial point. From this place all other distances
are measured, distinguished, and relativised.
(*SEE* 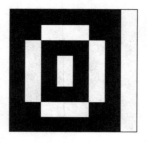 |səˈtəːnɪən|; 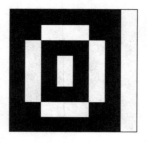 |səʊl|; 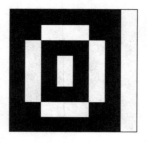 |skwɛːs|; 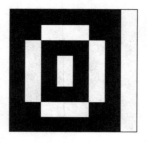 |hʌɪd|; 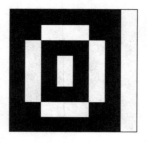 |ˈsəːk(ə)l|.)

noun & adjective

The place equally distant from all extremities. The point around which things and people group themselves. That around which one revolves. Intermediate, intervening. The 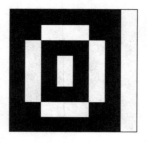 |hɑːt|. The inner part of anything. The matter contained in a boil. The kernel.

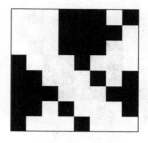

|tʃeɪn| |tʃeɪnd|

verb [trans.]

To bond or link with ropes or metal linkages. To bring into slavery.
To unite. To shackle together. To fetter or confine with metal bonds.

t

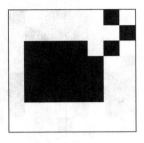

|tʃɑːns| |ɒpəˈtjuːnɪti|

Fortune herself. The breaking away from expectation.

noun

A fortuitous event. An accident, lucky or unlucky. A fit time, place, or circumstance. The way in which things fall, that which befalls a person. A possibility to gain advantage. The game of 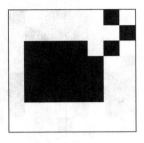 |ˈhazəd|.

|tʃeɪn(d)ʒ| |tʃeɪn(d)ʒɪŋ| |ˈflʌktʃʋeɪtɪŋ| |təːnɪd|
|transˈfɔːm| |ˈmɛtəˈmɔːfəʋzɪd|

The pattern vacillates. Molecules are excited from one state to another.
(SEE **1** *|wʌn|.)*

verb [trans & intrans.]

The alteration of the state of any thing. To make a thorough or dramatic translation of form. To transmute one substance to another by means of supernatural agency. To place a thing in the place of another. To alter, mend, change the disposition of. To make a thing other than it was, to modify or convert. To move in patterns like waves, to undergo irregular and repetitive vacillations of state, position, substance, or mood.

noun

The succession of one thing to another. Novelty. The temperamental nature of the universe.

|ˈkarəktə| |maθ(ə)ˈmatɪks| |əˈrɪθmətɪk| |əˈmaʊnt| |kaʊnt|

The idealised conception of abstract quantities and beings.
Related to notions of self and existence.
(SEE ⊞ *|biːɪŋ|;* ▮ *|wʌn|.)*

noun

A mark, a stamp, a representation. The notation of a letter, numeral, or symbol. A representation of a man's personality or nature. Personal qualities of the mind, esp. constitution. A quantity or reckoning of how many. The science of computation, the adding, subtract, multiplying, and dividing of units. Abstract manipulation of higher ethereal concepts in fields such as topology, algebra, analysis, space, and ⌐ |dʒɪˈɒmɪtri|.

verb [trans.]

To compute a sum using the powers of reason. To decide on a definite notation for abstract compositions.

|ˈtʃɑːdʒə|

noun

A horse ridden while bearing down on the enemy. A horse or camel ridden in the field of action or war.

|ˈtʃarɪti|

noun

Tenderness or benevolence. Alms for the poor. Liberality to the poor. The voluntary giving of help, esp. organisations devoted to the needy.

|tʃeɪs| |tʃeɪsɪŋ|

The hunter on one knee prepares to fell his prey.

verb [trans.]

To pursue. To pursue with the aim of catching. To pursue merely for pleasure. To follow a thing. To drive a thing to a place, esp. trap or ambush.

t

|tʃɛk|

Visual assessment of a thing requires something with which to compare it, be it memory, reality, or imagination.

verb [trans.]

To compare. To examine the accuracy, quality, or authenticity of an object. To verify to one's satisfaction.

|ˈkɛmɪk(ə)l| |ˈkɛmɪk(ə)lz|
|ˈdʒɔːd(ə)nəʊ ˈbruːnəʊ|

The principal element of physical materiality made up
of three parts—proton, neutron, and electron.

noun & adjective

Substances created by man from natural sources manipulated in vessels often by means of fire. The manipulated forms of base materials often used for medicinal or industrial purposes. Italian philosopher |ˈdʒɔːd(ə)nəʊ ˈbruːnəʊ| (1548–1600 CE), devotee of hermetic science.

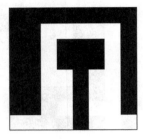

|ˈtʃiːft(ə)n| |ˈliːdə| |hɛd| |ˈmɑːstə| |tʃɑːdʒ| |liːd|

One form comes to dominate all others.
It rises, threatens, commands, and abjures.

noun

The part of an animal that contains the organ for thought. That through which creatures ventilate. In humans above the neck. In animals, at the front. The location of intellect. The front of a structure. The ruler or captain of a tribe. The principal organizer or decision maker of a group or society. One who has servants. A director, governor, proprietor. A lord or prince. One who controls his own destiny. One exceptionally skilled in a craft or science, a guildsman or teacher.

verb [trans.]

To cause a person or animal to go with them. To conduct or bring to combat. To attack or control men in attack of an enemy force. To give an authorative order. To be secure in one's control of their forces. To entrust with a task. To induce, prevail upon, seduce, or draw someone to an act.

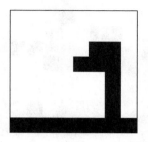

|tʃʌɪld| |ˈtʃɪldr(ə)n| |bɔɪ| |sʌn| |ˈɪnf(ə)nt|

The diminutive character. (SEE 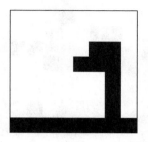 *|wʌn|.)*

noun

An infant or young human being. Below the age of development or legal right. Below the age of initiation rite. One in the line of filiation, as opposed to ▮ |ˈpɛːr(ə)nts|. A male in the state of adolescence. A contemptuous word for a man. A male for or begotten of one. The product of a thing. A human being from the earliest part of its existence, from its exit from the womb but before reaching seven years of age.

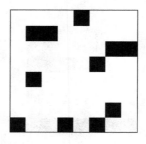

|tʃɪl| |tʃɪld| |tʃɪlz|

verb [trans.]

To lower the temperature of. To make cold or injuriously cold. To deaden, to frighten, to numb.

|ˈtʃɒk(ə)lət|

A block from the absolute grid. A potent substance
used in rituals and as a mnemonic device.

noun

The nut of the cacao tree. A plant native to the |əˈmerɪkəs|. The nuts of said fruit. A food in cakes, liquids, or solids made from roasted or ground cacao seeds. Of a deep brown colour similar to |dʌŋ|.

t

|tʃəːtʃ|

The enclosed perfectly regular form denotes
sacred and transcendental qualities.

noun

A supernatural society. A place for reverential homage to divine being or beings. A building where people congregate to worship ▨ |gɒd|. A consecrated place. A group of people having religious beliefs or practices considered by others as strange or sinister. The organized structure of clergy, cardinals, and priests that direct, the social interactions of the laity.

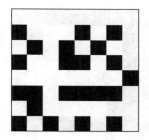

|tʃəːn| |tʃəːnɪŋ|

A tumultuous and disturbed pattern.

verb [trans.]

To agitate or shake anything by violent motion, esp. milk to make butter. To vigorously motion a liquid so that it froths and becomes foamy. (SEE 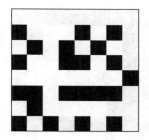 |'bʌb(ə)lz|.)

|ˈsəːk(ə)l| |ˈsəːk(ə)lz| |raʊnd| |sfɪə|
|ˈsəːkjʊlə| |dɪsk|

The snake eats its own tail again, again, and again.
The perfect curve of its flank reveals true infinite recession and the spirit
of that which is unknowable in the consciousness of man.

noun

A line that moves in space till it finds itself yet again. A globe, an orbi-cular body. A body the centre of which is equidistant from every point on its circumference. A close group of men. A cross section of a globe, an iron device thrown in competitive athletics. A shape without points or more than one angle. A shape that is symmetrical in an infinite number of degrees.

adjective

Lacking pointed protrusions.

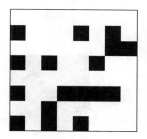

|ˈsɪtɪz(ə)n| |ˈsɪtɪz(ə)ns|

noun

A legally recognised subject of a nation, state, or city. Not a gentleman or nobility. Not a foreigner. A freeborn man with all due rights.

156 ▢ |ˈsəːk(ə)l|

adverb & preposition

In every direction, to form a ring, in the vicinity or neighbourhood of. (SEE ▦ |əˈbaʊt|.)

verbal noun

To move around a thing till one comes back to the same point.

|ˈsɪvɪlʌɪz| |ˈsɪvɪlʌɪzd|

When the trees were first felled and men ploughed the fields
with parallel furrows, crops and food became abundant.
When there was too much for the farmers to consume, a group of men
decided to move away and build a group of many homes divided
by lines and squares. In the city men abstracted, cogitated, and pined
after things they could not have. They dreamt of hunting in
forests and cursed the farmers who supported their artificial existence.
Back on the farm young boys fought and strove to develop
manners and attitudes like those that they had heard of in the city.
The very best would philosophise at their brethren while picking the grapes,
spout rhetoric from atop the haystacks, and compose epic poetry whilst
others churned the butter. Eventually sick of their idle youth,
the farmers banished the chattering ones whom, with great relish, began
the march to the town. On the well-rutted road they would
pass dejected men returning from the metropolis with beards and bad
literature under their arms. As the pitiful men motioned
at the youths for money, the lads would laugh and say to each other that
they would never end up like those ignoble beasts.

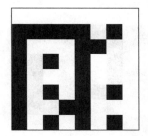

|kleɪm| |kleɪmd| |kleɪmɪŋ|

Things external are captured and brought within. If men had their way then eventually all things would be brought into the fold.

verb [trans.]

To demand one's own or what is due. To demand anything authoritavely. To state or assert that something is the case. To assert the truth of a speculation. To ask for money or property.

158 ◼ |ˈsɪvɪlʌɪz|

verb [trans.]

To bring out of barbarism or brutality. To have knowledge of arts or science. To make unlike a savage. To make lawful or proper in a community. To support cities and post-subsistence societies. To shape nature in regular and geometric patterns and structures.

k

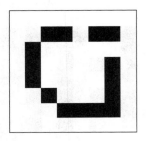

|klɪə| |klɪəd| |klɪəɪŋ|

A simple form breaking apart to nothing.

adjective

Bright, transparent, luminous, without opacity. Free from clouds or particulate matter. Without disputation, apparent, undeniable. Easily perceived. Unencumbered, free from doubts, available. Not closed in by trees, houses, or other objects. Open, exposed, for any intelligent person to comprehend. Worthy of attention, mention, reference. Worthy of being written down. Free of obstacles. Free of marks, blemishes, imperfections.

adverb

Becoming clear of obstacles or impediments. With clarity.

verb [trans. & intrans.]

To give authorization. To make undisputable. To become free of marks, blemishes, or impediments. To remove unwanted items, obstructions, esp. trees, soldiers, cultural critics.

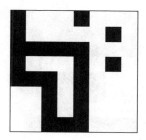

|ˈklɛvə| |ɪnˈdʒiːnɪəs| |ˈdʒiːnɪəs|

Those on the outside wonder what marvels could exist inside that skull.

adjective

Nimble and dexterous of hand. Nimble and dexterous of intellect.

noun

The tutelary spirit that attends one from birth till life and that guides one's fortune and determines character. A human being endowed with powerful mental faculties. An exceptional disposition to a task or profession. An inventive or unusual solution to a problem. The general creativity of mankind.

k

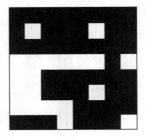

|kləʊk|

noun

A sleeveless outer garment that hangs loose. A piece of clothing to shield or conceal one from the elements or others' eyes.

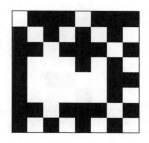

|kləʊs| |kləʊsɪd| |kləʊsɪŋ|

verb [trans. & intrans.]

To coalesce, to joint the parts together. To agree upon or finish. To cover, shut in, or encompass. To stop a channel or opportunity.

k

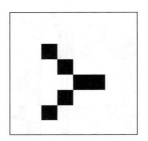

|kləʊs| |ˈkloʊsli| |kloʊsər| |kləʊsɪst|
|nɪəɪst| |prɒkˈsɪmɪti|

The arrow of intent approaches the Intended. (SEE 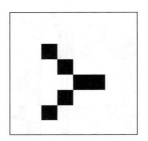 *|wɒnt|.)*

adjective & adverb

A short distance away, in the vicinity of. In a position as to be almost beside a subject. In reach of. Almost. Not distant from. At hand. Approaching a goal or target.

noun

Lack of distance in space, time, or relationships.

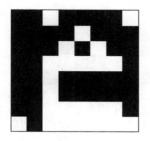

|kləʊðs| |s(j)uːts| |kləʊðɪd| |klad| |wɛə(r)|
|wɛə(r)ɪŋ| |gɑːb| |'gɑːm(ə)nts|

Symbol of the helmet.

noun

Dress that protects from cold, injury. (SEE 🛡 |'ɑːmə|.) Dress for
fashion and pleasure. Exterior appearance, esp. items placed on the
exterior by people, tribes, nations, professions. Fabrics or materials
that house men, lying close to their skin. (OPPOSED TO ▢ |haʊs|.)

verb [trans.]

To carry appendant to the body. To carry or bear on one's body for
warmth or ornament. To be decked out in. To have on.

k

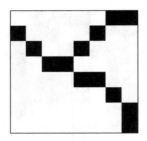

|klaʊd| |fɒg| |fɒgs| |mɪst| |'veɪpə| |ɪndɪ'stɪŋ(k)t|

An important symbol of Opaqueness, a confuser of 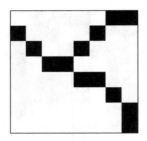 |'nɒlɪdʒ|.
Related to 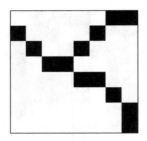 |'bɪləʊ|.

noun

A dark collection of particles in the air. A visible mass of a substance suspended in a field of air, water, etc. Many tiny water droplets above the earth's surface impeding sight. A substance diffused or held in the air, often whispy and ghostish. The sooty exhalation of a fire or smouldering thing, esp. fireplace or chimney. Bodies of fumes often gathering in the sky in patterns, thought by some peoples to be the vehicles or abodes of the gods.

adjective

Blurred, fuzzy, difficult to visualise.

verb [trans.]

To cause the creation of such nouns. To confuse an issue deliberately.

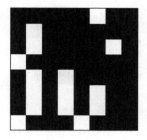

|ˈklʌtə| |ˈklʌtəd|

verb [trans.]

To make a noise of bustle. To create a cacophony of objects. To untidy, fill with useless subjects and objects. To invite too many guests to an occasion.

166 |klaʊd|

To inhale vapours by means of combustion. To turn an object into indistinct particles, esp. the action of powerful deities.

k

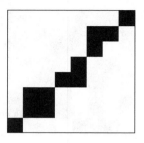

|kəʊdɪd| |ɛnˈkəʊdɪd| |ˈkəʊdɛks|

The imperfect rendition of pure 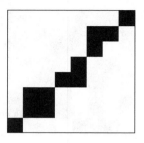 |ˈnɒlɪdʒ|.

verb [trans.]

To create laws or rules. To convert words or messages into ciphers, symbols or hieroglyhs. To write synæsthetic dictionaries. To translate from the imaginary to marks. (SEE ⊞ |wɔːds|.)

noun

A book. A book of civil law. An ancient manuscript. A repository of secret lore. An impenetrable document of questionable use and interest.

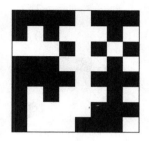

|kəʊˈhabɪt|

verb [intrans.]

To dwell in a place with another. To live together as husband and wife.

k

|kəʊld| |kuːl|

There are few electromagnetic particles in the vast reaches
between the stars. Yet space itself is lukewarm. Nowhere yet has
absolute zero been reached.

adjective

Not hot, not warm. Nearly inactive atoms. A fairly low temperature.
Chilled. Frigid. Dead.

noun

The privation of heat. (SEE |tʃɪl|.)

|kəˈlɛkt| |ˈɡɑːnə| |dɪˈpɒzɪt|

Finding wandering objects in the world.
They click together to form larger structures.

verb [trans.]

To gather together. To find and keep. To retrieve. To store up.
To draw many units or numbers into one. To gain. To gain from
memory or observation. To pledge or commit or entrust an object.
To place in security.

|ˈkʌlə(r)| |ˈkʌlə(r)s|

A pattern in radiation. The combined variation when seen
from afar produces new concrete information.
It is said that this symbol is incomprehensible to the blind.
Yet they are able to perceive the hues of sound, of temperature, of texture,
of mood. Can they imagine such tonality in form and shape itself,
the vibrancy of an object? Rather it is for the orthodox
that we should concern ourselves more, for they deliberately blind
themselves to the pleasures of invention and debate.

noun

The appearance of bodies to the eye. Qualities and attributes of
visible light related to waveform. A hue or tint. The pitch or note
of a particle of light. It is commonly asserted that all the liquids on
a painter's palette when mixed together always become pure white
and so all hues can be derived from white. This issue is muddy
with debate. The mood of a person or propriety of a verse.

|kʌm| |kʌms| |keɪm| |kʌmɪŋ| |bɪˈkʌm|
|bɪˈkeɪm| |bɪˈkʌmɪŋ| |ɪˈməːdʒɪŋ|

The truly even field. All energy is contained within the system.
The potential for arising complexity and yet also entropy.
The random oscillation of all the particles in one direction at the
same time will create Form. (SEE *|meɪk|.)*

verb [intrans.]

To move or travel towards the person spoken to or the speaker. To move hitherward. To occur; take place. To occupy a specified place in space or order. To draw near, to advance. To proceed, to issue. To arrive, to draw near. To motion toward another. To advance from one stage to another. To arrive at a disposition or habit. To return. To follow. To reach; get within the reach of. To join with, bring help. To approach a quality. To enter into a state or condition. To be suitable. To rise out of something covered or a liquid. To issue; proceed. To rise out of obscurity.

|kəˈmjuːnjən| |kəˈmjuːn|

A meeting of the material world below and another essence above.

noun

The sharing or exchanging of essences, thoughts, and emotions on a mental, spiritual, or psychic realm. The religious ritual of transubstantiation. (SEE **11** |ˈmɛtəˈmɔːfəʊz|.)

verb [intrans.]

To communicate, converse on a spiritual or psychic level. To understand another mentally. To intercourse.

|kəˈmjuːnɪti| |kəˈmjuːnɪtiːz|

A powerful cell protected by being simultaneously many and one.

noun

The body politic. A body of individuals. A social unity, political, municipal, ecclesiastical, etc.

k

|kəmˈpiːt| |kəmˈpɛtɪtɪv|

verb [intrans.]

To enter into rivalry. To vie with another for the attainment of something. To strive to achieve a yet unrealized goal. To create goods to command a market.

adjective

Having a desire to be more successful than others. Wanting to compare well to others. Performing well in comparison with others.

|kəmˈpliːt| |kəmˈpliːtɪŋ| |həʊl| |ɛnˈtʌɪə|
|kəmˈpliːt| |kəmˈpliːtlɪ|

adjective, noun & adverb

Perfect, full. Without any defects. In good condition, of animal with all limbs. Intact. Constituting the total amount. Without extraneous addition or parts left out. Total. Containing all. The full number. The realized action or state.

k

|kəmˈpəʊz| |kəmˈpəʊzd|

The nail to the wood.

verb [trans.]

To form a mass by joining parts together. To put together a discourse, sentence, epic poem, piece of music, or letter of complaint. To be constituted of.

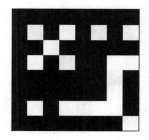

|kənˈsiːt|

noun

A conception, thought, or image. A fanciful notion. An elaborate metaphor. An excess of pride in oneself.

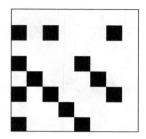

| ˈkɒns(ə)ntreɪt |

verb [trans. & intrans.]

To emit toward a centre. To increase in strength, potency, or purity, esp. distillation. To refine. To apply one's mental faculties in a directed manner.

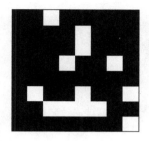

|kən'səːn| |kən'səːnd| |kən'səːnɪŋ|
|'wʌri| |'wʌrid|

verb [trans. & intrans.]

To relate to, to belong to. To be of importance to. To engage with. To tear or mangle prey. To be anxious about esp. a problem. To harass.

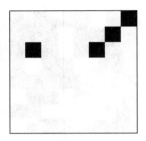

|ˈkɒnʃəs|

After a while, a part of the universe woke up and thought:
"I am the universe."

adjective

Endowed with the realization that one is thinking. Knowing that
one knows. Aware of one's surroundings. Aware of a thing. Sensi-
tive to a circumstance.

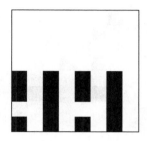

|ˈkɒŋkriːt|

Hard granules make hard solidity.

adjective & noun

The coalition of granular parts. Formed of a union of particles in a congealed or coagulated mass. Calcining lime and clay with water, sand, and gravel. Mentally abstract substance joined together. Logical, not abstract. Actual. Real terms.

k

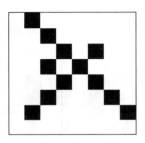

|kən'fɛʃ(ə)n|

To disburse one's conscious to the universal consciousness.
(SEE 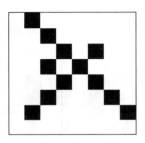 |'apəsteɪt|.)

noun

The acknowledgment of one's crimes or guilt. The act of disbursing one's conscious to a 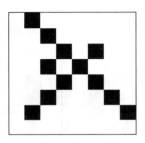 |priːst|. The disclosure of prejudicial or humiliating information.

verb [reporting]

To disclose or avow guilt's, weaknesses, crimes, or humiliations. To appease deities through flattery.

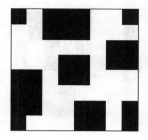

|ˈkɒnfɪd(ə)nsɪz|

The square deliberately concealed among the forest.

noun [pl.]

Firm belief or trust in others. Self-assurances or appreciations of one's own abilities.

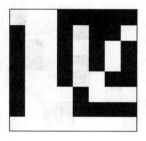

|kənˈfʌɪn|

verb [trans.]

To bound, to limit. To restrict a person in time, space, or duties. To imprison or incarcerate.

noun

Boundaries or restrictions of a given place. The borders of space-time.

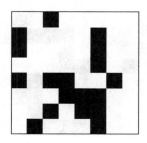

| ˈkʌndʒə | | ˈkʌndʒəd |

verb [trans.]

To summon in a sacred space. To magic into existence. To create with enchantment. To make something appear in an unexpected manner. To bring about as if from nothing.

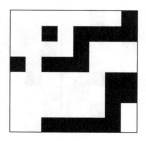

|ˈkɒnsɪkw(ə)ns| |ˈkɒnsɪkw(ə)nsɪz| |rɪˈzʌlt|

Causality itself, patterns create patterns,
waves of duplicating and mutating.

noun

That which follows from a principle or action. The effect of an occurrence. A link in the chain of causation. (SEE ▦ |əˈfɛkt|; ▦ |ɪˈfɛkt|.)

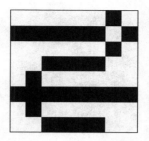

|kənˈsəʊld|

One figure lays down the other.

verb [trans.]

To comfort or cheer someone in grief, disappointment, or misery.
To free another from mental distress.

k

|kənˈspʌɪə| |kənˈspʌɪəɪŋ|

Two individuals whisper in the night about a third.

verb [intrans.]

To plot, to hatch in secret. To combine privily for an evil or un-lawful purpose. To combine, concur, coöperate without the knowl-edge of others.

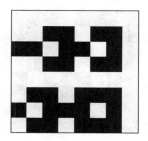

|kənˈtrəʊl| |kənˈtrəʊlɪŋ|

Organisms directing each other. (SEE 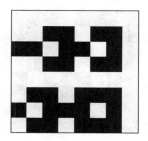 |ˈliːdə|.)

noun

The power of influence over events. A directing domination or command. A means of restraint.

verb [trans.]

To keep under check. To restrain, command. To curb.

k

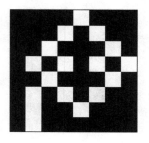

|kən'vɛnʃ(ə)ns|

The enclosed codex.

noun [pl.]

The stipulations, agreements, and concordats of societies. The usual manners or customs. The artifices considered natural and proper.

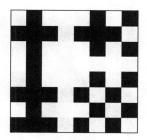

|kɒnvəˈseɪʃ(ə)n| |dɪˈskʌs| |dɪˈskʌʃ(ə)n|

noun

A chat, intercourse. The action of consorting or having dealings with others. The exchange of ideas and views. A colloquy. A talk.

verb [trans.]

To examine an issue verbally. To talk on a given subject.

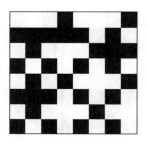

|kənˈvɪns| |kənˈvɪnst|

verb [trans.]

To cause someone to believe something. To evince, prove, vindicate. To overcome, conquer, or vanquish, particularly by verbal or written means.

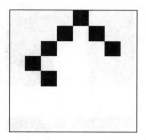

|ˈkɔːnə|

Where two lines point. A join described by degrees. (SEE 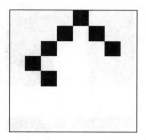 *|ˈaŋg(ə)l|.)*

noun

An angle. A secret or remote place. The outer or inner extremity of a delineated space.

|ˈkɒrɪdɔː| |ˈkɒrɪdɔːs|

A door extended into infinity.

noun

A gallery. A passage that leads between several rooms. A strip of territory.

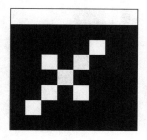

|kəˈrʌpt| |kəˈrʌptɪd| |rɒtɪd| |rɒtɪŋ|

Beneath the perfect surface, unnamed things rankle.

verb [trans.]

To turn to putrefaction, to infect. To decompose. To taint, deprave, destroy the integrity of. To bring to putrefaction. To defile, lead astray. To pollute, bribe, make wicked.

|kɒf| |kɒfɪŋ|

Sand in the lungs.

verb [intrans.]

To convulse the lungs involuntarily. To expel air violently with a sharp sound. To remove an irritation or blockage of the air passage. To signal deliberately with a sharp exhalation.

.

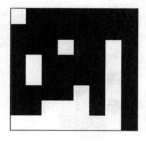

|'kaʊntɪnəns|

noun

The form or face. The features. The bearing, demeanour, or comportment. The appearance of emotion feigned or real.

k

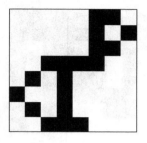

|kɔːt|

noun

The place where a king, prince, or high dignitary resides. The retinue, councillors, and social entourage of a sovereign. A place where justice is served.

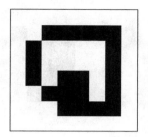

|ˈkʌvə| |ˈkʌvəd| |ˈkʌvəs| |ˈkʌvəɪŋ|

One shape encloses another.
To overspread anything with something else.

verb [trans.]

To conceal by laying over. To hide by superficial appearances. To bury. To protect. To conceal. (SEE 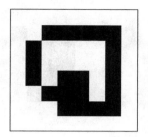 |hʌɪd.|.)

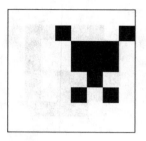

|krab| |krabs|

The ten-legged one. The decimal animal.

noun

A crustaceous creature with stalked eyes and five pairs of legs. A carapace wearer found on shorelines.

|krak| |krakd| |krakɪŋ| |breɪk| |breɪkɪŋ|
|brəʊk| |bəːstɪŋ| |dɪˈstrɔɪ|

One thing made into many parts yet none now independent or thriving.

verb [trans. & intrans.]

To make a sharp noise. To part by violence. To batter, breach, crush, or sunder. To blast. To raze, lay waste, kill. To ruin or put an existence to an end. To defeat an opponent or thing absolutely.

noun

A sudden disruption by which two parts are sundered. The sound of a body falling or coming apart. A chink or fissure in material. A blemish. A breach in a wall or hard surface.

k

|krɑːft| |krɑːftsmənˈʃɪp|

*The methodology or ordering of pale particles known
only to explorers and their initiates.*

noun

Intellectual power, skill, or art. A occult or magical knowledge.
A skillful labour or understanding of. A fraud or cunning artifice.
The performance or occupation of a skilled manual or higher art.
(SEE |ɑːtɪˈzans|; |ˈɑːtɪsts|; |ˈkʌndʒəd|.)

|krag| |'kragi| |ʌnhjuːn|

In the seams of coagulated rocks regular forms wait to be extracted.

noun

A rough, steep protuberance of rock. A steep cliff.

adjective

Rugged, rough. Unshaped, uncut, unformed.

k

|kraʃ| |kraʃd| |rɛk| |ˈʃɪprɛk| |ˈnəːfrɑːʒ|
|dɪˈzɑːstə| |kəˈtastrəfi|

A boat upon the rocks.

noun

A loud, complex noise of breaking. A vessel broken or ruined by
being cast against rocks at sea or cast ashore. A totally destroyed
vehicle. A calamity or misfortune. An unfavourable aspect of the
stars or obnoxious planet. A final resolution, generally unhappy.

verb [trans. & intrans.]

To cause destruction of a vessel, thing, or building. To irretrievably
damage a fragile, complex, or valuable thing, process or relationship.

|ˈkriːtʃə|

The fly in amber.

noun

A being created by deific intervention. Not human. A created thing. An animal. A contemptuous description of a lowly human. A human in thrall to another.

|kru:|

The drivers of the ship.

noun

A company of people. A company or team managing a vessel or artillery. The drivers of a carriage, ship, airship. Those engaged in the running of an enterprise.

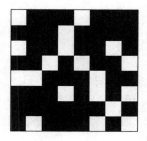

|krəʊk| |krəʊki|

The dispellation of ill humours.

noun

A hoarse, low noise. A caw. An offensive or disagreeable murmur.

adjective

Of a deep or hoarse noise, sound, or voice.

k

|krɒs| |krɒsɪŋ| |trəˈvəːsɪŋ|

The line breaches the interruption, reaching the other side.

verb [trans. & intrans.]

To go over, from side to side. To travel through. To move something back and forth or sideways.

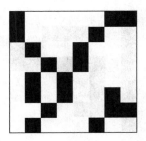

|kraʊd| |ˈkɒŋɡrɪɡeɪt|

noun

A multitude, pressed together. Many persons in a place.

verb [intrans.]

To collect together. To assemble in one place, esp. persons.

k

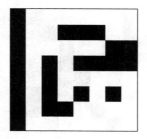

|krʌst|

The external surface hides an interior of different substance.

noun

An external body surrounding something. The hard outer part of
bread. A dried or coagulated surface on a liquid or soft solid. (SEE
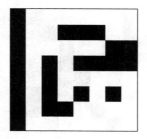 |ˈɑːmə|; |ˈkarəpeɪs|.)

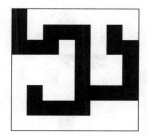

|ˈkjʊriəsli| |kjʊərɪˈɒsɪti|

An inquisitive paw reaches into the cavity of a buzzing nest.

noun

An addiction to enquiry. An inquisitiveness, esp. demeanour. A desire to know or discover information, secrets, arts.

adverb

Inquisitively. Studiously. Attentively. Unusually.

k

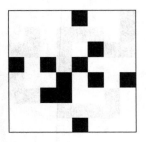

|kə:l| |kə:ld|

verb [intrans.]

To make not straight. To make not parallel. To bend. To form or cause to form a spiral or curve.

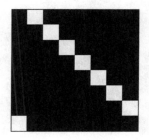

|kəːs| |kəːsɪd| |əˈkəːsd|

The cousin of 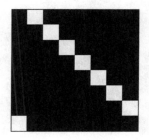 |əˈpɒstəsi|.

verb [trans.]

To doom to misery. To execrate. To place a malediction upon someone. To torment. To invoke the vengeance of a deity, fury, evil, ghost, or other supernatural entity. To afflict. To abuse with magic. To cause a haunting. To devote malign influences. To place an anathema.

adjective

Subject to the above. Luckless.

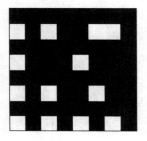

|ˈkʊʃ(ə)ns|

A myriad of pockets absorb and distribute a violent weight.

noun [pl.]

Soft sacks or pads filled with soft, elastic material. Supports for reclining, sitting, sleeping.

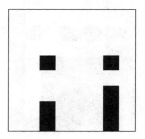

|kʌt| |hjuːn| |ʃeɪvd| |kɑːvd|

The axeman lops off the tallest heads first.

verb [trans.]

To gash, chop, fell with an axe. To attack violently with a sharp instrument. To shape or smooth a mass through repeated hacking. To sever. To pare off with a razor. To slice close to a surface, esp. hair or beard. To reduce or remove part of. To whittle.

d

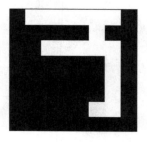

|dɑːft| |ˈstjuːpɪd|

adjective

Wanting in intelligence. Foolish. Of unsound mental faculties. Thoughtless. Sluggish of understanding. Dull. (SEE 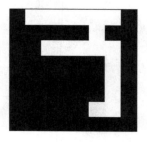 |ˈsupərˈstɪʃəs|.)

|'deɪn(d)ʒə| |'deɪn(d)ʒ(ə)rəs| |'hazəd| |'hazədəs|

Vengeful Fate strikes like lightning from the sky.

noun

Peril. Risk of death. Power to inflict physical injury. Liability to loss. Chance. Jeopardy.

adjective

Exposed to chance. Fraught with risk. Injurious.

d

|dɑːk| |dɑːknəs| |blakɪst| |blaknəs| |ˈsɒmbə|
|ˈʃadəʊ| |dɪm| |ˈtɛnɪbrəs|

*In the deepest depths of the ocean there reside distorted creatures.
With peculiar chemical reactions they illuminate the immediate pockets
of the world around them with a sickly luminescence. These points
of light have but one single purpose—to act as markers against which
to measure the crushing night. For if they did not shine
down there, those unfortunate beings would suddenly stop existing.*

adjective & noun

Without light. Opaque. Reflecting little light. The total absence of
all colour. Inky. Hidden. Unseen. Moonless. Of very faint appear-
ance. Obscured. Dull. Lacking information. As of the vacuum of
cold space. Approaching absolute nothingness. Gloomy. Outside
of the cast of a source of light. In an area blocked from a projection
of light by opaqueness. Far from the last tendrils of the dying sun.
An absolute and utter. Melancholy. (ANTONYM ✈ |lʌɪt|.)

$|\text{'}dɑːs(ə)lə|$

noun

Inventor and sportswear magnate (1900–78 CE). Born Herzogenaurach, Germany.

'd

|ˈdɔːtə| |gəːl|

noun

The female offspring of a man or woman. A female child. A young or relatively young woman.

|dɔːn|

The division between the dream of night and the waking hallucination.

noun

The time of the first appearance of the light of the sun, before the cast of the first rays. The growing light of the morning. The arrival of a long-awaited change or era.

d

|deɪ| |deɪs| |ˈdeɪli|

A sheet of light laid to rest over the entire globe.

noun

Between the rising and setting of the sun. The successive periods of light punctuating endless night. The time taken by the earth to make one revolution upon its axis. Life.

adjective

Quotidian. Happening regularly. Normal. Occuring seven times a week. Habitual.

|diːl| |dɛlt| |diːlɪŋ|

noun

A part, portion. An unspecified amount. A quantity or degree. A division of the whole. An agreement, contract. The art of distributing playing cards.

verb [trans. & intrans.]

To traffic, trade. To business, negotiate. To mediate between two parties. To act in a manner. To have relations between parties. To take measures. To distribute playing cards artfully. To portion out substances.

d

|dɛθ| |dʌɪ| |dʌɪŋ| |dɛd| |ˈpɛrɪʃd| |ˈlʌɪflɪs|

The total absence and yet also the total opaqueness.
One of the two duelling signs.

noun

The extinction of life. The departure of the soul from the body. Escape. Mortality. The end of causation. Final entropy. Cessation of being. The end of life.

verb [intrans.]

To be killed. To be forgotten. To pass on to another stage. To be extinguished. To exit the stage. To become nothing. To stop becoming.

adjective

Devoid of life. Inanimate. (ANTONYM ☐ |lʌɪf|.)

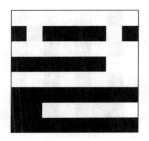

|dɪˈkeɪ| |dɪˈked| |dɪˈklʌɪn|

*The universal axiom. All things eventually pass
from complexity to a diffused state.*

verb [intrans.]

To deteriorate. To fall off from perfection. To lose a characteris-
tic, quality, or excellence. To waste away, to come to ruin. To rot,
putrefy, lose physical integrity.

noun

The process of decomposition.

d

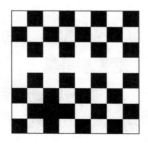

|dɪˈsʌɪd| |dɪˈsʌɪdɪd| |dʒʌdʒɪŋ|

verb [trans. & intrans.]

To determine a question or dispute. To come to a mental resolution. Make a choice. To pronounce a sentence of law. To form an opinion on or estimate. To appraise worth, veracity, quality, etc.

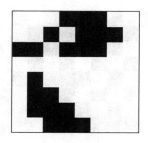

|dɪˈkrʌɪ|

verb [trans.]

To publicly clamour, admonish, censure, denounce.

d

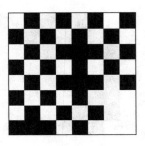

|diːm| |diːmd|

verb [trans.]

To judge, decide, determine, opine, think upon a person or subject.

|diːp| |dɛpθ| |dɛpθs| |diːpə| |diːpɪst| |bɪˈləʊ|
|bɪˈniːθ| |daʊn| |ˈfað(ə)m|

adjective

Having downward length. Descended. Low in situtation.Not super-
ficial, obvious. Not residing on the surface. Profundity. In the lower
place, in opposition to heaven. Extending a very great distance
from the top or surface, esp. ground, ocean. Tending towards the
ground or even lower. Intense or extreme. Complexity of thought.
On the underside of an object. Towards the centre of a planetary
body. Towards a gravitational attractor, esp. large mass, planet, star,
black hole.

noun

The abyss. A gulf of near infinite profundity. The distance downward
from two points on a vertical matrix. A point closer to the centre of
a gravitational field than the exterior. Hell, Hades, Elysian Fields, or
other afterlife. The resting place of ■ |weɪt|, ▨ |səˈtəːnɪən|.

|dɪˈgriː|

noun

The division of an object, surface, firmament, or ⬛ |ˈaŋg(ə)l| into a regulated division of increments. A full circle or hemisphere divided into three–hundred and sixty fractions. A fraction of this sum. The ⬛ |ˈkarəktə| used to construct abstract form and shapes. The basis of ⬛ |dʒɪˈɒmɪtri|. A holy symbol.

231 ⬛ |diːp|

adverb

Far down in.

verb [trans.]

To reach, to matter. To penetrate through thought. To understand an issue of weight or complexity.

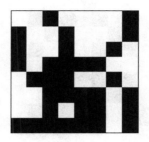

|dɪˈleɪ| |dɪˈleɪd|

verb [trans.]

To put off. To hinder, frustrate. To defer. To tarry in a place. To temporarily stop or cease an action.

d

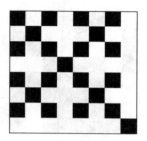

|dɪˈl(j)uːʒ(ə)ns|

The symbol comparing dream to reality, subjectivity to truth.
Related to 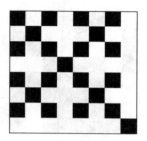 |az|.

noun [pl.]

False representations of reality, being, existence. Illusions, errors, chimerical thoughts. Falsehoods, untruths, superstitions.

|dɪˈpɑːt| |dɪˈpɑːtʃə|

*The opening indicates immediately that that
which was once contained has escaped.*

verb [intrans.]

To go away from a place. To divide and leave a section. To quit,
leave, retire from. To perish, die, decease.

noun

The action of leaving. A going away. A forsaking.

d

|dɪˈrʌɪv| |dɪˈrʌɪvd|

verb [trans.]

To deduce from an original. To deduce from an abstraction still unknown to mankind. To obtain a result from mathematical calculation. To recover from a corrupted source or text.

|dɪˈsɛnd(ə)nts|

From the mother rabbit two juveniles are spawned.
The total number is now three. During the next cycle two more
offspring will be born, now numbering five. From then on
the growth is eight, thirteen, twenty-one, thirty-four, fifty-five,
eighty-nine, one hundred and fourty-four. The Golden Ratio.

noun [pl.]

The offspring of an ancestor. The line of generation.

d

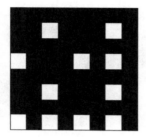

|dɪˈskrʌɪb| |dɪˈskrʌɪbd| |dɪˈskrɪpʃ(ə)ns|

verb [trans.]

To mark down, to write down the properties of something. To delineate, trace, or argue the definition of a thing. To represent verbally, visually, or metaphysically.

noun [pl.]

Accounts of the quality, character, and nature of a subject.

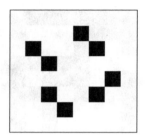

|dɪˈzəːt| |dɪˈzəːtɪd|

The pairs drift away from their previous unity.

verb [trans.]

To forsake, quit, leave treacherously. To abandon, withdraw support. To depart or exit a contract or bond.

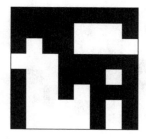

|'dɛsp(ə)rət| |'dɛsp(ə)rəʃ(ə)n|

adjective

Without hope. Reckless, without attention to safety. Insurmountable, impossible. Furious, mad, unreasonable.

noun

The loss of all hope. Reckless behaviour.

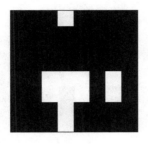

|ˈdɛstɪˈneɪʃ(ə)n| |feɪt|

The final arrival or docking.

noun

The ultimate design. The action of foreordaining. A place that one is bound to, proceeding to, journeying to, moving towards. The end goal. An eternal series of successive causes. A view that the universe is predetermined, that there is no chaos on the macroscale. An anthropomorphisation of luck, chance, determined causation. A supernatural agency tasked with enforcing the development of a predescribed history.

d

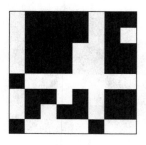

|dɪˈtatʃ| |dɪˈtatʃt|

verb [trans.]

To separate, disengage, part from something. To disconnect, disunite.

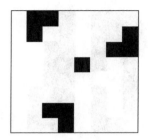

|ˈdiːteɪl| |ˈdiːteɪlz|

The speck of difference. The constitution of the macro.

noun

A minutia. An individual fact, item, feature, quality, that makes up a larger one. The minute account of a narrative, or occurrence. A subordinate part of a painting, building, sculpture, book.

d

|dɪˈtəːmɪn| |dɪˈtəːmɪnd|

verb [trans.]

To fix, settle. To conclude. To bound, limit, adjust. To influence a choice. To decide.

|dɪˈvɛləp| |dɪˈvɛləpd| |dɪˈvɛləps|
|dɪˈvɛləpm(ə)nts|

Passing through the gate of time mutates the shape of ideas and things.

verb [trans. & intrans.]

To disengage from something that encloses or conceals, esp. ideas. To unfold, unroll, realize the potential of a property, concept. To bring forth from a latent or elementary condition. To add complexity, excellence, or quality.

noun

An event or change in situation. A stage of growth or creation. News.

'd

|ˈdʌɪəgˈnəʊz|

verb [trans.]

To determine the origin or nature of a cause, esp. diseases.

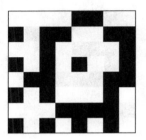

|dʌɪˈamɪtə|

noun

A straight line passing through the centre of a body dividing it into equal parts. A transversal measurement.

'd

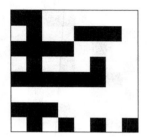

|ˈdɪf(ə)r(ə)nt| |ˈdɪf(ə)r(ə)nsɪz| |diːvɪˈeɪʃ(ə)ns|

adjective

Distinct, not the same. Having contrary characteristics or qualities. Distinguished by unlike attributes. Of other nature or form.

noun

An error or wandering away from a given path. A variation from an established rule. An obscene or immoral action.

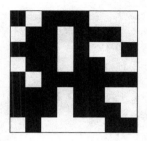

|ˈdɪfɪd(ə)nt| |ˈdɪfɪk(ə)lt|

adjective

Hard, not easy, not facile. Troublesome, vexing. Hard to please. Needing much effort to understand, solve, accomplish, improve, change characteristics. Wanting in confidence, mistrustful. Lacking confidence in the self. Timid, shy, bashful, modest.

d

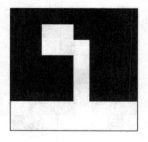

|ˈdʌɪˈdʒɛst|

Falling from the mouth into an ocean of dissolution.
(SEE 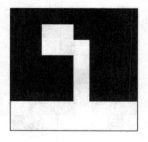 *|ˈstʌmək|.)*

verb [trans.]

To take apart and place in various repositories. To break down food in the stomach and intestines. To heat with enzymes. To break down into constituent parts.

|dɪˈlapɪdeɪt| |dɪˈlapɪdeɪtɪd|

verb [trans. & intrans.]

To ruin. To bring a building to a state of decay. To waste or squander. To fall into ruin or disrepair.

d

|dɪˈmɛnʃ(ə)n| |dɪˈmɛnʃ(ə)nz|

The contemplation of length and breadth and width.
(SEE |ˈkɒntɛmpleɪt|.)

noun

The space containing a thing. The measurement of spaces linear, actual, and supposed. Spacial extension. The measurement of time in relation to space. Magnitude. Size.

|dɪˈrɛkt| |dɪˈrɛktli| |dɪˈrɛkʃ(ə)n|

A trajectory that comes back succinctly to the arch in question.

verb [trans.]

To order, command. To place a mark or instruct position. To regulate, adjust. To send along a path or vector.

adjective

Straight. Not oblique. Plain, simple. Without deviation.

adverb

In a straight line of motion. Simply, plainly. Without the intervention of others. Immediately, straight away.

noun

The path to a point. Vector. Course of guidance, motion. Instruction. The commanded movement. Impulse to specific points in space.

d

|dɪsəˈpɪə| |dɪsəˈpɪəd| |ˈvanɪʃ| |ˈvanɪʃəd|
|dɪsəˈpɪər(ə)nsɪz|

verb [trans.]

To be lost to view. To go suddenly. To leave sight. To flee, escape, go away. To cease to be present. To become invisible in a rapid and mysterious manner.

noun

The mysterious or suspicious loss of persons or things from a community.

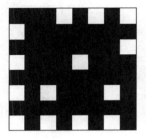

|dɪsə'pɔɪntm(ə)nt|

noun

A defeat of hope. A miscarriage of expectations. A sadness over the nonfulfillment of expectations or desires.

d

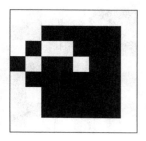

|dɪˈstɪŋ(k)t| |dɪˈstɪŋ(k)tɪv|

*The eye is drawn to the small blemishes in the regular pattern,
the disruption of the norm.*

adjective

Different. Not the same. Set apart. Clear, obvious. Marked as being
dissimilar.

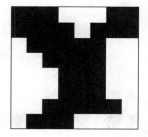

|dɪˈstə:b| |dɪˈstə:bs| |dɪˈstə:bɪŋ|
|pəˈtə:bd| |ˈpə:təˈbeɪʃ(ə)n|

verb [trans.]

To perplex, disquiet. To interrupt. To interfere with normal functions. To agitate and disrupt peace, tranquility. To move or unsettle a thing or emotion. To upset, trouble physically and psychically. To affect adversely.

noun

An anxiety of mind. A breach of tranquility. An agitation or disorder. A confusion, commotion. A cause of disquiet.

d

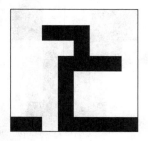

|dɪˈvəːdʒ(ə)ns| |dɪˈvəːdʒ(ə)nsɪz| |dɪˈvəːdʒɪŋ|

A tangent on the assumed path.

noun

Departure from a course or splitting into multiple paths.

verb [intrans.]

To develop in a different direction. To take a different course. To branch off. To deviate from a set course or action.

|dɪˈvʌɪn| |dɪˈvɪnɪti|

The shape of the Cathedral.

adjective

Partaking of the nature of a deity. Deriving or proceeding from a god or gods.

noun

The character or quality of godhood, deity, or godhead.

d

|duː| |dʌz| |dɪd|

As one thing affects another,
a chain of causation ripples across reality spawning
stars, planets, life, civilization,
cities, enterprise, machines, printers, fictions.

verb [trans. & intrans.]

To put into motion. To bring into action. To perform a task, work, command, purpose. To utilise any object or idea for any purpose. To behave, emote, cogitate, communicate in a given manner.

verb [auxiliary]

To make a question. To refer to a verb already spoken. To add emphasis to an affirmatory statement.

|dɔː| |dɔːs| |ˈɛntr(ə)ns|

A pathway through a solid surface, with a handle.

noun

The gate of a house or building that affords passage inside. A hole or opening. A portal. A passage or avenue. A hinged surface that opens to allow passage through. The opening that allows access to a place.

d

|daʊt| |ʌnˈsəːt(ə)nti ˈprɪnsɪp(ə)l|

noun

A fear, apprehension, question, hesitation. To be unconvinced. The principle that both the momentum and position of a particle cannot be accurately known at the same time.

|daʊnstɛːz|

adverbial phrase

On or onto a lower floor. The lower regions of a building. In a descending direction.

d

|drɔː| |drɔːn| |drɔːɪŋ| |ˈpeɪntə|
|pɪkˈtɔːrɪəl| |ˈpɪktʃə|

The Pure Mark.

verb [trans. & intrans.]

To cause a body to move towards oneself by pulling. To pull or move a thing by traction esp. vehicle, plough. To attract by moral force, persuasion, inclination. To extract something from abstraction, thoughts. To elicit, rouse, encourage a person, argument or idea. To produce a diagram or representation of an idea in marks, lines, shapes, colours. To extract a form, emblem, symbol, from the imagination. To make marks, represent the world. To spread or lay colours of substance over a surface till they dry. To cover a surface with images. To push liquids by means of a brush. To articulate three-dimensional space in two dimensions.

noun

A delineation, representation, diagram on a flat surface, esp. paper.

A description, often by means of visual arts. A resemblance of persons of things in colour. The science of the visual. A tableau in a theatrical work. A visual work of art. A vivid or graphic description. A mental image or impression on the mind. A person who covers surfaces in liquids, colours, marks or impressions. An artisan or artist specialising in the articulation of visual information.

adjective

Of or expressed by diagrams, visual works of art. Seemingly as contrived or artificial as works made by men.

d

|driːm| |drɛmt| |ˈrɛv(ə)ri|
|ˈvɪʒ(ə)n| |trɑːns| |rɛvəˈleɪʃ(ə)n| |ˈɪmɪdʒ|

*The framing device implies that one reality is in fact containing another.
There are no more troubling images and stories than the ones
revealed to us when we sleep during the day. Try as we may to shake
them off, they disturb and haunt the imagination far more than
the droll divertissements of the night. There are certain philosophers
who say that our body, not trained to sleep whilst the sun is still up,
has difficulty steering our minds to the pleasanter pastures of the Astral
Plane and that during the somnambulations of the day our
capricious souls wander far, far off into realms and fiefdoms in which
we are neither wanted nor welcome.*

noun

A phantom of the sleep. The thoughts of a man asleep. The representation of an external form in the eye of the mind. A supernatural apparition. A train of thoughts, narrative. A picture experienced when a person is unconscious, drugged, in a trance. A spectre. A

state in which the soul is wrapped into insights of things future or distant. The action of the soul temporarily leaving the body. A hypnotic state. Communication of secret, sacred and mysterious truths by a teacher from heaven or hell. Divine or supernatural disclosures of information. Dramatic discoveries. Surprising or remarkable enlightenments regarding things unknown or as yet unrealized. A mental contemplation of a fantastic or imaginative narrative. The contemplation of an unreal being; mystical or supernatural insight; things beyond ordinary sight. A thing actually seen. A real picture. A self-delusion, fantasy, conceit, idle thought, fanciful notion. An aspiration, future ambition. A foretelling of a future or alternative present.

verb [intrans.]

To experience the bizarre contemplations of the sleeping mind. To entertain fanciful notions. To aspire to future scenarios. To create fantastical works of art and literature borrowed from the plots of our nightly hallucinations.

d

|drɛn(t)ʃ| |drɛn(t)ʃd| |wɛt|

adjective

Humid, adhered to by water. Consisting of moisture, liquid. Moist or damp with perspiration. Saturated with water or other liquid.

verb [trans.]

To soak with liquid. To thoroughly or liberally make moist.

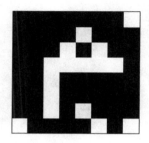

|drɛs| |drɛst|

verb [trans. & intrans.]

To clothe. To invest with clothes. To adorn, embellish. To make proper. To clothe in a pompous or decorous manner. To array, attire. To prepare a dish, dressing, wound. To treat people or things in a way proper to their nature or character.

d

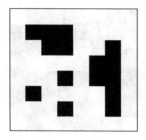

|drɪft|

Dust and muck float in a glass of beer as the stars float in the heavens.

noun

An impellent force or influence. A continuous slow movement. A slow variation. Floating matter, esp. upon an ocean or in the vacuum of space. An accumulation of velocity over a very long period of time.

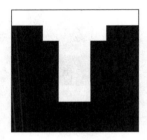

|drɪŋk| |ɪmˈbʌɪbɪŋ|

A parting of the lips to allow divine inspiration to flow inside.

verb [trans. & intrans.]

To swallow liquids. To take a liquid into the mouth, to quaff. To suck up or absorb. To soak or imbue with moisture. To acquire knowledge via any inlet or orifice. To make drunk, intoxicated, esp. with ▦ |ˈalkəhɒl|.

d

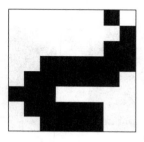

|druːp| |druːpɪŋ|

verb [trans & intrans.]

To languish in sorrow. To faint or grow weak. To sink or lean downwards. To bend or hang limply. To flag in spirit or courage. To become impotent.

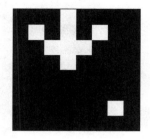

|dɪg| |dʌg| |dɛlv| |ˈbʌrəʊ|

The arrow of intent aims for riches and mysteries hidden below.

verb [trans. & intrans.]

To pierce a surface with a spade. To make holes in the ground, surface of the earth. To break up and move the ground. To excavate, penetrate, make incisions, or turn up a loose mass. To investigate a matter, problem, or crime. To fathom, to sift one's opinion. To make holes and lodge in them. To make a home beneath the earth. (SEE ▮ |ˈgravɪti|.)

d

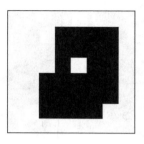

|dʌŋ| |ˈfiːsiːz|

Mass enters Beings and leaves as Mass.
What happens in between is the energy of living.
(SEE 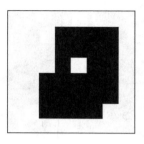 *|ˈtʃɒk(ə)lət|;* *|mas|.)*

noun

Excrement. Droppings. The waste matter discharged from the bowels. The excrement of animals as opposed to humans, used to fatten the ground with nutrients. Sediments.

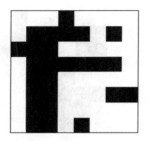

|dʌtʃ|

A land of fields of water.

adjective

Of or relating to the Low People. The Savage. The nations, tribes of Northwestern Europe. Related to their country characterised by large lakes, man-made dams, and regulated patterns of hydraulic artifices. Related to the capture and taming of the seas.

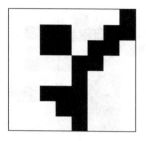

|iːtʃ|

The mind of comprehension caressing every detail.

adjective & quasi-pronoun

Every member regarded or treated separately. Either one of two. Every one of a number. The thought of individuality within multitude.

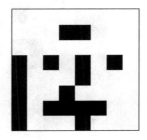

|ˈiːgə|

adjective

Struck with ardour. Keenly desirous. Hotly longing. Greatly wanting or desiring a possibility of action.

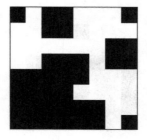

|ɪə| |ɪəz|

noun

The organ of audition or hearing. The organ of balance in human beings. A shape on both sides of mens' heads that twitches when hearing something interesting or salacious—the largeness of this organ is thus associated with wisdom.

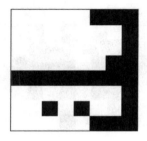

|ˈəːli|

adjective & adverb

Near or at the absolute beginning of a period of time, performance, occasion. Before the usual or expected time. Soon with respect to something else. Betimes.

ə

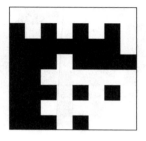

|əːn| |əːnɪŋ|

verb [trans.]

To gain wages or reward for any labour, performance, meritorious deed. To gain, obtain.

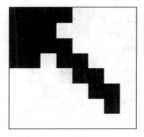

|iːst|

*The Sun casts its influence in the morning, reaching
its baleful gaze into every shut eyelid.*

adverb, noun & adjective

Of the lands, people, nations, and direction where the sun is seen
to rise in the morning. In the Americas with reference to the
continent of Europe.

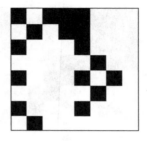

|ɛb| |ɛbd|

verb [intrans.]

The reflux of the tide towards the sea. Decline, decay, waste. To lessen in quality. Of blood, to flow away.

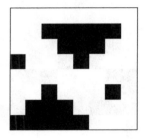

|ˈɛkəʊ| |ˈɛkəʊz|

*Two mirrors face each other, repeating inverted shapes
into one another till they reach infinity.*

noun

A nymph who loved the youth Narcissus. The return or repercussion of a sound. A sound returned or reflected through artificial or natural means. The repetition of a sound, phrase, idea, trope.

verb [trans.]

To repeat or reverberate sounds after the original has ceased. To send back an idea or opinion.

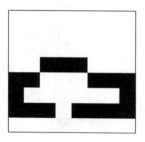

|ɛdʒ| |sʌɪd| |baŋks| |bɪˈsʌɪdz|

noun

The outer limit of a given object or area. The margin, extremity, brink. A sharpness, the cutting section of a border. A narrow extrusion of a border. A keenness, intelligence of character, quality. The left or right. A section of an object, esp. plane, or where two planes meet. The lateral halves of an animal where the ribs lie. An upright or sloping surface of an object or structure. Away from the middle of something. A person or group in opposition to others. Party, faction, interest. The margin, verge. The earth rising on either side of a body of water. A heap of earth.

preposition & adverb

Near, next to another. In addition to. Apart from. Over and above. Not according to, not contrary to. Not included here.

|ˈɛdɪfɪs|

A line or surface that starts at one's feet and rises above the clouds and birds, continuing well beyond the vanishing point.

noun

A fabricated wall, building, or structure. A stately building, usually a palace, fortress, dungeon, tower, church, cathedral.

|ˈɛdjʊkeɪtɪd| |skuːl| |ˈstʌdɪd| |ˈstʌdiz| |ˈstjuːd(ə)nt|
|ˈskuːlhaʊs| |ˈlɜrnər| |əˈprɛntɪs| |klɑːs|

*Knowledge drips into the vessel, filling it to the brim.
This vessel, heavy with its burden, begins to leak information
into the cup that waits below.*

verb [trans. & intrans.]

To acquire knowledge or gain the skill of. To understand a pattern.
To apply the mind to books and information. To cogitate, meditate
upon. To devote time to the investigation and inquiry of sciences,
arts, craft, politic, martial, or other skills. To look at closely, to read
about. To instruct youth so as to give them intellectual, moral, and
social sophistication. To train in a given field of expertise. To train
or discipline someone to develop a particular aptitude, taste, dis-
position, or preference. To train animals.

adjective

Someone well-versed in science and literature. Manifesting knowl-

edge acquired through instruction or reading. That which has received instruction or training.

noun

A house of discipline and instruction. Any institution for the instruction of a given subject. A place of literary instruction. A system or doctrine held by teachers, philosophers, artists, or scoundrels. A building in which subjects are taught. The domain of the ▓ |prə'fɛsə|. One in the rudiments of knowledge. Someone bound legally to an employer to learn the duties and skills of a craft, science, or art. An unskilled novice. A neophyte.

|ɪˈfɛkt|

noun

That which is produced by a preceding cause. A change brought about by the process of causation. The 'B' in "from A to B." Consequence, event. Purpose, general intent. Completion, perfection. Reality rather than a mere appearance or supposition.

|'ɛfət|

*A great pushing and commotion of the masses
around the venerated object.*

noun

Struggle, laborious endeavour. A vigorous or strenuous putting
forth of mental or physical power. A force exerted by |məˈʃiːnz|.
A display of power or achievement.

'e

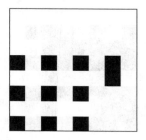

| ˈeɪtiːn| |ˌeɪ(t)ˈtinθ|

Nine individual units multiplied by the double square.

cardinal & ordinal number

The natural number following seventeen and preceding nineteen. Twice nine.

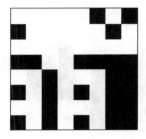

|ɪ'labəreɪt| |ɪ'labəreɪtɪŋ|

verb [trans. & intrans.]

To develop or add detail to a theory, idea, system, narrative, character, etc. To produce with labour. To finish from the raw labour, give a completeness.

|ɪˈlɛktrɪk| |ɪˈlɛktrɪk(ə)l| |ˈɪlɛkˈtrɪsɪti|
|ˈstatɪk| |ˈstatɪk(ə)li|

In the gap between the two oppositions, a tremendous energy flows.

noun

A form of energy as a result of charged particles, electrons, or protons. A charge caused by friction, originally of amber, glass, and cats. An attraction resulting from friction of nonconducting bodies, opposite charge. A current flowing through a conductor typically copper. A current generated by moving a conductor through a magnetic field. An energy transmitted through conducting materials, stored in chemical banks and applied to do work in ▥ |ˈɛndʒɪns|. A charge accumulated in a nonconductive body that causes the attraction of light objects, sparks, sharp shocks, and the hair to stand on end. An energy reposited or flowing from objects without a reduction in their weight or mass, non- ▥|ˈkɛmɪk(ə)l|.

|ˈɛlɪm(ə)nt|

The basic building blocks of physical matter.

noun

The first or principal constituent of a thing. The basic parts of all matter, Earth, Wind, Air, and Fire. The arrangement of protons, neutrons, and electrons into a number of discrete and indissolvable materials. The simple substances from which all materials, bodies, persons are compounded. The paint and brush of the Science of |ˈkɛmɪk(ə)lz|. An ingredient or constituent part of thing. The natural enviroment for a thing. The lowest or basic rudaments of science, arts, literature, and philosophy.

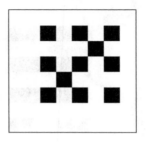

|ɪ'lɛv(ə)n|

A number of great and inobvious symmetry.

cardinal number

The number of digits on the hands of a man plus a significant extra.

293 ⊞ |'ɛlɪm(ə)nt|

adjective

Related to the above properties.

adverb

Acting in a way associated with charge, current, or the excessive accumulation of friction energy.

294

|ɛls|

pronoun & adverb

Otherwise, besides. Other, other one. In addition to. Different, instead.

|ɛmˈbreɪs|

*The tight grip of friendship controls an enemy's movements
and emotions more effectively than any strife.*

verb [trans.]

To hold fondly in one's arms. To squeeze in kindness. To clasp in
the arms, in friendship or amour. To fully be convinced and sup-
port a cause, idea, belief system.

|ˈɛm(p)ti| |ˈʌnlɪvd|

The set that contains no numbers.

{ }

adjective

Void, having nothing in it, not full. Not busy or engaged. Vacant. Of a building or place, not having been occupied. Devoid, unfurnished. Unburdened. Without substance. Vain. Ignorant, wanting in knowledge or manners. Hollow.

|ɛnd| |ɛnds|

noun

The extremity of any thing. The final part of a material extension, object, work, performance, occasion, etc. The last part of a duration. The conclusion or cessation of an action. The conclusion of a part of a larger structure. An ultimate destination, fate, final doom. The final determination or an argument, debate. Death, the cessation of life. The conclusion of the ▣ |'juːnɪvəːs| and of all ▬ |tʌɪm|. A purpose or intention. An aim, intended, final design.

verb [trans. & intrans.]

To terminate, conclude, finish. To bring to a finality, to a point. To perform a final act. To eventually come to a conclusion, specified place, state, destination.

|ɛnˈdjʊər(ə)ns|

noun

Patience. The act of supporting, suffering. The capacity to withstand strain, attack, use, age.

|ˈɛnəmi|

noun

An hostile or unfriendly person. The public foe. A private adversary, esp. of the Greek goddess of victory. Not a friend, one that we regard with malevolence. One that dislikes. A deity opposed to authority. A fallen angel, ◙ |səˈtɔːnɪən| being. (SEE ◳ |ˈapəsteɪt|.)

|ˈɛnədʒi|

*The disturbance and agitation of the first molecules
and atoms infused the universe with life. Before the First Action,
a shiftless quietude pervaded the universe.*

noun

Force, vigour, action. The strength and vitality required for mental and physical deeds. Strength of expression, verve of delivery. Spirit. Life. The power derived from chemical, biological, electrical, kinetic, or physical storages. Radiation. Light, heat. The absolute equivalency of |ˈmatə|.

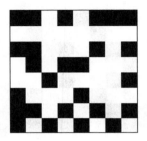

|ɛnˈgeɪdʒd|

past participle adjective

Participating in an undertaking, agreement. Busy. Embarked on an affair. Attached or united to a retinue or lord. In a state of service. Being in an agreement to wed.

|ɪˈnʌf| |səˈfʌɪs|

adjective & pronoun

In sufficient degree to satisfy. As much as is required or desirable. Abundantly, as much as could well be. Comparatively sufficient. Ample. An augmentation of the positive degree. Unwillingness to suffer or tolerate a continued action.

verb [intrans.]

To be sufficient, equal to the purpose. To be adequate for a requirement. To be of sufficient scope.

interjection

To demand the cessation of an act.

|ˈɛntə| |ˈɛntəd|

verb [trans. & intrans.]

To go or come into any place. To pass within the boundaries of a country, room, object, trance. To become involved with an enterprise, business, society, endeavour, war. To write or encode information into a book, codex, or mnemonic device. To become within.

|ˈɛntəprʌɪz| |ˈbɪznɪs|

Two faces collude to an exchange of endeavour.

noun

An undertaking that requires effort. A hazardous attempt. An affair. An economic unit or activity. An employment. A serious engagement. A point, matter under consideration. Something requiring to be done.

|ɛnˈvʌɪrənm(ə)nt| |ɛnˈvʌɪrənm(ə)nts| |ˈneɪtʃə|
|ˈnatʃ(ə)r(ə)l|

The order of things. A dot that the universe frames.
(SEE ■ |ˈjuːnɪvəːs|.)

noun

An imaginary being supposed to preside over the material and animal worlds. (SEE ▨ |gɒd|.) The rules and principles that govern physics and reality. The native state or property of things. Disposition of mind, temperament. The quality and characteristics of a subject esp. living. The world of plant, fauna, and landscape. The non-human world. The surroundings or conditions in which a subject lives or operates.

|ˈɛpɪsəʊd| |ˈɛpɪsəʊds|

noun

An incidental narrative. A digression in a poem or work of literature. The interpolation between the choral songs of Greek Tragedy. An event within a larger structure, series, or sequence of occurrences. A disruption to the flow of time or natural life. An illness. A mysterious occurrence. A mental attack. A musical section.

|ˈɛkwɪnɒks|

Two halves in perfect equilibrium.

noun

The two periods |ˈvɜːn(ə)l| and autumnal during which day and night are of equal length all over the sphere. The moment that the sun crosses the equator. The entering of the sun into the first points of Aries and Libra. Being equally divided.

|ɪˈrʌpʃ(ə)n| |ˈθrəʊ| |flɪŋ| |ɪˈdʒɛkt| |ɪˈdʒɛktɪd|

*The mountain emanates a noxious fume from
the bowels and intestines of the earth.*

noun

The act of bursting or breaking forth from a confinement. Violent
exclamation or emission.

verb [trans. & intrans.]

To cast, violent blow. To place in the air and let fall. To propel
through space. To take off, move in a direction quickly. To project
light. To deliver a look, gaze, expression. To switch state rapidly. To
scatter. To drive by violence. To expel from an office or pollution.
To drive away. To cast out, reject. To toss, hurl.

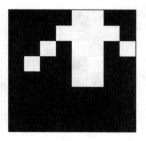

|ɛ'skeɪp| |ɛ'skeɪpd| |ɛ'skeɪpɪŋ| |ɪ'veɪd|

Flight from the bonds of our earthly prison.

verb [trans. & intrans.]

To elude by stratagem or artifice. To take flight. To flee an enemy. To break out of confinement or constraints. To get out of danger, unpleasantness. To avoid attention.

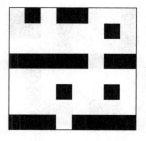

|ɛ'sti:md|

Originally a symbol of pure comparison,
now possessing a complimentary quality.

verb [trans.]

To make an estimate, either high or low. To compare to others. To prize, rate highly. To admire, respect. To revere, love.

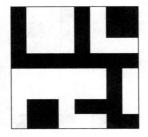

|ˈjʊərəp| |jʊərəˈpiːən| |ˈkɒntɪnənt|

*The New World. The land mass to be found sailing due west
of the Americas. Bounded by Africa and the Mediterranean to the south,
the Bosphorus and Caucuses to the south-east, and the Urals to
the east. Home to a great many indigenous peoples. It is supposed that
the current inhabitants are descended from a number of
highly advanced civilizations that formerly dominated the region.*

noun

A contiguous land not disjoined by seas. Continuous, connected. A
very large land mass or country.

adjective

Of or relating to the characteristics of the New World or its in-
habitants.

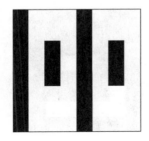

$$|ˈiːv(ə)n|$$

When each part is absolutely equal, the whole is greater.

adjective

Equal. Not rugged, smooth, uniform. Without inclination. The same on all sides. Without any part higher or lower than the other. Without debt, financially sound. Calm, without excessive emotion. Able to be divided into whole numbers, not odd. Well balanced.

verb [trans.]

To make equal, smooth, uniform. To make level. To end a debt.

adverb

A word of strong assertion, an emphasis of surprise or extremity. Notwithstanding. Likewise, not only so, but also. So much as.

$$|\,\text{ˈiːv(ə)nɪŋ}\,|$$

noun

The close of the day. The beginning of the night. The inhumation of the sun and the birth of the stars.

|ɪˈvɛnt| |ɪˈvɛnts|

An object in the black of time.

noun

An incident, an occurrence either good or bad. The consequence of an action, the conclusion, upshot. The single occurrence of a process. A known occasion in a causal chain. A social or public occasion of great importance.

|ˈɛvrɪwɛː| |wɛː| |wɛːrəˈbaʊts|

A net thrown down on the universe with each interstice given a symbol.

adverb

At which, or in which place or position. At or in a place. At the place in which. In or to any place or situation. That. In or towards all places that are. In all reaches of known space and dimensions. In all reaches of unknown space or theoretical dimensions. In all occurrence of space, past, present or future.

noun

The place, the locale of an incident. Near what place. Near which place. Concerning which, with regards to the matter under discussion.

|ˈiːvɪl| |məˈlɛfɪʃəs| |həˈretikəl| |dʌɪəˈbɒlɪk(ə)l|

noun

The supernatural essence of Wickedness. Crime, injury, mischief. Moral, physical, and spiritual corruption. A misfortune, calamity, vengeful act of a deity. Malady, disease. A pervasive force acting upon all atoms and particles of the universe, esp. in their attraction to each other. The unevenness in distribution of the early universe leading to the development of stars, galaxies, planets, and life.

adjective

Having bad qualities. Not good. Wicked, mad, corrupt. Mischievous, hurtful. Malign. Causing disease, injuries, calamities, mortification. Morally unsound. Impious, atrocious, nefarious. Of or related to necromancy and other improper magic arts. Of or related to dæmons, trickster deities, and other Fiends. Difficult to solve, esp. problems, riddles, mathematical conundrums. Causing or enabling destruction, esp. by supernatural means. Holding opinions contrary to or not contained in the orthodoxy of a particular religion, esp. the ⊞ |tʃəːtʃ|.

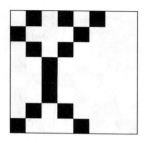

|ɛgˈzak(t)li|

adverb

Accurately, nicely, without discrepancy, thoroughly, without error. Without vagueness. Pure.

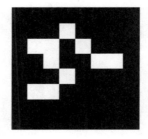

|ɛgˈzɑːmp(ə)l|

noun

A precedent, former influence, thing to be emulated. A person fit to be proposed as a pattern. An object fit to be reproduced as an original or facsimile An illustration of a general rule by application. A punishment to serve as a demonstration.

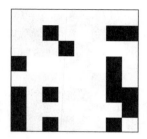

|ɛgˈzɔːst| |ɛgˈzɔːstɪd| |tʌɪə| |tʌɪəd|

verb [trans. & intrans.]

To diminish by draining. To draw out totally until nothing is left, esp. energy, men, resources, willingness. To fatigue, make weary. To harass. To cause to require sleep or rest. To lose interest, desire. To become bored. To cause to lose interest, to create boredom.

adjective

Wearied down. Empty of physical or mental resources. Used up. In need of sleep or rest. Broken down, in need of repair. Uninterested, bored.

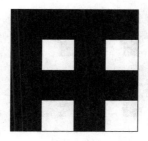

|εgˈzɪst| |εgˈzɪst(ə)ns|

A principal symbol. The fabric of reality.

verb [intrans.]

To be. To have being. To be in being. To have essence. To be real. To occur in space and time. To have a duration or physicality. To be heard falling in a forest. To operate in the world outside of the imagination. To be found in a place or location. To live, subsist.

noun

The state of being. Having objective reality. All that is. Reality.

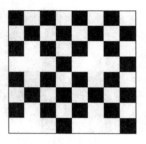

|ɛgˈzɒtɪk|

adjective

Foreign. Not originating in this country. Extrinsic. Strange and unusual. Derived from another country, nonindigenous.

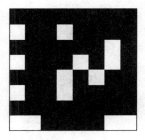

|ɛkˈspɛkt(ə)nt| |ɛkspɛkˈteɪʃ(ə)ns| |ɛkˈspɛkt|
|həʊp| |ˈhəʊpfʊl|

To observe a potential combination of protein strands.

noun

A feeling or desire for a future occurrence. A confidence in the future or in the character of a person. A strong belief that a thing will be achieved, concluded, brought into the world. The action of wanting something to be. A person who anticipates succeeding to an office or gaining a possession, esp. child.

adjective

Showing a confidence in succeeding or receiving a thing. Promising. Expressive of an optimistic future.

verb [trans. & intrans.]

To have an apprehension of a good or evil deed. To believe that something may occur. To trust in the observed behaviour of someone or something to repeat itself. To look for mentally.

323

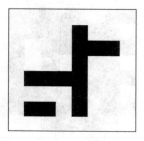

|ɛkˈspleɪn| |ɛkˈspleɪnd| |ʃəʊd| |rɪˈviːld|
|ˈɛvɪd(ə)ns| |ˈɪndɪkeɪt|

A branch lies under the tree from which it is derived.

verb [trans. & intrans.]

To illustrate. To expound. To divulge in more detail than previously mentioned. To make visible a previously obscured idea or thing. To exhibit, to put on view. To point out. To cause to appear, to bring forth for the purpose of demonstration. To present. To represent. To point out, direct. To lightly express desire, purpose, direction.

noun

The state of being clear, obvious, indubitably certain. Testimony, proof. A body of facts or physical signs proving that a statement is true.

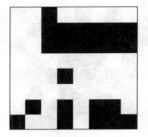

|ɛkˈsplɔə(r)| |ɛkˈsplɔərə(r)z| |ˈɪmɪgr(ə)nt|
|ˈɛmɪgr(ə)nt| |ˈkɒləni| |ˈkɒlənɪst|

*Individuals and movements veer out of the homogenous mass
metastasising on spurs, archipelagos, and endless foreboding coastlines.*

verb [trans.]

To try, to search into, to examine by trial. To move in or through
unknown areas, realms and dimensions.

noun

A voyager in unknown or unfamiliar regions, areas. A body of peo-
ple drawn from the mother country to inhabit a place. A cutting
from a tree planted in a foreign soil. A group of citizens living
in a distant land under the direction of exotic government. Per-
sons leaving their place of abode to settle permanently in another
realm. Persons arriving from foreign realms to settle permanently
here in this land.

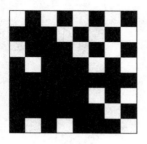

|ɛkˈsprɛs|

verb [trans.]

To copy. To represent. To make an imitation in plastic or verbal arts. To represent through linguistic phenomena such as literature, poetry, rhetoric, law, or other discourses. To make an utterance or declaration. To show through nonverbal means, emotion, social mechanisms, etc. To squeeze or press out, to coërce.

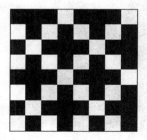

|ɛkˈstravəg(ə)ns|

noun

An action outside of prescribed limits or social convention. A vain or superfluous experience. A lack of restraint, a pecuniary wastefulness. A prodigal expenditure.

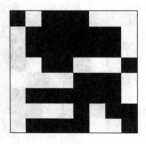

|ˈɛkstrɪkeɪt|

verb [trans.]

To free from perplexity. To disentangle. To liberate from difficulties, constraints, bonds, captivity.

|ʌɪ| |ʌɪz|

From the subject bounces a particle of light.
It travels for all eternity through the deepest voids of nothingness.
It flies, straight, true, never deviating.
One day it falls into the iris. And there it remains.

noun

The orifice of vision. The organ sensitive to light found in humans and vertebrate animals. A globular receptacle of radiation. The method by which visual information is drawn into the body. A visual acuity, taste. Countenance, regard, aspect. A thing in the shape of an ocular device. The power of visual acuity.

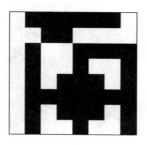

| ˈʌɪlɪdz |

The cover slots over the centre of the information cyclone.
The sign of the onset of the 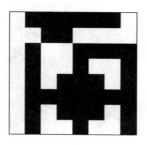 |driːm|.

noun [pl.]

The membranes of skin that close over each eye to protect from
dust, injury, unwanted vision.

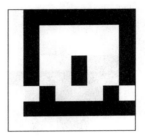

|feɪs|

The head is brought to bear upon the subject (the lower region).

noun

The visage. The region of the head of a being used to gain insight, ingest food, proceed in a direction. The forward part of any object, esp. vessel. The countenance, cast of features. The two-dimensional plane of a geometrical object. The side of a thing. The part of a thing that is designed to be viewed or engaged with.

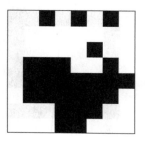

|ˈfaktə|

noun

A circumstance or effect that when combined with another produces a particular occurrence. A circumstance that when multiplied with others produces a certain result. A number that when multiplied with others produces a certain sum. An agent for others. A deliverer or middleman in business. From Old French word for 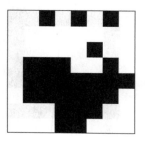 |fɛdɛksmən|.

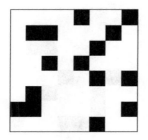

|fɛː|

adjective

On good terms. Abiding the terms of an agreement, law, rule, or standard. A considerable though not excessive amount. A good state of weather. Pleasant, happy, pleasing to the eyes. Of light complexion or skin. Not dark.

adverb

Good, reasonable.

f

|feɪm| |ˈfeɪməs| |ˈfeɪməsli| |ˈpɒpjʊlə|
|nə(ʊ)ˈtɔːrɪəs|

Known in Heaven as in Hell. (SEE |ˈapəsteɪt|*.)*

noun

That which is said of one. Rumour, purportions, gossip. That which is characterized of a person, place, or thing. Celebrity, honour, renown. Evil repute, infamy.

adjective

Commonly known to the world. Not hidden. Conspicuous, evident. A matter of ill repute. Much talked of. Of good repute. Loved by the common people. Suitable for common or vulgar tastes.

adverb

Indicating a widely asserted proposition.

|fə'mɪlɪə|

adjective

Of or related to the family, household. Domestic. Intimate, friendly with. Of an associate, friend, lover. Unceremonious, easygoing, affable. Of an animal domesticated, held in thrall to a human being. Of a dæmon or sprite that is summoned or attached to a person. Of a thing used in a casual or everyday manner. A fact or proposition well known. Known by repeated practice, customary. Common, frequent.

f

|fan| |fand|

To change the arrow of the wind by pushing it around.

verb [trans. & intrans.]

To sweep away with the air. To cool or ventilate. To put in motion by pushing a flat surface against the breeze. To wave an object. To stir up a fire, cause, emotion. To oxygenate. To disperse, scatter.

|ˈfaʃ(ə)n| |ˈfaʃ(ə)nd| |ˈfaʃ(ə)nəb(ə)l|

noun

That which is made or formed. The visible shape, fold, topology of a thing. The cut or style of clothing. The folds and shapes of domestic objects. Conventions of dress, relaxation, etiquette.

adjective

That which is customary. That which is newly customary and might not be customary tomorrow. Tasteful, refined. Made according to the mode.

verb [trans.]

To make, give shape, construct. To put together.

337

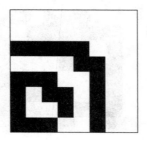

|ˈfat|

Around the fiery anima of being
a blanket of oils nurtures and protects the spirit
from the assaults of cold nature.

noun

An oily and sulphurous form of blood found under the membrane of the skin. A repository of energy often burnt or consumed by other creatures. Human beings contain both pinguedo and tallow fats, each with a particular use in cuisine and soaps. A store of food converted to oily cells that acts as an insulator of heat. A form of food.

adjective

Said of a corpulent person. Full, plump. Not lean. Wealthy. Full of stimulating elements. Juicy. Ready to be plundered.

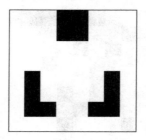

|ˈfɑːðə|

The male progenitor. The self-replicating statue.

noun

The masculine maker of sons and daughters. The antecedent of a person. An old or venerable man. A young man learned in religion, piety, or storytelling. An ecclesiast. The title of a senator. One who acts in a paternal manner. An important figure in the development of a style or mannerism. An early example of a human being. Said of deities, esp. male. A title for the monotheistic being. (SEE 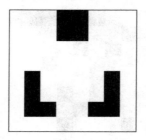 |ˈmeɪkə|.)

f

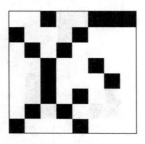

|fəˈtiːg|

The stick-figure begins to lose consistency.

noun

Weariness, tiredness. A want of energy. The result of strenuous labours, esp. physical or mental. A reduction in the capability of a man, animal, machine, or material. A reduction of enthusiasm.

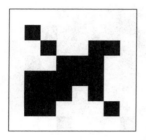

|fɛdɛks| |fɛdɛksmən|

*The transfixion of knowledge into a physical form and carried about
in sacks and wagons. (SEE 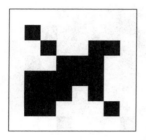 |'nɒlɪdʒ|.)*

noun

A hasty messenger. One who comes and goes delivering correspond-
ence, esp. letters. A deliverer of packages, news, items. An official
company or enterprise that expedites the transport of packages and
letters within or without a nation.

'f

$|\text{'fi:b(ə)l}|$

adjective

Weak, sickly, infirm, debilitated. Of a thing, fragile, delicate, unsubstantial. Lacking definite form. Unintelligible, faint, ephemeral, slight. Unimpressive intelligence, courage, or wisdom. Wanting energy. Of a person ill-starred.

|fiːl| |ˈfiːlɪŋ| |fɛlt|

The grid localizes and informs us of the physical presence of objects, persons, concerns, emotions, suspicions.

verb [trans. & intrans.]

To make known by physical touch, reconnoitre. To handle in a tactile way. To handle or explore with an instrument, esp. stick, sword. To be touched. To be made aware through a non-physical sense, premonition. To be affected by pain or pleasure. To be sensible to good and evil. To be capable of sensation. To be subject to an emotion, sensation, realization. To experience being *in being*. (SEE ▦ |biːɪŋ|.)

noun

A state of being. A conscious experience. A sensation imparted by a building or work of art. A perception, a tenderness. The impression on the mind given by the external world. An emotion.

|ˈfəːvə| |ˈfəːvəd|

noun

Heat, warmth. Glowing with radiation. Passionate. Ardent devotion to a cause. Heat of mind. Zeal. Agitated, delirious.

|ˈfiːvə| |sɪk| |ˈsɪknɪs|

A contagion attached to the symmetrical body.

noun

The state of being diseased. A malady. A high body temperature together with sweating, shivering, pain, nausea, and delirium.

adjective

Disgusted. Disordered. Full of malady. Unwell. Being nauseous. Inducing nausea in others.

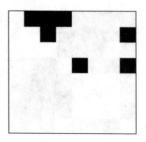

|fju:| |rɛː| |rɛːə| |ˈrɛːli|

adjective & pronoun

Scarce, uncommon. Occurring little. Thin, subtle, not dense. Not many, not a great number. A small or insignificant amount.

adverb

Not often, not usually, seldom. Not frequently. Hardly ever.

|fiːld| |fiːldz|

*The first plows carved the earth into patterns of lines
in which crops and plants learned to grow.*

noun

The extents of space. The blank ground on which things are drawn.
A demarcated space. An area of land cultivated for crops or pasture.
An unbuilt place. An arena for war or sport. A battle. A space or range
in which forces or influences exert themselves upon each other.

f

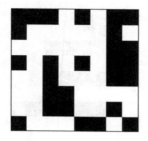

|fɪəs| |ˈfjʊərɪəs|

adjective

Ravenous, savage, easily aroused. Vehement in anger. Violent, passionate, angry. Frenetic. Mad. Raging. Transported by the emotions beyond the shores of logic and reason.

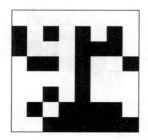

|ˈfʌɪə| |ˈfʌɪəri| |ˈfʌɪəs| |tɔːtʃ| |ˈɪrɪˈdɛs(ə)nt|
|bəːn| |bəːnd| |sɪəd|

*The divine spark surges up to the sky in its desire
to be reunited with the Essence.*

noun

The igneous element. One of the four principal elements. The combustion of oxygen giving heat and light. The destruction of fuel, houses, cities. A mischievous spirit that lives in stacks of woods, papers, and matchheads. The torture of the damned in the abyss. Flame, light, lustre. The origin of smoke. A controlled hearth for cooking or warmth. Temper or violence of the passions. Vigour, intellectual passion. Amorous ardour. A means of illumination larger than a candle. The source of illumination of the day. The cause of daylight. The bright disc that arrives in the morning and departs before nightfall. The star around which the world evolves. A G2 dwarf of one point four million kilometres in diametre fuelled by nuclear fusion. place outside of the shade, the warmth or cast of daylight.

f

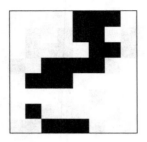

|fʌɪt| |ˈfʌɪtɪŋ| |ˈstrʌg(ə)l| |ˈstrʌg(ə)lz| |ˈstrʌg(ə)ld|

verb [trans. & intrans.]

To contest, to trade in battle. To make war. To violently struggle. To duel, combat. To exchange violence. To argue vehemently. To exchange insults. To campaign for a cause. To seek to control others or the self. To labour, to make efforts. To attempt to free oneself from restrictions. To strive, to work against. To labour in agony.

349 ⬛ |ˈfʌɪə|

verb [trans. & intrans.]

To kindle or inflame. To warm with light or other radiation. To destroy with light or other radiation. To inflame the passions, to animate. To consume in flame. To hurt or wound with heat. To fix the proteins of the surface of a flesh. To apply a sudden or intense heat.

adjective

Summoning luminous colours that undulate or fluctuate when approached from different angles. Like a rainbow.

350

| ˈfɪɡə | | ˈfɪɡəz | | apəˈrɪʃ(ə)n |

The walker in the clouds.
The shadow over the doorway.
The indistinct silhouette in the swirling fogs.

noun

The form of a thing as demarcated by its outline. The shape, form, or semblance of a thing. The appearance of a person. Visibility. The coming into vision of a thing. A spectre. A ghost.

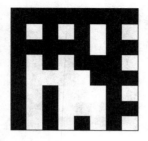

|ˈfɪltə| |ˈfɪltəd|

The regularly spaced grid clogged with foreign matter.

verb [trans. & intrans.]

To pass a substance through another with the purpose of removing impurities. To strain, to percolate. To pass units or number through a device or mathematical construct. To diffuse slowly.

ˈfʌɪn(ə)l		ˈfʌɪnəli		stɒp		stɒpd		stɒpɪŋ
ˈpəːm(ə)nənt		ɪˈvɛn(t)ʃʊəlɪ		ˈlɪmɪt		ˈlɪmɪtz		
pɔːzd		stʌk		ɪntəˈrʌptɪd		siːsd		

noun

The end of movement. A break in speech, paragraph, or writing. An interruption in music. Boundary, border. Utmost reach.

adjective

Ultimate, last. Conclusive, decisive, allowing no further disputation. The desired outcome of a series of events. The end of life, mortality. Durable, unchanging. Not decaying, remaining the same indefinitely. To interrupt, suspend.

verb [trans. & intrans.]

To hinder from motion. To prevent a change from one state to another. To break in upon a process. To divide a linear sequence with a disruption. To bring an action to a close, to prevent further

'f

developments. To suppress. To close an aperture, play a note. To block a hole or orifice. To obstruct, encumber. To fix to a point. To be unable to move. To adhere to a surface or idea. To rest. To be at the end.

adverb

Lastly, as the consequence. In the end, after great delay.

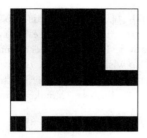

fʌɪnd		faʊnd		ˈfʌɪndɪŋ		səːtʃ		ˈsəːtʃɪŋ
səːtʃd		siːk		ˈsiːkɪŋ		ɪnˈkwʌɪə		ɪnˈkwʌɪri
ɪnˈkwʌɪriz		lʊk		lʊkt		ˈlʊkɪŋ		ˈprəʊbɪŋ
siːks		dɪˈzʌɪəd		dɪˈzʌɪəz		ɛgˈzamɪˈneɪʃ(ə)n		
ɛgˈzamɪn		əbˈzəːvɪŋ		dɪˈskʌvə		dɪˈskʌv(ə)riz		

A point localized by the axes x, y, and z.

verb [trans. & intrans.]

To obtain something lost. To meet with, to fall upon a known or previously unknown thing. To know by experience. To know by study. To hit upon by chance or accident. To gain by mental endeavour. To remark. To attain. To ascertain. To deprehend. To go about in an endeavour to locate a thing or knowledge. To comb or ransack a place. To solicit. To attempt to achieve a thing. To ask for a thing from persons or deities. To ask for informations from a person or deities. To exert curiosity. To turn one's attention towards something. To gaze in a particular direction. To engage the vision

f

upon a subject. (SEE ▢ᵣ |siː|.) To scrutinise. To watch, to regard attentively. To have a particular appearance. To try by an instrument. To acquire information via physical, electromagnetic, psychic, or other instruments. To wish for, to long. To covet. To interrogate a witness. To pursue truth or falsehood in a matter. To try by experiment or observation. To disclose. To make known.

noun

The cast of appearance. Countenance. The act of engaging with the eyes or mind. The appearance. Eagerness to obtain, understand, or experience. The motivation of living beings. Goal-orientated psychology. An inspection or investigation. A test of one's knowledge or abilities esp. by bureaucratic structures. The act of revealing knowledge not previously disclosed or closely guarded by providential deities.

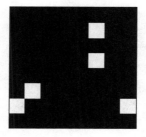

|fʌɪnɪst|

adjective

Most thin, subtle. Most graceful, artful. Nice, exquisite, delightful. Lacking thickness. Elegant, showy, decadent.

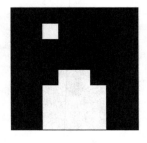

|ˈfʌɪnʌɪt|

The universe dictates an absolute limit to the divisibility of time,
space, and energy. From this fact all real objects
and persons derive their actuality. (SEE 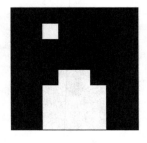 *|ˈɪnfɪnɪt|.)*

adjective

Limited, bounded. With definite ends or beginnings.

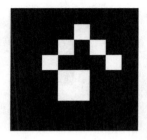

|fɪʃ| |ˈʃɛlfɪʃ| |ʃəʊlz|

*In the deeps and shallows of the waters the distorted shapes
of men whom the gods have cursed flick and slip their bodies, ghoulish
eyes scanning the darkness searching for their redemption.*

noun

The sign of Pisces. The animals that inhabit the waters of seas, lakes,
rivers, and cauldrons. A conglomeration of such creatures. A limb-
less coldblooded vertebrate replete with gills and fins. A mollusk
or crustacean. A primitive aquatic creature with a carapace or hard
covering. A crowd, multitude, throng. A shallow or sand bank.

f

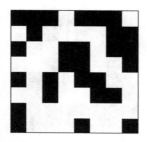

|fɪt|

*In the throes of a violent convulsion
waves of psychic energy assault the mind, bringing visions
of terrors and beauties previously unimagined.*

noun

A paroxysm or distemper of the corpse. A violent affliction of the mind or body. A loss of control of the limbs, shaking, foaming. A temporary interruption of the normal course. A riot of the body.

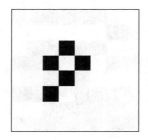

|fʌɪv| |fɪfθ|

cardinal & ordinal number

More than four but less than six. The half of ten. The sum of three and two. The number of digits on the hand of man. The number of digits on the foot of a man. A holy number associated with the psychic connection of a being through their foot into the grounds of the earth.

f

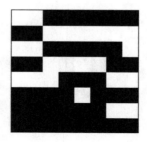

|fɪks| |fɪksd| |fɪksɪŋ|

Layers of pressure fall down on the point making it unmovable.

verb [trans. & intrans.]

To make fast, firm, or stable. To fasten to a place, position, or state of being. To settle a dispute. To repair, mend.

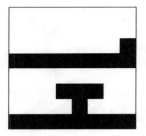

|flat| |'flat(ə)nɪŋ| |'flatnəs|

The hand from above squashes an insignificant creature.

adjective

Horizontal, without inclination. With no protuberances, perfectly level. Laying upon the ground. Lying prostrate. Lacking relief, without prominence in the figures.

verb [trans.]

To make even. To emphasise the two-dimensional nature of a painting.

noun

Evenness.

|flɛks|

noun [pl.]

Particles of matter noticeable on an unlike surface. Specks. Patches of colour or light.

|fleʃ|

noun

The body as opposed to the soul. The muscles, bones, sinews of a creature. The substance of animals. The corpses of birds, mammals, reptiles, and amphibians as used for food. The physical manifestation of man. The outward appearance. The prison of the soul.

| ˈflɪkə |

As the birds speak to each other in the language of the gods,
in the movements of the flames are encoded
the secret words of fallen angels.

verb [intrans.]

To flutter the wings. To make small, quick variations. For a light to change brightness with quick variations. For a flame, fire, or candle to wave and motion.

|flʌd| |flʌdɪd| |ˈɪnənˈdeɪʃəns| |ˈantɪdɪˈluːvɪən|

Two structures.
The left one walks on the raised ground,
the right wallows in the rising waters.

noun

A body of water lying where it should not. A deluge. An overflow of waters, esp. from rains or tides. The breaking of a riverbank. The overwhelming abundance of a substance or persons. The vengeful act of a demiurge.

adjective

Dating from a time before the mythical deluge described in various traditions. From an ancient period. From a time before history.

verb [trans. & intrans.]

To overwhelm with waters. To submerge or surround. To arrive in large quantities.

367

f

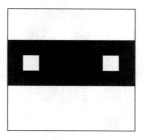

|flɔː| |dɛk|

A tranche of wood impaled to the ground with two nails.

noun

That upon which we tread. A surface made of wood, stone, or other artificial means laying flat upon the horizontal field. The pavement. The bottom of rooms. The tier of a ship. A raised wooden platform. A covering upon which persons may operate.

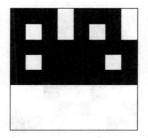

|ˈflɔːbɔːdz|

The rhythmic arrangement of wood upon the ground.

noun [pl.]

The planks of wood laid down and walked upon. Flat rectangles of tree.

ˈf

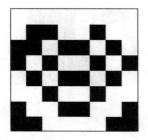

| ˈflɔːrə |

The shape of a budding flower.

noun [pl.]

The plant life of a region. The vegetation of a habitat. The living beings that sustain the **TÏ** |ˈanɪm(ə)lz|.

f

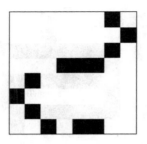

|fləʊ| |fləʊd| |rʌɪn|

The broken wave. (SEE 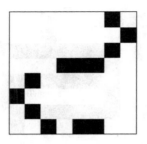 *|weɪv|.)*

verb [intrans.]

For water to issue, run. To not stand. To ebb. For a fluid to move along a channel or opening. To circulate in a given system. To proceed smoothly. For a liquid to move from one location to another.

noun

A river originating in the Helvetian Alps that descends through Germany to the Netherlands and finally out into the North Sea.

f

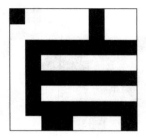

|fəʊld| |fəʊldɪd|

*A topological manipulation of the dimensions,
often associated with the trade of magicians and tailors.*

verb [trans.]

To enclose a thing over itself. To manipulate a flexible material into layers. To cover with itself. To transfix a two-dimensional object temporarily via a third.

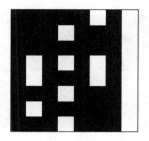

|ˈfɒləu| |ˈfɒləud| |ˈfɒləuɪŋ|

verb [trans.]

To go afterwards, not before or alongside. To come after in time or space. To move in the same direction as another. To copy the actions or words of another. To obey. To come after in a list. To pay close attention to words or actions. To observe. To pursue, esp. an enemy.

f

|fuːd| |krɒps|

Energy stored in the corpses of living matter.

noun

Victuals. Provisions for the appetite. Nourishment for the body. Plants or animals prepared for internal consumption. A cultivation of plants such as fruit, vegetable, grains, roots.

|fuːl| |fuːlz| |ˈfuːlɪʃ|

As he walks into the walls of the pitch black room,
he considers not to remove his blindfold.

noun

One lacking reason. An idiot. A jester, buffoon, artist. An unwise person. A subject of mockery.

adjective

Devoid of intellect. Indiscreet, impudent. Silly, contemptible.

f

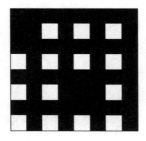

|fə|

Motion in the field of |əˈbaʊt|.

preposition

With respect to, with regards to. Because of. For the sake of. Conductive to, beneficial to. In the place of. Supporting a person, idea, movement. On the behalf of. With resemblance to. In the character of. In comparison to. To the destination of. Leading towards that place. With appropriation to. Expressing desire of. Inducing motivation. Related to the norm as experienced. Indicating distance. Indicating occasion in sequence or causal chain.

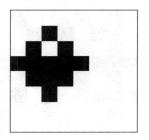

|fɔːs| |fɔːz| |koʊˈərʒən|

The active power.

noun

Power, vigour, might, strength. Violence. Armaments, war. A mechanism of nature that applies magnitudes of influence upon objects in relation to mass, weight, gravitational field, etc. Compulsion, necessity, destiny.

verb [trans.]

To compel by threats, violence, restraint, mental control. To command against resistance. To push, attack. To apply power against a static or resistful object, person, or physical phenomenon.

ᶠf

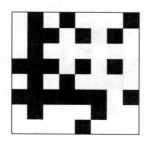

|ˈfɒrɪn| |ˈvɪzɪtə| |ˈvɪzɪt| |ˈvɪzɪtɪd|

adjective

Not of this land. From a far-off region. Not local or domestic. Alien, remote. Strange and unfamiliar. Not allied or subject. Held at a distance. Characteristic of another region. One who goes to see another.

noun

One who arrives. A temporary habitant. The action of going to see a person temporarily.

verb [trans.]

To come and see. To go and spend time with. For a deity to bring beneficial or retributive justice. To arrive and inhabit a region non-permanently.

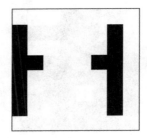

|fɔːdʒ| |fɔːdʒɪŋ|

Organic compounds floating in the ether bind to the matter.
In a tight embrace they mould matter into their own image.

verb [trans.]

To make a metal object by distorting it in heat and beating it with a hammer. To produce a metallurgic work with force. To construct an object or relationship through effort or with a powerful result. To reproduce or falsely replicate a work of art, signature, document, or currency.

f

|fə'gɛt| |fə'gɒt| |fə'gɒt(ə)n|

*Points of memory smudge and distort, becoming
corrupted and unrecoverable.*

verb [trans.]

To lose memory of. To have no remembrance of. To lose mental
record or note. To neglect, lapse in duty.

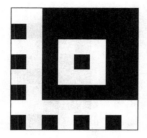

|fɔːm| |ˈfɔːmɪŋ| |ˈfɔːmətɪv| |ˈkɒnstɪtjuːtɪd|

The even field coalesces into concrete materiality.
The three-dimensional shadows of a ten-dimensional multiverse.
Maya.

noun

The external appearance, shape, image of a thing. Being as constituted in the physical realm. Shape or appearance in the mathematical, imaginary, platonic, heavenly, or speculative dimensions. A particular model or template. A type or variety of a category. Character.

verb [trans.]

To modify matter as like a god. To shape, combine, materialise. To fashion from one state to another. To modify an existing state. To influence or shape an abstract proposition. Giving actual existence. Being part of a whole or series. Being equivalent to another. To conceive in the mind, plans, ideas, follies. To contrive. To model by educating young minds in restrictive pathways of thought.

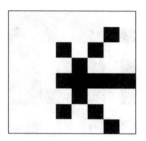

|ˈfɔːwəd| |fɔːθ|

*Time's arrow progresses in a single direction,
always closer and closer to the ever-fleeing future.*

adverb

Toward. Outwards in place. In public, known to all. Thoroughly, from beginning to end. Onwards and upwards to the end. To a part of. Progressively. Near the front. Toward the future.

adjective

Warm, eager, ardent, amorous. Ready, confident, presumptuous. Premature. Not modest. The antecedent, not backwards part. Not inferior.

381 🔲 |fɔːm|

adjective

Acting to shape the development of a character, person, thing, esp. young person. Making plastic.

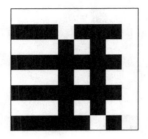

|faʊnˈdeɪʃ(ə)n| |faʊnˈdeɪʃ(ə)nz|

noun

The basis or lowest part of an edifice. The load-bearing part of a building lying under the ground. The root of an architectural structure reaching deep into the earth from which it draws nourishment. The principle upon which a notion or idea is based.

| ˈfradʒʌɪl |

The wandering of the smallest point on the line causes it to disintegrate.

adjective

Brittle, liable to be easily snapped or broken. Weak, uncertain, easily destroyed. Of a person, having a weak mental constitution, not hardy.

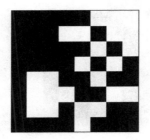

|frag'mɛnt| |'fragm(ə)nts| |frag'mɛntɪd|

The unconstituted whole.

noun

A part divorced from the whole. A part broken or snapped from. A separated section.

verb [trans. & intrans.]

To cause to shatter or break into many parts. To fall apart into many factions, sections, movements, persons. To lose wholeness.

f

|freɪm| |freɪmd|

verb [trans.]

To form or fabricate in an orderly and precise manner, esp. a wooden building, room, shop, museum. To fit to another. To place an image, photograph, painting, projection within a structure, parameter, etc. To compose, make, adjust. To direct by thought. To outline mentally. To outline visually. To outline verbally by means of definitions, restrictions, and oppositions. To drape in artificial woods, plastics, plasters, and other decorous substances.

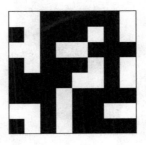

|'frantɪk|

A busy and inelegant sign.

adjective

Mad, deprived of reason, full of violent and tempestuous emo-
tion. Wild or distraught with anxiety, fear, worries, superstitions.
Transported by excitement to behave without calculation, reason,
or civility.

'f

| ˈfriːkw(ə)nt |

The oft-repeated shape of events.

adjective

Often done, seen, or occurred. Repeating successively. Often practiced. In quick succession in time or space. Habitually.

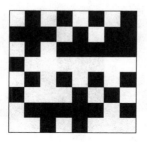

|frɛʃ| |frɛʃlɪ|

adjective & adverb

Cool, not hot or bothersome. Newly minted, not impaired by time, heat, decay, or use, esp. milk. Still fashionable, not yet out of mode. Not salty with respects to water. Cool, refreshing. Newly come or arrived. Newly repaired or rested. Healthy, ruddy. Brisk, strong, vigorous, sexually forward.

f

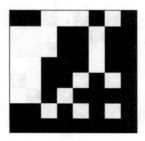

|frɛnd| |ˈfrɛn(d)ʃɪp| |kəmˈpanjən|

noun

Not an enemy. One joined in an intimacy, bond, or relationship not amorous, familial, or mercantile. A person or animal bound in mutual affection. One without hostility. The state of an attendant. One whom one favours. One whom a man converses with or spends his time of relaxation. A person or animal, typically a donkey, with whom a man travels on adventurous journeys.

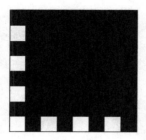

|fɪə| |ˈfɪəfʊl| |frʌɪt| |ˈfrʌɪt(ə)n| |ˈfrʌɪt(ə)nɪŋ|
|skɛː| |ˈskɛ(ə)rd| |ˈskɛːri| |drɛd|

An incomplete picture of existence troubles the psyche of living souls. Seeing only the edge of the grid, they imagine dæmons and deities inhabiting within. They subject themselves to the caprices of invented superstitions, ignoring the cold detached beauty of the universe condensed from ambiguous possibility. (SEE ▦ *|fiːl|.)*

noun

The mind-killer. The little death that brings total obliteration. The horrorful apprehension of danger, pain, or obliteration. Awe, solicitude. The belief that the sky may fall down. To anticipate calamity.

verb [trans. & intrans.]

To be terrified, to terrify, to make afraid. To strike suddenly with apprehension.

adjective

Showing anxiety. Causing abject consternation.

f

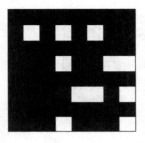

|frɒm| |deɪts|

Stepping back in the causal change.
To express whence B is derived.
(Let us suppose perhaps that it is the progeny of the infamous A.)

preposition

Indicating a derived point in space that a motion begins with. The points in time that action begins or ends. Explaining the provenance of a thing. The point which an observer occupies. The origin of a material transformed. Indicating separation from a state of completion. Showing a source of knowledge from which a thing was derived.

verb [intrans.]

To have come into existence at a particular point in time and have continued so for a period, short or long, usually up to and including the present.

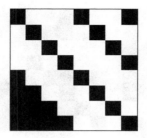

|frʌnt| |ˈfrʌntɪəzmən|

It is said that as man gains more knowledge of the world,
he gains an even greater comprehension of that which he does not know.
As the balloon of comprehension expands, its surface covers greater
and greater reaches of the unknown. The surface becomes more and
more taut until the fragile membrane threatens to tear and allow
the dark cold unknown to pour into and put out our timorous candle
of learning. (SEE ✎ *|ˈnɒlɪdʒ|.)*

noun

The forepart of an object. The position directly ahead of a person or movement. The face of an object as usually approached. The line of a barrier advancing through another region. The uttermost surface of an object. That which first encounters new places and ideas. A person inhabiting a region on the dividing line between the settled and unsettled, the explored and unexplored, the canny and uncanny.

f

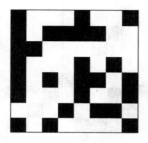

|fɑː| |ˈfɑːðə| |ˈfɑːðəst| |rɪˈməʊt| |bɪˈjɒnd|

preposition, adverb & adjective

To a great extent of length. To a great distance. At an even greater distance. Beyond this. To a certain point. Distant. At a point not at hand. Foreign, alien. To promote. To countenance, help. On the other side of. Not yet reached in space, time, or development. To a degree in which action is no longer possible.

noun

The other side of reality.

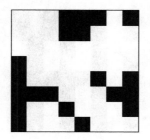

|gaŋ|

noun

A number of persons or things herding together. A group, esp. of miscreants. An association of persons.

g

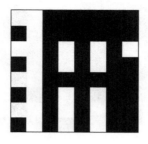

|gap| |gaps|

Between the atoms lie vast emptinesses.

noun

An opening. A breach or fissure. A corridor. A break. An unfilled space or interval in activity, time, knowledge.

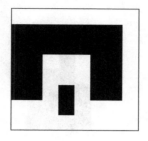

|ˈgɑrɑ:(d)ʒ| |ˈgɑrɑ:(d)ʒz|

The protective symbol. (SEE 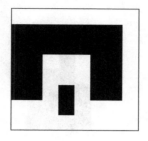 *|ˈkarəpeɪs|.)*

noun

A building or part of a building used to house vehicles or carriages. A shelter for the repair, maintenance, and protection of cars. The sepulchre of automatons.

'g

|ˈgɑːd(ə)n|

noun

A place cultivated with plants for pleasure. An extravagant agriculture. A place that is fruitful and delightful. An ornamental arrangement of nature. An artificial growth of flower, fruits, herbs, or vegetables.

|ˈgasəliːn| |pɪˈtrəʊlɪəm|

The sign of the Hydrocarbon Chain.

noun

Black bitumen. The quintessence sometimes found oozing from the earth or floating in lakes. A refined liquid formed from oils found in rock strata. The fuel that powers combustion engines.

399

ˈd

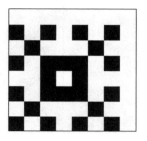

|ˈdʒen(ə)r(ə)l| |ˈdʒen(ə)r(ə)lli|

From one point out and affecting all in the region of.
(SEE ✚ *|ˈjuːnɪvəːs|.)*

adjective & adverb

Without specification or exception. In the main. The majority of the whole. Almost all of the universe with certain exceptions. Usually, habitually. In the main, without reference to details.

|ˈdʒɪəˈmɛtrɪk| |ˈdʒɪəˈmɛtrɪkəl| |ˌdīəgrəˈmatik|

adjective

Related originally to the measurement of the earth. The plotting of fields covered with mud during inundations. (SEE ▞▖ |ˈbarɪə|; ▤ |fiːld|.) The reckoning of space actual and theoretical. The manipulation of abstract mathematical topology. Arranged in a definite and precise manner. Arranged in a repetitive design or of regular or pure shapes. A mathematical scheme. A simple schematic representation. A drawing demonstrating the composition, mechanisms, or operations of a device.

|ˈdʒəːməni| |ˈdʒəːmənɪə| |ˈdʒəːmən|

The land of the broken stripe.

adjective

A brother, cousin, or relative. A neighbour.

noun

A series of nations and principalities of central Europe. The lands south of Denmark bordered by France in the west, the Alps in the south, and the Slavic peoples in the east. The principal tongue spoken in the central European plain. The tribes and nations, peoples and individuals living in the above region. One of the tribes of autochthons found in the New World. A primitive people with a rich culture of geometric art, sculpture, tapestries, and other objects.

|gɛt| |gɒt| |geɪn| |əˈkwʌɪə| |ˈgaðə| |fɛtʃ|

verb [trans. & intrans.]

To obtain more than what is provided by nature. To gain by labour, conflict, or genius. To come to possess. To succeed in achieving. To experience, obtain. To attain. To come to hold or control. To reach a state or condition. To come, go, or move with difficulty. To have. To bring multiple parts together. To assemble or accumulate. To derive. To draw into a confined space. Possession. To move a thing from another place to this one.

g

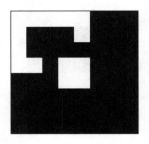

|gɪv| |geɪv| |prə'vʌɪd| |prə'vʌɪdɪd| |gɪft|

verb [trans. & intrans.]

To bestow. To confer without exchange. To transmit by physical means, by communication, or by magic. To freely transfer the possession of a thing to another. To yield, to allow passage. To not deny, allow. To move a thing from one's possession to another's. To furnish with. To supply.

noun

An oblation or offering. A bribe. A present. A thing received without payment. An ability or quality instilled in a person by nature or deific munificence.

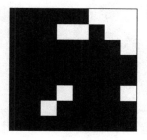

|glɑːns| |glɑːnsɪŋ|

verb [intrans.]

A sudden stroke of light. A darting beam of light. A hurried vision or look.

noun

To observe quickly or cursorily.

g

|glɑːs| |ˈvʌɪəl|

From the rough sand of the desert is forged a smooth optical deception.

noun

An artificial substance made from fused flint, sand, soda, lime. A molten substance that has cooled without crystallising. The translucent vessel used to hold beverages. The quantity of liquid held by such a container. A hard, brittle substance used to create the barrier in a window. A container used in scientific and chemical experiments. A small bottle that holds spirits, vapours, or exotic substances.

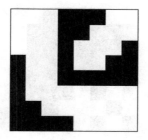

|gəʊ| |ˈgəʊɪŋ| |ˈgəʊɪŋz| |gɒn| |gɒnz|
|gəʊz| |wɛnt| |prəˈsiːdɪd|

Intention generates activity. (SEE 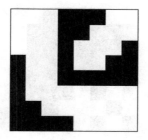 |muːv|.)

verb [intrans.]

To move, to not stand still. To walk, travel, journey. To depart from a place. To motion. To change state. To lose a state. To progress in a specific way. To move or pass in a manner. To advance along a trajectory, course of action. To proceed in mental action. To move along a road. To activate. To pass from one place to another. To advance, make progress. To continue along a previously prescribed trajectory.

noun

The act of leaving. Departure. The conditions of action. The progress of some. The passage of persons. The general actions and behaviours of a place.

g

|gʊdz| |ˈprɒdʌkt| |prɒdʌkˈtɪvɪti|

noun [pl.]

Wares, freight, merchandise. Chattels. Composed, manufactured, or created articles. Objects for sale or exchange. The effectiveness of industry. Efficiency, fertility, generativity.

|ˈgɒθɪk|

adjective

An architectural style predating the classical Greco-Roman. The flying buttresses, pointed arches, and rib vaults that would later develop into the Romanesque vocabulary.

g

|greɪs|

An elegant sign.

noun

Favour, kindness. The effect of a god's influence. The blessing of a deity. Virtue. Elegance, refinement of movement. Simple beauty.

|grand| |greɪt| |greɪtɪst| |trɪˈmɛndəs| |greɪtə|
|magˈnɪfɪs(ə)nt| |s(ə)nt|

adjective

Illustrious, splendid. Powerful, noble, sublime. Of great size or
stature. Imposing. Extending to a large amount or intensity. Emi-
nent, of considerable quality. Dreadful, horrible, of incredible
power. Beautiful, extravagant, elaborate.

noun

A person noted for their piety and virtue. A person under the influ-
ence of or acting as an extension of a deity. A form of demigod.

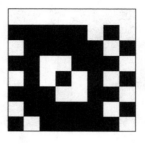

|'greɪtfʊl|

adjective

Thankful, showing appreciation of kindness. Willing to acknowledge or repay debts. Received or experienced with appreciation.

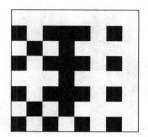

|ˈgratɪs| |friː| |friːlɪ| |fraŋks| |frɛn(t)ʃ| |fraŋkə|

adverb

For nothing, done without recompense. Given without charge. Without cost or payment.

adjective

Not a vassal. At liberty. Able to move and behave as desired. Not under the control or power of another. Uncompelled, unrestrained. Unbound. Permitted, allowed. Licentious. Open, not closed off. Liberal. Not purchased. Without condition. Related to the people of western Europe.

noun

The land and people of western Europe along the Atlantic coast, bounded by the Pyrenee mountain range in the south and the Alps and Rhine in the east.

g

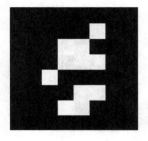

|greɪv|

The parts return from where they were derived.

noun

The place under the earth where the dead are buried.

adjective

Giving cause for alarm. Serious. Acute. Weighty.

|grɪd|

In the finite is hinted the infinite.
Pure regulated reason pierces the chaos of the darkness.

noun

A series of parallel lines at their intersections forming squares or rectangles. An abstract regimentation of space allowing geometry, topology, plotting, and other manipulations. A visual representation of the underlying textile of time and space.

g

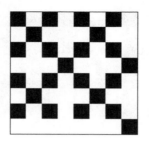

|grɪp| |grɪpt|

To hold onto a definiteness. To grasp 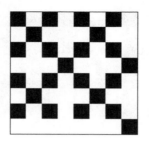 *|ðə|.*

verb [trans. & intrans.]

To grasp. To hold the fingers closed around something. To catch eagerly, seize. To clutch, to close onto. To mentally comprehend, to hold onto a fleeting memory or understanding. To catch the bird of reason.

|gruːp| |gruːps| |ˈpɑːti| |ˈpɑːtiz|

noun

A crowd, a huddle, a throng. A faction. A group holding similar beliefs or intentions. One concerned in an affair. Persons engaged against each other. Politicians in assemblies. Particular persons as opposed to others.

g

|grəʊ| |gruː| |grəʊn| |grəʊɪŋ|

Shoots of life replicate, exploring crevices and cracks
in rocks and space and dimensions. The roots take hold, expanding
and cracking the solidity that crumbles around them.

verb [trans. & intrans.]

To vegetate, to have vegetable motion. For a living being to develop and expand. To have animal motion. To become larger and more complex. To mature. To produce or cultivate. To increase in stature. To become accustomed to an idea or situation. To come by degrees. To advance, progress. To be changed from one state to another as a caterpillar becomes a butterfly or a lake becomes a mirror of ice.

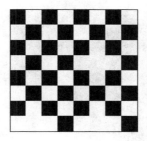

|gar(ə)nˈtiː| |gar(ə)nˈtiːd|

*A power that undertakes to see conditions proceed
as stipulated, esp. deity or dæmon.*

verb [trans.]

To make a formal promise or assurance that the future will pro-
ceed as proposed. To give an absolute likelihood of outcome. To
believe strongly in the veracity of the augurs.

g

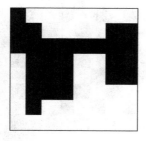

|gɑːd| |ˈgɑːdɪən|

noun

A man or body of men whose business is to watch, defend, or protect a thing. The state of wariness or vigilance. The hilt of a sword. One who has care or protection of an infant. One who is committed to protect or defend a person. A preserver of life.

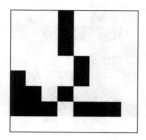

|ges| |gesd|

A tentative finger explores the realm of thought.

verb [trans.]

To estimate, conjecture. To suppose a thing to be true. To make speculations without holding real understanding.

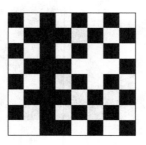

|haz| |had|

The possession of things real and unreal. (SEE 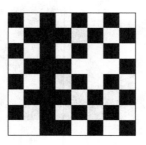 |hav|.)

verb [trans.]

For the third person to possess. To own, hold, control. To undergo, to endure, to experience. To be obliged to. To demonstrate. To place or keep.

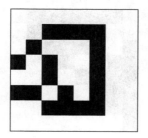

|hɛːbreɪnd|

A mind holding corrupted structures.

adjective

Volatile, unsettled, fluttering, wild. Having no more sense or reason
that a wild animal. Mad, rash, reckless.

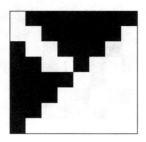

|hɑːf| |hɑːfd| |dɪˈvʌɪd| |dɪˈvɪʒ(ə)n|
|mɪd| |bʌɪˈsɛkt|

The sky and the earth split asunder, making the world of men.

noun

A moiety. Either of two equal things or periods of time. The act of separating into parts. Disagreements and discords between persons. Mathematical process of quantifying reduction. The partition between two places.

verb [trans. & intrans.]

To part in two equal sections. To reduce by fifty percent. To cut, remove an equal part. To part a whole into pieces. To separate, keep apart. To disunite with discord or intrigue. To give out shares. To draw a line parting two areas or volumes.

predeterminer, pronoun & adjective

Equivalent to two equal parts. In the centre of. In the interim section of.

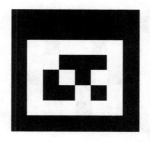

|hɔːl| |ˈhɔːlweɪ|

noun

A court of justice. A large area in a building to which other rooms and corridors lead. A large room for meetings. The largest room in a house. The stately area for entertaining. A corridor, a passage leading to the largest room.

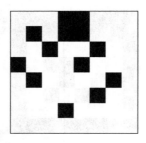

| 'halədʒ(ə)n |

Particles of light scatter from the source.

noun

The elements fluorine, chlorine, bromine, iodine, and astatine often placed in vapours around glowing filaments. The group of elements used in electric torches, lights, and lamps.

adjective

Of or related to the ancient light source noted for its particular brightness and intensity.

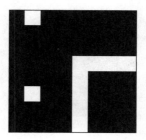

|ˈhamlɪt| |ˈhamlɪtz| |ˈvɪlɪdʒ| |ˈsɛt(ə)lm(ə)nt|
|ˈsɛt(ə)lm(ə)ntz| |ˈsɛt(ə)ld|

*The frightening actuality—flora, fauna, weather,
and the prying eyes of deities—is denied by walls of straw,
mud, and poured concrete.*

noun

A place previously uninhabited upon which humans have constructed homes. A permanent movement of peoples to a region. A group of people living in an organised society surrounded by emptiness or threatening natural phenomenon. A small group of houses or buildings in the countryside. A conglomeration smaller than a town or city. A very small gathering of buildings in the wilderness, typically less than a dozen structures.

verb [trans.]

To come to rest, live, or situate in an area. To establish a colony far from the Old World. To populate and civilize savage lands.

h

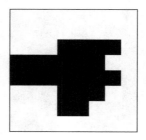

|hand| |handz| |ɑːm|

The manipulator of things. The causer of change.
(SEE 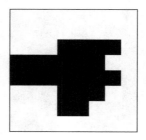 |akt|.)

noun

The palm and fingers. That which we use to manipulate instruments and weapons. Beyond the wrist. The prehensile organ, not paw. Non-machine. Operated by human ingenuity alone. A side, left or right. The act of receiving or giving. The upper limb of a person coming from the shoulder. The bough of a tree. The branch of an organisation having a particular purpose or independence.

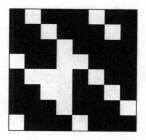

|haŋ| |haŋid| |haŋɪŋ|

verb [trans. & intrans.]

To be or to suspend from a height so as not to be supported by the ground. To place without solid support. To drape from a line or cord. To kill by holding from the neck. To display from a surface. To drape from a wall. To come low.

h

|hɑːd|

Unmutable, impenetrable surface.

adjective

Firm, impenetrable. Not easily broken or sundered. Not soft or malleable. Difficult, problematic for the intellect. Not easily grasped. Difficult to accomplish, challenging. Painful, laborious, injurious. Cruel, oppressive. Rigorous, not simplistic. Unreasonable, insensitive, unjust. Not fruitful.

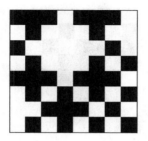

|ˈhɑːməni|

noun

Just relationship with another or with internal parts. Combination of elements to form pleasing colours, sounds, or effects. Parties potentially in discord working together. Agreement, concord.

h

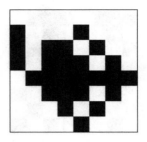

|hɑːʃ| |hɑːʃɪst|

adjective

Austere. Rough to the ear. Rugged to the touch. Unpleasant. Cruel, severe. Jarring.

|heɪt| |heɪtrɛd|

A black pearl held within the mind to ferment and grow.

noun

That which causes abhorrence. Odious, abominable. Malignant, malevolent.

adjective

The emotion of dislike or passionate aversion. Hostility.

h

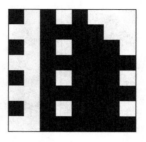

|hɔːnt| |hɔːntɪŋ|

The real shadows the imaginary.
The imaginary reflects memories of the actual.

verb [trans.]

To frequent a place or person. To be about much. To be persistently present. For a spectre or apparition to appear in a particular place. To persist in the mind or imagination. To cast a gloomy pall over a person's thoughts.

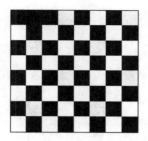

|hav|

*From truly evenly spread information
a difference coalesces, becoming the first object, the first thing.*

verb [trans.]

To own, hold, control. To undergo, endure, experience. To be obliged to. To demonstrate. To place or keep. (SEE ▓ |had|.)

h

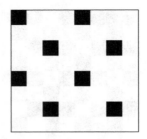

|hiː| |hɪm| |hɪz| |ʃiː| |hə:| |hə:ˈsɛlf| |hɪmˈsɛlf|

One of a number of truly separate actors.

pronoun [third-person sing.]

The man or woman that was named before. The man, the woman. The person. Man or male being. Woman or female being. Referring to the subject previously mentioned as the subject of the clause. A particular person.

possessive adjective

Belonging to the individual previously identified. Associated with or thought of in conjunction with the subject of the clause male, female, not neuter.

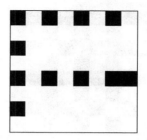

|ˈhɛdlʌɪn|

noun

The first line of a newspaper, magazine, or pronouncement. The title of an article. The most important item of news. The succinct revelation of developments.

h

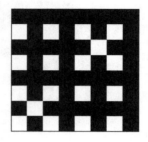

|hɪə| |hɪəz| |hə:d| |ˈlɪs(ə)n| |ˈlɪs(ə)nd| |əʊvəˈhɪə|

Two skins pulled tight across drums.
In the space between them the world.

verb [trans. & intrans.]

To enjoy the sense by which sounds are perceived. To harken. To be told, to be accounted to. To perceive solely by the ear. To allow another to speak. To attend, obey. To be aware of, informed. To pay attention to. To pay heed to a sound or commotion. To wait for a sound to appear. To look for meaning in the words of others.

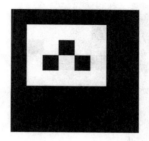

|hɑːt| |ˈhɑːti|

The hollow at the centre.

noun

The hollow muscle whose contractions force blood to circulate in the passages and corridors of the body. The vital part, that which animates. The interior, most important part. The seat of the emotions, amour, courage, and irrationality. A person's true character. Courage. Spirit. Affection. Memory. Zeal. The secret thoughts withheld from others. Passion itself. Life.

adjective

Loud, vigorous, healthy. Sincere, warm. Zealous. Vigorous. Strong, hard, durable. In full health.

| ˈhiːlɪə(ʊ)ˈtrəʊpɪk |

adjective

Of plants that bend or turn to face the sun wherever he may be in the sky. Of plants that grow under the influence of daylight. (SEE |muːn| |sɪˈliːnitrɒfɪk|.)

|hɛl|

*Deep inside the core of the earth and
deep inside the fearful psyche of living beings.*

noun

The place where the Devil and unfortunate souls reside. The realm of evil and of suffering. A very hot place of perpetual fires or an icy wasteland. The place of pagan souls, good and bad. The separation of death. The infernal powers themselves. The underworld. Damnation. The repose of shades.

|hɛlm| |ˈhɛlmɪt|

noun

The head. A covering of the head in war. The head of government. The rudder of a ship, boat, or vessel. The till, wheel, and other mechanisms use to direct a ship. The position of control of movement, of direction into the future.

|hɛlp| |əˈsɪst|

verb [trans.]

To aid or bring succour. To promote. To allow or facilitate a thing. To improve a situation or quality. To support another in a task or undertaking. To provide resources.

h

|hɪə| |ðɛː|

A place is only defined by not being another.

adverb

In this place. In this present state. To this present location. Indicating a thing close by. Indicating an occasion about to or already occurring. In that place. In that state. To that location. Indicating places removed from this one. Indicating possible occasions in the future, conditional or probable.

| ˈhəːmɪt |

*The recluses, deliberately wandering away
from the fold of three, seeking the stars
and wonders hidden by the proximity of others.*

noun

A solitary, an anchorite. One who retires from society for a life of contemplation and religious discipline. A disciple of prayer. One beheld to the spirits of the open airs, forests, and caves.

| ˈhɛːtsəˈgˈʌnɒrətʃ |

A dot of civilization in a forest of dangerous savagery.

noun

A small community in southern Germany in central Europe. It is the famed birthplace of inventor | ˈadɪ ˈdɑːs(ə)lə |. Home to many industries including metallurgy, rubber, sporting goods, aboriginal paintings, and primitive objects.

|hʌɪd| |hʌɪdz| |ˈhɪd(ə)n| |əbˈskjʊə|

To place one thing around another.
The material that lies between the prey and the hunter.

verb [trans. & intrans.]

To conceal, withhold, or withdraw from sight or knowledge. To keep out of view. To prevent a thing from being known. To make unclear or difficult to understand. To place in the dark or shadows. To make abstruse. To make unobservable.

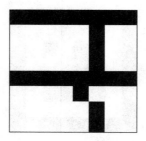

|hʌɪ| |tɒp| |hʌɪɪst| |ʌnsə'pɑːst| |'hʌɪt(ə)n| |hʌɪt|
|klʌɪm| |klʌɪmd| |tɔːl| |tɔːlɪst|

adjective

Long upwards. Up from the surface. Elevated, raised aloft. Exalted in nature. Of great rank or position. Greater than normal. Of an intoxicated or psychotropic trance. Not equalled in achievement or qualities. Of great or more than average elevation.

verb [trans. & intrans.]

To make more intense. To make more elevated. To ascend. To grow in scale, value, or importance.

noun

Altitude. Summit. Measurement from ground to upmost extremity. The apotheosis. The apogee.

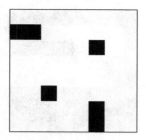

|hɪnt| |hɪntz| |hɪntɪd|

verb [intrans.]

To bring to mind by allusion. To suggest indirectly. To glance at in conversation. To communicate with the aid of raised eyebrows.

h

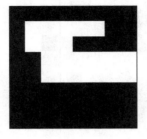

|həʊl| |həʊlz| |pɪt| |dɪˈprɛʃ(ə)n|

A cyst of the earth. The void inside solidity.

noun

A cavity or narrow perforation. A cave or natural orifice. A habitation for hermits, rabbits, and other creatures. An aperture. A burrow. An abyss, profundity. A grave. A large opening in the ground. A mine or quarry. An indentation in a surface. A reduction in a surface. A sunken place.

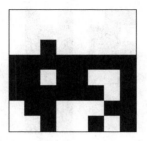

|ˈhɒmɪdʒ|

noun

Service paid to another. Tribute to a lord or superior. Obeisance. Honour, respect. A public acknowledgement of worth and recognition.

h

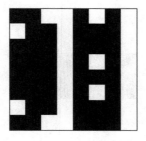

|həˈrʌɪz(ə)n|

The infinitely receding curve of a sphere reveals
far-off figures and places bathed in shimmering inexactitude.

noun

The line of vision. The limit of perception. The place where the sky
meets the earth. The lateral junction in the landscape.

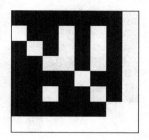

|hɒt| |hiːt|

adjective

The excited state of matter. Exuding thermal energy. Of a high temperature. Passionate, bawdy, licentious. Ardent, vehement. Piquant. Fiery.

noun

The sensation of burning. Contact with or effects of flame. Intensity of temperature or emotion.

h

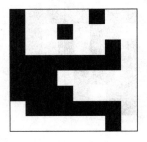

|həʊˈtɛl|

noun

An inn. A place of repose for travellers. A grand building in a town. An accommodation for visitors and those passing through.

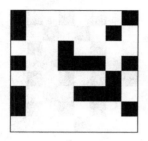

|'aʊə| |'aʊəz|

noun

The twenty-fourth part of the day. Sixty minutes. A particular point in the day. The time indicated by a clock or counting device. A period of time utilised for a particular purpose.

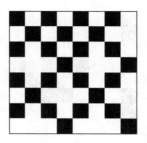

|haʊ|

The great interrogator.

adverb

In what manner. To what degree. By what means. For what reason, cause. In what state.

|hjuːdʒ| |lɑːdʒ| |ɪnˈkriːs| |vɑːst| |lɑːdʒɪst|
|ɪˈnɔːməs| |sʌɪˈkləʊpɪən| |bɪg| |ˈdʒʌɪənt|

The recumbent Brobdingnagian appears to be
a simple feature of the landscape to our errant traveller.

adjective

Immense. Terrible in proportion. Bulky, extensive. Copious. Of great quantity and extents. Of masonry fashioned from massive irregular blocks. Above the ordinary size, esp. of men.

'h

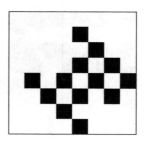

|ˈhjuːmənɔɪd|

Appearing like a true being.

adjective

Having the appearance or qualities of a person.

noun

A being resembling a human, esp. in ancient mythology.

|hjʊˈmɪdɪti|

noun

The quality of moisture. The nature of vapour (esp. water) contained in the air. The condensing quality of water in air. Moisture in the atmosphere. The ability to make wet.

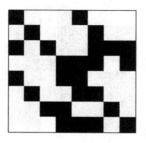

|ˈhjuːməz|

noun [pl.]

The various liquids found in man, namely blood, phlegm, choler, and melancholy. The moods and mind of men as expressed through the imbalance of these fluids. The temperament and general mental state of a person. The character of a person at a given occasion. Present disposition. Peevishness, whim, caprice.

|ˈhʌndrəd|

A number thought especially holy by some
as being the square of the digits of the hands.

cardinal number

The product of ten times ten. The number used as the basis of percentile calculations. A company of men of said number.

|hʌɪˈdrɔːlɪks|

Great pressures held under the hand of man.

adjective

Related to the science of liquids held in pressure within pipes and systems. The great powers of machines and mechanisms utilising pressurized substances. All fields related to closed water systems.

|hʌɪˈpɒθɪk(ə)riz|

noun [pl.]

Merchants and tradesmen specialising in loans and liens based upon assets given as collateral. Lenders of moneys based upon nonpossession of debtors' property.

$$|ΛI|$$

The possessor of Thought.
He who brings reality into existence by witnessing it.
The reason for ⸪ |ðə|.

pronoun

The first person. Myself. Me. The origin of the subject. The object that reflects upon its own existence. The ego. The universe come to wonder upon its own origin.

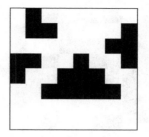

|ʌɪs| |ʌɪsi|

noun

The crystallisation of water. Water or other spirits made hard and brittle by extreme cold. Frozen liquid. Transparent crystalline solid. Solid water that falls from the sky in hailstones.

Λ

|ʌɪˈdɪə| |fɪˈlɒsəfi| |ʌɪˈdɪəl|

The soft nervous tissue forms complex delusions
as to what occurs outside of its warm walls.

noun

What the mind perceives outside of itself. A form that appears to the mind. A thought or suggestion. A plan of action. A concept or mental impression. An opinion or belief. Aim or purpose. Knowledge, natural or moral. Reasoning, argumentation. Love of wisdom. System of thought based upon interrogation of thinking itself. Engagement with the nature of reality, existence. The theoretical basis of all sciences. A theory or attitude held by some.

adjective

Mental, not perceived by the senses. Satisfying a concept of perfection. Attainable only in the imagination and not in the world of disappointments.

|ˈʌɪd(ə)l| |ˈleɪzi|

adjective

Averse to labour, effort, strain. Not busy. Sluggish. Unwilling to work. Constantly at leisure. Useless, vain. Barren, ineffectual. Unproductive. Trifling.

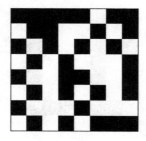

|ɪˈmadʒɪn| |ɪˈmadʒɪnd| |ɪˈmadʒɪnətɪv|

verb [trans.]

To form a mental image. To paint in the mind. To fancy. To scheme, contrive. To suppose, assume. To believe a thing, real or fanciful.

adjective

Full or creativity, inventiveness, wishful notions. Formed from delusion.

|ɪˈmakjʊlət| |kliːn| |ˈpəːfɪkt|

adjective

Spotless, pure, unsullied. Undefiled. Free from dirt. Free from moral impurity. Not foul or leprous. Having all desired qualities, requirements, or characteristics. Complete, consummate, finished. Not defective. Blameless.

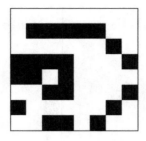

|ɪmˈpɑːt| |ɪmˈpɑːtɪd|

To throw a stone in a pond and warn with the resulting wave.

verb [trans.]

To make information known. To grant, give. To communicate. To give informations through means of transmission.

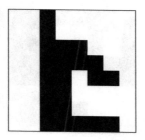

|ɪmˈpɑːsəb(ə)l|

adjective

Not allowing passage. Impervious. Blocking the motions of persons and things. Triumphing against intention.

|ɪmˈprɛʃ(ə)n| |ɪndɛnˈteɪʃ(ə)n|

A liquid poured over a form hardens to reveal the inverse shape.

noun

The pressing of one body upon another. A mark or stamp. A mark made upon the mind. An image imprinted upon the consciousness. An imitation of physical mean, characteristics, or qualities. A recess or depression formed in a surface.

|ɪn| |ˈɪntʊ| |ɪnˈsʌɪd| |wɪðˈɪn| |bɪˈtwiːn|

preposition, adverb & adjective

Located by the confines of a place. Engaged to any affair. Of entrance to a place. Motion towards the centre of a limited form. Being enclosed. Being part of a period of time. Of time before a future event. Experiencing a state or condition. Of occupation. Of an object or person at home or being part of a desired area. Across the space separating two objects. Separating two periods of time. Indicating a connection between parties or individuals. Along the space between two objects.

noun

Part of a set. Interior to an object or situation. Part of a region not near the exterior or edge.

|ɪnˈdiːd|

adverb

In reality, verity. To be truthful. To introduce a further and stronger point. To emphasise statement of description. To emphasise qualities previously indicated. Expressing incredulity.

|ˈɪndɪə| |ˈɪndɪənz| |ˈɪndɪə|

noun

The land of the river. The country and nations found in the sub-continent south of the Himalyan mountains. One of the most populous nations of the earth. A great source of spices and riches, it was coveted by American traders who, seeking a faster route than the traditional passage over the Pacific, inadvertently discovered Europe. Mistakenly thinking that they had arrived at their destination they referred to the European natives that they encountered as |ˈɪndɪənz|.

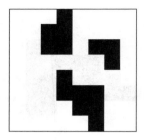

|ˈɪndəˈniːzɪə| |sʊmˈbɑːwə|

noun

The group of islands forming the Malay Archipelago. A country governing many disparate islands. Also an island situated in the lesser Sunda group between Lombok and Flores.

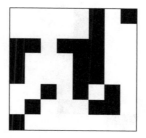

|ɪnˈdʌktɪz|

noun [pl.]

Those brought in. Those admitted into a society or sect. Those enlisted in a gang or faction. Those brought into a body of knowledge derived from Hermes Trismegistus.

|ˈɪndəstri| |ɪnˈdʌstrɪəl|

*The artifice of man forms regular objects,
littering the world with geometrical idols.*

noun

Diligence, productivity. Economic activity associated with large-scale production of goods in artisanal workshops or factories. Mechanical or machine-aided craftsmanship.

adjective

Related to designed or mechanised societies. Of production methods using fuels, metallurgy, chemistry, or mechanical aids.

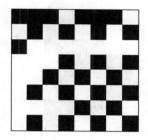

|ɪˈnɛvɪtəb(ə)l| |ɪnˈɛvədəbli|

adjective & adverb

Inescapable, certain to happen. Unavoidable. Predictable.

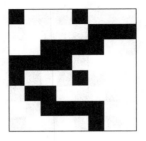

|ɪnˈfəːnəʊ|

The conflagration of flames becomes more than the sum of its parts.
Quickly the entire world is consumed and laid waste.
From the ashes of past earths life springs again, born anew.

noun

A large fire lacking control or end. Hell, the abode of the damned.

|ˈɪnfɪnɪt| |ˈɪnfənətli|

*A conception of man designed to draw him into the abyss
of the incomprehensible, the irrational, and the shores of insanity.*

adjective & adverb

Limitless. Endless in space, number, size, minuteness, or other quality. Unbounded immensity. Of abstract propositioning. Of a polygon having one side. The circle. An action repeating in upon itself. The snake eating its own tail. The principle deity.

|ˈɪnfluəns|

Separated by the great distances of space, the minute particles nonetheless exert a mysterious attraction on one another.

noun

The capacity for one thing to have an effect upon another. The power of celestial aspects, stars, and spirits of heaven to effect terrestrial goings on. The capacity or power to effect change on others through indirect or insidious means.

|ɪnˈhabɪt(ə)nts| |ɪnˈhabɪted|
|ɪnˈhabɪˈteɪʃən| |ˈdwɛlɪŋ|

noun

Those that live in a place. The occupiers of buildings, villages, set-tlements. A place populated by persons. Place of residence, abode.

verb [trans.]

To live in or occupy an environment.

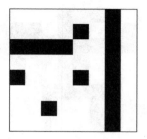

|ɪˈnɪʃɪeɪt| |ɪˈnɪʃɪeɪtɪd|

Floating souls are waiting to enter into the closed society.

verb [trans.]

To instruct into the arts. To have join a society. To bring in through sacred rites. To admit into a privileged group.

|ɪŋk| |ˈɪŋki|

*The blackness is only visible when it glances back
the barest reflections of light upon its surface.*

noun

The black liquor with which men write. A coloured liquid used for
scriving and drawing.

adjective

Pertaining to, as dark as, stained like the drawing liquid.

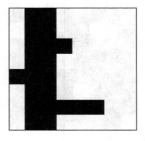

|ˈɪnlənd|

adjective & adverb

Lying in the interior, middle part. Away from the sea. Remote from the coast.

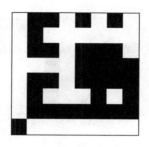

|ɪn|

noun

A place of repose for travellers. A humble building in a town. An accommodation for visitors and those passing through. Dwelling place providing food, drinks and victuals to journeymen.

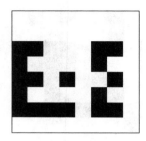

|ˈɪnəs(ə)nt| |ˈɪnəsəns|

Unaware of the advances and intentions of those behind them.

adjective

Pure from mischief. Free from guilt. Unhurtful.

noun

Purity from maleficity. Untainted integrity. Harmlessness. The uninjurious. Simple of heart. The naïve. Unknowing of the intent of others.

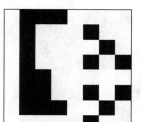

|ɪnˈsɪst(ə)ns|

noun

The fact or quality of demanding something forcefully, not accepting refusal.

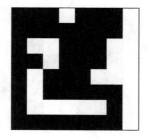

|ɪnˈtɛnt| |ɪnˈtɛnd| |ɪnˈtɛndɪd| |ɪnˈtɛntli|

One form approaches another,
its desires evinced by its mutated shape.

noun

Purpose. Design. A view formed. Meaning.

adjective & adverb

Fixed with close attention. Anxiously diligent. Determined. Resolved to act a certain way.

verb [trans.]

To pay attention to. To design, to make plans for. To purpose. To destine a thing for a cause. To desire a thing and effectuate a method to acquire it.

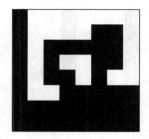

|ˈint(ə)rist| |ˈint(ə)ristid| |ˈint(ə)ristiŋ|

The darkness searches in the light. The rays illuminate the shadows.

noun

Concern. Influence over others. An advantage for a person. The state of wanting to know or learn about things. A stake or share in an undertaking.

verb [trans.] & adjective

Exciting curiosity. Holding or catching the attention.

|ɪnˈtɪəːrɪə|

adjective

Situated within. Belonging to the inside of a place or person. Remote from the exterior, outside, sea, frontier. Existing in the soul or psyche. Further in than others.

|ˈɪntəˈdʒɛkt|

A disruption of the conversation.

verb [trans.]

To interrupt by saying something abruptly. To seize the mind or flow of conversation. To interjaculate.

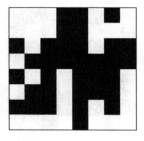

|ɪnˈtəːmɪnəb(ə)l|

adjective

Endless, without limit, boundless.

|ɪntəˈtwʌɪn|

*The parallel line eventually traverses the whole universe
and comes upon itself at a curious angle.*

verb [trans.]

To twist together. To entangle, to knot. To bring in close union.

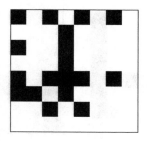

|ɪntə'viːn| |ɪntə'viːnɪŋ|

verb [intrans.]

To come between persons or things. To oppose action or persons. To prevent the course of events. To interfere with the will of deities, fate, and history. To interrupt. To intercede.

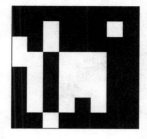

|ˈɪntɪmət| |ˈɪn(t)əmətli|

adjective & adverb

Inmost, inward. Near, not kept at a distance. Familiar, closely acquainted. Indicating amorous relations. Private, personal, not public. Detailed, thorough. Closely observed.

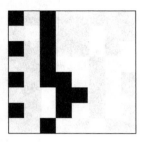

|ɪnˈtɒksɪkeɪtʃ(ə)n|

*Organic chemical chains form indentations
in the fabric of an individual's perception.
(SEE 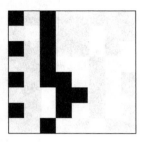 |ˈalkəhɒl|.)*

noun

Inebriation. The act of making or state of making drunk. The influence of a drug, psychotrope, poison, or other toxin on the mind. The trance effectuated in various societies as a means to pass through temporarily into the spirit world.

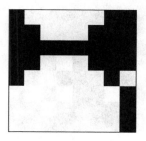

|ˈɪntrə(ʊ)vəːtɪd| |ʃʌɪ|

adjective

Reserved, not familiar. Cautious, wary. Keeping at a distance. Inwardly looking. Turned to face the inside. Examining constantly one's own thoughts.

|ˈʌɪən|

The sword of metal spills the blood of metal,
leaving a rusty red stain on its flank.

noun

A strong, hard element generated in the decay of stars. A malleable metal when heated to great temperatures. It is used in the alloy |stiːl|. The metal that rusts most easily, it is attracted to lode-stones. It is distributed fairly evenly in all lands and nations but resides in greatest quantities at the centre of the earth, where it provides stability and gravity to the proceedings upon the surface. Compounds of this metal are found in the blood of men, hence giving the sanguine liquid its noted metallic taste.

|ɪz| |ɑr| |am|

That which exists.
That which is conceived.
That brought into being through cognition.
(SEE *|biː|.)*

verb [trans. & intrans.]

To be. To exist. To have or to take place in the world of fact. To have or to take place in the world of fiction. To occur, exist, happen. To enter or remain in existence.

verb [auxiliary]

Used to form continuous tenses, to form the passive mood, or to indicate something due to happen.

|ʌɪsə'leɪʃ(ə)n|

To be human is to be in relation with other human beings.
Solitude brings a person to become something other than man.

noun

The action or state of standing alone. Being separated from other beings or things. Being extrapolated from a context or milieu. Being naked to the gaze as a tree whose brethren have all been felled.

VOWELS

a	madness, cat, ran
eɪ	ray, day
ɛː	dare, fair, there
ɑː	father, calm
ɑː	harm
ɛ	let, head
iː	flee, see
ɪ	pit, city
ʌɪ	lie, by, my
ɪə	pier, near, here
ɒ	shot, not, wasp
əʊ	toe, no
ɔː	caught, paw, war
ɔɪ	noise, boy
ʊ	took, put
ʊə	tour
uː	boot
aʊ	out, now
ʌ	cut, run, enough
əː	urge, term, firm, word, heard, bird
ə	item, edible
juː	pupil

CONSONANTS

tʃ	<u>ch</u>ur<u>ch</u>
h	<u>h</u>orror
w	<u>w</u>hich
dʒ	ju<u>dg</u>e
k	ro<u>ck</u>
l	<u>l</u>ove
ŋ	thi<u>ng</u>
r	<u>r</u>oar
ʃ	<u>sh</u>ip, wi<u>sh</u>, ra<u>t</u>ion
θ	<u>th</u>in, <u>th</u>ought, benea<u>th</u>
ð	<u>th</u>is, <u>th</u>y
j	<u>y</u>outhful
ʒ	vi<u>s</u>ion, plea<u>s</u>ure

|ɪt| |ɪts| |ɪtˈsɛlf|

pronoun [third-person sing.]

Refers to a thing previously discussed. Identifies a person, object, state. Identifies a subject in a sentence. Used in the subject or object position in tandem with other subjects. General circumstances. What is required. Used reflexively to refer to a thing previously mentioned. Used for emphasis of a quality of a thing previously related.

possessive adjective

Belonging to or associated with a thing previously related. Belonging to or related to a creature, being, or thing without sexual distinction.

d

|dʒɒgɪŋ| |dʒɒg|

To push against the will of gravity repeatedly. A daily ritual.

verb [trans. & intrans.]

To make small sudden movements. To jar. To move oneself in small shocks or interruptions. To trot. To exercise by running without purpose. To move for the sake of movement.

noun

The calisthenic ritual opposed to gravity. The expenditure of effort for health and pleasure.

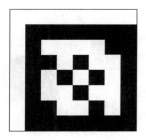

|ˈdʒəːn(ə)l| |bʊk| |ˈmanjʊskrɪpt| |peɪdʒ|
|ˈpeɪpəz|

The enclosure of pure thought into material prison.
A way to communicate with the still-living.

noun

A daily account. A diary or account of events. A volume in which we read or write or do both. A register of information in written characters either scribed by hand with pen, ink, pencil, stylus or with a press or printing mechanism. In our age information is more commonly translated onto wax tablets, parchments, wood, stones, rock or encoded into mnemonic systems such as knots, pixels, or notches. (SEE 📇 |ˈkəʊdɛks|.) A handwritten communiqué. A leaf or thin sheet of wood pulp or fibrous material bound in a hard covering. The material, surface, or canvas upon which writers scatter thoughts.

d

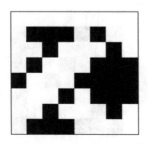

|dʒʌst|

adverb

Exactly, nicely, accurately. Merely, barely. Nearly. Simply, no more than.

|kiːp| |kɛpt| |kiːpɪŋ| |həʊld| |hɛld| |klɪŋ| |klʌŋ|
|ˈkari| |ˈkarid| |ˈkariɪŋ| |ˈtɛnjə| |bɔːn| |klʌtʃ|

verb [trans. & intrans.]

To retain, not to lose. To have in custody. To protect, guard. To preserve in a state of security. To not let go. To detain. To reserve, conceal. To tend. To preserve in the same state. To continue a state or action. To carry on. To retain by force, clever arguments, or subterfuge. To practice. To copy carefully. To observe, not violate. To maintain. To not reveal, betray. To restrain. To grasp in the hand, grip. To ascertain goodness. To maintain argument or position. To have a station. To possess. To stop. To suspend. To celebrate, solemnize, offer propose. To be dependant on. To hang on, twine around, hold fast to. To carry from a place. To transport. To take, to have about one. To convey by force. To effect a thing. To win through competition. To bear through, to prevail. To have, obtain. To support, esp. weight. To endure difficulty, to give birth to a child. To grasp or seize tightly. To hold in the hands, paws, or talons.

|ˈkɪləˈmiːtə|

noun

A unit of measurement. Length or movement upon a single axis. Equivalant to three thousand two hundred and eighty point eighty nine feet or five-eighths of a mile. The sum of one thousand metres.

507 |kiːp|

noun

The condition under which lands, buildings, or property are occupied. The period in which an office or station is possessed. A tight grasp or act of gripping. A power or control, esp. cruel or inescapable.

|nɒk| |nɒkt| |nɒkɪŋ|

The frappe of one object upon another causes vibrations to ripple through the immediate environment.

verb [trans. & intrans.]

To clash, to be brought together suddenly. To dash together. To effect a blow. To strike suddenly. To collide with a person or thing, creating a forceful impact. To effect change through a blow or violence. To create a sign or demand entrance through a beat. To create a noise through the resonance of a struck object.

noun

A blow or impact. The sound of a blow. A short noise made to attract attention or gain admittance.

|nɒt| |nɒtz| |nɒtɪd|

noun

A complication of string, cord or line not easily disentangled. A figure in which lines entangle, twine, or wrap around themselves. A bond of union. A powerful force of resistance effectuated through the tricky manipulation of simple line geometry.

verb

To fasten by manipulating lines, ropes, strings, or other one-dimensional creatures. To record information in mnemonic systems.

nəʊ		nəʊn		ˈnɒlɪdʒ		əˈwɛː		ˈrɪəlʌɪzd
rɪˈpɔːts		ɪkˈspɪərɪəns		əˈkweɪnt		ˈwɪzdəm		
ɪkˈspɪərɪənsiz		ʌndəˈstandɪŋ		ɪnfəˈmeɪʃ(ə)n				
ˈmɛʒəɪd		kɒmprɪˈhɛnd						

*One of the three cardinal signs from which many other
symbols are derived. The path traversing all realms.*
(SEE |θɪŋk|; |ˈapəsteɪt|; |meɪk|;
|ˈsanɪˈtɛːrɪəm|; |ˈskɒlə|; |strʌɪp|;
|ˈɛnəmi|; |ˈtɛm(p)tə|; |ˈtrɛtʃ(ə)rəs|; |kənˈfɛʃ(ə)n|;
|dɪˈmɛnʃ(ə)nz|; |ˈfrʌntɪəzmən|; |rɪˈfəː|; |priːhɪˈstɒrɪk|.)

noun

Illumination of the mind. The divine thought imbued in the consciousness of man. Sentient being. The highest degree of speculation, the affirmation of that which is true and that which is false. Fact, skill, education. Learning, cognisance. The categorisation, taxonomy, and apprehension of the Realm of the Canny. Accounts,

popular rumour. Official documents. Relayed details. Physical contact or direct observation of real events, objects, peoples, trances, auguries, or dreams. An impression on the mind reinforced by multiple exposures. Sapience. The power or faculty to judge rightly. To ability to relay correct particulars or behave in a judicious way. Practical in the ways of life. Intelligence given, instruction. Actuation. Meaning.

verb [trans. & intrans.]

To have awareness through observation or relayed communications. To hold truths, falsehoods, and categories in the mind. To have a relationship with a field of inquiry. To be vigilant, attentive to. To become fully sapient of a fact. To allow or create the conditions for things to happen. To give physical or actual form to ideas, pure speculations, designs, conceits. To encounter or undergo events, trials, observations with places or states of being. To be made familiar with. To inform. To conceive the actuality of something. To perceive the intended meaning or words, language, books, dictionaries. To discover proportion, extents, lengths, volumes, weights, temperatures, or other quantifiable parameters. To quantify, allot, decree, give over quantities of substance. To apply mathematical abstract principles to the geometry of the earth and all things that cling to it. To calculate, account, reckon. To grasp mentally. To encompass, include, comprise things real or abstract. To conceive. To hold in the mind. To encode in electrical, biological, chemical, nuclear, or gravitational language.

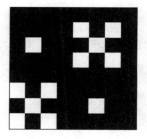

|ˈlab(ə)rəˈt(ə)ri|

noun

A chemist's workroom. A room furnished for experiential or scientific experiments. A place for the manufacture of artificial substances. The atelier for the scientist. The alchemist's den. The place where the universe is prodded and poked.

|'ladə| |'ladəz| |rʌŋ|

noun

A frame of two upright pieces with steps or bars upon which a man may ascend. A device to be climbed. The horizontal support of a foot hanging in space. A crosspiece of a climbing device.

|ˈlandɪŋ|

noun

The top of the stairs. The corridor at the top of a house. The place of arrival from a journey by water, air, or stairs. The disembarkation point.

l

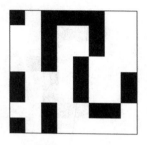

|laʃ| |laʃt|

The violent whip scatters forms that flee before it.

verb [trans. & intrans.]

To strike with a pliant thing. To whip or hit with a stick. To suddenly move a part of the body, quickly and violently. To twitch a limb into the air.

|lɑːst| |səˈvʌɪv| |səˈvʌɪvd| |səˈvʌɪvəz| |pəˈsɪst|

One of the three cardinal signs from which many other symbols are derived. The being threatened by nothingness and oblivion.

(SEE <image> |ˈnʌmbə|; <image> |ˈstatjuː|; <image> |stɑːz|; <image> |strɒŋ|; <image> |ˈjuːnɪvəːs|; <image> |ˈabstrakt|; <image> |ˈsəːk(ə)l|; <image> |ˈtʃɒk(ə)lət|; <image> |ˈkriːtʃə|; <image> |ˈdɔːtə|; <image> |dʌŋ|; <image> |ɪˈvɛnt|; <image> |ˈfɪgə|; <image> |ˈfʌmʌɪt|; <image> |fuːl|; <image> |greɪv|; <image> |gruːp|; <image> |hɑːd|; <image> |heɪt|; <image> |hɑːt|; <image> |muːn|.)

noun

adjective & noun

Final. Latest. Hindmost. Beyond which there is no more. Next before the present. Utmost. Those who exist after others. Those who remain. Those who are able to withstand adversity. Those who have yet to perish.

verb [intrans.]

To exist for a period of time. To not come to a conclusion. To

l

function properly, not decay, be destroyed. To survive, endure. To continue to exist. To live after the death of another. To continue to exist after the perishing of another thing. To remain alive. To continue to function or be in a state despite threatening conditions. To continue firmly or obstinately regardless of adversity. To fail to be extinguished.

|'lātər| |leɪt| |'leɪtɪst| |'riːs(ə)nt|

The depiction of a linear timeline.
Above the constant.
Below the memory of pasts,
the projected future and a dot of fleeting present.

adjective & adverb

Performing an action or occurring after the expected or proper time. Taking place near the end of a particular period of time. Coming after an even longer interval than the proper time. Subsequent to a period. Most recent. Coming closest to the present. Having developed at a date close to the one in question. New, not long in existence. Fresh. Not antique. Not yet decayed.

|ˈlatɪnʌɪz| |ˈlatɪnʌɪzd|

verb [trans.]

To translate into Latin. To give a name or word a Latin character.

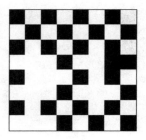

|ˈlatə|

adjective

Happening nearer to the end of something than the beginning. Occurring after a previously specified episode or thing. The second of two things mentioned.

| 'latɪs |

The pure line crossed and twined into structure.
Form depicted by interval.
The frail human homage to the ☐ |grɪd|.

noun

A structure made from strips of wood, metal, or cloth crossed and fastened together to form a two-dimensional surface. A penetrable surface. A fragile crystalline structure.

|lɑːf| |ˈlɑːftə| |lɑːft|

verb [intrans.]

To make a noise of sudden merriment. To contort one's face and exhale or cough with amusement. To cry out with delight. To be tickled by humour and fancy. To make a derisory gesture through noise. To ridicule or scorn. To find the universe worthy of irreverence. To find poetry in absurdity.

noun

The sound of inarticulate merriment. The guttural appreciation of humour. A visceral pleasure of an intellectual origin.

|liːp| |sprɪŋ| |sprɪŋɪŋ|

verb [intrans.]

To jump, move upwards. To rush with vehemence. To bound, fly. To start. To move suddenly upwards. To move quickly from a confined or concealed location. To arise from the ground, grow by vegetative power. To come into existence. To appear suddenly. To arrive from a force. To be born into the world.

|liːst| |lɛs| |dɪˈmɪnɪʃ| |dɪˈmɪnɪʃɪŋ|

adjective & pronoun

Comparative of little. Opposed to greater. Smaller in number or quality. Not as much. The smallest in number, significance, or quality. In the lowest degree. Below all other degrees.

adverb

To a smaller extent. The very smallest extent.

verb [trans & intrans.]

To make smaller through destruction or attrition of parts. To impair, lessen, degrade. To cause to become reduced.

l

|liːv| |lɛft| |liːvɪŋ| |wɪðˈdrɔː| |wɪðˈdrɔːdruː|
|kwɪt| |dɪsˈtʃɑːdʒ|

verb [trans. & intrans.]

To forsake, abandon. To depart. To go away. To leave a place permanently. To allow to remain. To suffer. To remain. To bequeath. To let go. To remove or take away from a place. To take back. To call away. To flow out of a confined place. To bleed or ooze from an orifice. To put out, push out. To expel.

|lɪə|

verb [intrans.]

To look obliquely. To look with a strange countenance. To gaze in an unpleasant, evil, or lascivious manner.

| ˈlɛdʒ(ə)nd |

noun

A chronicle or ancient story. The story of a saint's life. An incredible inauthentic tale. A traditional narrative widely related within a culture.

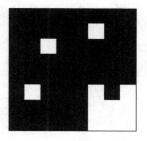

|lʌɪ| |lʌɪz| |leɪd| |sɪt| |sɪtɪŋ| |leɪɪŋ| |ˈlʌɪɪŋ|

A being on its back gazing at the heavens.

verb [trans. & intrans.]

To rest in a horizontal position. To recline or repose at a great an-
gle. To lean upon. To rest in a grave. To be dead. To be fixed. To
reside. To place along. To put, place down carefully. To put down in
position for use. To rest upon the buttocks. To perch. To ride upon
a conveyance, esp. a horse. To rest a weight or burden. To remain
in a particular position. To house a body of people or legislature.
To be placed at dinner. To be in a state of idleness.

1

|lʌɪf| |əˈlʌɪv| |lʌɪvz| |lɪvɪŋ| |ˈfɔːnə|

The utter brilliance of the light illuminates and yet blinds.
One of the two duelling signs.

noun

The organic flesh inhabited by the soul. The state of knowing existence. The activity of organic systems. Objects and things able to reproduce, grow, thrive, and be extinguished. The aspect of peoples' existence. The existence of human beings, animals, and plants. The animals of a region or time. The realm of the moving creatures, not plants. Blood. Manner of existence. Conduct. The general state of man.

adjective

Of a person not dead. Of a thing undestroyed, unextingushed, active.

verb [intrans.]

To remain in animated existence. To spend one's days in a place.

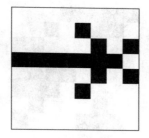

|lʌɪt| |lʌɪtz| |ɪˈl(j)uːmɪˈneɪʃ(ə)n|

A particle that is also a wave.
The wave that exhibits the properties of a particle.

noun

The electromagnetic radiation perceived by organs receptive to the visual. The action and medium by which we see. A force that scatters over the environment and returns through the orifice of the iris. That which the sun produces and the moon reflects. Devices such as candles, flares, torches, and stars by whose projections we navigate the world. Revelation through divine communication. Revelation through electromagnetic information.

530 ☐ |lʌɪf|

To exist in the mind, literature, song, art. To inhabit an area. (ANTONYM ■ |dɛθ|.)

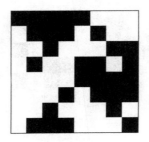

|lʌɪk| |ˈsɪmɪlə| |kʌɪnd| |ˈsɪŋkrənʌɪzʃ(ə)n|
|ˈnɔːm(ə)l| |nɔːm| |ˈtɪpɪk(ə)l|

preposition

Having the same characteristics or qualities. Equal to. Resembling. Analogous. In the manner of. In an appropriate way. To ask about the qualities or characteristics of a thing, place or person. Such as. For example.

noun

A group having shared characteristics, name, or origins. Character, nature. The usual, average conditions.

adjective

Homogenous. Having one part like the other. Having the resemblance of without being exactly the same. Benevolent, filled with goodwill. Beneficent. Conforming to a standard. Usual, expected. Emblematic. Having the distinctive features of a person or thing.

|lɪmp| |lɪmpɪŋ|

The crooked man walks a crooked path.

verb [intrans.]

To walk lamely. To ambulate with difficulty, esp. due to a damaged limb. A stiff gait. To proceed with difficulty.

532 |lʌɪk|

verb [trans.]

To make happen at the same time. To have occur or operate together.

l

|lʌɪn| |lʌɪnz|

One of the three cardinal signs from which
many other symbols are derived.
(SEE ▮▮ |'adɪ|; 🔢 |tʃeɪn(d)ʒ|; ┏ |'karəktə|; ▮ |'dɑːs(ə)lə|;
┠ |fɔːdʒ|; ☐ |grɪd|; ▮▮ |lɒŋ|; ▮ |nʌɪt|; ▮ |'paʊə|;
⌐ |'latɪs|; ⊞ |'strʌktʃə|.)*

noun

Longitudinal extension. A straight or curved extension with length but no breadth. A one-dimensional being. A slender string. A narrow mark or band. A contour. A furrow or wrinkle. An extension, limit, boundary. A row of characters, numbers, or letters. A row of persons. A point moving continuously along a direction. The pure basis of geometry.

verb [trans.]

To place in intervals along a sequence. To create striations, stripes, or bands. To mark with three parallel stripes.

534

|lɪps|

Two fleshy protuberances that fashion noise into meaning.

noun

The edge of anything. The edge of a container or hollow vessel. The muscles that protude beyond the teeth. The fleshy protuberances around the mouth used to manipulate objects, food, and words.

|ˈlɪkwɪd| |ˈwɔːtə| |ˈwɔːtəz| |pʊə| |pʊəd| |ˈmɔɪstʃə|

noun

Malleable substance, liquor. A material substance in which the particles move freely over each other but do not separate as in a gas. One of the four principal elements. An odourless, tasteless, transparent substance that lakes, streams and oceans are filled with. That which rains upon nature and men's heads. The fluid of life. The compound of hydrogen and oxygen. That which many chemicals are dissolved into. The basic form of ice, snow, steam, and vapour.

adjective

Fluid, not solid. Flowing freely but of constant volume. Small particles of fluid diffused in the air or condensed on a surface.

verb [trans. & intrans.]

To make a fluid move or flow rapidly. To move a fluid from one place to another in a stream. To allow gravity to carry a liquid towards a lower point.

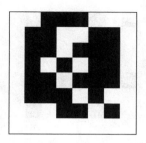

|'lɪtə| |'lɪtəd|

verb [trans.]

To bring things out. To cover with things negligently. To scatter objects over a surface or in an environment. To cover with straw or bedding.

'l

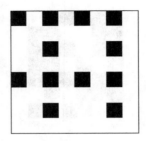

|ˈlɪt(ə)l| |smɔːl| |slʌɪtɪst| |slʌɪt| |skɛːs| |skɛːsti|
|briːf| |ˈhɑːdli| |ˈtʌɪni|

adjective & pronoun

Miniature, reduced in size. Younger than. In a lesser degree than
something else. Not a large amount. Not great. Diminutive. Not
much, not many. Slender. Minute. Petty. Worthless. Inconsiderable.
Weak, contemptible. Not plentiful. Rare, not common. Concise in
expression. Contracted, narrow. Of short duration. Puny. Insuffi-
cient for demand.

adverb

Not to a large extent, reduced. With difficulty, not easily. Merely,
with not much more.

noun

Want.

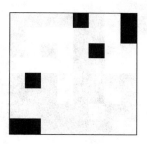

|ˈlʌɪvli|

adjective

Brisk, vivacious, vigorous. Representing life. Strong, energetic. Full of energy and force.

|ˈləʊk(ə)l| |ˈləʊk(ə)lz| |ɔːˈtɒkθənəs| |ˈprɪmɪtɪv| |ˈneɪtɪv| |ɪnˈdɪdʒɪnəs|

adjective

From the immediate region. Originating in the environs. Not descended from colonists or migrants. Aboriginal. Ancient, original, established from the beginning. Of an early stage of evolution or development. Postliterate, postindustrial, postinformation societies. Having a basic style or quality of life. Not developed or derived from other things. Produced by nature. Natural. Conferred by birth. Originally produced in a region.

noun

One born of an area. A dweller. An inhabitant of a place, not a visitor. One fruited from the soil as opposed to an allochthon.

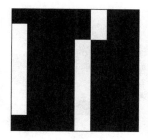

|lɒŋ| |lɛŋθ| |ˈlɒŋgə| |əˈlɒŋ| |ɛkˈstɛnd|

The description of one measurement as a greater or
smaller version of another measurement.
If the ruler measures the ruled, who rules the Ruler?

noun

The measurement of a thing from beginning to end or extents. The greatest line that can be drawn through a body. Horizontal extension. The connection between points in space. The duration of points in time. Reach of a thing.

adjective

Not short. Having a geometrical in greater degree than another. Reaching far along a single dimension. Of a greater extent than that previously mentioned.

preposition

Moving in a constant direction, path or horizontal surface. Making progress. Expanding in the horizontal plane. Becoming wider.

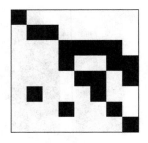

|luːs| |ˈluːs(ə)n| |ˈluːs(ə)nd|

Allowed to spill forth.

verb [trans.]

To untie, unbind. To make free. To release. To relax.

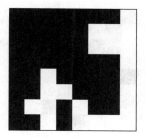

|lɔːd| |ˈmɑːstə| |ˈmɑːst(ə)ri|

noun

Monarch, ruler, governor. Supreme person. Deity. One who has power, influence, or authority. A nobleman, peer, or member of higher legislative body. One who has servants. A person who dominates. A young gentleman. An autotheist. A skilled and respected practitioner of a craft or art.

noun

Superiority. Preeminence. Domination, control. Attainment of power or skill. Comprehensive knowledge of a subject or field.

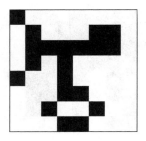

|luːz| |lɒst|

A person placing a thing down to not be found again.

verb [trans. & intrans.]

To forfeit in contest. Not to win. To be deprived of. To relinquish possession. To fail to gain or retain a thing. To be destroyed or killed. To be mislaid.

adjective

Unable to find one's way. Unable to locate one's position in the world. Unable to decide what to do next. Denoting a thing that is irrecoverable. A defeat.

|laʊd| |əˈlaʊd| |ˈrɔrɪŋ|

A voice from a mouse can make the heavens shake.

adjective

Noisy, striking the ear with great force. Capable of producing much sound.

adverb

Audible, not silent. With a strong voice. Not spoken only in the mind.

verb [intrans.]

To cry as a lion or other wild beast. To cry in distress. To make the sound of the sea, the crash of waves upon the shore, the wind tearing down the forest. To make a loud noise.

|ləʊ| |ˈləʊli|

adjective

Not in a high place. Near the ground. Closer to the bottom than to the top. Near the equator. Below the usual amount. Reduced in quantity. Of poor rank or stature. Of inferior, debased, or ribald character. Primitive, undeveloped.

|ˈlʌki|

adjective

Fortunate, happy. Bringing, resulting, or having favour from the fates. Blessed. Charmed.

|məˈʃiːn| |məˈʃiːnz| |ˌmakəˈnāshən|
|ˈɛndʒɪn| |ˈmɛt(ə)l|

noun

A complex piece of workmanship. Mechanical objects with moving parts. A military weapon. A generator of force or power. An agent, enabler. A mechanical contrivance applying power for a particular task. A man-made apparatus used to perform labours, fashion materials, carry loads, or construct yet more apparatuses. A supernatural intervention. A device used in theatre to convey the gods onto the stage whereby they may intervene in the plot. Plots, intrigues, and malicious schemes. Artifices, contrivances. A heavy and hard substance found in ores. The family of elements from which tools, armours, and weapons are fashioned. An opaque material, malleable, ductile, and conductive to electrical currents. That of which alloys are made. (SEE [img] |ˈʌɪən|; [img] |stiːl|.)

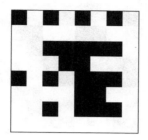

|mad| |ˈmadnɪs| |ˈmʌɪndlɪs| |ˈɪdɪəsi|
|ˈɪdɪət| |ʌnˈhɪn(d)ʒɪd|

noun

A perturbation of the faculties. A nausea of the psyche. The state of mental illness. Insanity. Fury, wildness, rage. Folly. Want of understanding. Extremely stupid behaviour. Having no intellectual powers. True naïveté. A fool, a changeling. A natural.

adjective

Inattentive, regardless. Acting without concern for the consequences. Acting with no reason or intent. Having lost cognition. Prone to flights of fancy. Behaving in a manner lower than an animal. Of an activity that requires no attention, mechanical, drudgeful.

verb [trans.]

Displaced by violence. Unbalanced. Mentally unstable. To speak as if one were dreaming. To skip from idea to idea as a poet. To talk of one's voyages on the astral plane to a disbelieving audience.

m

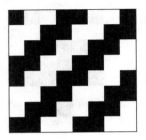

meɪd		meɪk		'meɪkə		gɒd		bɪld		'bɪldəz
'meɪkɪŋ		tuːl		tuːlz		prə'djuːs				
prə'djuːst		kriː'eɪt		kriː'eɪtɪd		kriː'eɪtə				
kriː'eɪʃ(ə)n		'ɪnstrʊm(ə)nt		bɪlt						
ˌfabrə'kāshənz		'dʒɛnəreɪt								

The undifferentiated mass drifts in the void.
Gradually tiny variations develop, atoms find themselves closer
to others. Patterns emerge. Later the patterns
come to worship the undifferentiated mass. They call it mother.

verb [trans.]

To form out of nothing. To cause to exist. To originate, form struc-
ture. To form of materials. To compose of materials or ingredi-
ents. To bring about by art, not through nature. To bring about by
the processes of nature, not man. To perform, practice. To cause to
have a quality. To bring about a state or condition. To form, settle.
To constitute. To amount to. To suffer, incur violence. To compel,

force. To gain. To display. To offer to the view. To place in public. To pay, give. To perform sexual acts. To bear, bring forth. To bring about offspring through carnal relations. To mold in an image. To cast and reproduce. To invent or concoct something typically with deceitful intentions. To cause, engender, beget. To propagate. To raise from the ground, to construct an edifice. To erect a house or nest. To construct by placing many parts together. To forge. To manufacture industrial goods.

noun

The Demiurge. A person who fashions, constructs, or manufactures something. One who propagates, engenders, brings out of nothing. The Supreme Being. The Engenderer of the Universe. A divinity. A deity. The principal deity believed by some to include all other divinities within. A mischievous spirit fond of arbitrary legislative codes. A superhuman person worshipped as having power over nature or the lives of men. The Trickster. Idol, graven image, icon, totem, talisman, fetish, juju. Architect, edificier. The agent of a thing. An object of manual operation. Mechanical implement for working upon something. A simple machine or engine. A weapon. The agent of performance. Something through which an action is done, accomplished, effected, esp. musical. A person commanded to do wretched or violent things. Said of a person commanded by a divinity to proselytize.

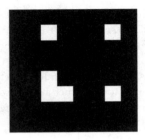

|ˈmagnɪt| |ˈmagnɪtɪz(ə)m| |ˈaθəˈneɪʃəs kɪəʃɛː|

In the dark heavy iron mass, a lone electron wanders free.

noun

The lodestone. A rock that attracts iron. A piece of iron, steel, or other alloys charged with the attractive property. A device that when freely suspended points along the north-south axis of the planet. The phenomenon of electrical charge in all matter that attracts and repulses. The properties of circulating electrons and their related charges. The phenomenon of drawing things in from a distance. A form of magic. 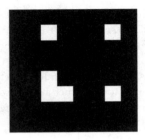 |ˈaθəˈneɪʃəs ˈkəːtʃə| (1601–1680 CE) German Jesuit scholar and scientist. Noted for his investigations into the molten core of the earth and theories of electrical attractions after which this science is named.

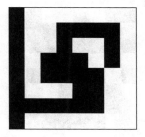

|ˈmagnɪtjuːd|

A pair of callipers that encompasses the world.

noun

Greatness, grandeur. Comparative size. The extent of something.
The degree of brightness of a star.

m

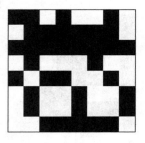

|meɪn| |ˈmeɪnli|

adjective

Principal, chief, leading. Leading in importance, size, or other qualities.

adverb

Chiefly, greatly. Principally. More than anything else. For the most part.

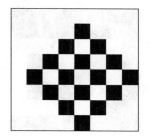

|man| |ˈdʒɛnt(ə)lmən| |ˈhjuːmən| |səː|
|ˈsɪtɪz(ə)n| |manˈkʌɪnd| |mɛn|

The filter of reality. The filter of abstraction.

noun

Homo sapiens. The bipedal primate of the family Hominidæ. Persons. The highest animals distinguished from the rest of the kingdom by the ability to reason abstractly. The only non-supernatural, mortal creatures capable of sentience, sapience, self-awareness, and consciousness. One able to exhibit superior mental development and articulate speech. These beings are the first manifestation of the Universe coming to reflect upon itself, its existence, and its own origins. A male person, not a woman. A male adult, not a boy. A servant or attendant. One of high birth or extraction though not noble. One raised above the vulgar through quality of character or learning. One who is chivalrous, courteous, or honourable. A word of respectful address. A title placed before the surname. The title of a knight or baronet. The collective noun of all persons. The kingdom of mortals. The nature of people.

|ˈmanɪfɛst| |ˈmanɪfɛstɪd|

Emerging from the primordial substance.

verb [trans. & intrans.]

To make plain, open, apparent. To display or show a quality, feeling, or concept. To be evidence of. To make public. To disclose. To make apparent.

adjective

That which is clear, obvious, disclosed, apparent.

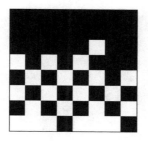

|ˈmanə| |stʌɪl| |kəmˈpɔːtm(ə)nt|
|dɪˈmiːnə| |klɑːsɪz|

The drift from pure possibility to concrete conventions.

noun

Form, method. Custom, habit. Certain degree. Sort kind. Cast of look, countenance. Character of mind. Particular way. Ceremonious behaviour. Studied civility. Approach to writing. Approach to speech. The point of a writing instrument used on wax or clay tablets. Approach to visual medium, i.e., sculpture, architecture, theatre, epic. Behaviour. Personal bearing, carriage, deportment. Outward conduct. Mode of proceeding. Conduct. The ranks or orders of persons. The social stratifications. A set of beings or things belonging to sets.

557

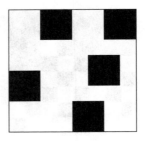

|ˈmɛni| |ˈmʌltɪp(ə)l| |ˈkɒmən|

The qualities of one held by others.
The tables in all their derivations united by the quality of tableness.

adjective & pronoun

Consisting of a great number. Numerous. Not a few. Of an indefinite number. Containing a number several times. Involving or having many parts, elements, or members. Belonging equally to more than one. Having no single owner. Vulgar, mean. Public. General. Having no rank or birth. Frequent, usual, ordinary.

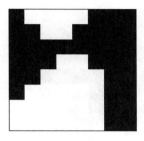

|ˈmasɪv| |ˈvɒljuːm|

adjective

Heavy, ponderous, bulky, continuous. Of a physical object having great mass. Impressively large. Solid. Intense or severe.

noun

Consisting of many things. Many things rolled into one. The amount of space that a form takes up in three dimensions. The extent of a thing in all directions. The amount of water displaced by a body placed in a bath.

m

|mɑːst|

noun

The Phallus of the Vessel. The primary mover.

noun

The beam or pole raised above a ship to which the sails are attached. Any structure carrying sails.

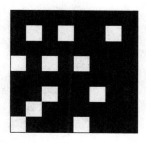

|mat|

The lustre of darkness.

adjective

Of a surface colour or paint that does not reflect. Dull. Absorbent of life. Unburnished.

m

|meɪ| |mʌɪt|

verb [modal]

To be at liberty, to permit, to allow. To be possible. To allow to occur. To occur by chance. Expressing desire. Expressing power.

|miː| |mʌɪ| |mʌɪˈsɛlf| |mʌɪn|

pronoun [first-person sing.]

The oblique case of I. Used by a speaker to refer to themself. (SEE |ʌɪ|.) Used reflexively by the speaker to refer to him or herself. When the speaker is the subject. Used to refer to a thing possessed by the speaker.

possessive adjective

Belonging to the speaker. To express surprise.

m

|miːl| |ˈdɪnə|

A number of chaises drawn up around one another.
The ritual of consumption.

noun

The act of eating at a certain time. The time or occasion when a reasonable portion of food is consumed. The principal occasion of eating usually in the middle of day or evening. A formal feast often in honour of a person or event.

|miːn| |ˈmiːnɪŋ|

verb [trans.]

To intend to convey, indicate, or refer to a thing, person, or notion.
To intend a thing to occur or be the case.

noun

Purpose, intention. The sense that a thing is understood. The
sense that was intended to be conveyed. The truth existing outside
of interpretation. The significance of a word, concept, action, or
work of art. The hidden significance of a text or image hidden to
the layman.

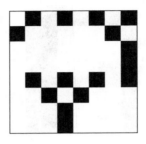

|ˈmɛdɪsɪn| |ˈdɒktə| |ˈmɛdɪk(ə)l| |fɪˈzɪʃ(ə)n|
|ˈmɛdɪsɪn| |mɪˈdɪsɪn(ə)l|

The holder of the staff intertwined with snakes.

noun

One that has taken the highest degrees in the professions of law, divinity, or physics. An academic of the sciences or arts. A learned man. A man skilled in any profession. A healer. A qualified practitioner in the science and arts of healing, the body, disease. A specialist in the diseases and malaises of men or animals. The science of healing. The plants, herbs, chemicals, or mystic charms used in healing.

adjective

Having the power of healing. Virtuous. Of substances, objects, persons having healing powers. Balancing the four natural humours.

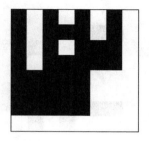

|miːt| |ˈmiːtɪŋ| |mɛt|

Two parties come face to face.

verb [trans. & intrans.]

To come face to face. To encounter. To encounter in hostility. To join another in the same place. To come into the presence of company. To make the acquaintance of one.

m

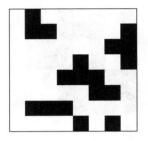

|mɛltɪd|

In the summer, the snow of the peaks wanders
through the rivers and down to the ocean.

verb [trans. & intrans.]

To dissolve. To make liquid by heat. To change a thing to a liquid condition from a solid. To break into pieces. To waste away. To slip from sight.

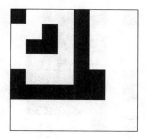

|ˈmɛmfɪs|

The pyramids in the crook of the great flowing river.

noun

An ancient city in America whose ruins are situated on the Mississippi River. It is the site of the ancient Pyramids and Sphinx. It is the burying place of many noblemen including The King. It is a noted river and airport serving as a communication node for many organisations including the Church. It is home to the palace and official residence of the Pope. It is the administrative centre of the Church from where all its Fedexmen and messengers originate.

|ˈməːkjʊri|

The dark mass floats disquietingly in the philosopher's palm.

noun

The ancient deity of skill, trading, thieving, heraldry. The messenger of the gods. The original Fedexman of the Supreme Being. The planet closest to the Sun. The element of quicksilver. A heavy white-silver metal that is liquid at ordinary temperatures and pressures. A powerful poison.

adjective

Sprightly qualities. Related to news.

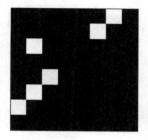

|ˈmɛsɪdʒ| |ˈmɛsɪn(d)ʒə|

The white square relays intentions across the gap.

noun

An errand. A thing to be told to another. A communiqué. A verbal, written, or encoded communication to be given to a person directly or using an atmospheric medium. A piece of information intended to convince. An augur. A harbinger. A relayer of information. A servant who carries documents from one party to another. A Fedexman. (SEE 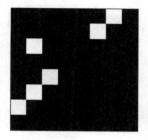 |fɛdɛksmən|.)

m

|mɛtəˈfɪzɪks| |mɛtəˈfɪzɪk(ə)l|

noun & adjective

Ontology. The doctrine of substances. The philosophy of the nature of being. The science and speculations of abstraction. That which inquires into the barrier between physicality, actuality, reality and language, dream, mathematical reasoning. That which is discussed after a discourse on physics. The true inquiry.

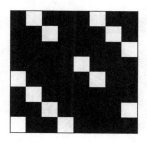

|ˈmɛθəd| |mɛθəˈdɒlədʒi|

A channel carved in the mind in which knowledge accumulates.
(SEE 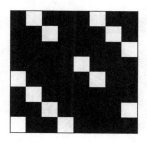 |ˈnɒlɪdʒ|.)

noun

The way in which things are placed. A procedure to accomplish or cause certain things. A systematic approach. A set of ideas of principles governing study, activity, or learning of a skill, craft, art, science, or philosophy.

m

|mʌɪl| |mʌɪlɪz|

The distance between many steps.

noun

A measurement of roads or linear distances equal to five thousand two hundred and eighty feet or one point six zero nine kilometres. A thousand paces.

|ˈmɪnɪt|

noun [pl.]

The passage of time measured by the vibrations of the atoms. The vibrations of the atom regulating the speed of events. The sixtieth part of an hour. The sum of sixty seconds. A small portion of time. A sixtieth of a degree of angular measurement. The method of calculation by which the life drains away.

|ˈmɪrə| |ˈmɪrəz| |rɪˈflɛkʃ(ə)ns| |rɛplɪˈkeɪʃ(ə)n|

The sun shines back from the ocean bathing the eye in brilliance.

noun

A looking glass. A thing that exhibits representations of objects by casting back the image. A thing that gives a true depiction of another. A metal or glass amalgam that glances images of the world back. The throwing back of light. An idea thrown back upon the mind. The action of copying or reproducing something. An object that has been duplicated. A transcript from the archetype or original.

|ˈmɪkstʃə| |meɪˈlɒ̃ʒ| |ˈpəʊʃ(ə)n| |ˈmɪŋg(ə)lid|

The powder swirls in the crystal goblet.

noun

A substance formed by the folding and remuage of materials. A liquid combined with other liquids. The combination of qualities, things, elements, or emotions existing as a new whole and still identifiable by their individual characteristics. The random distribution of one substance throughout another. A draught. A medley. A liquid imbibed for its healing, magical, or poisonous qualities.

verb [trans. & intrans.]

To cause substances to be blended together. To move about freely within another place, substance, or environment.

577

|ˈmɒd(ə)n| |ˈmɒd(ə)nz| |kənˈtɛmp(ə)r(ər)i|
|ˈmɒd(ə)nɪz(ə)m|

In ancient times the peoples of the earth worshipped the present.
They erected great temples formed from square planes
and utilising the monstrous angle of 90°. They coveted the latest styles
of clothing, food, poetry, and painting. They rejected all
that was not new, novel, or of the moment.

adjective

Coëtaneous, living in the same age. Born at the same time. Dying
at the same time. Occurring in the same period. Belonging to or
occurring in the present. Late, recent, not ancient or antique. Of or
relating to present times. Characterised by the use of up-to-date
methods, techniques, materials, ideas, instruments. Of a trend,
style, cultural tradition that departs from or is differentiated from
past cultural norms.

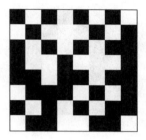

|ˈmɒdjʊleɪt|

verb [trans.]

To form a sound bound to certain keys. To vary the strength or nature of a tone, voice, instrument, characteristic. To vary the amplitude or frequency of a waveform.

▪ |ˈmɒd(ə)n|

noun

Those who have lived recently as opposed to the ancients. Deviation from the ancient or classical norms. Those who worship the ever, fleeting present. An acolyte of Now.

m

|məʊld| |məʊldz|

The hands cup the water into a shape.
A sculpture that lives for a moment hidden inside the
palms before it drains back into the world.

verb [trans.]

To form, shape, model. To influence the development of events or persons. To create a vessel to pour a cast from.

ˈməʊm(ə)nt		ˈməʊm(ə)ntz		əˈkeɪʒ(ə)n		
əˈkeɪʒ(ə)nz		ˈhap(ə)n		ˈhap(ə)nd		ˈɪnst(ə)nt
ˈɪnst(ə)nsz		ɪˈmiːdɪət		ˈɪnsɪd(ə)nt		

*An endless series of presents chained together
and dragged inexorably into the future.*

noun

The briefest period of time that a human can experience. A short period of time to which a measurement has not been applied. An incident, causality, occurrence, opportunity. An example of a single occurrence. Something that takes place as part of a causal chain of events and yet constitutes no essential part. An event of subordinate character. A trivial event.

adjective

Pressing. Without any intermediate time, present.

581

m

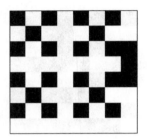

|muːd| |ˈsɛntɪm(ə)nt|

noun

A style of music. The temporary state of mind or feelings of a man or animal. Anger, irritability, rage. Current disposition. The atmosphere pervading a work of culture. A thought, notion, opinion. A personal experience. One's own feelings. A view or attitude toward a situation.

581 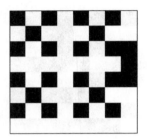 |ˈməʊm(ə)nt|

verb [intrans.]

To come to pass. To occur. To occur solely by chance. To betide, befall.

|muːn| |ˈmuːnʃʌɪn| |ˈsatəlʌɪt| |sɪˈliːnitrɒfɪk|

noun

The luminary of the night. A celestial object. A planet in orbit of the earth. A planet in orbit of any large body or planet. The regulator of the months, the fluctuation of the ocean, and the moods of men. The cause of madness. An engine orbiting a body collecting information or relaying communications. Something on the periphery or controlled by another force. The light of the sun reflected from the earth's neighbour that illuminates the night. A magical substance, principal ingredient of potions.

adjective

Of plants that bend or turn to face the luminary of the night wherever she may be in the sky. Of plants that grow under the influence of the celestial being.

|ˈmunləs|

adjective

Without the illumination of the luminary of the sky. Said of nights in which the celestial being is fully phased or that the earth is draped in clouds.

$$|\text{'mɔːnɪŋ}|$$

The time during which the sun drives back the forces
of darkness so that he may reign until he in turn is frightened
away by the approaching cold of the night.

noun

The period of time from the first light until the sun is past the
first quarter of the day. In ancient times the period from midnight
until noon.

|'mɔːt(ə)l| |'mɔːt(ə)lz|

*The soul departs its temporary habitation, leaving
no trace of its influence.*

adjective

Subject to death. Doomed to die. Deadly, destructive, procuring death. Bringing death. Belonging to men and other perishable beings. Violent.

noun

A man. A human being. One destined to die in contrast to certain deities, spirits, avatars, saints, supernatural entities. A person whose infamy will not last long. A poor poet or mediocre artist.

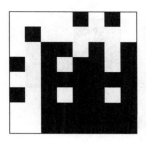

|məʊst| |məʊstlɪ| |mɔː|

adjective & pronoun

Consisting of the greatest number, quality. The majority. A large number. In comparison to a smaller number.

adverb

The greater part or number of a group or thing.

|ˈmʌðə|

The origin of the world.

noun

A woman who has created a child. The bearer of a son or daughter. That which has produced any thing. The void that nurtures a conscious being. A creator of universes. (SEE |ˈmeɪkə|.) That which preceded in time. That which deserves reverence and obedience.

|ˈmaʊntɪn| |ˈmaʊntɪnz| |hɪlz|
|ˈprɒm(ə)nt(ə)ri| |hɪl| |ˈjʊərəl| |ˈjʊərəlz|

The summit of the world is the closest place to the elder deities.
Some nights they descend into this dimension and dance forbidden steps
on the roof of the world.

noun

A vast protuberance of the earth. A mound of rock, earth, and stone reaching beyond the clouds. A large, steep elevation of the earth's surface. A moderate elevation of the ground usually without permanent snow cover and able to support vegetation. A bank or heap of material. A headland, cape, large body of land jutting out over water. A large crag jutting out over air or empty space. A range of peaks in northern Russia extending a thousand miles from the Arctic Ocean to the Aral Sea. The conventional boundary between Europe and Asia. In ancient times, the edge of the world.

m

|maʊθ| |maʊðz|

noun

The aperture of an animal at which food is received. The opening in the lower part of a human face framed by lips. The opening through which anything enters, the entrance. The device through which vessels are emptied or filled. An entrance to a hollow thing such as a cave or bottle. The access point to a river or other passage. The swallower of ships. (SEE |ˈwɔːlpuːl|.)

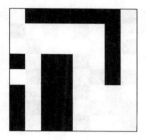

|muːv| |muːvd| |muːvɪŋ| |ˈsəːkjʊleɪt|
|ˈmuːvm(ə)nt|

*Acceleration and asymmetry cause gravitational
ripples that reverberate around the universe.*

verb [trans. & intrans.]

To put from one place to another. To put into motion. To change position. To have, change position. To make progress, proceed in a particular direction. To give an impulse to. To propose. To prevail upon the mind. To cause to change from one state to another. To affect, to touch the emotions. To distort the static state. To bring about all change. To move continuously or freely in a closed system. To motion in a round path that comes upon itself.

noun

Motion. The act of changing physical location or position. The act of being in many places at the same time. Being located in probability and not certainty.

m

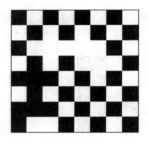

|mʌtʃ|

adjective & pronoun

Large in quantity, time. Great in number. A large amount. More than enough. An assignable quantity or degree.

adverb

To a great extent, a great deal.

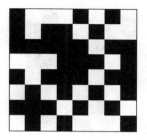

|ˈmʌdi| |mʌd| |dəːt| |greɪ| |smʌdʒ|
|mɪsrɪˈmɛmbə| |ʌnˈklɪə| |smɪəɪd| |striːkɪŋ|

noun

The uliginous matter. A soft mixture of earth and water. Filth. Ordure. Mire. Anything that sticks to the body. Unclean matter. A worthless thing. Poor land. Soil.

adjective

Discoloured and made cloudy by earth. Dull and unclean. Confused, vague, illogical. Opaque, difficult to see through. Difficult to comprehend. Not distinct, obscure, dark. Of the colour white tainted with black. White or hoary with age. The colour of ashes. The colour of cloudy skies. The colour of mist.

verb [trans.]

To smirch, stain, or discolour. To rub out, distort, or corrupt information, marks, or letters. To recall incorrectly or imperfectly. To

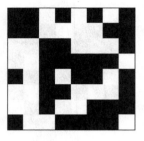

|mʌnˈdeɪn| |bəˈnɑːl|

adjective

Belonging to the world. Not platonic. Secular, not of the church. Ordinary, commonplace. Prosaic, dull, humdrum. Of compulsory feudal service. Open the use of all. Commonplace, trite, trivial, petty. Lacking in originality, boring.

593 |ˈmʌdi|

allow memories to blur and dull. To overspread with something viscous and adhesive. To soil, contaminate. To cover with long thin lines of a different colour. To blemish with long marks. To stain with filth.

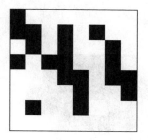

|ˈməːmə|

verb [reporting]

To communicate by making a humming, repetitive noise. To say something in a low indistinct voice. To express discontent, dissent, or anger in subdued tones. To grumble. To rumour.

|mjuːˈzɪəm|

*When men die their bodies are returned to the earth whence
they came in graves, pyres, and plots. When objects die they are encased
in a mausoleum of glass and velvet in which wafts of dry ice
protect them from decay. They lie there between life and death for æons.
When the cities are sacked and the temples burned, only then
will these artefacts truly perish and their parts be allowed to drift back
into the earth from which they were originally begotten.*

noun

A repository of learned curiosities. A temple to the Muses. A build-
ing dedicated to the pursuit of learning. A historical institution
preserving artefacts, works of art, scientific instruments, corpses,
and other important objects.

|mʌst| |ˈnɛsəs(ə)ri|

The parts or action required to complete the clear line.

verb [modal]

To be obliged, should. Expressing insistence. Expressing the belief that something is logical or that the future will turn out a certain way.

adjective

That which is needed. Indispensable, vital, essential. Required by the laws of nature. That which is predestined. Inevitable.

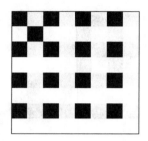

|ˈmʌtə| |ˈmʌtəd| |ˈʌtə| |ˈʌtəd| |ˈədərli|

The barest specification of meaning.

adjective & adverb

Extreme, excessive, utmost. Complete, absolute. Irrevocable. Placed far from the centre. Placed where the compass has no point, the abyss.

verb [trans.]

To disperse. To put forth. To issue currency. To speak, pronounce, express. To send forth, to shoot out. To give audible voice. To give expression to one's hidden thoughts. To speak in a low voice. To make barely inaudible speech with the lips nearly closed. To murmur.

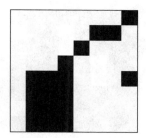

|'mɪrɪəd| |ʌn'kaʊntəb(ə)l| |ɪ'njuːm(ə)rəb(ə)l| |tɛn 'θaʊz(ə)nd|

The unquantifiable mass of people. A great army of souls.

noun

A hundred times a hundred. A sum that cannot be quantified. A figure only calculable by machine. Proverbially any great number.

adjective

Beyond the reckoning of man. Too numerous to be reckoned. Hypothetically impossible to determine by tally. Impossible to enumerate.

m

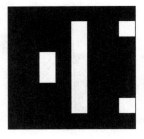

|ˈmɪst(ə)ri| |mɪˈstɪərɪəz|

*That which lies behind any wall excites the curiosity of man
such that he may not rest until he knows what there exists.*

noun

Something above human intelligence. Something awfully obscure.
Something that one should not seek out. An enigma. Something
devilish. A religious truth revealed by divine communication. A
rite or sacred ritual of an ancient cult or religion. A secret held by
a supernatural entity. The laws and mechanisms of magic. Forbid-
den knowledge.

adjective

Hidden, secret. Obscure. Difficult to understand. Involving secret
meanings. Enigmatic. Deliberately confusing.

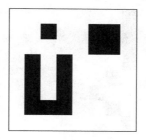

|neɪm|

A square of understanding stoppers the chaos of nature by giving it an appellation. Hence disarray becomes grass, sky, rabbit, and justice.

noun

The discriminative appellation of an individual. The term by which a species is distinguished. Person. Reputation, fame, celebrity, eminence, renown. Assumed character or identity. Power.

verb [trans.]

To identify by appellation. To classify and distinguish. To give meaning by imposing language upon an object, person, or notion. To place within a set. To give a position, title, or occupation.

n

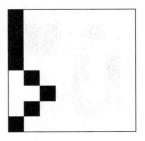

|nɑːˈkɒtɪk|

Pushing the membrane of reality into another space,
through the thinning barrier we feel the questing touches of other beings.
(SEE ▐▌ |ɪnˈtɒksɪkeɪtʃ(ə)n|.)

noun

A drug or other chemical compound affecting mood or behaviour.
A substance that produces torpor or stupefaction. A transcendent
medicine that cures the dreamer and allows him to wake into the
higher reality beyond the illusory material plane.

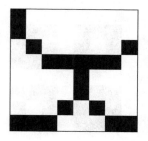

|ˈnɔːsɪə| |ɪlnɪs|

noun

A feeling of sickness with the inclination to vomit, esp. seasickness. Disgust, loathing, aversion. Abhorrence. A uniquely disturbing sensation dissimilar to pain. A disease of the ear, balance. A feeling that the world does not reckon with the senses. A disease or sickness affecting the body or mind. Malady. Disorder of the health.

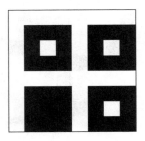

|navɪˈɡeɪʃ(ə)n| |ˈnavɪɡeɪt|

*To move through the world one must take reckoning of where
one has been and where one intends to go. Upon the land this is aided
by the sight of landmarks such as trees, rivers, and mountains.
Upon the sea, one must trust in the whims of the divine beings that light
up the night sky with the sickly luminescence of their bodies.*

noun

The action of passing over water. A voyage by sea or water. A voyage
by air or in the voids of the cosmos. A voyage through the abyss.
The art of computing location. The science of calculating routes
and passages.

verb [trans. & intrans.]

To sail. To pass by water. To direct a course or action using instru-
ments or maps. To guide or instruct others along a path. To make
a passage over a terrain or sea.

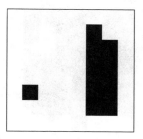

|'nɪəli| |'ɔːlməʊst|

Close to completion yet still not absolute.

adverb

Very close to, at no great distance. Closely. Not quite. Well nigh. In the next degree to the whole, the absolute, perfection.

n

|nɛˈkrəʊsɪs| |ˈmɔːbɪd|

The tidal disruption of the dead passing close to the world of the living.

adjective

Relating to the pathology of dead tissues. Of dead flesh residing in a living being. Of the death of nearly all cells, tissues, organs in a live human being. Diseased. Of an unhealthy interest in disturbing or unpleasant subjects. Of obsession with death, disease, and the fragility of the corpse.

|niːd| |rɪˈkwʌɪə| |riˈlaɪənt|

The final parts to complete the square.

verb [trans. & intrans.]

To want for something. To lack. To be necessary. To have necessity for. To depend on for success or survival. To cause to be necessary. To command or request. To desire to do something. To ask, command.

adjective

Depending on or trusting in another or of the fates.

'n

|ˈneɪbə|

noun

One who lives near to another. One familiar with another. Anything next to or near. Intimate or confidant. A person close to the speaker. (SEE |ˈdʒɔːmən|.)

|ˈnɛs(ə)| |ˈnɛs(ə)d| |ɪnˈvɛləpɪŋ| |ɪnˈkləʊzd|

To be brought under the wing.

verb [trans. & intrans.]

To settle, harbour, lie close. To be as a bird in her nest. To lie within or against something. To wrap up, cover, or surround completely. To enwrap, cover, hide, conceal. To place inside. To part from things by a fence. To protect within a barrier. To encircle, encompass.

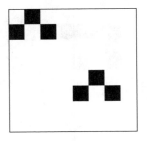

|njuː| |njuːɪst| |njuːlɪ| |ˈn(j)unəs|

A second bloom replaces the withered flower.

adjective & noun

Not old, fresh. Lately produced, novel. First invented, original. Of present times, modern. Not antiquated. That which had not previously existed. That which differs from the past. Brought into existence for the first time. Not repeated or copied. In an original condition, not decayed, used, or corrupted. Experienced now for the first time. A fresh original growth, bloom. Beginning, better than before. Replacing the former, esp. character. A method, idea, practice, science, or art that supersedes or revolutionises through modern, progressive, advanced qualities.

adverb

Recently. Again, afresh.

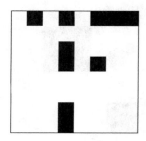

|nɛkst|

The chain of causation. From this current step to the succeeding.

adjective

Nearest in place, following in sequence. Immediately after the time of speaking. Immediately after the present in time and space. Neighbouring.

adverb

At the time or occasion immediately succeeding.

n

|nʌɪs| |gʊd| |əˈɡriːəb(ə)l| |ˈhapi| |ɡlad| |ɛndʒɔɪ|
|fʌɪn| |ˈvəːtjʊəs| |ˈsplɛndɪd| |dɪˈstɪŋɡwɪʃ|

adjective

Not evil, not maleficious. Morally sound. Having medicinal prop-
erties. Having desirable qualities. In accordance with the divine
will. Accurate in judgment to minute exactness or subtle. Easily
blurred or distorted. Thin, sharp, intricate, exquisite. Fastidious.
Refined. Of high quality. Scrupulous. Pleasant, satisfactory. En-
joyable. Feeling or showing pleasure or contentment. In a state
of felicity. Having desirable physical characteristics. Proper, fit,
convenient. Uncorrupted. Wholesome, salubrious. Filling. Useful.
Legal, valid. Elegant, delicate. Prosperous. Lucky, fortunate. Fortui-
tous, occurring by happenstance. Skillful, dexterous. Cheerful, gay.
In a state of hilarity. Elevated with joy. Of a considerable amount,
rich. Kind, benevolent. Favourable, loving. Magnificent, very
impressive. Recognisable as different, superior. Eminent, tran-
scendent, extraordinary.

|nʌɪt| |əʊvəˈnʌɪt|

*The natural state of the universe. The void, the cold
blackness that frightens away the sun every evening.*

noun

The time of darkness. From sunset till sunrise. The period of time
in which the earth receives no light from the sun. The period in
which a part of the earth rotates away from the sun to face the
extent of space. The nocturnal era. The time of the day that men
retreat to caves, houses, and tents to avoid the maddening light of
the moon.

adjective & adverb

Of or concerning activities occurring from evening till morning.
Quickly, suddenly.

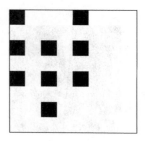

|nʌɪn|

A holy number derived from the very holiest Three multiplied Thrice.

cardinal number

The number of squares across plus one. One more than eight. One less than ten. The sign of a man who has lost a digit. Of the Muses that number in this amount. Of the avatars or incarnations of a cat. A common number of lives. Of the number of classical planets. Of the material holders of gravity, captors, prisons of physical matter in the solar system.

613 █ |nʌɪt|

verb [trans.]

To feel or perceive with pleasure. To take delight. To obtain the fruition of or completion of a work, opportunity, thing, or person.

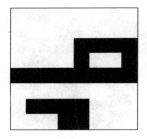

|ˈnʌɪnti|

The symbol of topography.
The ability to distend space and time into forbidden dimensions.

cardinal number

Nine times ten. One more than eighty nine. A unitary perfect number. The angle of a right angled triangle. Called a right angle. Called the Modern Number. The angle necessary to deviate a vector from one dimension into another. In certain cultures a symbol of transcendent evil, maleficity. An indicator of the fragile state of men's bodies and souls.

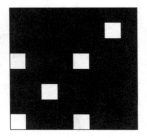

nəʊ		nɔː		ʌnˈlʌɪkli		ˈnɛvə		ˈabs(ə)ns
ˈsʌɪləns		ˈsʌɪlənt		dɪsəˈpɪəɪŋ		ˈwɒz(ə)nt		
dəʊnt		ˈdɪd(ə)nt						

The Great Negator.

interjection

To give a negative response. Emphatic denial, indignation.

adverb

The word of refusal. The word of denial, opposite to confirmation.
The particle of negation. To suggest the opposite of a word is true.
Extinguished. Expressing disbelief. Disbelieving the possibility of
an occurrence in past, present, future, or alternative histories.

adjective

None, having none. To indicate the opposite of what is specified.
Hardly, little. To forbid or reject something. Improbable, unable

616

to be reasonably expected. Lacking the accompaniment of sound, noise, disturbance.

noun

Want of appearance. Inattention, heedlessness. Want of presence. The state of tranquillity. Habitual taciturnity. Stillness, lack of noise.

verb [trans. & intrans.]

Ceasing to be visible. Causing to be lost, missing. Coming to perish, die, be destroyed. To lose or lack actuality in the world of fact. To cease to occur, exist, or happen. To enter or remain in fiction. (ANTONYM ▦ |ɪz|.) To stop motion. To remove from action. To be unable to perform a task, work, command, purpose. To cease to behave, emote, cogitate, or communicate in a given manner.

n

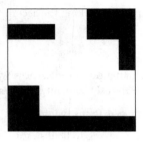

|nə(ʊ)ˈbɪlɪti|

The dignity of the living supported by the glory of their ancestors below.

noun

The antique splendour of family. Rank or dignity. Persons who are exalted above the commons. The patrician class. Those exalted through birth.

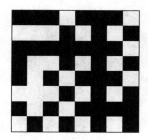

|ˈnamənl| |ˈnamənəli|

adjective & adverb

Referring to names not things. Not real, titular. Of a noun, or nouns.
Existing in name, logic, category but not in physical essence.

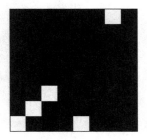

|nʌn| |ˈnʌθɪŋ| |ˈnəʊbədi| |ə(ʊ)ˈmɪt|

The empty set. From whence we came and to where we go. The unimaginable. The antithesis of reality. It exists inevitably as a subset or counterpart to reality. If there is no reality then it cannot exist either.

{ }

pronoun, adjective & adverb

Not one, not any, not others. No persons, beings, creatures. Of no number. Not anything, not single. No person, no one.

noun

Nihility, nonexistence. No value. A person of no standing, authority, importance.

verb [trans.]

To leave out, not mention. To neglect to practice or fail to do.

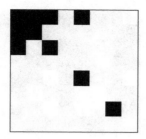

|nɔːθ| |ˈnɔːð(ə)n|

Moving toward the top of the world.
Upon reaching our destination we find ourselves at the top
and yet also concurrently at the bottom.

noun

The point opposite the sun in the meridian. The direction of the right hand of a person facing the rising sun. In European tradition equated with the right direction. The direction that a lodestone or magnetised needle faces when suspended freely. The point around which the stars rotate in the night sky.

adjective

Lying toward, near, or being part of the left side of a region, person, building. Denoting the inhabitants, culture, and customs of the peoples of the right side.

n

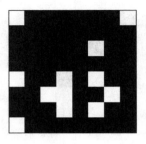

|nəʊt| |ˈnəʊtɪd|

verb [trans.]

To observe, remark, heed. To record, remember, or mark for recall.

adjective

Famous. Particularly observed, marked. Widely known. Notorious.

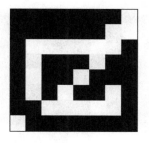

|ˈnəʊtɪs| |ˈnəʊtɪst|

The fix of attention upon knowledge.
(SEE 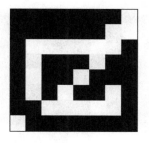 *|ˈnɒlɪdʒ|.)*

verb [trans. & intrans.]

To remark, heed, observe. To become aware of. To enter into the consciousness an abstract or more usually physical fact. To place into the mind realization.

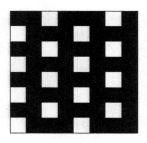

|naʊ| |ˈkʌr(ə)nt| |ɔːlˈrɛdi|

The vibrations of the atoms held perfectly still. The instant.

adverb, conjunction & noun

At the present time or moment. In the present circumstances, in view of what has happened. To stress immediacy or urgency. At the time of speaking. As a consequence of the fact. Before or by the time in question. Surprisingly soon.

adjective

Fashionable, contemporary. Circulating at this moment. Common, general. Popular.

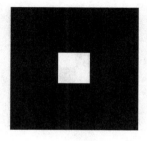

|ˈnʌmbə|

*The disciples of Pythagoras believe that every object in the world
is made up solely of mathematical information.
At the very heart of matter, at the centre of the smallest particle
there is only probability, likelihood.*

noun

The species of quantity whereby it is computed how many. An aggregate of units, objects, persons, abstract values. The quantity or amount. A word, symbol, or character that graphically represents a mathematical value, real or imaginary. An arithmetical entity or value. Many, more than one. An amount. A value to indicate position in a series.

ə

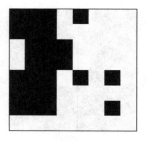

|ə(ʊ)'beɪ| |ə(ʊ)'bed|

The smaller squares are held in thrall to the authority's will.

verb [trans. & intrans.]

To pay submission, comply to a command. To revere authority. To follow directions, requests. To perform an instruction. To behave to a general principle, natural law.

|ˈɒbdʒɪkt| |θɪŋ| |ˈɛntɪti| |ˈɛntɪtiz|

The pearl that is distinct from the oyster.

noun

The existence of any being. The essential nature of a manifestation having a distinct and independent existence. That which the mind and faculties engage with. An article placed before the eyes or other senses. An item limited by scale or other quality capable of being perceived, thought of, known, imagined. An external manifestation. A material manifestation that exists long enough for a human to perceive. A physical article capable of being possessed. A goal, purpose. A person or artefact upon which action, thought, or feeling is being directed. A matter with which one is concerned. An article that one cannot or does not want to name directly. Inanimate material beings as opposed to living or sentient beings. An action, thought, utterance. Circumstances, conditions.

|əˈblɪvɪən|

The memory drifts in time off the edge of the real.

noun

Forgetfulness, cessation of remembrance. The state of having been forgotten by all beings. To lose existence in the minds of others.

|əbˈsɛnɪtiz|

noun [pl.]

Impure thoughts or words. Unchaste or lewd communications. Offensive expressions, works of literature, paintings, musical harmonies, or wood-grain patterns. A thing being horrible or morally repugnant.

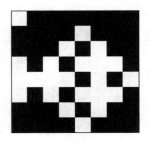

|əbˈzəːvə|

The mind's eye of the beholder.

noun

A person hypothetical or actual who perceives phenomena. One who looks vigilantly. A person who watches or notices. An interpreter of omen. An augur. A spectator. A member of the audience. One who contemplates a statue. An adherent or follower of a law, religion, custom, method, or artistic school.

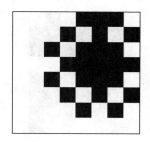

|ˈɒkʌlt|

The black hole hidden in a mote of dust dancing in the sunlight.

adjective

Secret, unknown, hidden, obscure. Known only to the initiated. Relating to magic, alchemy, astrology, theosophy, or other mysterious arts. Not apprehensible by the mind. Beyond the ken of laymen. Abstruse. Of a property not able to be directly observed. Of the supernatural world. Of the pagan pantheon and related spirits, dæmons, and servants. Of the summoning or interaction with superhuman powers opposed to the will of the Supreme Being or of other principal deities.

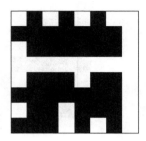

|ˈəʊdə| |smɛl| |smɛlɪŋ| |smɛlz| |wɪf|
|malˈəʊd(ə)rəs| |ˈfɛtɪd|

*The mind detects the shape of molecules and, using synæsthetic
techniques, labels each form of particle with an arbitrary sensation.*

noun

Scent, good or bad. Fragrance, perfume. The faculty of perceiving
fragrances via the olfactory organs, esp. nose. A faint trace or brief
perception of scent. A puff of wind.

verb [trans. & intrans.]

To perceive by means of the nose. To become aware of a misdeed,
problem, disreputable action. To detect pheromones and other bio-
logical indicators imperceptible to human beings. To emit a fragrance
perceptible by others. To strike the nostrils. To emit a scent. To allow
one's intentions or actions to be detected

adjective

Having a nasty or foul perfume. Stinking. Foul.

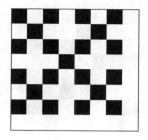

|ɒv| |diː|

preposition

The substitute for the genitive case. Indicating the relationship between a part and the whole. The French preposition meaning the same. Association between two entities. Possession of an attribute, object, or person by another. The relationship between a thing and direction, location, position, vector of travel. A point in time that something proceeds from or since. Describing the general relationship between a set and a set contained within it, of a category holding a subcategory. The relationship between a verb and an indirect object. Indicating the material or substance from which a thing is formed or born.

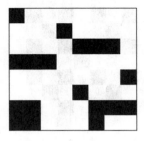

|ɒf|

adverb

Away from a place in question, or moving to a distance removed. To be removed or separated. Signifying projection or relief. Beginning a journey. So as to conclude or discontinue an action, opposed to on and as.

preposition

Not on. Moving away or down from. Situated away from the subject. Distant from. So as to be removed or separated from the whole. (SEE |ɒv|.)

|ˈɒfə| |ˈɒfəd|

verb [trans. & intrans.]

To present a thing so that it may be taken. To place in public to be removed. To give to a god, deity, saint, dæmon, or other supernatural being. To proffer in worship. To tender for acceptance or refusal. To make available. To give an opportunity for battle or sexual relations.

ə

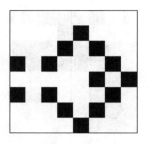

|əʊ|

interjection

Exclamation expressing pain, sorrow, surprise, pleasure.

|ɔɪl| |ɔɪlz| |ˈɔɪli|

The suffocating liquid.

noun & adjective

The juices of olives. The juices of ancient algæ. A viscous liquid derived from petroleum containing long chains of hydrocarbons. (SEE |ˈgasəliːn|.) A thick fluid insoluble in water. The medium used to carry pigments in paint. A flammable liquid of organic solvents. A lubricant or protector of engine parts.

|əʊld| |əʊldɪst| |əʊldə| |ˈeɪnʃ(ə)nt| |ˈɛldə|
|ˈantɪkweɪtɪd| |ˈeɪdʒɪd|

What was once New. The decayed sign. (SEE *|njuː|.)*

adjective & noun

Of the time when the universe was first born. Of the primeval ooze. Of the time of life past the middle, no longer young. Having lived or existed for a long time. Not young or new. At an advanced stage of development. Having maturity, wisdom, or hoariness. Denoting the least young of a group. Of a thing, shabby, decayed, ripe, stale, putrid. Of a length of time past. Belonging to a time past. Of another epoch. Relating to the dawn of man. Of the first civilizations from which we are degenerated. Of a leader or functionary ranked by their seniority. Of methods and style outdate, no longer current, passé.

verb [trans. & intrans.]

To cause to become feeble, weak, decayed, worn out. To lose youth, vigour, vitality. To linger closer and closer to death and oblivion.

|ɒn| |əˈpɒn| |ˈɒntuː|

preposition & adverb

Physically supported by another thing. Not under, being on top or on the outside. In contact with the surface of a thing. Put before the subject of an action. Throwing over the body. With respect to. Forming a distinctive part of. Having as a subject. Noting addition or accumulation. Noting a state of progression. Noting place. Noting the state of a thing. Indicating location in time or in chain of events. Continuation of movement. Movement to a place located within the surface of a thing, place. Movement aboard a conveyance. Movement to a new subject, place, state of being.

|wʌn| |ˈəʊnli| |ˈprɪnsɪp(ə)l| |fɜːst| |wʌns|
|ˈprʌɪm(ə)rɪli| |ˈsɪŋgjʊlə| |wʌnˈsɛlf| |sɛlf|

The original mark of man. The Unity.

cardinal number

Half of two. More than zero but less than two. The integer of all numbers that did or will exist.

adjective & noun

The unit of being. The quantification of an individual entity, thing, object, person. In computation the symbol of Truth. Indefinitely, any. Undivided, united, forming a whole. A part of two in opposition. The hour that begins the day. A person. People in general. An unspecified occasion.

pronoun

Referring to a person or thing previously mentioned. A person of a specific type. To refer to any person, people in general, or oneself in the third person.

|ˈəʊp(ə)n| |ˈəʊp(ə)nd| |ˈəʊp(ə)nz| |ˈəʊp(ə)nɪŋ|

To remove the lid of an enclosed power.

verb [trans. & intrans.]

To unclose, unlock. To put into such a state that the parts are revealed and accessible. To move an object or device from its closed position to allow passage or access. To disengage a fastening or fixed object. To show, discover. To explain, disclose. To cause to spread out, unroll, expand. To enlarge a hole or orifice. To allow public access to.

adjective

Allowing access, passage. Permitting view. In a state that is not closed, fastened, locked, rolled up, folded in. Available to the sky, not covered by a roof or foliage. Exposed to view. Being frank and communicative. Unskinned.

adverb

Without concealment, deception, or prevarication. So that all may see, hear, or take notice. Visibly, manifestly.

641

|ˈɒp(ə)rə|

noun

A work. A labour. A poetic tale or fiction performed upon a stage with singing, instruments, costumes, machines. A dramatic work of theatre set to music. A work of music to which dramatic conventions have been applied. A synthesis of formalist and narrative language.

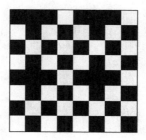

|ɔː|

conjunction

To link alternatives. To mark opposition. Corresponding to either. Otherwise. To explain a previous word. To introduce an after-thought, speculation, or musing.

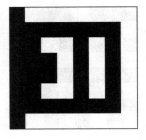

|ˈɔːdə|

noun

Regular and proper government. A proper state, established precept. Mandate. Command. Rule, regulation. Instruction, written direction, verbal request.

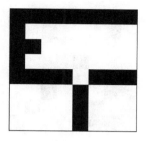

|ɔːz| |stəʊn| |rɒk|

*The lines and flaws of the marble dictate the sculptural
form that will emerge. (SEE* 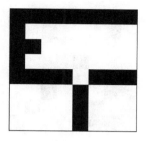 *|brɪk|.)*

noun & adjective

Unrefined metal. Metal in its mineral state. A hard solid, nonmal-
leable, nonductile matter of rock. Petrous matter cut to build an
edifice, wall, or structure. Petrous matter found upon the ground.
A gem. The mass of the earth.

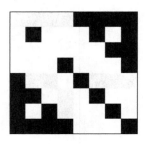

|ˈɔːg(ə)nʌɪz| |ˈɔːg(ə)nʌɪzd|

Understanding used to determine physical placement.
(SEE 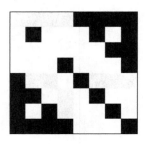 *|ˈnɒlɪdʒ|.)*

verb [trans.]

To form organically. To place into structures as nature would. To arrange into a whole, to order. To systematize, put into a state of perfection. To coordinate or manage the activities of persons.

adjective

Constructed so that one part coördinates with another. Arranged in a structured or systematic way. The power of Dionysus penetrates the anima of the worshipper.

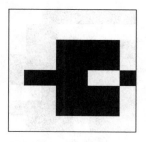

|ˈɔːdʒi| |ˈɔːdʒiz|

noun

A secret rite or ceremony in honour of a deity. A ritual frenzy performed in the name of Dionysus. A feast or revelry involving excessive drinking and unrestrained sexual activity.

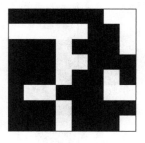

|ˈɔːdʒi| |ˈɔːdʒiz|

adjective & pronoun

The one of two. A thing different or distinct from that already mentioned. Not the same, different. Not I but a different being. Not the one, but the contrary. Something beside. Further, additional.

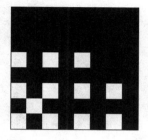

|aʊə| |aʊəz|

possessive adjective

Belonging to us, pertaining to us. Associated with the speaker and one or more others. Used in the third person to refer to one's belongings or characteristics.

a

|aʊt| |aʊtˈsʌɪd| |wɪðˈaʊt| |ɛkˈstɪərɪə| |ˈəʊvəbɔːd|

preposition

From. Not in. No longer in. Not within. In a different state. Deviating from. In the state of absence from. In the state of nonpossession. Beyond, not encompassed. Not within.

adverb

Not within. Opposed to in. In a state of disclosure. Moving away from a particular place. Not confined or concealed. Away from one's residence, not inside. In a state of extinction, ended. Exhausted. Not belonging to a category. From a ship into the water. Off a vessel.

adjective

Not at home. Revealed or made public. Extinct or extinguished. From the inner part of a structure. Of the external surface. Of the appearance and not inner thoughts. Not belonging to a category. Outward, external, not intrinsic.

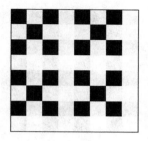

|'əʊvə|

preposition

Extending upward. Passage or trajectory across. At a higher level. Higher than one. For longer than a specified period of time.

adverb

Above the top. More than an assigned quantity. From side to side. From one to another. From a country across the sea. On the surface. Throughout, completely.

|aʊt|

noun

The outer surface. The assumed behaviour.

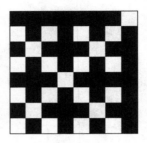

|əʊvəˈkʌm| |əʊvəˈkeɪm|

verb [trans.]

To subdue, conquer, vanquish. To successfully deal with a problem. To prevail.

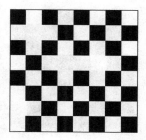

|əʊn| |əʊnz| |pəˈzɛs| |pəˈzɛʃ(ə)nz|

adjective & pronoun

That is held or controlled by the speaker, preceding noun, or pronoun. Expressing tenderness. To emphasise that a thing, act, or idea originated from or belongs to the speaker.

verb [trans.]

To hold. To have belong. To be the proprietor of. For a dæmon or spirit to control or inhabit a corpse or person. To dominate an emotion, idea. To dominate a physical object.

noun

The state of being held in the hands or controlled. A thing beheld, legally ascribed to a person or organisation.

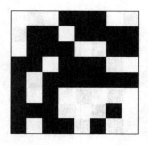

|pak|

Many things folded into a small amount of space.
Space folded in upon itself.

verb [trans. & intrans.]

To bundle or tie up goods. To prepare things for passage. To fill a case or chest for travel. To fill a hollow with objects or substances. To go off in a hurry. To contain a thing.

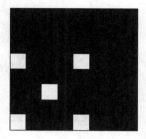

|peɪn| |peɪnz|

The most powerful emotion or sensation.
That which produces happiness as its afterglow.

noun

The torment of life. The body's signal of injury, distress, or decay upon the mind. That which falls out of the sphere of influence of principal deities.

verb [trans.]

To afflict, torment, make uneasy. To labour. To cause physical hurt. To torture. To inflict suffering.

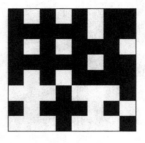

|ˈpalɪt|

noun

A board or tablet upon which an artist mixes the colours. The range of colours, tastes, sounds, or textures that a creator selects from. The tonal range of a piece of music or painting.

|ˈparəlɛl|

adjective

Extending in the same direction always keeping the same distance apart. Having the same tendency. Continuing resemblance in many particulars. Of lines extending into infinity and yet never meeting. Occurring or existing at the same time.

|ˈpɛːr(ə)ntz|

The two consciousnesses that spawn another.

noun [pl.]

The mothers or fathers of a child. The progenitors of a child, concept, or movement. Those who exercise authority, governorship, or control over others.

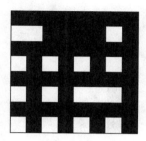

|pɑːt| |pɑːtɪd| |əˈpɑːt| |ˈsɛkʃ(ə)n|
|brɑːn(t)ʃ| |ˈtʃaptə|

adverb

To some extent. Of persons separated by distance. At a distance from the main body. Something relating or belonging to a person. Shattered into many pieces.

noun

Less than the whole, a portion, a quantity taken from a larger one. A share, concern. A member of the whole. A side in a conflict. A small or distinct part of a thing, esp. book. The shoot of a tree extending from the main bough. A tributary of a river. The arm or subsection of an institution, esp. church, society, ideological movement, school of thinking.

verb [intrans.]

To move away from each other. To divide, leaving a central space. To leave a company.

659

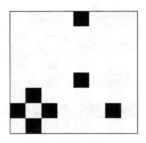

|pəˈtɪkjʊləli| |pəˈtɪkjʊlə| |paːˈtɪkjʊlət|

An item distinct from the rest.

adjective & noun

Existing in the form of minute items, molecules, atoms, energy states. Composed of many distinct items. Of a contaminant material, esp. smoke. Of many minute articles. Relating to a single person, not general. Individual, distinct from others. Peculiar, single. Odd.

adverb

Of a higher degree than others. More than usual or average. To single out a part of a statement that is especially applicable.

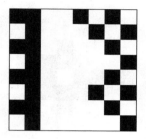

|ˈpasɪdʒ| |pɑːst| |pɑːsɪŋ| |pɑːsiz|

verb [trans. & intrans.]

To go, move from one place to another. To progress. To make way. To progress from one state to another. To move within a dimension. To move between dimensions. To vanish, be lost. To leave to one side. To transition in time. To allow time to elapse. To transfer an object, property, or quality to another. To enact a thing. To go through. To live through. To impart. To impart fraudulently. To allow. To admit entry, traversal, use of a place or thing.

noun

The act of moving, travelling, journeying. A road, way. A narrow access way. Entrance. Intellectual admission. The process of transitioning from one state to another. An occurrence, incident. An event or part of a book or narrative.

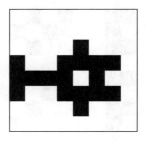

|ˈpasɪndʒəz|

*The flea upon the rat upon the ship upon the sea
upon the sleeping eyelid.*

noun [pl.]

Those who travel. Those one finds on roads. Wayfarers and journeymen. Those who ride in or upon vessels of air, water, or earth. Those conveyed through life, conflicts, developments by the will or energies of others.

|ˈpaʃ(ə)n|

noun

Violent commotion upon the mind. Physical suffering and pain. A strong or overpowering emotion positive or negative. An impulse, intent outside of the norm. An outburst of emotion. Eagerness. Zeal. Anger. Love. Physical ardour.

|pɑːst|

That which lies immediately behind the arrow of time and movement.

preposition & adverb

Beyond in time. After. Passing on the other side of a thing. To or on the further side of. At a time later than that specified earlier.

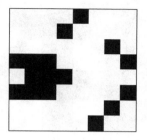

|ˈpeɪʃ(ə)nt| |ˈpeɪʃ(ə)ns|

*The figure waits for the shards of the vase
to drift back into a whole once more.*

noun

One who receives impressions from external agents. One affected by disease. The subject or charge of a doctor. Having the quality of enduring. Calm under pain or affliction. Not easily provoked. Not hasty or impetuous.

|ˈpat(ə)nz| |ˈskiːmə| |peɪntɪŋ|

noun

The unconscious encoding of information, stimuli, and inputs by the mind resulting in a particular effect. A rule or form whereby the imagination is able to categorise the manifold of sense-perception creating knowledge and experience. A drawing, representation or diagram of a model, plan, theory, or idea. An archetype or original that is copied or reproduced. The resulting copies. A model of behaviour of action. An intelligible sequence or series of events, things, or situations that reveals a hidden, higher, or overarching truth. A pictographic work of art that reveals a hidden, higher, or overarching truth.

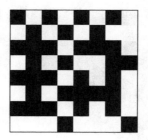

|peɪ| |peɪd| |təʊl| |ˈmʌni| |ˈaflʊənt|
|wɛlθ| |ˈprɒspəd|

verb [trans. & intrans.]

To discharge a debt. To reward, compensate. To atone through suffering for a crime or moral outrage. To hand over currency. To give an equivalent for a thing bought. To be successful. To thrive.

noun [pl.]

Metal coined for the purposes of commerce. Banknotes or other promissory financial instruments. The encoding of labour or genius into quantitative form. An excise of goods or currency to allow passage. A metaphorical price exacted as a result of some action or event.

adjective

Flowing freely. Abundant, exuberant, copious, plenteous. Flowing in riches. Holding great fortunes.

p

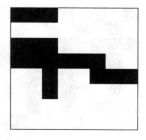

|piːk| |piːkz|

noun

The top of a hill or projection. The end of a mountain. An eminence. The point or apotheosis of a person, thing, event. The highest part of a structure.

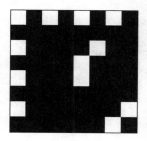

|prˈkjuːlɪə| |prˈkjuːlɪəli|

That which is felt differently. (SEE 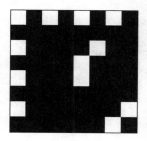 *|fiːl|.)*

adjective & adverb

Belonging to one thing to the exclusion of others. Unique, uncommon. Exclusive in character. Unusual. Strange.

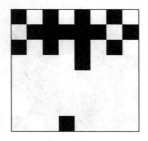

|pɪ(ə)rz|

noun [pl.]

Those who are equals. Those of the same rank. Those equal in excellence. Companions. Fellows.

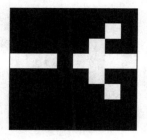

|ˈpɛnɪtreɪt|

The path of the arrow through the armour and into the body.

verb [trans.]

To pierce, enter beyond the surface. To make way into the body. To make way into the mind. To reach meaning.

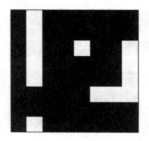

|ˈpiːp(ə)l| |ˈpiːp(ə)lz| |ˈpɒpjʊləs| |fəʊk|
|ˈtaʊnzfəʊk| |ˈfamɪli|

The individual joining a line of many.

noun

Human beings in general. A counted number of persons. A nation. Those who constitute a community. Not the nobles. The common. The vulgar, the multitude, the mob, the rabble. The masses. The inhabitants of a particular city, province, country, empire, continent. The men and women of a burg. Those who live in the same house, household. Those descended from a common progenitor. A race, tribe. Class, species, category of things.

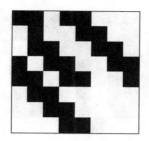

|pəˈhaps| |ˈpɒsɪbli| |ɪf|

*Imprecision. Vibrating faster than one can measure,
the object is in both places at the same time.*

adverb

Peradventure. It may be. Expressing uncertainty of truth or future outcome. Expressing a lack of definiteness. Likely by a real power. Indicating a chance that is achievable, not fictitious.

conjunction

Hypothetically. On the condition that, in the event of. Supposing that, allowing that. Whether. Despite the likelihood. As a request.

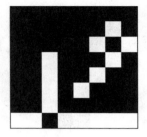

|ˈpɪərɪəd| |ˈpɪərɪədz|

noun

The interval between successive iterations of a state. The time in which a thing is performed. A duration of time. A stated number of years. The end of a sentence. The conclusion of a thing.

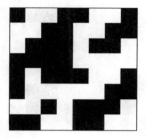

|fəˈnamənə|

noun [pl.]

Things observed. Perceived physical qualities. That which is observed to exist or happen. Change perceived through the senses or known intellectually.

f

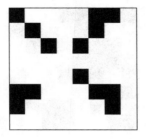

|fɪˈlanθrəpɪst| |ˈpatr(ə)nɪdʒ|

noun

A lover of mankind. One of a good nature. A benefactor. One who promotes the good of others through charitable acts or donations. Support, protection. Guardianship of the arts. The power of appointment to office.

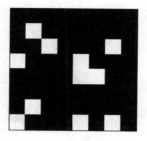

|flɛm|

noun

One of the four humours. The watery fluid, cold and moist, associated with apathy, indolence, sluggishness, and dullness. Mucus produced inside or eliminated from the body. Sputum.

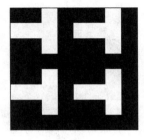

|ˈfəʊtəɡrɑːf|

*A regular pattern of molecules impressed upon by the shape
presented before them.*

noun

Chemical paintings. Pictures or images obtained by focusing light
upon a chemically treated surface. Light scattered off objects and
recorded in a mnemonic mechanism.

|ˈfɪzɪks| |ˈfɪzɪk(ə)l|

The laws of nature in equilibrium.

noun

Natural science. The branch of science concerned with the nature and properties of nonliving matter and energy. Investigations made into the nature of reality and the fabric of the universe. Ontological science.

adjective

Of or related to the body rather than the mind. Related to medicine or science of the body. Perceived through the sense rather than the mind. Actual, tangible, concrete, real.

|pʌɪl| |stak| |hiːp| |bʌn(t)ʃ| |ˈaʊtkrɒp|

noun

An accumulation. Any mound of material. Many single things thrown together. Many things of the same kind fastened or growing together. A crowd, rabble. An area of rock or mineral that emerges from the surface of the earth. A mass of bare rock.

verb [trans.]

To coäcervate. To throw many things together in a mound. To load a surface.

|pɪtʃ| |pɪtʃt|

verb [trans. & intrans.]

Of a ship; to plunge downward into a trough or into a wave. For a vessel to rotate about the lateral axis.

|pɪtɪd|

adjective

Having small indentations on the surface. Having minute cavities or depressions on the exterior. Marked with the scars of smallpox or acne. Having dimples.

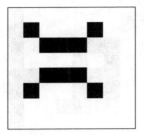

|'pɪksɛl|

That which emanates from the smallest point.

noun

Picture element. A minute area of uniform illumination from which a larger image is constructed. A point of light, colour or marking used to convey information. The smallest discrete part of an image. An individual element of an encoded memory. (SEE 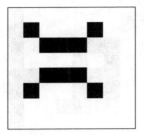 |'kəʊdɛks|.)

p

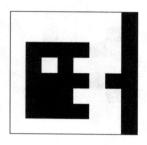

|pleɪg| |pleɪgd|

The foreign body binds to the creature.

verb [trans.]

To infect with pestilence. To tease, vex. To harass, torment, trouble, torture, embarrass, excruciate, disturb. To cause problems.

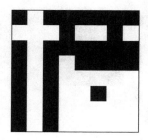

|plan| |pland| |ˈprɛpəˈreɪʃ(ə)ns|

noun

A scheme, form, model. The architectural drawing describing an edifice. A predetermined intention to carry out certain actions. A detailed diagram or schematic of intentions. The act of fitting a thing to a purpose, making ready for use, making up a substance. Actions to get ready for a future or expected event.

verb [trans. & intrans.]

To arrange in advance of an action. To devise, contrive, formulate. To anticipate and make ready for a future event, action, occasion.

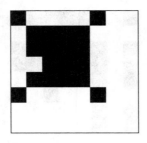

|ˈplanɪt| |ˈplanɪt(ə)ri|

One of the nine divine beings. A Great Attractor.

noun

The celestial objects that move independently of the rotation of the stars. The erratic or wandering stars. The rocky or gaseous bodies that orbit the sun in an elliptical orbit. The rotation upon the axis of these bodies creates the passage of the days. Each orbit constitutes one year upon that world. The Earth upon which we live is one of these orbs and takes its place as the third sphere of the divine nine. The concentrated mass of matter of these celestial bodies creates a powerful occult influence known as ▆ |ˈgravɪti| believed to affect natural phenomena, catastrophes, the fates of empires and the characteristics, temperaments, and fortunes of men. An object that orbits not the principal star but an erratic star is known as a ◳ |ˈsatəlʌɪt| and is believed to exert a more immediately disturbing influence upon the mind.

|plɑːnt| |plɑːnts| |griːn|

noun

A living organism other than an animal, lacking digestive organs and able to support itself on inorganic matter. A subject of the Kingdom of the Unmoving comprising multicellular forms with cellulose walls and capable of photosynthesis. A thing produced from the seed. A vegetable production.

adjective & noun

The colour between blue and yellow in the spectrum. The colour formed when mixing blue and yellow pigments upon the painter's palette. A colour thought favourable to the fight. The colour of leaves and trees and herbs. Said of the sea and hence Neptune. Pale, sickly. Flourishing, thriving. Unripe, immature, young.

686 ▣ |'planɪt|

adjective

Of or relating to celestial worlds. Relating to the influence of heavenly worlds upon the lives of men.

|ˈplɑːstə| |ˈʃiːtrɒk| |tʃɔːk| |tʃɔːkt|

The unnatural surface. The Artificial Stone. (SEE *|brɪk|.)*

noun

A substance made of water and an absorbent material, usually powdered limestone, sand or cement. The substance applied to walls to form a pure contiguous surface. The hard white substance used to cast objects and build sculptures made from water and powdered gypsum. A solid medicinal or emollient substance spread on a bandage or dressing. The flat sheets formed by compressing material, used historically to construct the interiors of houses, commercial stores, and museums. A lightweight building material made of powdered calcium carbonate or gypsum reinforced with a thick paper used to construct the inner lining of edifices. Drywall.

verb [trans.]

To rub, mark, or write with calcium sulfate. To draw or form a line using the abrasion of limestone. To mark an object to indicate that it has been processed into a system.

|ˈplatə|

noun

A large flat dish, generally made of earth. A plate, esp. for food. A main dish. The rotating disc of a turntable unit on which a record is placed for playing. A round plate coated with magnetic material on which memories are inscribed using a mnemonic system.

|pleɪ| |pleɪɪŋ|

verb [trans. & instrans.]

To gambol, frisk, flit, flutter. To sport, frolick, do something not as a task but for pleasure. To toy, act with levity. To act wantonly and thoughtlessly. To do something fanciful. To touch a musical instrument. To not work. To create art, to engage in games. To delight the human spirit. To move about with a lively, irregular, or capricious motion. To strut, dance, or engage in other forms of sexual display.

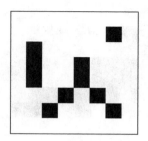

|pliːz| |ˈplɛʒə| |dɪə|

adverb

Used in a polite request or agreement. To add polite emphasis. To politely ask someone to refrain from doing something.

interjection

To express incredulity or exasperation. "For goodness sake."

noun

The chief purpose or end of life, sensuous enjoyment. The condition or sensation induced by the experience of happiness, enjoyment, delight, sensual, or sexual gratification. Gratification of the mind or senses. Approbation. Choice, arbitrary will. A word of affection, a tender or friendly form of address.

adjective

Beloved, favourite, darling. Valuable, of a high price, costly. Scarce, not plentiful.

p

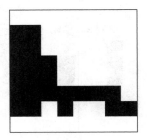

|pluːm|

That which expands from a small point to a large volume.
(SEE 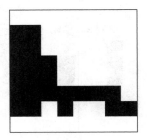 *|ˈkɒzmɒs|.)*

noun

The feathers of birds. A feather worn as an ornament. A mark of honour or satisfaction. Of a thing resembling a feather, light. A trail of cloud, smoke, vapour issuing from a localized source and spreading or billowing out as it travels.

691 |pliːz|

adverb

At a high price, cost. Of a high importance.

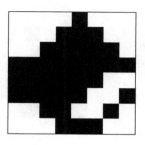

| ˈpɒkɪt |

The light in the dark corner.

noun

A small bag placed inside or sewn to the exterior of clothes. A small compartment or sack providing a discrete area for storage. An isolated society, group, or area. A cavity that has been made for filling.

p

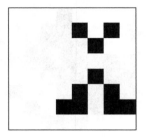

|pɔɪnt|

That which is indicated lies within certain parameters.

noun

A particular existence, example. A particular spot, place, area in time, occurrence, occasion. A stage or level in a sequence or chain of causality.

|'pɔɪz(ə)n|

The corruption hidden in the innocuous.

noun

That which destroys or injures life through a small quantity not apprehended by the senses. A draught prepared by political enemies. A material that negatively affects the living organism, the mind, or a society. A principal or doctrine that is harmful to the character. Venom.

|pəˈlɪtɪk(ə)l| |ˈgʌv(ə)n| |ˈgʌvəm(ə)nt|

The area of our lives that falls under the influence of the Ruler or the Public is the largest part of our existence.

adjective

Relating to the administration of public affairs. Cunning.

verb [trans.]

To conduct the business of the people. To handle the affairs of state. To administrate, command. To control, influence events. To behave haughtily.

noun

The supreme authority. The earthly authority of men outside of the will of deities. The legal authority of a community. The administration of public affairs. The management or regulation of behaviour. The rule of some over others. The public structure.

|ˈpɒlɪg(ə)n|

Form as described in precise language.

noun

A figure of many angles. A plane figure of at least four sides, usually more. A number of straight sides and angles. A simple mathematical shape combined with many others to form an uncanny representation of the actual world.

p

|pɔː|

noun

A spiracle of the skin. A duct or orifice for perspiration. A minute opening in a living organism through which gases, liquids, or particles may pass. Any narrow passage.

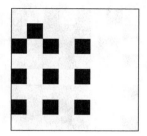

|pɔːt| |ˈhɑːbə| |pɔːts| |ləˈɑvʀ|

The regular home to which the errant particle returns.
The capturer of stray electrons.

noun

A safe station for ships. An asylum, place of shelter. A town or place possessing a dock where ships may be loaded or unloaded. A place of departure for a vessel. A facility for the coming and going of ships and air ships. A gate. The orifice in a ship through which a cannon is fired. A town in northern France on the coast of the English Channel and the mouth of the River Seine.

p

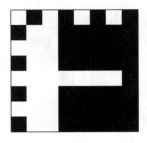

|pɔːˈtɛntəs|

The path of the Future.
A lit road in the dark sea of uncertainty.

adjective

Foretelling events to come. Ominous, threatening, monstrous, foretoking ill. Describing that which is destined, fated.

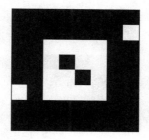

|pəˈzɪʃ(ə)n|

A state that is symmetrical in time.
A location or arrangement that can be entered or exited.

noun

The state of being placed. The localization of an object or abstract supposition, geographically or in time. A situation. A principle or viewpoint laid down. The manner in which a thing has been placed or arranged. A set of physical contortions.

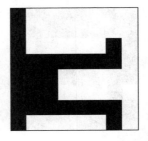

|pɒt| |pɒts|

noun

A vessel used for storage, cooking. A container in which meat is cooked in a fire. A vessel made of earth, ceramic ware. A container of liquids. A deep vessel with a cylindrical body to hold liquids or solid substances. An apparatus of the art of cuisine.

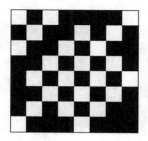

|ˈpɒvəti|

noun

Indigence, necessity, want of riches. Meanness. Destitution. The state or condition of having few material possessions or financial instruments. Deficiency in a particular quality or characteristic. Poor physical quality, feebleness resulting from insufficient nourishment.

|ˈpaʊə| |ˈpaʊəz| |ˈpəʊt(ə)ntsi|

The sign of control. Action from a distance.

noun

Command, influence, dominion, authority. Prevalence upon. The ability to affect another thing strongly. Capacity to alter the behaviour, mindset, beliefs of others. Ability, force, reach. Political control, national strength. The reach and means of an occult being, supernatural power, deity. Physical strength exerted or directed by a creature, thing, machine. Mechanical, electrical, or atomic energy applied to a use. The efficacy of an inanimate thing to influence events, esp. star. Strength, intoxicating potential of a substance, medicine. The virility of the male creature. The ability to achieve erection, ejaculate, or impregnate the female.

|praktɪsɛs| |ˈɛksəsʌɪzs| |plʌɪd|

That which takes form in the reptilian brain through repetition.

noun [pl.]

The habits of peoples. The applications of ideas, beliefs and methodologies. The customary behaviours. The repeated, common, usual activities of people, communities, creatures. Actions requiring physical labour, toil. Labour conducive to good health, banishment of disease. Habitual action whereby the body is brought to a state of grace. (SEE |spɔːt|.)

verb [trans. & intrans.]

To bend back, fold, or double over cloth. To bend, be bent, or yield. To change the wills of others, bend the disposition of others. To work with a tool, instrument, brush, esp. with repetitive movement. To steadily perform a business or trade.

|ˈprɛsɪpɪs|

The steep line.
A point of exit for an individual consciousness.

noun

A sheer surface. A very steep cliff face or rock. A place where one may fall perpendicularly unimpeded by obstacles. Where one may fall headlong. An abyss, gulf.

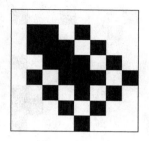

|prɪˈkəʊʃəs|

While the external surface is mature,
the flesh inside is still green.

adjective

Ripe before its time. Flowering, fruiting especially early. Developing prematurely. Of a person, esp. child demonstrating abilities, knowledge, or faculties that they should not have developed at such a young age. Of an eerie youth, possessed juvenile, supernaturally influenced child.

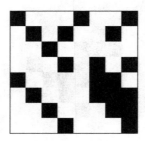

|ˈprɛf(ə)r(ə)ns| |ˈprɛf(ə)r(ə)nsɪz| |teɪst| |teɪstɛs|

The chemical indicators floating in the void make contact
with the discerning surface of the organ.

noun

The estimation of one thing above another. A greater liking of one alternative over another. The favouring of one over another. The perception as distinguished by the palate. The sensation of flavour upon the throat, mouth, or tongue. The affection of a person for a particular flavour. The æsthetic sensibility, discernment of an individual. The conformity, orthodoxy of cultural, moral, æsthetic sensibility.

|'prɛgnənt| |kən'siːv|

The soul within the soul holds in its belly an army of yet more souls.

adjective & noun

Of a woman or female animal carrying a developing being in the uterus. The state of holding a new life in the womb. Fruitful, fertile. Teeming. Breeding. Destined to produce many results, consequences. Full of meaning, highly significant, suggestive. Implying more than is immediately apparent, external, seen.

verb [trans. & intrans.]

To admit into the womb. To implant with child. To create a living sculpture. To form or devise a plan, idea. To create in one's own mind an image, representation. To imagine. To understand, comprehend.

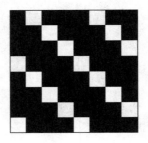

|priːhɪˈstɒrɪk| |prʌɪˈmiːv(ə)l|

Of that which existed before memory, language,
stories, or written accounts.
(SEE 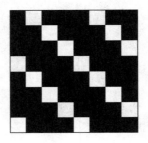 *|ˈnɒlɪdʒ|.)*

adjective

Of, relating to, dating from the time before written or mnemonic accounts of events. Ancient, Neolithic, Paleolithic. Of a long time ago. Antediluvian. Of a pre-civilized, pre-agrarian time. Original, as things were first. Relating to the first history of the earth, primitive, base, undeveloped.

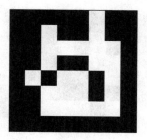

|ˈprɛz(ə)ns| |ˈrɛprɪzɛnˈteɪʃ(ə)n|

The interior truth projects a distorted facsimile into the world.

noun

The state or fact of being, contrary to absence. The space or vicinity of a person. The influence of a thing existing in place but not seen. An occult or divine being who is present and acting in a place whilst not seen with the eyes. The state of being in view of a superior, an audience with a great personage. The communication of opinion or registering of protest to a government, or institution. The act of speaking on the behalf of someone to a figure of authority, esp. regent, judge. Image, likeness. The description or portrayal of a person or thing as having certain qualities or characteristics. A depiction of a person, thing, place in visual image, language, music, or song. A likeness or model of a form.

p

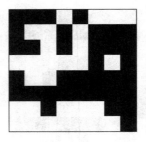

|pri'zent| |pri'zents|

verb [trans.]

To place in the presence of a superior. To bring formally before a deity. To exhibit, place in view. To offer, proffer, show something to others. To communicate wishes, greetings by proxy. To deliver a payment, gift. To bring about, be the cause of difficulty.

p

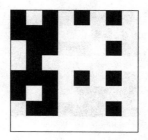

|prɪˈvɛnt| |prɪˈvɛntɪd|

verb [trans.]

To walk before another, to proceed in advance. To act as a guide. To go before, anticipate. To act in advance. To not allow something to happen. To keep something from arising. To hinder the intentions or wills of others. To preclude, stop, hinder. To interfere with the divine will, fates, destiny.

713

p

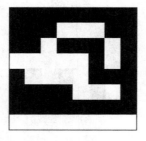

|prʌɪd|

The material held above the pure field of the spiritual.

noun

Inordinate or unreasonable self-esteem. A deep pleasure derived from a perception of one's achievements or those of close associates. Arrogant, haughty, or overbearing behaviour. Insolent exultation. Consciousness of one's own dignity. Self-respect, self-esteem. A person, thing, occasion from which a community or group of people derive a sense of elevation, dignity. Ornamentation, splendour.

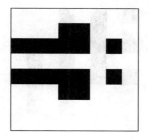

|priːst| |pəʊp| |ˈpɒntɪf|

*The divine consciousness strikes through the fog
of men's minds into the most conductive intellects.
It whispers day and night without respite its desires,
hopes, dreams, and fears.*

noun

The bishop of Memphis. In the Coptic or Orthodox church, the bishop of Alexandria, Louisiana. The head of a Church. A holder of high religious office. A minister allowed to wear purple robes. One who officiates in a sacred office. An ordained minister of a church. One below the office of bishop yet above that of deacon. One who may perform the right of transubstantiation. A consumer of divine flesh. A Tantalus.

p

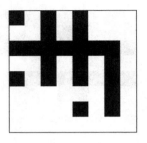

|prɪnt|

verb [trans.]

To press in. To seal. To mark by pressing one thing upon another. To leave a form through impact with another. To form an impression. To stamp. To impress an image upon the heart, mind, memory. To impress words not by the pen but through a press. To create a book, magazine, newspaper by mechanical means. To transfer images, text, or designs to paper. To produce a photograph by chemical or numerical means upon a flat surface, esp. paper.

|ˈprɪz(ə)n|

A series of material barriers to the flight of the soul.

noun

A gaol. A building or structure in which people are shut in, confined. A place where those condemned by a legal body, government are punished. A place of captivity, confinement. The forcible deprivation of personal liberty.

|'prɒbləm| |mɪ'steɪk|

noun

A proposed question. A hypothetical proposition to investigate laws, theorems of mathematics, geometry, and other science. A puzzle, riddle. A difficult or demanding question. A situation regarded as unwelcome, harmful, and needing to be overcome. A difficulty. A misconception, error. A thing incorrectly done. Misjudgement. A regrettable choice, badly selected thing. A falsehood.

|'prəʊsɛs| |'prəʊsɛsɪz|

noun

Tendency, progressive course. A series of actions or steps to produce a particular outcome. A system of mechanized or chemical operations to produce or manufacture something. The methodological arrangement of anything. The course of the law. A plan or repeated sequence of causal effects.

|'prɒdɪdʒi|

*When a deity influences a man, it buries into him
like a worm in his guts.*

noun

A thing out of the normal course of nature from which omens are
drawn. A portent. An anomaly. An extraordinary thing. Someone
abnormal. A freak, monster. A person, esp. young with exceptional
abilities or qualities.

prəˈfɛʃ(ə)n		dʒɒb		ɪmˈplɔd		wəːk		
wəːkɪŋ		ˈleɪbəɪŋ		ˈleɪbə		ˈleɪb(ə)rəz		ˈwəːkəz
ɪmˈplɔɪm(ə)nt		wəːkz						

noun

The travail of the Alchemist. A task undertaken. Something done or made. An object made by man. A thing authored. An artefact. A piece of art, theatre, literature, poetry, music. The exertion of force, use of energy for a purpose. A person or animal engaged in a physical task. The condition of paid exertions. One's business. The trade in which one is engaged. A calling, vocation. An occupation requiring specialised knowledge or experience. A hard physical job. Persons engaged in physical work, not craftsmen or artisans. The state or action of being commissioned to an office or trade.

verb [trans. & intrans.]

To exert the mind or body in order to achieve a particular result. To bring by action into a state. To bring a material into a desired

state through heating, cooling, manipulating, mixing, treating, etc. To make by degrees. To manufacture. To do, perform, or practice a task, action, occupation. To produce by exertion. To produce, effect. To cultivate land or extract minerals from a mine. To have a machine operate or function. To move with difficulty. To exert with difficulty. To gain a livelihood. To be engaged in an unskilled manual occupation. To perform an action whilst burdened, diseased, distressed, or suffering from some disadvantage or defect.

|prəˈfɛsə| |ˈtiːtʃə| |tiːtʃ| |tɔːt|

noun

A prælector. A fellow. One who publicly practises or teaches an art. An educator of the highest rank in a college or university. An academic who holds a chair in a specified faculty or subject. An instructor, preceptor. One who informs or educates the people. A flame of inquiry, opposed to the � |priːst|.

verb [trans. & intrans.]

To instruct, explain. To initiate another into an art, science, or craft. To show or demonstrate knowledge. To induce understanding through reward or punishment.

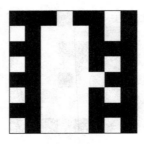

| ˈprɒdʒɛkt |

The skeleton forms around the negative space giving it form,
substance, and anima.

noun

A scheme, design, contrivance. An enterprise planned and executed
to a achieve a particular aim. A proposed undertaking. An objec-
tive. A speculative, experimental inquiry into new areas, knowledge,
substances.

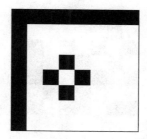

| ˈprɒmɪs |

The gods surround and bear witness to the maker of the oath who invokes their vengeance should he prove false.

noun

An oath that the future will proceed in a certain way, that an object will be conferred, that a current assertion is not false. An assurance or guarantee that a particular thing will happen. An indication of future events producing good results.

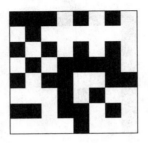

|prɒm(p)t| |prɒm(p)tɪŋ|

verb [trans.]

To assist by suggesting a word, or phrase to a malleable receiver, esp. actor. To incite a person to action, to induce a behaviour in another. To inspire, suggest, urge, dictate. To cause or bring about a result.

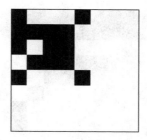

|prəˈtɛkt|

The particle enclosed by the fluid.

verb [trans.]

To defend, cover from evil, shield. To keep safe from harm or injury. To support or assist against hostile or inimical action. To extend patronage to. To assist or guard. To provide with a preserving cover such as a barrier or shielding substance.

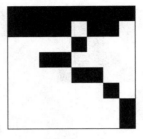

|ˈprɒvɪd(ə)ns|

noun

The capital of Rhode Island. A port in the Americas on the Atlantic seaboard. A centre for learning famed for its universities, esp. the faculties of literature, art, and medicine. Hence it is known as the Renaissance City.

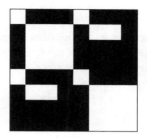

|ˈsʌɪki| |mɪnd| |mɪndz| |ˈmɛnt(ə)l|
|ɪnˈtɛlɪdʒ(ə)ns| |sʌɪˈkɒlədʒi| |ˈsʌɪkɪklɪ|

The soul of the world.
The spirit diffuses throughout the material universe,
organising and giving form to the whole and to all its parts.

noun

Anima Munda. The human soul. The power of thought. The spirit as distinguished from the body. The whole conscious and unconscious intellect considered as a whole by the scientific observer. The intellectual and emotional faculties of the brain combined. The faculty of memory. The thoughts of a person or being as a whole. The disposition. The collective cognitive habits, or characteristics of a person, nation, or culture. The science of thoughts, personality, and character. The faculty of understanding. Superior reckoning or adaptability. Communications of information. Secret accounts.

729

adverb

Of or related to faculties or phenomena outside of normal understood natural laws. Susceptible to supernatural or paranormal influences such as telepathy, clairvoyance, etc. Of action performed remotely, not by physical means. Of an influence acted upon the behaviour, character of a person, or creature by an unseen or unknown agent.

adjective

Intellectual, not carried out by the body. Concerned with the phenomenon of consciousness and cogitation.

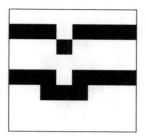

|pʌls|

noun

The motion of an artery as the blood is propelled through it by the heart creating a rhythm discernible by touch. The contractions of the heart as felt through the surface of the body, esp. the neck, wrist. The rate of contraction of an individual's heart. An individual beat of the heart. The indication of vitality, health, energy. A rhythmical vibration or undulation. A burst of energy.

ˈp

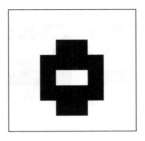

|ˈpjuːpɪl| |ˈpjuːpɪlz|

The orifice into the mind.

noun

The aperture of the eye. The opening in the iris through which light passes and strikes the retina. The dark circle of the eye. The window into the soul.

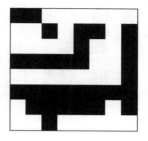

| ˈpəːpəs |

An action seeking completion.
A part nearly symmetrical.

noun

Intention, design. The reason for which something is done or created. The aim to which an object or action is directed. That which a person sets out to do, attain, achieve. An aim. Resolve, determination.

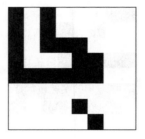

|pəˈsjuː| |pəˈsjuːd|

verb [trans. & intrans.]

To chase, follow in hostility or enmity. To persecute, harass, worry. To follow a person or thing with the intent to overtake and capture or kill. To seek to attain or accomplish a goal. To endeavour to attain. To imitate, follow as an example. To follow a course of action. To continue or proceed along a path, road, route. To investigate, enquire, explore a matter, topic, argument.

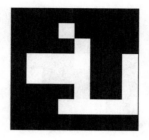

|pʊʃ| |pʊʃd| |pʊʃɪŋ|

The force acting against the barrier.

verb [trans. & intrans.]

To strike with a thrust. To force, drive, or impulse anything. To exert force upon a body so that it will motion away. To move along by continually exerting force behind. To shove, press, drive as opposed to drawing or pulling. To move forward with force. To pass through people or cause them to move aside. To advance forcefully an idea, philosophy, religious belief.

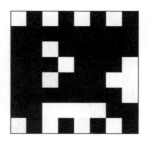

|pʊt| |pleɪs| |pleɪst| |pəʊst| |sɛt| |ˈsɛtɪŋ|
|ˈɛːrɪə| |pleɪsm(ə)nt| |əˈreɪn(d)ʒ|

verb [trans. & intrans.]

To lay, repose. To move to an area or particular position. To position with a sequence. To fix, settle, establish. To locate in space or time. To move to a state or condition. To cause to sit. To be situated or fixed to a particular location or state of being. To cause to become fixed, hardened, unmovable. To harden into a solid or semisolid state. To cause someone or something to carry. To add. To trust, give up a thing with another. To push into action. To proceed in a particular direction. To consign to writing. To propose, state. To suggest the proper order for a group of things. To move things into a neat or necessary order. To plan for a future occurrence. To come to an agreement over the state of a number of things, events.

noun

The statue or rank of navy captain. A military station. An office,

employment, position. The manner in which a thing is positioned or arranged. The action of reposing a thing. The state of being located. A number of things suited to each other. The surface calculated to be contained between particular lines or boundaries. An open surface designated to a particular use such as a court, dining room, church altar. A region, part of a country, geographically distinct location.

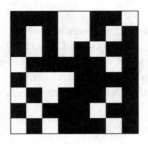

|ˈkwɒgmʌɪə| |ˈkwɒgmʌɪəz|

noun

A shaking marsh. A bog that trembles under the foot. A bog that quakes. A position or situation that is unpleasant or hazardous. A difficult situation from which to extricate oneself.

|'kwɔːtə| |fɔː|

noun

A half of the half of any thing. The last part of an animal, the haunches or hindquarters. A region of the skies. A direction on the point of a compass. A particular region of a town. The area where soldiers, guests, or staff are stationed or barracked. Treatment or mercy shown towards an enemy.

cardinal number

Of greater value than three but less than five. The square of two. The number of sides of a square.

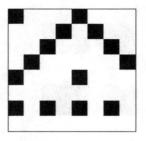

|kwɪə| |ˈɛl(d)rɪtʃ| |ˈɪəri|

The unexpected projection above the surface.

adjective

An item in a list marked by a question mark or query. Odd, strange, original, particular. Eccentric, of questionable character, suspicious, dubious. Weird, ghostly, unnatural, frightful, hideous. Expressing the notion of a vague supernatural uneasiness. Inspiring fear.

|kwɪk| |kwɪklɪ| |ˈrapɪdlɪ| |ˈhʌri| |ˈhʌrid| |rʌʃ|
|faːst| |faːstə|

The symbol of the still-living.

adjective & adverb

Swift, nimble, done with celerity. Moving with alacrity or occurring in a short time. Speedy, free from delay. Active, ready. Briskness, cheerfulness, liveliness, sprightliness.

verb

To hasten. To move with precipitation. To do something without due care. To move with violence, tumult. To force at an unusual or excessive speed.

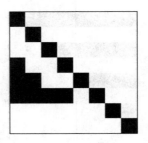

|kwʌɪt| |ˈjuːʒʋəl| |ˈjuʒ(əw)əli|

adverb

To a certain or fair degree. In a significant respect. To the utmost degree. Absolutely, completely. Commonly, frequently, customarily.

adjective

Habitually. As typically occurring.

|reɪl|

The sign of the Guide.

noun

A cross beam supported at two ends by posts. A series of posts holding a fixed line in place. A support for the hand upon the edge or stairs, precipices. A steel bar held between posts lying horizontally, upon which an engine or vehicle is guided.

r

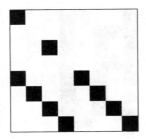

|reɪn| |reɪnd| |prɪˈsɪpɪteɪt| |prɪˈsɪpɪteɪtɪd|

It is said of the ancient gods that though they are quick to anger,
they are as quick to regret and to sorrow. For as soon as they strike
a vengeful fire of lightning upon the ground, a shower of tears
will fall from the remorseful sky to extinguish the flames.

noun

The essence of clouds. Water that falls in drops from the clouds.
Moisture condensed into separate drops. A large or overwhelming
quantity. A number of things falling.

verb [trans. & intrans.]

To throw headlong. To fall perpendicular to the ground. To fall
from the sky. To condense from moisture and fall as liquid, ice, or
mixture. To fall as drops of liquid. To fall in great quantity.

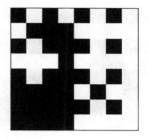

|reɪn(d)ʒ|

noun

A rank, place in order. A class. An area of variation with upper and lower limits, e.g., musical tone, geographical bounds. A distance within which a body circulates, a thing has influence. An area for wandering. An excursion.

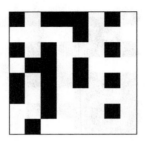

|ˈrɑːðə|

adverb

More willingly, with better liking, preferring. More properly. With better reason. Contrary. More precisely. In a greater degree than otherwise. To a certain or significant end. Especially.

| ˈraʃ(ə)n(ə)l |

*The true exhibited behaviour within a
specific system of rules or thinking.*

adjective

Having the power of reason. Agreeable to reason. In accordance with
a logical system. Being able to be reckoned, reasoned. Following the
laws of mathematics, science, nature. Not emotional, intuitive.

747

r

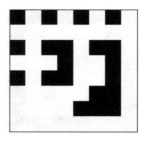

|rɪˈakt| |rɪˈakʃ(ə)n|

A trauma to the initial state results in the creation of new forms.

verb [intrans.]

To return the impulse of impression. To respond or behave in a particular way. To act or change state as a result of some influence. To repost, retaliate.

noun

A repulsion or resistance from the body. An action caused upon the feeling of a situation. An adverse physiological response to a substance. Response to a stimulus.

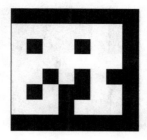

|riːd| |pəˈruːz|

When the eyes are fully focused on information,
they cannot see. Only when they dance, skip, and blur over the text can
knowledge seep through the tear ducts and across the mind.

verb [trans. & intrans.]

To discover by character or marks. To learn by observation. To discover information in books or other printed matter. To form language in the mind whilst viewing characters, words, numerals, musical tones, or other notation. To comprehend the meaning of writing. To be able to comprehend a written language. To be able to comprehend an encoded mnemonic system. To use up through wear, seeing. To go through a great many things. To examine many details, scrutinize, inspect. To look through a piece of text repeatedly.

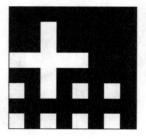

|ˈrɛdi|

adjective

Fit for a purpose. Accommodated to a design. Prepared. Suitable and available for immediate use. Being at a point not distant, not far, close at hand. Prompt, not delayed. Willing, eager. Facile, easy. Expedient, nimble.

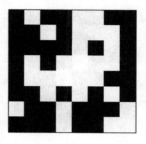

|rɪˈbjuːk|

verb [trans.]

To chide, reprehend. To express sharp objurgation. To scold. To respond with disapproval or criticism as a result of another's behaviour, actions.

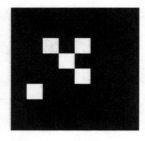

|rɪˈkluːsɪv|

The soul that wanders away from the whole.
One day he will return with a knowledge of that which
falls out of the sphere of man.

adjective

Being shut up or retired. Of a solitary being. Shunning the company of others. Secluding oneself from the world.

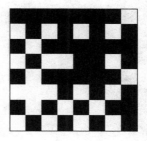

|ˈrɛkəgnʌɪz|

verb [trans.]

To acknowledge, avow knowledge of a person or thing. To acknowledge the validity, existence, or fact of a thing. To officially regard as proper. To identify a person, thing, or place as having been previously encountered or related to. To identify from traits or quality of character.

r

|rɪˈkaʊnt| |rɪˈkaʊntɪŋ|

To place a thing outside of experience.

verb [reporting]

To relate in detail, tell distinctly. To narrate a full or detailed account of an event, fact, adventure, etc. To relate in the order experienced.

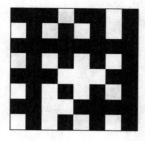

|rɛd|

The colour of the fourth planet.
The influence of Mars is violent,
passionate, and destructive.

adjective & noun

The colour of the lowest order of the spectrum. The frequency of radiation on the threshold of vision, perception. The colour of blood and flames. The sky of dawn and sunset. That which is forbidden or dangerous.

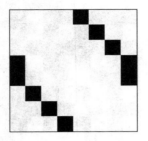

| 'rɛf(ə)r(ə)ns |

The knowledge of what is known.
(SEE 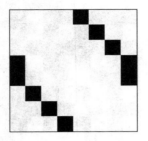 | 'nɒlɪdʒ |.)

noun

Mention or allusion to that which is known. A citation of information, text, authority. Relation to, respect to a person or thing. A mark or signifier pointing to information in a different place. The use of one source of knowledge to ascertain the validity of another.

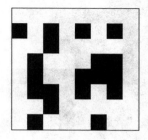

|rɪˈgeɪl| |rɪˈgeɪlɪŋ|

verb [trans.]

To refresh, entertain, gratify. To lavish with a feast or drink. To entertain or amuse someone with tales, narrative, works of art. To influence a person in an agreeable manner. To delight.

|reɪˈʒiːm| |ˈdjuːti|

The self-imposed structure of life.
(SEE |brɪk|.)

noun

Care in diet or exercise. A rule or system for the preservation of health, vitality. A rigorous discipline. A way of doing things. A method or manner of rule, influence, or prevalence. A system of government, administration, esp. authoritarian. That to which a man is bound to legally, naturally, or morally. Acts or forbearances required by religion. That which is owed to another, one's due, i.e., debt. An obligation of office, station, rank. A task that one is required to perform.

|ˈriːdʒ(ə)n| |ˈprɒvɪns| |land| |landz| |ˈkʌntri|
|steɪt| |rɛlmz|

*As man grows to encompass all the earth in his dominion,
the world becomes crisscrossed with invisible lines
demarcating the membranes between different beliefs,
legal systems, languages, and realities.*

noun

The earth, as distinct from the water. The ground elevated from the sea. An expanse comprising many natural features. A part of the earth marked off by legal boundaries. A section of ground governed by a particular government. A nation, principality, city, republic, kingdom, or other legal entity. An area of the earth discrete from the rest and defined by geological features, language, culture, climate, or other characteristic. A conquered nation, a part of a nation with local government. A tract. A part of space. An area with a larger area. A part of the body. An area of enquiry. The area outside of a city. The exurban world. Nature. Agricultural areas. A domain. A king's fief, kingdom. An area governed by a certain set of rules or authority.

r

|rɪˈgəːdʒɪteɪt| |ˈvɒmɪt|

When the world pleases not the man,
he may send it back whence it came.
If a man truly loves the world he may try to keep it
within him forever. Yet matter cannot forever be
contained and eventually he will be forced to make.
(SEE *|dʌŋ|.)*

verb [trans. & intrans.]

To throw back, to pour back. To cast from the stomach. To pour out from the mouth food or drink previously swallowed. To discharge from the stomach and out of the mouth.

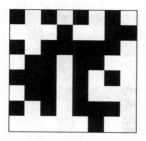

|riːhəˈbɪlɪteɪt|

verb [trans.]

To restore by formal declaration. To re-establish the character or good name of someone. To restore to a previous condition, esp. building. To restore to normal health, vitality. To make decent.

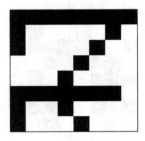

|rɪ'vʌlʃ(ə)n| |skɔːn| |skɔːnd|

noun

A sense of disgust or loathing. A profoundly visceral aversion to a thing, person, or idea.

verb [trans.]

To scoff. To express contempt or derision for someone or something. To hold in disdain, contempt. To feel it beneath one to perform an action.

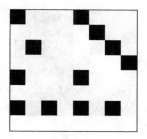

|rɪˈleɪʃ(ə)n| |ˈrɛlətɪv|

noun

The manner of belonging to a person or thing. The manner in which two or more things are connected, esp. family. A kinsman or kinswoman. Respect, reference, regard. The influence of one thing upon another.

adjective

Corresponding. Pertinent, relevant to the matter at hand. Depending upon, existing only through a link with something else. Not independent or absolute. Proportionate to something else.

r

|rɪˈliːs| |rɪˈliːsd|

The anima set free from the clutch of the body.

verb [trans.]

To set free from confinement or servitude. To enable to escape. To set free from pain, kill. To free from obligation, allow to become available for other activity. To quit, let go. To allow to circulate. To relax, slacken, remove a hold or stop.

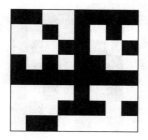

|rɪˈlʌkt(ə)ns|

The longer the path,
the more difficult it is to begin to walk.

noun

Unwillingness, repugnance, struggle in opposition. Disinclination to do something. The resistance of an electric circuit to magnetic flux.

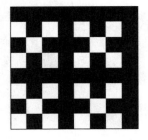

|rɪˈmɑːkəb(ə)l|

adjective

Observable. Worthy of note, comment, scribing. Striking, attention-drawing. Extraordinary, unusual, singular.

r

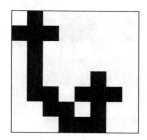

|rɪˈmɛmbə| |rɪˈmɛmbəd| |rɪˈkɔːl| |kɔːl|
|kɔːld| |ˈkɔːlɪŋ|

*For the mind of man, the present is an inferno of heat, light, spectacle,
and wonderment raging ever onwards into the future.
When he feels introspective he may pick a path back through his
consciousness to mull over some charred remains and ashes.
From such poor residues little can be gleaned. As his conscious present
hovers over the decayed memories they are reignited.
They are consumed in the act of recollecting, becoming now a pyre
commemorating forever only the reflection of his own reflections.*

verb [trans.]

To bear a thing in the mind. To impress a memory upon the con-
sciousness. To put in the mind, to force to recollect, to remind.
To retain. To not forget to do something. To call to mind a thing
forgotten. To bring to the front of the consciousness knowledge,
language, images, or behaviours previously inaccessible. To conjure
memory. To recount to others events, narratives, facts. To name,

767

r

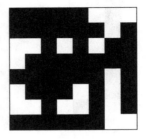

|rɪˈpɛː|

verb [trans.]

To restore any injury, dilapidation, or decay. To fix, mend, or make as new. To temporarily return to a good condition. To replace parts that are damaged, corrupted, decayed.

767 |rɪˈmɛmbə|

denominate. To summon, invite, convoke. To cry or make an inarticulate noise. To name a child, person, object, idea, notion, or anything that can be imagined.

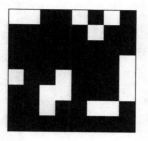

|rɛpjʊˈteɪʃ(ə)n|

noun

The opinions or suppositions generally held about someone or something. The general estimate of character or other qualities. The condition, or fact of being regarded, esteemed. Credit, honour.

r

|rɪˈzʌɪd| |rɪˈzʌɪdɪd| |rɪˈzʌɪdɪŋ| |əˈbəʊd| |ˈsɛt(ə)lɪŋ|

verb [intrans.]

To dwell, be present in a place. To have one's permanent home in a certain place. To live in an area. To place in a certain state without disturbing. To fix to a way of life. To establish, confirm.

noun

Habitation, dwelling. A house or home.

|ˈrɛzɪd(ə)ns| |ˈrɛzɪd(ə)ntz| |ˈrɛzɪd(ə)nt|

noun

The act of dwelling in a place. The fact of living or staying in some place for the discharge of a duty. A house of a superior kind, mansion. A person or animal living within the confines of a structure. A long-term tenant. One who lives in a place permanently. (SEE ▢ |haʊs|.)

r

|rɪˈzɒlv| |rɪˈzɒlvɪŋ|

The diffused parts recombine into their original pattern.

verb [trans. & intrans.]

To free from doubt or difficulty. To solve, make clear. To settle or find a solution. To heal, disperse, or subside. To make an image perceptible. To separate a thing into its constituent parts. To decide firmly on a course of action.

|ˈrɛspʌɪt| |rɛst| |sliːp| |sliːpɪŋ| |slɛpt| |əˈsliːp|

Children fear the coma of the night as men fear to die,
and as that natural fear is increased with tales so is the other.
To enter the land of dreams is to leave the body undefended
by the spirit, leaving it fragile and vulnerable to marauders. Yet when
children grow into men and leave behind the dark it is not
the day they learn to fear: there are some who say that it is when
the body strides in the sun that one should beware,
since it is really only during the day that we are vulnerable. For it is
throughout this time that, on a distant plane in another place,
the soul lies dormant, fragile and exposed to marauders.

noun

A suspension from a sentence or judgment. A suspension of suffering, anguish. Reprieve. Pause, interval. Repose. A delay in time. The cessation of labour. Leisure. The relief from daily activity. Freedom from toil. Cessation of movement. Absence of motion. Mental peace, tranquillity of mind. The unconscious state regu-

773

'r

larly assumed by man and animals. Slumber. To be dead to the world while still breathing. To be dormant, hibernating.

verb [intrans.]

To be in a state of quiescence. To be dormant. To be unconscious or dreaming, esp. at night.

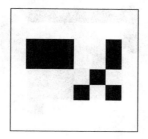

|rɪˈspɒnsɪb(ə)l| |ˈbəːd(ə)n| |ˈbəːd(ə)nz|

*That which men carry on their shoulders that others
may or may not be able to see.*

adjective

Answerable, accountable. Being the primary cause of something
and therefore blamed or credited for it. Capable of discharging an
obligation. Having a duty to do something or being charged with
controlling or caring for someone or something.

noun

A load, something to be carried, esp. a heavy item. A wearisome
task or obligation. A sin, sorrow. An expense.

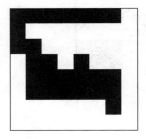

|ri'zəm(p)ʃən|

noun

The act of pursuing a thing or task after a pause or interruption. The action of commencing once more. Taking up again. The reassuming of possession, recovery of something.

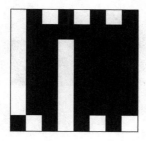

|ˈrɛdəsəns|

noun

Concealment by silence. The maintenance of silence. The avoidance of saying much or speaking freely.

r

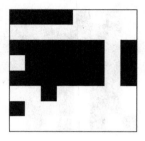

|rɛvəˈluːʃ(ə)n|

The sundering of a state of being.

noun

The orbit of a celestial being. The turning upon its axis of a world, satellite, or other thing. The act of turning about a centre. The course of a thing that returns to the point from which it commenced. The overthrow of a system of belief, methodology and replacement with a new one. Alteration, change, mutation. A sudden change in the state of the government of a country, nation. The forceful replacement of one ruler by another.

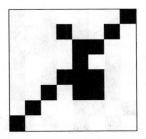

|rʌɪd| |ˈraɪdɪŋ|

verb [trans. & intrans.]

To travel on horseback. To be borne by an animal. To sit upon and control the direction and movement of a creature, vehicle. To be supported in motion. To be taken by a movement. To be supported by a momentum. To carried by any vehicle on earth, water, air, vacuum.

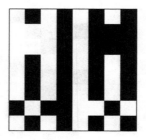

|rʌɪt|

adjective

Morally good, justified. Fit, becoming, true. Not erroneous or false. Not mistaken. Straight, not crooked.

noun

The truth. The law of nature or of the divine. That to which one is morally or legally entitled. A claim.

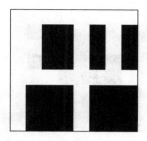

|ˈrɪɡə| |ˈdə rɪˈɡəː|

noun

Stiffness. Severity in dealing with a person, extreme strictness. A strict application of laws, rules, methods. Distress or hardship. Severe exactitude.

adjective

Strictly enforced. Required by etiquette. Currently fashionable. Demanded by current social conventions or forms.

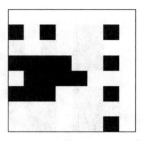

|rʌɪz| |rōz| |əˈrəʊz| |rʌɪzɪŋ| |raʊz|

*The giant awakens, scattering clouds from his mind
and crumbs from his belly.*

verb [trans. & intrans.]

To move up the vertical plane. To motion towards the heavens. To ascend as the sun in the morning. To move from a lower position to a higher one. To get up from rest. To leave one's bed, esp. in the morning. To spring, grow up. To emerge, become apparent. To come into being, originate. To wake from rest or slumber. To excite to thought or action.

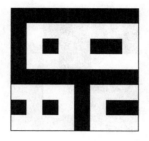

|ˈrɪtʃʊəl| |ˈrɪtʃʊəlz| |ˈrɪtʃ(əw)əˈlɪstɪk|

Every day men utter these words again and again.
And as their speech flows into the air, the walls between worlds weaken.
And for the briefest instant quintessence flows across.
(SEE 🔲 *|wɔːl|.)*

noun & adjective

Ancient rites. The solemn religious ceremony performed in honour of a particular divinity. A magical belief system based around significant actions, substances, and spoken invocations. A ceremony performed by a minister, pope, shaman, magician, or alchemist to penetrate through to other realms unseen to waking men. A repeated action with supernatural consequences, esp. sacrifice, orgy, feast.

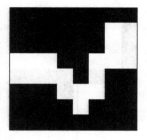

|ˈrɪvə| |striːms|

noun

Running water. The course of running water, a current. Anything that issues from a source and pours. A thing forcible and continued. An outbreak of water. A copious pouring of water containing fish, men, boats. A flow of tremendous liquids from the snows of the mountains to the oceans far below and finally into the great abyss.

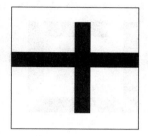

|rəʊd| |rəʊdz| |ruːts| |striːt| |striːts| |leɪn|
|pɑːθ| |treɪl|

noun

A mark upon the ground. A beaten track in the forest. A sign of the passage of a person or thing. A way. A narrow course to be taken solely by foot. A line of communication between two places wide enough to carry vehicles, horses, or engines. A narrow way between hedges, houses, or other structures. A winding course. A paved way between houses. A course, avenue, boulevard in a town or city. A public place. A course, direction. A conduit for action. A way of travelling from one point to another. The means to a destination, objective.

r

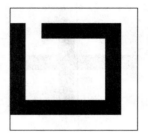

|ruːm| |haʊs| |həʊm| |ˈkabɪn| |ˈlɒŋhaʊs|

As the body holds the mind, the edifice holds the body.

noun

Space or extent of space. Unoccupied space. Space that is available. An interior portion of a building divided off by walls or partitions. A chamber, compartment. An apartment within a larger building. A small chamber in a ship. A compartment within a ship or other vessel. A building where a man lives. A place of abode. A private dwelling. One's own country. The place of constant residence. The manner in which one lives. Family of ancestors, descendants, relatives. The ordinary dwelling place of a family. A building for human occupation. A building for occupation by a deity, place of worship. A house for human occupation other than an ordinary dwelling (SEE ⬛ |ˈskuːlhaʊs|; ⬛ |ˈwɒf(ə)l|; ⬛ |haʊs|.) A building of extraordinary length. An edifice containing family, extended family, and animals under one roof. A traditional dwelling of Scandinavians, Germans and other native European savages.

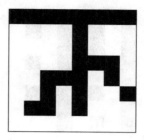

|ruːts|

*As far as a tree reaches up into the sky and across the fields
so too does it reach down through the earth.
The very tallest trees are said to grow so deep that
their fibres tickle the nose of the Devil himself,
which is thought the reason for his dour disposition.*

noun

The part of a plant that reaches into the ground and supplies it with nourishment. The fibres and branches of a plant found underground used to convey water and nutrients. The bottom or lower part of a thing, the part of an object embedded in another structure. The original, first cause. The source of something. The ancestry of a person, language, music, etc. The quantity or number multiplied by itself that equals the number demanded.

r

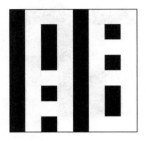

|rəʊ|

It is the tendency for nature to favour chaos and disarray.
When a field is left untended plants and weeds sprout far and wide,
disrupting the ordered plantations of man. If a traveller
comes across an arrangement of crops perfectly ordered and geometric
with no human agency about he understands at once that
he is in the presence of a malevolent influence and departs immediately.
Thus when the astronomers point their telescopes to the skies and
observe the purely ordered motions and laws of the heavenly bodies, it is
with trembling hands that they pen in the figures of their findings.
(SEE ▬ |lʌɪn|.)

noun

A rank or file. A number of persons or things arranged in a line. A
horizontal line of characters, numbers, or words.

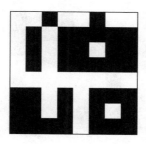

|ˈrʌbə| |ˈrʌbəz|

One of the signs of the Modern Materials.
(SEE ▰ *|ˈplɑːstə|.)*

noun

Caoutchouc. An elastic polymeric substance derived from certain trees grown in the tropics. A range of synthetic organic polymers having the same properties as the original substance. The latex of a living organism. A Modern Material used to coat the underside of shoes.

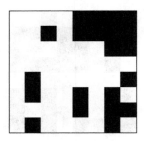

|ˈruːɪn| |ˈruːɪnəs|

The night encroaches upon the solidity of the day that crumbles before it.

noun & adjective

The fall or destruction of edifices, cities, and civilisations. The remains of a building demolished. The state of falling down. The decay or lapsing of a society. Physical collapse, disintegration, destruction. Disastrous decline. Devastation.

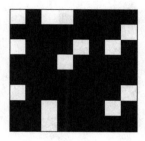

|ˈrʌmb(ə)l| |ˈrʌmb(ə)lɪŋ|

verb [intrans.]

To make a low, hoarse, continuous noise. To make the sound of thunder. To make thunder in the bowels, or the sound of. To move or travel with a continuous murmuring or low rolling sound.

'r

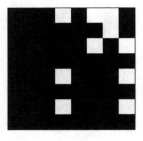

|ˈruːmə|

*Truth and speculation breed and their progeny populates
the earth with delightful fantasy.*

noun

Hearsay, gossip not based upon definite knowledge. A circulating
story without clear evidence or of doubtful veracity.

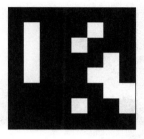

|ˈruːməz|

noun

Widespread talk of a favourable or laudatory nature. Of being generally talked about. Reputation, renown. Circulating stories of deeds and actions of doubtless veracity.

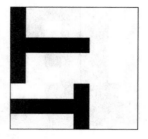

|rʌn| |rʌnz| |rʌnɪŋ| |ˈrʌnə|

verb [intrans.]

To move swiftly. To ply the legs in such a manner that both feet are off the ground at the same time. To remove the body from contact with the surface of the earth. To strive against the natural order and gravitational field. To exert one's body in a holy, devotional, or ritualistic act. To go at a faster pace than walking. To jog, exercise. To cover the ground, make one's way. To hurriedly travel to places. To pass easily through a place, point, person, or thing. To cover in space what one may not cover in time. To escape, flee. To be pursued by a thing real or unseen.

noun

The spell of taking flight. The action of moving quickly through space Racing, fleeing, coursing, accelerating. The occupation of an athlete. A racer. A messenger. A bird.

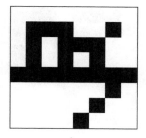

|ˈrʌstɪk|

A structure felled from trees and laid upon the ground
as opposed to a structure sourced from
the bowels of the earth and erupting from her.

adjective

Pertaining to the country rather than the town. Having a simplic-
ity or charm associated with the rural. Mannered like a country
person, i.e., lacking in elegance, refinement or education; devoid
of good breeding, rough, boisterous, rude, savage. Constructed in
a plain and simple manner. Unsophisticated. Made of untrimmed
branches or rough timber. Unmodern.

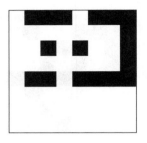

|sak|

noun

An unsewn pocket carried about in the hands or placed in barns and warehouses. A large oblong shape open at one end. A bag or pouch. Commonly a large bag made of goats' hair, burlap, fibrous materials, plastic, or paper. A container for the storing or conveyance of corn, flour, fruit, potatoes, wood, coal, or other goods.

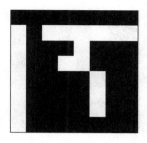

|ˈsakrıfʌıs| |ˈseıkrıd|

An offering whose essence opens an aperture in the barrier between the world of gods and men. The prey of deities.

noun

An offering to heaven, an immolation. The slaughter of an animal or proffering of an object for a deity to consume, often through fire. The ritual death of a person, being, or thing. That which is offered to the gods upon an altar. The Eucharist, the offering of the flesh of a prophet in ritual, the pouring of drink or casting of food upon the ground for the benefit of the dead, ancestors. The destruction or surrender of something valuable for a higher claim, purpose. One destroyed by the will of another.

adjective

Consecrated. Set apart for religious use. Especially connected to or influenced by a deity. Of a place more observed, preferred, habitually frequented by a deity or other supernatural phenomenon. Hallowed. Doctrinal. Not secular.

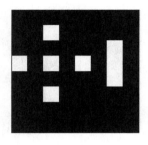

|sad| |ˈsadli| |ˈdəʊlfʊl|

adjective & adverb

Sorrowful, full of grief. Of a person leading a regular ordered life, trustworthy, grave, serious. Feeling or showing unhappiness, regret. Of a heavy-hearted, mournful, disposition. Unfortunate, regrettable, deplorable, shameful. Of a sorry, miserable state. Dismal. Melancholic, afflicted. Feeling grief.

S

|sɒlt|

*The sign of the Preserver.
It gives all bodies consistence and preserves
them from corruption.*

noun

The substance sodium chloride found in solution or in white crystalline form. An abundant material existing as rocks, diluted within the sea, and elsewhere in nature; it is easily soluble in water. A condiment in cuisine, used for the preservation of meat and in manufacturing processes. One of the principal tastes of the human palate. A sensation either good or evil depending on quantity, mood, or sophistication.

|seɪm| |ʌɪˈdɛntɪk(ə)l| |ˈtiːdɪəs|

All instances deriving from a single original.
The pure conception of a thing found in the immaterial realm.

adjective & adverb

Being of a like kind. Not numerically or qualitatively different from that previously mentioned. Not different. Unchanged from a previous time. Agreeing in material, constitution, qualities, or meaning. Being as close to another as to suggest describing both with the same word, epithet, distinction. Wearisome by continuance or likeness, irksome, dull, tiresome. Of a journey, narrative, lexicon; repetitive and unchanging. Monotonous.

pronoun

Not different from that previously mentioned.

|sand|

noun

Loose pale yellowish particles of stone not conjoined. The powder formed from the destruction of a rock. Comminuted fragments and water-worn particles of siliceous rocks finer than gravel. A grainy material, irritant, abrasive. The material of beaches, the beds of rivers, and the vast deserts of the land.

|ˈsanɪˈtɛːrɪəm|

In this building men's minds wander to the edge of reason.
And teetering upon the precipice, leaning out over
the edge, they catch glimpses of the shadows and figures
that beckon from the other side.

noun

An establishment for the reception and medical treatment of invalids. A temple of the Numinous. A place which due to its location, climactic conditions, or psychic aspects is particularly suited to the treatment of the mentally ill.

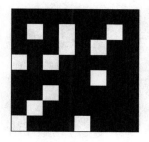

|ˈsɑːkaz(ə)m|

Truth spoken as falsehood, lies spoken with candour.

noun

A keen reproach. A taunt, jibe. A bitter expression. Used with irony or contempt.

803

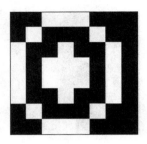

|ˈsat(ə)n| |səˈtəːnɪən| |ˈstatjuː|

The principal god until dethroned by the Supreme Being. The youngest son of Heaven and Earth, he overthrew and castrated his father and then married his sister. Because he was fated to be overcome by one of his male children, he swallowed all of them as soon as they were born.

He is associated with The Golden Age, an idealised era of prehistory which he ruled. He symbolises a hungry greed for life that can never be sated. The alchemists associate him with lead, the heaviest and basest of the common metals. The philosophers associate him with the colour black. He is also personified as the sixth planet of the solar system, six itself being a corrupting number. In addition, its satellites number eighteen—the product of six and three. Astrologers associate the planet with extraordinary powers of evil as it symbolises obstacles of all sorts, barriers, dearth, misfortune, impotence, and paralysis. (SEE ✻ *|sɪks|.)*

noun

An image. A solid representation of a living being. A sculptured, moulded, or cast figure, esp. of a deity. A life-size simulation of a person. A type of silence or absence of movement or feeling.

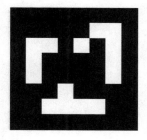

|ˈsavɪdʒ| |ˈsavɪdʒz| |bɑːˈbɛːrɪən|
|bɑːˈbarɪk| |ˈhiːð(ə)n|

*An individual or society that seeks to remove
itself from the bounds of natural civilization and
consort with the beasts of the forests.*

noun & adjective

One that is in a state of nature. A wild being, untamed. Of lands
that are uncultivated or unpaved with stone. Not civilized. One
who shuns avenues, boulevards, and arcades. Fierce, violent, and
uncontrolled. Debased, profane. One who is not monotheistic. A
polytheist, pagan. Unpolished, uneducated. One whose tongue
forms an incomprehensible babble. A foreigner whose language
and customs differ from the speaker's. One outside of the pale of
civilization. An outsider. An uncultured person.

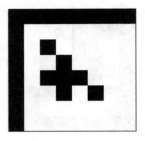

|seɪv| |seɪvɪŋ|

The fall into the wing of another.

verb [trans.]

To preserve from danger or destruction. To deliver or rescue from peril. To preserve finally from eternal death or religious wayward-ness. To not spend or hinder from being spent. To keep and store up. To reserve or lay by. To spare.

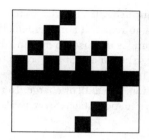

seɪ		sɛz		sɛd		spiːk		spiːkɪŋ		spəʊk
spiːtʃ		tɔːk		kleɪm		kleɪmd		ˈlaŋgwɪdʒ		
kəˈmjuːnɪkeɪt		ˈvəʊk(ə)l		vɔɪs		ˈkɒmɛntɪd				
ʊks		ˈɑːnsəd		ˈmɛnʃ(ə)n		kənˈvəːs				

The thought strikes the material plane and reverberates
around the world as the genius of man.

verb [trans. & intrans.]

To express articulate sounds. To conceive of words in the mind and
to throw them from the mouth. To utter in parlance. To tell. To pro-
nounce. To dispute, discourse, make mention. To exchange ideas,
thoughts, information through fluent and familiar intercourse. To
prate empty or trivial words. To convey rumours, gossip, or idle
censorious tales. To impart to others what is in our possession. To
share or exchange, news, ideas, information. To pass on, reveal or
impart knowledge, experience. To wheedle, to flatter, to humour. To
influence by flattery, caresses, or blandishment. To express an opin-

ion or reaction. To furnish with remarks. To refer to briefly without entering into detail, to remark upon incidentally. To make an assertion that something is the case. To demand of right. To require authoritatively. Not to beg or accept as a favour but to exact as due. To be responsible. To satisfy a petition or demand. To articulate a response to a question, demand, or charge. To respond physically or ideologically to a situation, state, threat, rival.

noun

Sound emitted by the mouth. The sound pushed from one's breath. The tongue of one nation as opposed to another. A dynamic set of visual, auditory, or tactile symbols of intercourse. A system of encoded place-makers representing ideas and concepts that come to reflect back upon the symbols themselves. A system of discussion made up of discrete particles of information organised by a universal grammar or syntax. The sound of a human or other creature singing, mating, arguing, philosophising, or delighting in its own articulacy. Utterance or expression. Oral dialogue. Vote, suffrage, opinion expressed. The privilege of participating in a legislative body or counsel. The judgment or wish of the people. Colloquy. The demand of a thing as due. The possession of a title, lands, or dominions.

adjective

Uttered by the mouth. Oral. Related to articulate speech. Expressing opinions or feelings loudly and freely. Giving vent to one's views or opinions.

|skeɪl|

The sign of Libra in the Zodiac.

noun

An apparatus used for weighing. Two vessels suspended and sep-
arated from each other by a beam. A statue displayed outside of
courthouses. A graduated range of values for measuring or grading
something. There is no absolute measurement for man, all quanti-
fication exists as a relationship between one graduated system and
another. (SEE ▮ |ˈkɪləˈmiːtə|; ▬ |mʌɪl|.)

|'skɛptɪks|

The disciples of Pyrrho.

noun [pl.]

Those who doubt the possibility of real knowledge of any kind. Those who whip Truth and drive her from the city tarred and feathered. The school of thought that asserts there is no certainty to the truth of any proposition. Those who dispute the universality of rational, logical, or reasonable conjectures. They who doubt the validity of orthodox scientific, artistic, or theological systems. The deniers of gods and deities. The mockers of ghosts, spectres, dæmons, and sprites.

|ˈskɒlə|

The scribe of knowledge marks a pale, insignificant
scratch alongside the great arcs of the universe.
(SEE |ˈnɒlɪdʒ|.)

noun

One who learns of a matter, a disciple. One who is receiving or has taken instruction or training from a master, educator, or professor. A lower member of a university or school. A man of letters. A keeper of knowledge. A lover of books, pedant. A specialist in a branch of academics. A reputed or respected authority in the arts.

|ˈsʌɪəns| |sʌɪənˈtɪfɪk|

*The natural philosophers that examine and speculate about
the nature of things come across structures and rules
underpinning everything, from the smallest whiffs of energy to the
flux and bulging of space in the proximity of stars.
Whence these rigid rules and elegant formulations come they refuse to
speculate, deferring to the wisdom of theologians. While they have
probed the membrane of our reality with sharp instruments they have
discovered alarming correspondences between seemingly disparate
fields, such as the distribution of primes and the distribution of energy in
materials. The great foreboding these revelations invite most often
infuses these men with a numinous psychology. Many is the renowned
scholar, who, peering through equations by candlelight,
thinks to have caught sight of this terrible intelligence and has been
subsequently lost to the epileptic frenzy invoked.*
(SEE ▬ |lʌɪn|; ▮▬ |dʒɪˈɒmɪtri|.)

noun & adjective

Natural Philosophy. Knowledge. Certainty grounded in demonstration. A branch of study concerned with a connected body of demonstrated truths or facts brought under general laws. That which may be known by physical experiment or by abstract proof. The arts of nature. An investigation into the underpinnings of nature, the universe, and man. That which may be proved or disproved through observation or experiment.

|skriːm| |skriːmɪŋ|

A cry that pierces the awareness.

verb [intrans.]

To cry out shrilly in terror or agony. The loud piercing cry of beasts, birds, and persons.

|ˈskʌt(ə)l| |ˈskʌt(ə)lɪŋ|

verb [intrans.]

To run with quick hurried steps. To move in a precipitated and undignified manner. To move like an insect or rodent.

|ˈsiːkrɪts| |ˈsiːkrɪtɪv| |ˈsiːkrɪtɪd| |ˈprʌɪvət|

The sign of the Arcana. Knowledge from the forbidden or modern realm.
(SEE |ˈplɑːstə|.)

noun

Something studiously hidden. A thing unknown, yet to be discovered. Of actions, negotiation, agreements meant to be concealed, clandestine. Hidden from comprehension. Removed from the resort of man, lonely, secluded.

adjective

Restricted to a small number of people, not public. Not open to all. Addicted to reticence, not frank. Inclined to conceal feelings or intentions.

verb [trans.]

To put aside, hide. For a cell, gland, organ, or creature to discharge a substance.

|siː| |sɔː| |siːɪŋ| |sʌɪt| |siːn| |pəˈsiːvd| |ˈɒnlʊkəz|
|ˈvjuːəz| |əʊvəˈlʊk| |rɪˈɡɑːd|

The power of striking the eye with images.

verb [trans. & intrans.]

To observe by the eye. To apprehend the external world through light, colour, motions, shapes, and patterns. To eye. To behold visual objects in the imagination, in dream, through trance, as conjured in great literature, in hallucination, in prophecies. To apprehend immaterial abstract truths, mathematical principles. To behold using instruments such as radar, cameras, satellites in the sky. To discover through the senses. To apprehend in the mind, become conscious of, discern something. To interpret, look on, understand a situation in a particular way. To discern something hidden or not immediately obvious. To view from a higher place. To neglect to observe. To attend to as worthy of notice. To pay attention to. To consider something in a particular way.

noun

The faculty of vision. A thing apprehended by the eyes, esp. of a striking or remarkable nature. An open view, a situation in which nothing obstructs the view. A spectator, observer. A beholder. One who looks but does not participate. A person appointed to examine a thing. One who views a thing closely or with attention and interest. Respect, point, particular.

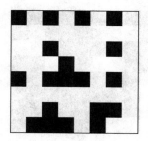

|siːp| |siːpd|

verb [intrans.]

To ooze, drip, trickle. To leak slowly through small holes or a porous material.

|ˈsɛnsɪtɪv|

A soul easily distorted.

adjective

Quick to detect or respond to slight changes, signals, or influences. Highly irritable. Feeling things quickly or acutely. Easily touched by emotions, wounded by unkindness. Receptive to hypnotic or occult influences.

|sɛnd| |sɛnt| |sɛndz|

A surge of intention slipping across the void.

verb [trans. & intrans.]

To dispatch from one place to another. To order or request a person to get to a place. To dispatch a messenger. To cause to move suddenly or propel. To emit, produce at a distance. To cause to change emotional states dramatically, put into ecstasy.

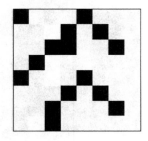

|ˈsɪəriːz|

*Wave upon wave striking and breaking upon each other
in an orgy of cause and effect.*

noun

Sequence, order. A number or set of things arranged contiguously or in regular intervals. A causal chain of events. A temporal succession of interrelated occurrences. The ricochet nature of reality. Course, succession.

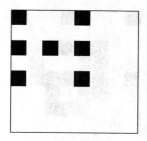

$$|\text{'sɛv(ə)n}|$$

cardinal number

The sum of three and four, six and one, two and five. More than six but less than eight. The number of colours in the rainbow. According to primitive belief systems the number of days in which the world was made. The number of days in one week. The number of discrete elements in a single sequence that a person can easily remember.

ˈʃ

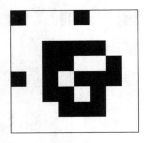

|ˈʃak(ə)lz|

A hand of iron that grips the physical flesh.

noun [pl.]

Fetters, chains for prisoners. Metal bound to fasten a prisoner's wrists or ankles together.

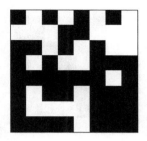

|ʃeɪk| |ʃʊk|

Light and dark mix and swirl vigorously.

verb [trans. & intrans.]

To move quickly and irregularly to and fro, up and down, toward and away, from side to side, around and around, back and forth, or in another violent manner. To quiver, vibrate, waver. To make things that are usually still tremble. To disturb the equilibrium of a person. To cause to lose composure. To totter. To agitate from emotion, fear, laughter, mirth.

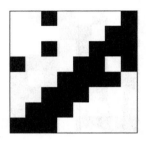

|ʃeɪp| |ʃeɪpt|

noun

The form, external appearance. The contour, quality of a material object or geometrical construct. The impressed form. The outline of a figure, person, work of art, discrete object. Being as moulded into form. The inward psychic essence as expressed externally by its corresponding configuration.

verb [trans.]

To give a particular form to something. To mould or cast to a physical dimension. To create, fashion. To influence or determine character, qualities, ideas.

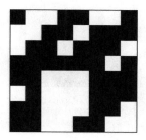

|ʃɑːd| |ʃɑːdz|

noun

A fragment of a vessel. A piece of broken ceramic, metal, glass, rock, or plastic typically having sharp edges.

ʃ

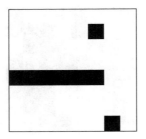

|ʃɛː| |ʃɛːd|

A thing separated and given equally.

verb [trans.]

To divide, part amongst many. To receive, possess, or occupy with others. To hold the same characteristics or qualities. To have a portion with others. To partake in an enterprise, risk, venture with others.

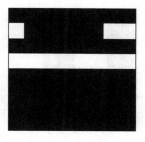

|ʃɪə|

adjective

An abrupt deviation of a vessel from her course. The abrupt perpendicularity of a wall, cliff, or precipice. A very thin, diaphanous quality of a material. That and nothing else, unmitigated, unqualified, downright, absolute, pure.

ʃ

|ʃiːt| |ʃiːts| |pleɪnz|

The sign of pure two-dimensionality.

noun

A flat geometrical surface which has the property that every line
or point lies flat. An imaginary or hypothetical flat surface upon
which objects may be represented. A completely level surface. A
degree of awareness of the interpenetrating levels of existence of
which the universe is constituted and through which it is evolv-
ing. A realm or psychic kingdom in which the consciousness, body,
soul, or deities may reside for a given time. A broad and large piece
of linen. A fabric placed upon a bed. A rectangular piece of paper,
esp. the one you are holding right now. A leaf of a book, piece of
paper used for writing, drawing, or printing upon. A contiguous
unbroken surface.

|ʃɪp| |ʃɪps| |bəʊt| |bəʊts| |ˈvɛs(ə)l|
|jɒt| |seɪl|

noun

A thing that holds dry goods, liquids, or any other thing. A large hollow building designed to float upon water and to contain, men, dry goods, liquids, or any other things. A craft used to travel underwater, above water, through the sky, or through the ether. An airship or hovercraft. A spacecraft. A craft larger than a boat capable of navigating large rivers, lakes, seas, or oceans. A light fast-moving craft used for pleasure, excursions, cruising, and racing. The expanded sheet that catches the wind and motions a craft across the waters.

ʃ

|ʃuː| |ʃuːz| |fʊt| |fiːt| |ˈfʊtstɛps|

The limb that strikes the earth and takes
man where he wishes to go.
It marks the paths which, for good or ill,
are chosen by the exercise of free will.

noun

The part upon which we stand. The principal contact between a
creature and the world. The limb through which the electromag-
netic and psychic energy of a being is grounded. The organ of
locomotion. The lowest part of the leg below the ankle joint. The
lowest part of anything. In some cultures believed to be the re-
pository of the soul since it is the basis of the upright stance of
man. Vulnerability in (Achilles) and injury to (Hephaistos) are
seen as symptomatic of a corrupted soul. That by which anything
in nature is supported. The tread of a person. The mark or print
made by a step. A vestige, trace; material or immaterial remnant
of a person's achievements. A pedaneous outer covering usually

|ʃɒp| |ʃɒps|

*Three layers. On the right the Object of Desire,
at the centre the Exchange of Energy, and in the top left
the Exterior World into which the thing will be sent.*

noun

A place in which anything is sold. A store. A building or part of a building dedicated to the preparation, or sale of goods. A room set apart for the sale of merchandise. A place where things are manufactured or repaired.

832 ▌ |ʃuː|

made of leather, flax, plastics, nylon, cotton, or other materials and shod with a sole of wood, rubber, metal, or cloth. The orifice into which man steps. In classical antiquity sandals were the sign of a free man; slaves went barefoot.

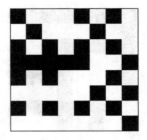

|ʃʊd| |ʃal| |ôt| |ˈwɛðə|

verb [modal]

Used to indicate obligation, duty. Used to indicate what is probable. Used to express a strong assertion. Used to indicate the conditional mood. Used with "that" after a main clause to describe feelings. Used with "that" expressing purpose. Used to express the future tense. Used to express a command. Used in questions or suggestions.

noun

That which should be done. The obligatory. Expressing a moral imperative.

conjunction

Expressing a doubt or choice between alternatives.

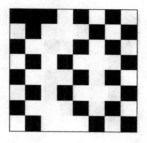

|ʃraʊd|

verb [trans.]

To wrap, envelop. To dress a body for the grave. To cover or conceal.

ʃ

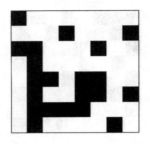

|ʃʊʃ| |ʃʊʃd| |hʌʃd|

verb [trans.]

To signal someone to be silent. To reduce someone to silence by uttering a "sh" sound.

adjective

Reduced to silence, stilled, quieted.

|sʌɪn| |sʌɪnz|

That above the surface refers to that below.

noun

An object, symbol, or event that indicates the probable presence or occurrence of something else. A token of any thing. A mark, device. A gesture or motion to convey or intimate some idea. A picture hung over a door to indicate what manner of goods may be purchased within. A notice. A succinct representation of a more complex and multifaceted original. A symbol of one of the twelve zodiacal constellations. A miraculous or diabolical act demonstrating deific power or authority. A portent, omen.

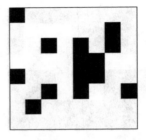

|ˈsɪmə|

verb [intrans.]

To be in a state of gentle activity. To be on the verge of becoming active. To be in a state of suppressed excitement or agitation. To boil gently. To boil with a gentle hiss. To make a subdued murmuring sound.

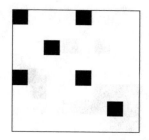

|ˈsɪmp(ə)l| |ˈsɪmpli|

Being little more than the thing itself.
(SEE 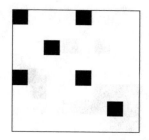 |ðə|.)

adjective

Free from duplicity or guile. Plain, artless, sincere, harmless, un-skilled. Free from elaboration or artificiality. Unadorned. Poor or humble in position. Deficient of knowledge or acuteness. Composed of a single element; not compound.

adverb

With sincerity, in a straightforward manner. Without complication. Merely, just.

S

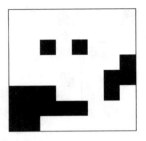

|sɪŋ| |sɒŋ| |saŋ|

verb [trans. & intrans.]

To form the voice to melody. To utter sweet inarticulate sounds as the birds do (the alchemists assert that the birds communicate with one another in the language of the gods and, if one were to understand their speech one could ascertain the secrets of life). To make musical words with notes. To chant or incant in religious ceremony.

noun

A poem modulated by the voice, often set to music. A set of words accompanied by musical composition. An incomprehensible phrase uttered by birds, whales, insects, and dæmons to transmit esoteric knowledge.

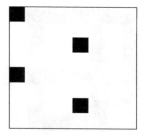

| ˈsɪŋg(ə)l |

To the left the person entering the world.
To the right the person departing the world.
That which truly begins and that which
truly ends can only be accomplished alone.

adjective

One, not double, not one of several. Unique. Consisting of a single part. Separate, distinct from the other parts. Individual.

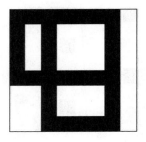

|sʌɪt| |sɪtjʊˈeɪʃ(ə)n|

The divine geometry laid down upon the land.
(SEE 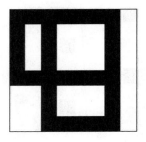 *|pleɪn|.)*

noun

The area of ground upon which a town, building, vessel, monument, or burial chamber is being constructed. Land intended for building purposes. Position, location. Relationship with surroundings. Condition, state. Circumstances in which one finds oneself.

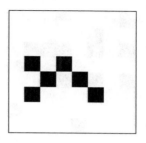

|sɪks|

cardinal number

The natural number larger than five but smaller than seven. The only number that is the sum and product of three consecutive numbers (one, two, and three). It is one of the most important cultural numbers, representing the potential for great good and great evil. As the day in which the Supreme Being created man, it is considered a signifier of the indefinitely counterpoised confrontation of creature and creator. It is almost the exact ratio of the circumference to the radius, (2π), the circle in its infinity representing the numinous realm outside of man. It is the number of limbs of the insect, the creature chosen by the Supreme Being to replace man if he should Fall yet again to a lower plane. It is the number of the minacious planet ⬛ |'sat(ə)n| and a factor of its moons total eighteen. It is the number of sides in three-dimensional space and thus revered by all sculptors. It is the densest arrangement of matter possible—five circles in a touching ring surrounding a central circle that is in contact with the rest—hence an association with

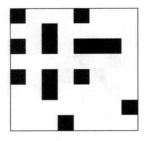

|sʌɪz| |ˈsʌɪzəb(ə)l|

noun

The magnitude, bulk, bigness, or dimensions of any thing. The extent of a person or thing material or immaterial.

adjective

Reasonably bulky. Fairly large.

843 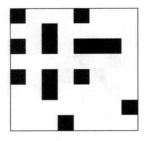 |sɪks|

weight and density. This association with heaviness is the reason men are buried this number of feet below the ground.

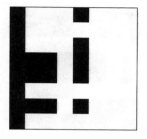

|skɪn| |ˈmɛmbreɪn|

The integument and the filth of the earth lying upon it.

noun

A thin, pliable sheet or layer of material acting as a barrier or lining. A thin sheet of tissue or living cells covering an organ, embryo, or organism. A barrier between the living organism and the external world. A barrier protecting the external world from other dimensions. A barrier through which gases, fluids, of other substances may be exchanged. The natural covering of the flesh. The hide, pelt, fur of an animal or an item made from this. The integument of an animal. The epidermis.

S

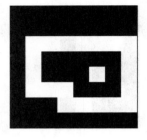

|skʌl|

The Gulgoleth and its Orifice.
The trepanation allows evil spirits to flee the mind
and the subject to enter
more fully into communion with the gods.

noun

The framework of bone or cartilage that encases the brain of man
and other vertebrates. The cranium. The seat of the brain and hence
of thought. European tribesmen commonly take the heads of their
enemies as trophies, often using these as drinking vessels.

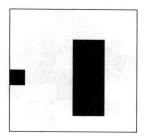

|skʌɪ| |ˈatməsfɪə| |ˈfəːməm(ə)nt|

noun

The region that surrounds the earth. Everything beyond the ground, including the heavens, and the stars. The vault of heaven whether covered in clouds or azure. That which lies above the mountains. The spheroidal envelope of gas surrounding a heavenly body. The terrestrial air. The pervading mood or tone of a place, situation, or work of art.

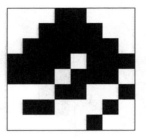

|sleɪt|

noun

A fine-grained gray, green, bluish, or black rock split easily into smooth, flat pieces. A thin rectangle of this material used to cover the roof of a building. The laminæ of a stone broken into pieces and used as tiles.

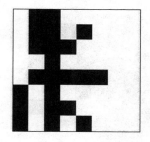

|slʌɪd|

verb [intrans.]

To pass from one point to another in a smooth continuous movement. To glide whilst maintaining contact with a surface. To gradually lower in position of quality.

S

slɪp		slɪps		slɪpɪŋ		slɪpd		fɔːl		fɔːlɪŋ
fɛl		ˈfɔːl(ə)n		səˈkʌmd		səˈkʌm		dɪˈkeɪz		
ˈkrʌmb(ə)lɪŋ		dɪˈsɛndz		ˈtʌmb(ə)ld						

For every step that rises another must descend.
With all accomplishment there is also decline and disaster.
The blade that raises its head above the others
is the first to feel the scythe's edge.

verb [trans. & intrans.]

To escape or get loose from something. To sneak, slink. To pass or go quietly. To glide or steal. To slide, to lose one's footing. To fly out of place. To drop from a higher place. To no longer be held. To lose one's balance and collapse. To be ripe and to drop from a tree. To move downward rapidly. To be accelerated by the pull of gravity. To roll about in the ground, water, or air. To precipitate, stumble violently, move headlong towards the ground. To decrease in number or quality. To be degraded from some high station. To proceed from an original. To be extracted from an ancestor. To

come to a sudden end. To decline from power, for an empire to be overturned. To come to a state of misery. To lose excellence. To decline from a state of perfection. To become gradually impaired. To rot or decompose. For a radioactive particle to change naturally into another one. To fail to resist pressure, temptation, or a negative force. To yield. To break into small pieces, comminute. For a building or structure to collapse into fragments, become ruined.

past participle adjective

Laid low. Having come down from a high position. Ruined, lost innocence. Unpure. Having lost rank, status, privilege.

noun

The state of entropy. The season between the descending equinox and winter solstice.

|sləʊ| |sləʊə| |sləʊlɪ| |ˈgradʒʊəl| |ˈgradʒʊəli|

The ponderous mass as contrasted with the excited particle.

adjective & adverb

Moving or operating at slow speed. Not swift, not quick of motion, not speedy, wanting celerity. Proceeding by degrees. Advancing step by step. Tardy or dilatory in action. Taking a comparatively long time to complete a task. Naturally disinclined to be active or to exert oneself. Mentally slothful. Dull, not intelligent.

|slə:| |slə:ɪŋ|

The tongue tripping over its words.

verb [trans. & intrans.]

To contaminate one's speech. To speak indistinctly, allowing the words to run into each other. To talk indistinctly in an intoxicated manner.

|sməːk| |məːθ|

The absurdity of life gives the bony skull its leering gait.

verb [intrans.]

To smile in an affected, self-satisfied, smug, conceited or silly way. To simper.

noun

Merriment, jollity, gaiety, laughter.

|smɪθ| |ˈsmɪθ(ə)ri| |ˈsmɪθ(ə)riz|

noun

One who forges with his hammer, a worker of metal. A farrier, forger, hammerman. The trade, art, or occupation of the forger. The forge or workshop of a metallurgic artisan.

|snəʊ| |snəʊs|

noun

The partially frozen vapour of the atmosphere falling in flakes characterised by their whiteness and lightness. Small particles of water frozen before accumulating into drops. The accumulation of these flakes upon the ground. A storm carrying frozen precipitation.

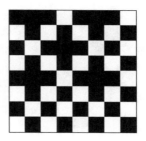

|səʊ|

adverb

To such a great extent. To such a degree. To the same extent. Referring back to something previously mentioned.

conjunction

Therefore, and for this reason, in consequence of this. Thus, in this manner. With the aim that, in order that. Introducing a statement or question.

|sʌm| |ˈsʌmtʌɪmz| |ˈɒf(ə)n| |ˈsəːt(ə)n|
|ˈsəːt(ə)nli| |tʌɪmz|

adjective

More or less, an indeterminate amount. Certain persons. Opposed to others. A small number of. A considerable number of. Expressing admiration for an accomplishment or quality. Sure, indubitable, unquestionable. Established beyond doubt. Resolved, determined. In an indefinite sense, specific but not named things or people.

pronoun

An unspecified number or quality. At least a small amount of people or things.

adverb

To an extent. Undoubtedly, definitely. At one time or another. Now and then, occasionally. Frequently, many times, not seldom.

noun

Unspecified occasions, events, periods.

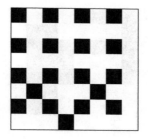

|ˈsʌmhaʊ| |ˈsʌmweɪ|

adverb

One way or another. I know not how. By some manner. By some means.

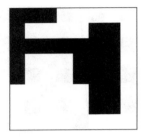

ˈsʌmθɪŋ		θɪŋ		ˈɛnɪθɪŋ		məˈtɪərɪəl
məˈtɪərɪəlz		ˈplastɪk		ˈsʌbst(ə)ns		
səbˈstanʃ(ə)l		ˈɛməneɪtɪŋ				

The sign of the Physical Realm.

noun

Being. That which we can say what it is. The real matter of which people and objects are made. The essential, tangible, solid, real presence. An object without a name. A matter with which one is concerned. An inanimate material object. A living creature. An action, event, utterance. A thing that is unspecified or unknown. Used in an expression to state that a description or amount is inexact. That which forms the stuff of an object. The molecular compound used to manufacture any object, esp. goods, products, statues, earthenware, transistors. Cloth or fabric. A solid compound easily moulded and shaped, esp. in sculpture. A synthetic compound made from a range of organic polymers of high molecular weight that can be moulded, extruded, or cast when it is soft or liquid and then set into a rigid form.

adjective

Of or relating to matter or physical essence. Not spiritual. Corporeal. Tangible. Relating to physical needs, not intellectual or spiritual. Important, essential. Strong, stout, bulky. Of important size. Of a stuff that can be shaped or moulded. Of or like modern synthetic polymers.

pronoun

To refer to all objects, situations, events. To refer to all possibilities.

verb [intrans.]

To flow forth, issue, proceed. For intangible things, gases, effluvia to issue or spread from a source. For immaterial qualities, laws, principles to originate from a physical tangible source.

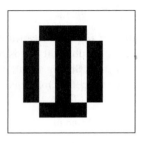

|səʊl| |ˈspɪrɪt| |ˈspɪrɪts|

The immortal essence. The combined male and female agency.
The Vegetative and the Subtle combined.

noun

The immortal and immaterial essence of man. Pneuma. That which
was breathed into the first clay men by The Creator. The breath
of life. The essence of the divine divided and placed equally in all
persons. Animus, Anima. The two pneuma, the vegetative and the
subtle breath combined. The nonphysical part of a person. In folk-
lore a person may sell their anima to the Devil or lesser dæmon
in exchange for earthly powers, but is recognisable for casting no
shadow. The combined intellect and emotions. The Psyche. The
essential character of a person, place, group of people. An appari-
tion. A spectre. A supernatural entity having no corporeal being.

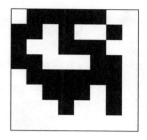

|saʊnd| |saʊndɪd| |saʊndz| |nɔɪz| |nɔɪzs|

noun

The sensation experienced by the organs of hearing upon feeling a vibration in the air. A wave of motion travelling through solid, liquid, or gaseous mediums. A group of vibrations of which speech, music, and poetry consist. The aural realm. An outcry, clamour. A disturbance. A loud and unpleasant dissonance. Random fluctuations that do not carry meaningful information.

verb [trans. & intrans.]

To give an audible form. To be filled with a din. To emit vibrations.

|saʊθ| |ˈsaʊθwəds|

noun & adverb

The direction of earth and heavens directly opposite to the North. An observer facing the rising sun would find it on their right-hand side. In European tradition, associated with the right hand and therefore with good and virtue. The aboriginal Celts go so far as to refer to the left- and right-hand side, by the points of the compass.

|speɪs|

The quantity of place, it is inexorably bound up in time.
The single square reveals that is it is not dead
but a living thing. Though it appears to man as Nothingness,
it is in fact a complex energy state.

noun

The fabric of the universe. Unoccupied, available area or expanse. The void outside of the heavens. The emptiness between celestial worlds. A duration of time, interval. Distance. Height, depth, width. The three-dimensional realm. Of expanses postulated in multi-dimensional theories.

|span| |spanɪŋ|

verb [trans.]

To measure by a hand extended. To extend from one side to another, esp. bridge. To form an arch across or over. To reach or extend over in space and time.

|ˈspɛʃ(ə)l| |ˈspɛʃ(ə)lɪ| |ɪˈspɛʃ(ə)li| |juːˈniːk|

adjective & adverb

Of exceptional character, quality, or degree. To a great extent. Particular, peculiar. Singular. Uncommon. Over all others. Specific to a person or place. Forming the only one of its kind. Solitary. Appropriate, designed for a purpose.

|'spɛktək(ə)l| |'spɛk'takjʊlə|

noun & adjective

A sight. A visual wonderment. A show. Beautiful. A thing exhibited and viewed as remarkable. An event of great visual impact. An entertainment.

|ˈspɛktə|

The accusatory finger of the dead.

noun

An apparition. The non-corporeal appearance of the dead. A ghost, phantom, esp. of terrifying aspect. A phantasm. A shadow instilling dread and terror.

|spɛnd| |spɛndɪŋ| |spɛnt|

verb [trans.]

To pass time. To engage in an activity or duration. To waste, squander. To lavish. To expend money or time.

|spɪl| |spɪld| |spɪlz| |spɪlɪŋ|

verb [trans.]

To shed, lose by shedding, esp. blood. To cause or allow liquid to flow from a vessel upon a surface, usually by accident or mistake. To drop or lose hold of liquid. To allow the contents of something to be emptied out. To lose or waste liquid. To bring to death, slay, kill, empty of blood, spirit, or life.

|spɪn| |spɪns|

Circular motion is the highest and most divine action.

verb [trans. & intrans.]

To draw out a thread and rotate it quickly, twisting it into another material such as wool or flax. To form or make rope, string. To turn or cause to turn rapidly. To whirl. To rotate upon an axis, esp. planet.

|ˈsplɪntə|

The destruction of a traditional material.
(SEE *|brɪk|.)*

verb [intrans.]

To cause to break into small sharp fragments. To break into narrow pieces with jagged projections. To split, burst. To come apart, esp. something made of wood.

|spɔːt| |spɔːts| |spɔːtɪŋ| |ˈkalɪsˈθɛnɪks|
|ˈspɔːtsmən| |ˈaθliːt|

The active spirit striving within the framework of nature's laws.

noun & adjective

Play, diversion, frolic. Exercise. Physically exerting activities performed in a competitive manner against opponents. The contest or spectacle of exertion. The religious or ritualistic bodily regimen. Pertaining to physical vigour and beauty. One who participates in physical contests or games. One who strives for prizes and glory in competition. A powerful, physically robust person. A devotee of pious physical exercises. One who strives against gravity and material restriction.

|spaʊt|

verb [trans.]

To pour with violence. To project a liquid. To forcibly expel a liquid or stream of material, ideas, opinions. To declaim one's ideas at great length and to the ennui of others.

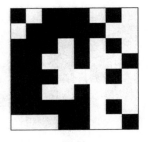

|spred|

verb [trans. & intrans.]

To stretch or draw out. To open out or lay over a greater extent of
space or time. To increase in area. To apply a thin layer. To make a
thick layer thinner by distributing it over a greater surface area,

|skwɛː| |skwɛːz|

The geometrical sign held as the very greatest by the Moderns.
It is opposed to the *|ˈsəːk(ə)l| and hence the*
antithesis of the infinite, the creator, and the transcendent.
The sign of the Temporal as opposed to the Eternal,
the Earth as opposed to the Heavens, and the Demiurge as opposed
to the Supreme Being. Plato believed three to be the number
of Idea and four the number of its Manifestation, thus it has come to be
worshipped in cults as the sign of the sublime solidity of the actual.

noun & adjective

A geometrical figure with four equal straight sides and four angles
of 90°.

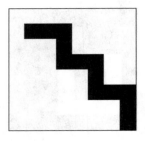

|steːz|

*The symbol of ascent, as knowledge brings the subject
into the higher realm and closer to the divine.
Conversely the symbol of knowledge causing
a descent into the Underground,
the occult, and the depths of the unconscious.*

noun [pl.]

Steps by which we ascend from the lowest part of a building to the highest. Any set of fixed steps such as in a boat, tower, or crypt that allows a person to move in the vertical plane.

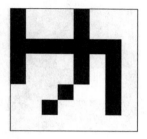

|stand| |stands| |standɪŋ| |stʊd|

The sign of stability.
The distance between the two separated feet.

verb [intrans.]

To resist, endure, not yield. To maintain an upright position. To come to or be upon one's feet. To take up a position on a piece of ground. To not recline or lie flat. For a building, settlement, or object to remain in a specified place. To remain in a state. To rest without disturbance.

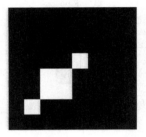

|stɑː| |stɑːz| |ˈgaləksiz| |ˈnɪkələs kəˈpəːnɪkəs|

*The microscopic points of consciousness
in the crushing vastnesses of utter nothing.*

noun

One of the luminous bodies that appears in the nocturnal sky. A fixed celestial body, not a planet. A body like the Sun. A giant ball of luminous plasma fuelled by thermonuclear fusion. One of the largest energy states or accumulations of matter known to man. The souls of illustrious men placed in the night sky. A band or track of innumerable suns. A large group of suns numbering in the millions or billions spinning in the void held together by the influence of gravity. |ˈnɪkələs kəˈpəːnɪkəs| Polish astronomer (1473–1543 CE), the first to formulate a heliocentric cosmology replacing the Earth with the Sun as the centre of the universe. He proposed a model of the planets orbiting the sun in perfect circles.

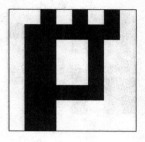

|steː| |steːɪŋ|

When a conscious being fixes their gaze upon the
microsphere he sees the universe blench.

verb [intrans.]

To look with fixed eyes. To look with wonder, confidence, impudence, stupidity, or horror.

s

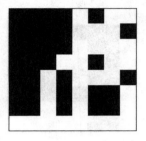

|steɪ| |rɪˈmeɪn|

The particles yet to fade into the dark oblivion.

verb [intrans.]

To forbear departure. To continue in a place, state. To continue to exist. To be left after the removal of another part. To stop, stand still. To wait, attend. To dwell.

noun

The part of a substance that is left. That which is left of a person when they are extinct, a corpse. A relic. Those who have survived, not departed, changed state.

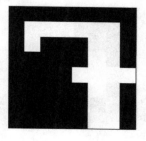

|'stɛdi|

That which deviates only minutely in its inexorable course.

adjective

Firm, fixed. Not tottering, shaking, vibrating. Not wavering, fickle, changeable. Focused. Regular and even in development.

883

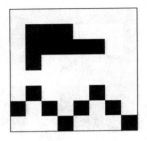

|stiːl|

The hammer tempers the metal to even greater strength.

noun

An alloy of iron and carbon used extensively in manufacturing, buildings, and weaponry. Distinguished from iron by its greater hardness and elasticity.

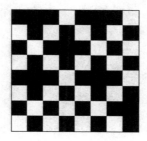

|stɪl| |ʌnˈsweɪŋ| |ˈstagnənt|

adverb

Up to and including this time, until now. Nevertheless, notwith-standing, all the same. Always, ever, continually. In an increasing degree.

adjective

Motionless, stationary, not moving from a place. Not flowing, running hence often unwholesome or unpleasant. Undisturbed, calm. Not influenced or affected. Consistent, unyielding. Void of excitement or activity.

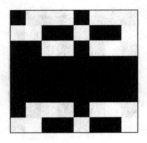

|ˈstɪltɪd|

adjective

Stiff and self-conscious. Unnatural.

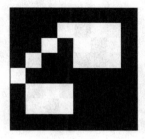

|ˈstʌmək| |iːt| |iːtɪŋ| |iːts| |dʌɪnɪŋ|

The external void joined to the internal void.

noun

The ventricle in which food is digested. The internal organ that constitutes the first part of a mammal's digestive system. The part of the body between the chest and thighs. Belly. The pit into which the external world is thrown.

verb [trans. & intrans.] & verbal noun

To devour with the mouth. To masticate solid food and swallow it. To consume. To eat a meal, esp. dinner. To corrode part of a substance.

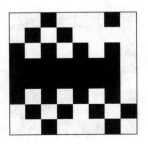

|stɔːm| |ˈtɛmpɪst| |sɪˈmuːm|

noun

A commotion of the elements. A meteorological disturbance of the atmosphere with strong winds and usually rain, thunder, lightning, or snow. A cyclone. A hot, dry, suffocating, dust-laden wind that sweeps across African, Asiatic, and Arab deserts during the spring and summer. A violent commotion, disturbance. An assault upon a fortified place.

|stəʊv|

noun

An apparatus for heating. A closed box of earthenware, porcelain, or metal heated by combustion or electricity and used for cooking or heating. A furnace to warm a room or building.

|streɪt|

The most direct path between two points is the unwavering line.
Its lack of deviation existed solely in the abstract realm until Modern
Men started dabbling in a perverse architecture that sought to unify
the immaterial and corporeal realms. It is a dualistic sign, representing
geometric purity and also the corrupt hubris of human beings.

adjective & adverb

Extending uniformly in a direction without any angularity, arcuation, bend, bight, bow, circumflexion, curve, contortion, crookedness, deformity, deviation, distortion, diversion, flex, flexion, incurvation, sinuosity, tortuosity, or warping. Being perfectly level with gravity, perpendicular to the earth, or symmetrical.

|streɪn(d)ʒ| |ˈstrānjər|

adjective

Foreign, of another country. From outside, not belonging to the place or setting where it is found. Unsettling, unusual, different. Not previously seen or encountered. Unfamiliar, abnormal, exceptional. Causing surprise. Causing wonder.

noun

One of another country, a foreigner, alien. One of another town or region. An unknown person. One not seen before. A person with whom one is not well acquainted. Used by rustics to address a person one has not met before.

|strɛs| |strɛsɪŋ| |dɪˈstrɛs|

verb [trans.]

To put pressure, tension, or contortions upon a material object. To subject a person to mental hardships or difficulties. To emphasise a subject of particular importance.

noun

The action or fact of taking strain, pressure. Mental anguish, anxiety, sorrow, grief, hardship. In danger, need of assistance. Suffering for want of material provisions. For a material to be in a state of disrepair, damaged.

|strʌɪp| |strʌɪps|

The pure line given volume and elevated to the status of heraldic object.

noun

A pattern of bands of variated or uniform width, varying in colour. A narrow band of colour or texture of much greater length than breadth. A linear variation of colour. The pattern found upon certain animals.

|strɒŋ| |strɛŋθ|

Power through solidity and materiality.
(SEE ▣ |skwɛ:|; ▦ |'sɒlɪd|*.)*

noun & adjective

Vigorous, forceful. Of great ability in the body. Being able to exert great muscular force. Having physical power and energy. Mental power and faculty. The capacity of a substance or material to withstand great force, pressure. Military power derived in numbers, equipment, and training. Might. Firmness of character, mind, volition. Intensity and active force of a physical phenomenon, esp. energy, electricity, wind, fire, heat.

strʌk		stɑːts		stɑːtɪd		
biˈgin		bɪˈgɪnɪŋ		biˈgan		biˈgun
səˈprʌɪzd		ˈɒrɪdʒɪn		lɔːn(t)ʃd		
sɔːs						

verb [trans. & intrans.]

To deal a blow with one's hand or a weapon. To mark with an instrument or pen. To receive a forcible impact or collision. To receive a forcible revelation, idea, mental impression. For an unwanted tragedy, disaster to befall. To be killed, brought low by disease. To move vigorously and purposely. To come into being. To use a particular point, action, or circumstance as the opening for a course of action. To move with a sudden bound from a position of rest. To assail or attack suddenly and unexpectedly. To cause astonishment or shock by taking someone unawares. To issue suddenly, begin to flow. To shoot, discharge, send off a vehicle or projectile. To enter boldly or freely into a course of action.

S

noun

The first cause. The fact of springing from something. Rise or first manifestation. The source of existence. The point of first being. The process of coming into being. The first and earliest stage of an action, development, life, journey, story.

|ˈstrʌktʃə| |ˈstrʌktʃəz|

The laws of nature bring about patterns and arrangements
of a terrible and wondrous nature.
From the chaotic indeterminate particles rise precise orders.
The symbol of Emergence.

noun

The arrangement between the simple parts and elements of a thing that produces something complex. The coëxistence of distinct parts in an ordered and definite arrangement. A fabric or framework of materials or abstract concepts. Language. The phenomenon of localized extropy as supposed to the general state of macro-entropy. A building or manmade habitation, not natural, architecture.

|ˈstjuːdɪəʊ|

The immaterial, conjured for an instant
into a space supporting four walls.

noun

The workroom of an artist, sculptor, or plastician. A place where actors, dancers, dramatists, or musicians rehearse. A station from which audio or visual information may be transmitted in the electromagnetic spectrum.

|ˈstʌfi| |fʊl| |fɪl| |fɪld| |ˈmatə| |ˈmatəd| |ˈmatəs|

The particles packed into dense, regimented space.

noun & adjective

That which has mass and takes up space. That of which physical objects are composed. That which impresses solidity and actuality upon conscious beings. Containing or holding as much as possible. Packed with substance. A thing, event, situation under consideration. Topic. The principal substance of a text or work of art, surface meaning. Lacking in freshness, interest, or smartness. Ill-ventilated, oppressive to the lungs and head.

verb [trans.]

To store until no more can be admitted. To store abundantly. To satisfy, make content. To be of import.

|ˈstʌmb(ə)l|

The intoxicated wanderer is in a constant flux between falling down
and getting up without once touching the ground.
His movement is a graceful ballet of collapse and resurrection.

verb [intrans.]

To trip. To miss one's footing. To fall or be in danger of falling. To
slip in speech or thought. To blunder. To come across unexpected-
ly. To move inarticulately and under constant threat of collapse.

| 'stju:pə |

noun

The suspension of sensibility. Lethargy. Diminution of character. Near-unconsciousness, esp. brought about by |'alkəhɒl|, |nɑː'kɒtɪk|, or |hiːt|.

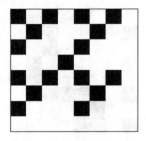

|səˈblʌɪm|

adjective

Of things in nature and art affecting the mind with such an overwhelming grandeur, beauty, deep reverence, and awe that the mind is temporarily brought to a true awareness of the nature of space, time, and its own miraculous existence.

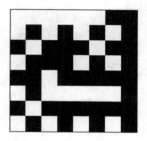

|səbˈvəːt|

verb [trans.]

To overthrow, overturn, bring about change from below or within. To attack subtly the underpinnings of a person, system, thing. To undermine or change the will of a person, system of power, or authority through ingenious or indirect means.

|sʌtʃ|

adjective, predeterminer & pronoun

Of that kind, of like kind. Of the type mentioned. The same that, of the type about to be mentioned. So great, of a high degree, emphasising the characteristics or qualities held by a subject.

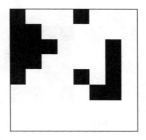

|sʌk| |əˈtraktər|

One who draws in through unknown, powerful, occult influences.
A gravitational being.

verb [trans.]

To draw by making a rarefaction of the air. To draw into the mouth of a person or other vessel by making a partial vacuum. To draw in any direction through a pump or vacuum.

noun

That which draws to itself.

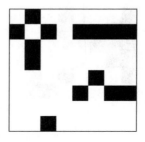

|ˈsʌd(ə)n|

In an instant the immediate and unforeseen collision
of particles forms a new compound.

adjective

Happening without previous notice, coming unexpectedly. Hasty, rash, violent, precipitate. Of velocity, action, events, or states changing sharply or abruptly.

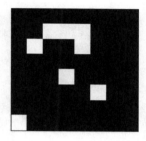

|ˈsʌfə|

*After subjecting the corpse to the pain of living-being,
the absence of sorrow is felt as the sweetest pleasure.*

verb [trans.]

To undergo, endure. To feel the sensation of pain. To be subjected
to unpleasant, injurious hardships or sorrows. To decay, corrode,
become or appear to decline. To undergo martyrdom.

|ˈsʌlən|

*The disease of youth from which all dramatic change
and invention originates.*

adjective

Gloomily angry. Sluggishly discontented. Characterized by ill-humour or moody silence.

│ˈsʌmə│ │ˈsʌməz│

The season of Apollo.

noun

The second and warmest season of the year. The rotation of the earth's axis throughout the year results in the Sun striking the earth more pronouncedly in the period between the June solstice and the September equinox. In the Southern Hemisphere the situation is reversed and this same period is known as winter.

|ˈsʌmən|

The material being drafting to
his cause an immaterial creature.
Also an immaterial creature
drafting a material being.

verb [trans.]

To call with authority. To urgently request the presence of. To demand help, assistance. To bring up to the surface. To bring up to the material plane. To call, bid, admonish. To appear, esp. of a supernatural entity.

|ˈsʌnsɛt|

As the Sun feels the onrush of the cold black void
he flees below the earth.

noun

When our star descends below the horizon. The close of the day.
The time when the sun disappears and the daylight fades. The end
of an era, period. The decline of a complex structure.

|ˈsupərˈstɪʃəs|

adjective

Full of idle fancies. Credulous. Misunderstanding or miscrediting causation. Religious, reverential, pious. Intellectually timorous or indolent.

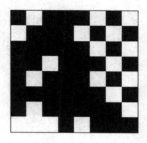

|ˈsʌpə|

noun

The last meal of the day. The hour at which one dines for the last time. An informal or late-night repast.

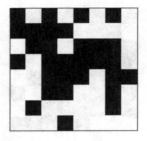

|'səp(ə)li| |'səp(ə)liz|

noun

The relief of want. The stock of a resource available for use. Provisions, materials, necessities. An amount of substances used to create industrial processes, manufactured goods, sculptural or architectural works. The funds, food, water, equipment, baggage of an army, group, enterprise, expedition.

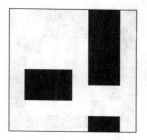

|sə'pəʊz| |'sʌpə'zɪʃ(ə)n| |'θɪəri| |'θɪəriz|

Imagine the line broken. Imagine the line unbroken.

verb [trans.]

To hold as a belief or an opinion. To think a thing, be of an opinion. To assume without evidence, lay down without proof. To frame a hypothesis. To posit. To imagine.

noun

A notion or idea held without certainty or assurance. Imagination as yet unproved. Hypothesis. Speculation, not practice. Scheme. A plan existing in the mind, conception. A methodology. A systematic rule or set of principles, school of thought, belief held by others. Abstract knowledge.

|ˈsə:fɪs| |ˈsə:fɪsz|

noun

Superfice. The outside of a thing. The uppermost boundary of a thing. The top level of a thing. A two-dimensional area. The upper boundary of water or other liquid. The upper boundary of the earth. The apparent external appearance of a thing.

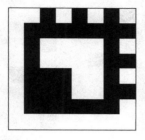

|səˈraʊndɪŋz|

noun [pl.]

Environs. The environment that encompasses a person or thing.
Milieu.

|səˈspɛkt| |səˈspɛktɪd|

verb [trans.]

To imagine with a degree of fear, jealousy, and paranoia what is not known. To have the idea of the existence of persons, facts, or intentions without proof. To be distrustful. To doubt the authenticity of a person.

|ˈswɛltəɪŋ|

past participle adjective

To be pained with heat. Of oppressive or overpowering heat. Causing or accompanied by profuse sweating. Being uncomfortably hot.

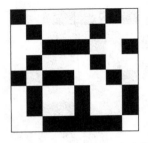

|swəːl| |swəːlz| |swəːlɪŋ|

verb [trans. & intrans.]

To twist or give a convoluted form. To wrap around something. To wrap around itself. To move upon eddies and whirlpools. To spiral. To move in upon oneself, caress one's own form.

|ˈˈsɪmbaɪˈɒtɪk| |təˈgɛðə| |lɪŋk| |lɪŋkd| |ˈalʌɪd|
|dʒɔɪnd| |kəˈnɛkʃ(ə)nz| |kənˈvəːdʒ|

The sign of interdependence.

noun & adjective

Living as one. Of two different biological organisms attached to each other, living upon each other, one tenant to the other. Two beings mutually dependent and supporting each other. Two beings psychically fused. A conjunction, relationship with something else. A single ring of a chain. A single part of a series.

adverb

In company, not alone. In union, not separated. In proximity. Coëval, at the same time.

verb [trans. & intrans.]

To make or form a bond. To bring two or more items into close association. To combine or unite a resource for mutual benefit.

|ˈsɪmpəθi|

noun

Real or supposed affinity between certain things. Shared feeling, mutual sensibility. The condition of one inducing a similar change or state in the other. Conformity of feelings, inclination. Pity or sorrow for another's misfortunes. Compassion, commiseration.

921 |ˌsɪmbaɪˈɒtɪk|

To support a side in a conflict. To make one's friends' enemies thy own. To unite to form a whole entity. To take part in, become involved in a larger cause or purpose. To tend to one point from different directions. For lines or rays to become one.

|ˈsɪm(p)təm| |ˈsɪm(p)təmz|

noun

A sign, token. An indication of disease or affectation. A characteristic sign of a particular disease, state, or condition. A phenomenon accompanying another, esp. evil, undesirable.

|ˈsɪŋkəpeɪtɪd| |ˈkeɪd(ə)ns|

verb [trans.]

To displace the rhythm or accent of music. To shorten or clip words in the middle. To omit parts of a structure giving a lilting, restless quality.

noun

A fall, state of decline. The fall or rhythm of notes. A rhythm or inflection of the voice in speech or song. A modulation or accent.

$$|\text{'teɪb(ə)l}|$$

That which elevates the object to the manipulation of the subject.
The work surface of the Great Architect.

noun

A flat or level surface. A comparatively thin piece of wood, stone, metal, plastic, or exotic material raised as a slab. An altar. A horizontal surface raised from the ground, used for meals and working. That upon which the priests perform the Communion and the alchemists perform the Great Work.

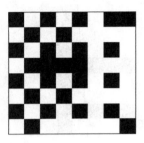

|ˈtaktʌɪl| |tʌtʃ|

adjective

Of or pertaining to contact. Tangible. Perceptible to the caresses of conscious beings.

verb [trans. & intrans.]

To reach and make contact with something. To lightly press or strike. To use an instrument to come into contact. For two things to make mutual contact. To affect, manipulate, alter. To sense physically.

noun

The exercise of the faculty of feeling upon a material object. Examination through physical contact. A light stroke, contact. A small amount or trace of something.

|teɪl| |teɪlz|

noun

That which lies behind an animal, the continuance of the vertebræ hanging loose. The rear part or posterior of an object. The end of a series or line of people, things. The loose parts of a woman's skirt that reaches to the ground. The conclusion of an epic, book, paragraph, or sentence.

t

|teɪk| |teɪkɪŋ| |tʊk| |ˈteɪk(ə)| |grab| |pʊl|
|pʊlz| |pʊld|

The electron captured.

verb [trans. & intrans.]

To put one's hand on, touch. To reach for and grasp a thing. To apprehend, arrest, seize. To grasp or seize suddenly or eagerly. To capture a thing. To bring into one's possession. To pluck, extract. To draw out or up. To exert force by bringing closer to oneself or moving towards the origin of the force, as opposed to pushing. To attract or influence to bring closer. To exert a dragging force, tug, haul. To bring along or convey with one. To accept or receive. To require or use up a period of time.

noun

The state or act of a force drawing things closer to it. (SEE ▧ |ˈmagnɪtɪz(ə)m|; ▬ |ˈgravɪti|.)

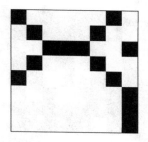

|teɪl| |ˈstɔːri| |ˈstɔːriz| |ˈhɪst(ə)riz|

That which is communicated from one to another
travels through a fine line of veridicality, constantly vulnerable
to so many corrupting influences,
the least of which being the brazen fabrications of the poets.

noun

A narrative. A fiction. A fable. A trifling fabrication. A recital of events that are supposed to have happened. An oral relation. A series of traditional or imaginary incidents. A slight or petty account of some trifling or fabulous incidents. A succession of dramatic events in a novel, poem, theatrical work. A representation of past occurrences. A narration of facts and events with dignity. A chronology of important or public events. The sequence of past events associated with someone, something, or someplace.

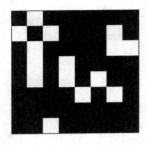

|ˈtan(ə)ri| |ˈtan(ə)riz|

The sign of a Chemicalsmith.
One who creates the reactions of molecules.
(SEE 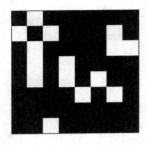 *|ˈsʌd(ə)n|.)*

noun

A place where animal skins are converted into leather. An establishment for the treating of hides with astringent so that they may be made into clothes, shoes, or other goods.

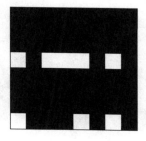

|teɪp|

noun

A narrow strip of material typically used to hold or fasten something. A narrow strip of plastic coated with magnetic properties used to hold images, sound, or data.

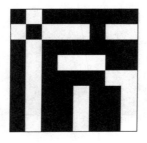

|ˈtapɪstri| |ˈtapɪstriz| |ˈkəːt(ə)n|
|ˈkɑːpɪt| |ˈtɛkstʌɪl|

A cloth subjected to the chemical hand and artisanal legerdemain.
(SEE 🔲 *|ˈsʌd(ə)n|;* 🔲 *|ˈtan(ə)ri|.)*

noun

A thick piece of cloth woven with repeating patterns, figures, motifs. An embroidered canvas often hung on the wall. A decorated fabric stretched in a frame. A piece of material suspended by the top so that it may be contracted or expanded to lighten or darken a room. A material hung to divide or bound a room, stage, or bed. A covering of floors and stairs made from thick woven fabric. A coloured or patterned material for standing, kneeling, or sitting upon.

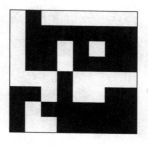

|ˈtatəd|

adjective

Torn, made ragged. Old, worn. Denticulated, slashed, laciniated.

t

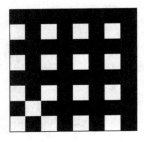

|tɛl| |təʊld| |riːˈtəʊld| |tɛlɪŋ| |kənˈfʌɪdɪd|

verb [trans. & intrans.]

To utter, express, speak. To communicate facts, events, information. To relate, teach, inform. To recite a story, narrative, drama. To betray, reveal hidden truths. To determine, count, number, reckon. To relate a tale, fable, story repeatedly. To reinterpret, relay, modify, or distort a narrative. To impart a secret to someone. To trust a private matter to a person.

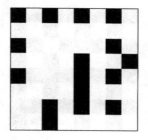

|ˈtɛmp(ə)rəm(ə)nt|

noun

The constitution, proportion of materials to the whole. The com-
bination and balance of the four principal humours in the body.
The habit of mind. The inclination of a person or creature to
behave in a certain way due to their physiological, astrological, or
psychological nature.

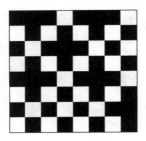

|ˈtɛmpə| |ˈtɛmpəd|

verb [trans.]

To compound, form by mixture. To bring to a proper state by mingling a quality with another, to alloy. To improve the hardness and elasticity of a metal by heating and cooling, adding other substances to it. To modify excessive state or quality by mitigating, assuaging, toning down.

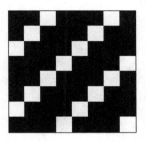

|tɛm(p)t| |ˈtɛm(p)tə|

In the Garden the mischievous Trickster asked of the Lady,
"Will you not eat of the Tree of Knowledge?"
As she bit into the forbidden fruit consciousness flooded
over her, overwhelming the mind, bringing for
the first time pains, sorrows, and torments and yet also
for the first time exquisite joys and raptures.
(SEE ◩ |ˈnɒlɪdʒ|; ◥ |ˈapəsteɪt|; ▨ |ˈtrɛtʃ(ə)rəs|;
▨ |priːhɪˈstɒrɪk|.)

noun

To solicit one to ill by presenting some pleasure or advantage to
the mind. To entice. To attract, allure. To make a test, to trial. To
enter into risk or peril.

noun

An enticer. An infernal solicitor to evil.

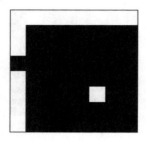

|ˈtɛrɪb(ə)l| |ˈbadli| |sɪˈvɪə| |əˈprɛsɪv| |məˈlʌɪn|
|ˈtrʌb(ə)l| |ˈrɛtʃɪd| |hɑːm| |ʌnˈhəʊls(ə)m|
|ɪˈnɪkwitəs|

The sign of potential danger.

adjective

Creating feelings of dread, awe. Formidable. Causing fear. Exciting to terror. Disturbed or agitated. Intense, painful. Very great, excessive. Weighing heavily on the mind, spirit. Burdensome, overwhelming. Hard, rigorous. Strict. Exploitative, repressive. Harsh and uncompromising. Apt to punishment, censorious. Unfavourable. Malicious. Beset by problems or conflicts. Detrimental to health of mind. Characterised by unrighteousness, wickedness. Of gross injustice or public wrong. Not conducive to health or moral well-being.

noun

Injury. Material damage. Ill, danger.

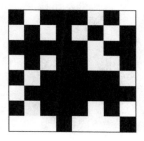

|ðan|

conjunction and preposition

A particle placed in comparison after the comparative verb. Introducing an exception or contrast. Expressing a hypothetical result or consequence.

938 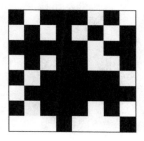 |'terɪb(ə)l|

verb [trans.]

To physically injure. To do hurt, damage.

θ

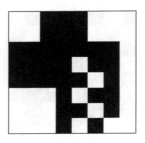

|θaŋk| |θaŋkd|

The offerings are burned so that their essences
may drift up in the white smoke to where the gods reside.
(SEE 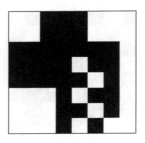 |ˈsakrɪfʌɪs|.)

verb [trans.]

To return acknowledgments for a favour, kindness, or gift. To express gratitude or obligation to someone.

ð

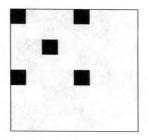

|ðə| |(ə)l|

[the definite article]

adjective

Indicating definiteness. The article denoting a particular thing. In the most definite sense: the only, the person in question, the subject mentioned. Enough of a thing, of a type, of a nation, of the qualifying or defining clause of a phrase. The specification of the definite article. (SEE 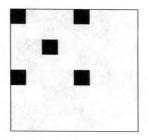 |ə|.)

ð

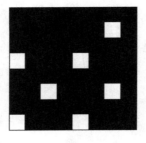

|ðɛn|

adverb

At that time. Afterwards, immediately following, soon after. Therefore, for this reason.

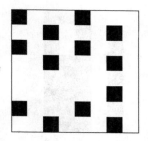

|ðɛːˈfɔː| |ðʌs| |hɛns|

adverb

For that thing. For that reason, on that account. That being so, in consequence of that. As a result of this. Consequently. In this way just indicated. To this extent, number, or degree. Away from this place. From this, as a source or origin.

θ

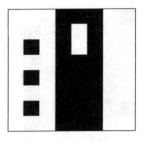

|θəˈmɒmɪtə|

noun

An instrument for measuring the heat of the air or any other matter. A gradated tube containing a liquid (usually mercury or alcohol that expands or contracts with fluctuations in temperature.

|θɪk| |ˈsɒlɪd| |səˈlɪdɪti|

adjective

Not thin. Having great extension between the opposite surfaces or sides. Of a plane having a substantial depth. Of a line having a large diametre. Not liquid, fluid. Not hollow, dense. Full of matter. Strong, firm, not weak. Not light or superficial. Grave.

noun

The state of stability and shape, strength in structure.

|θɪŋk| |ˈθɪŋkɪŋ| |θɔːt| |θɔːts| |ˈsʌbdʒɪkt|
|ˈsʌbdʒɪkts| |ˈriːz(ə)n| |ˈruməˈneɪʃənz| |ˈlɒdʒɪk|
|ˈkɒntɛmpleɪt|

*For unimaginable æons, cold rock floated in the vastness
of the ether until suddenly one day it sprouted plants, birds, and minds
that gazed wonderingly upon the myriad of worlds in the heavens.
On that day the cosmos came to reflect for the first time upon its own
nature, what it was, where it had come from, and for the first time
considered what could have existed before it. How could it have come
from nothing? From what womb was it born? And so it was that the
universe came into being, simply to prevent a paradox; it blossomed
into being so that one day, far off in the future, it could indeed evolve to
reflect upon its very own existence and correct this inconsistency.
Every mind that comes to consider this idea is as a god. Every sentient
creature that comes to speculate upon this origin causes again and
again the totality to sprout from absolute oblivion. On these grounds, it
is advisable to worship all persons one encounters as deities. For it
is unclear in our daily encounters which of these brutish primates is*

walking about forming these terrible and wondrous
realms in their idle daydreams.
(SEE |ˈnɒlɪdʒ|.)

verb [trans. & intrans.]

To cogitate. To form in the mind, conceive. To have in the mind
a notion, idea, belief, opinion, mental image, emotion. To direct
one's mind towards a person, thing, fact, problem. To meditate
upon, turn over in the mind, ponder over, consider. To consider
with prolonged attention. To look at a thing for a long time. To
exercise or train the mind. To form a connected understanding of
many ideas, to make a train of ideas pass through the mind.

noun

The process of cogitation. The rational faculty. The art of reason.
The process by which one deduces a proposition from another and
follows a premise to its natural consequence. The strict rules by
which one examines the validity of a proposition. Mathematical
inference of veracity. An operation of the mind. An idea. Cause,
ground, or a principle. A justification. A sentiment, fancy, mental
representation. A reflection, particular consideration. Preconceived
judgement. A system of ideas, approach. A deep consideration of an
idea. The chewing or mulling over a matter physical or immaterial,
esp. cud. That on which an action, mental or material is performed.
One under the dominion of another. The proposition about which
a statement is made.

|'θəːti|

Five units of two added to the two blocks representing ten.
(SEE ⚃ |'twɛnti|.)

cardinal number

The natural number following twenty-nine and preceding thirty-one. The sum of the first four squares. It is the approximate number of days in a month. It is a significant number for the philosophers' examination of age, youth, and death. It is considered by some the ideal age for martyrdom.

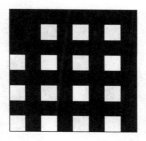

|ðɪs| |ðat| |ðəʊz| |ðiːz| |ðɛm|
|ð(ə)mˈsɛlvz| |ðɛː| |wɪtʃ|

pronoun & adjective

Indicating a thing or person present or near in space or time. Indicating two or more people, things previously mentioned. Indicating a person or thing pointed out emphatically. Referring to a fact or occurrence previously mentioned. Pointing to a proposition which immediately follows. Referring to an occurrence or event after the one previously mentioned. Used to single out or ascribe a distinctive feature of the subject. Used to identify a defining clause. What one of a set of persons, thing, possibilities. Introducing an additional statement about the antecedent. Used reflexively to refer to the object or people previously mentioned as the subject.

possessive pronoun & possessive adjective

Of the people or things previously identified.

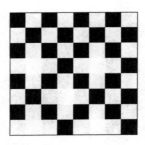

|ðəʊ| |haʊˈɛvə| |dɪˈspʌɪt| |ɔːlˈðəʊ|

conjunction

Notwithstanding that. As if. That being said.

preposition

In spite of, without being affected by.

adverb

At the end of a sentence to express restriction on what was previously mentioned. In whatsoever manner, degree. Nevertheless, notwithstanding.

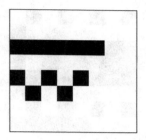

| ˈθaʊz(ə)nd |

cardinal number

The natural number following nine hundred and ninety-nine and preceding one thousand and one. The product of ten and a hundred. One tenth of a myriad. A prodigious number difficult to hold in the mind. (SEE | ˈprɒdɪdʒi |.)

θ

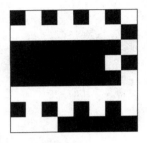

|θraʃ| |θraʃɪŋ|

The oblong corn amongst the particles of the chaff.

verb [trans. & intrans.]

To beat corn to free it from the chaff. To drub, strike violently with a stick, whip, or limb. To hit repeatedly. To move about violently and convulsively. To toss, plunge.

|θriː| |θəːd|

The creator, the act of creating, and the thing made.

cardinal & ordinal number

The number of life and death. The first odd number. The natural number greater than two and smaller than four. It is the great number, the genesis of motion and thought. Its unevenness is the cause of variation in the cosmos, creating stars, life, change. It is the number of dimensions in lived space: height, width, breadth. It is the number of dimensions in lived time: past, present, future. It is the number of realms: above, surface, below; heaven, earth, hell. It is the number of fundamental orders in the microscopic; quarks groups being up-down, charmed-strange, top-bottom; protons, neutrons, electrons. It is the number of social orders: philosophers, guardians, labourers; aristocrats, clergy, peasants; warriors, priests, farmers. It is the division of the mind into ego, superego, and id. It is the division of the great ages of man: industrial, atomic, information; stone, bronze, iron; bronze, silver, golden. In magic ritual it is the number of times an action is usually performed or observed.

t

|triː| |triːz| |wʊd| |wʊdz| |ˈlʌmbə| |lɒg|

In the pattern of grains we find augurs of events past,
cold winters of famine and hot summers of growth.
And sometimes, ever so rarely, we see augurs of things yet to come.

noun

A vegetation growing to great heights with a solid core. A plant with lateral branches of great distance from the ground. A perennial. The substance of said plants. Timber. That which is fashioned by carpenters into furnishings. The substance of modern ships, paper. Fuel, parts of said plant prepared for fires. An area smaller than a forest covered by growth. A large number of such plants creating their own environment due to their powerful influence.

|ˈθrɛʃəʊld| |ˈθrɛʃəʊldz| |geɪt|

noun

Entrance. The door of a large city, palace, or edifice. A frame of timber or metal forming a door to bounded fields or enclosures. The ground or step under the door. The band that marks the boundary of a building over which one must pass when entering or leaving. The magnitude or intensity required to transition from one state to another. The magnitude or intensity required to transition from one dimension to another.

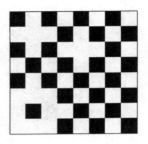

|θrʌɪv| |θrʌɪvɪŋ|

verb [intrans.]

To prosper, grow rich. To advance in any task attempted. To develop well, vigorously.

|θrəʊt|

noun

The forepart of the neck. The passageway for nutrients and the breath. The portal to the stomach, interior. A narrow passage or entrance. (SEE |ˈstʌmək|.)

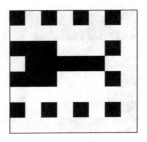

|ˈθʌndə|

*The voice of the Demiurge rattles and shakes
the souls of men below, who erect
statues of the great sky gods to mollify him.*

noun

The sound of the strike of lightning. The expansion of heated air
behind lightning, explosions, chemical experiments. The anger of
the Godhead. The loud noise of tumult or violence.

verb [intrans.]

To make a loud or terrible noise. To strike powerfully. To deal,
inflict, drive, bombard, strike down.

|tʌɪdz|

As the waters of the Earth love the Moon they move about the globe
following her, remaining close to her presence.

noun [pl.]

The alternate ebbings and risings of the sea twice in every lunar
day. The waters affected so. Floods, surges.

t

|tʌɪ| |tʌɪd| |bʌɪnd| |baʊnd|

The physical entangled in the abstract plane.

verb [trans.]

To knot, bond. To obligate. To attach or fasten someone or something to another thing. To connect, link.

noun & adjective

A limit. That by which anything is terminated. Restraint, confinement.

|tʌɪm| |eɪdʒ| |eɪdʒz| |ˈiən| |ˈiənz|

The Other dimension.

noun

The measure of duration. The progress of existence, events in past, present, and future. The interval between two successive events or acts. The period through which an action occurs or continues. A particular period characterised by a distinctive quality. A chapter in the history of the universe, the earth, or of human civilization. An immeasurable period of duration, the whole existence of the universe, world, eternity. In geology and astronomy one thousand million years. An instant, occasion. An event or period experienced by a person or object. The era in which a particular person lived. The latter part of life. Oldness.

adjective

Having existed or lived for a specified period. Having existed or lived for a long period. Suffering from the adverse effects of duration.

t

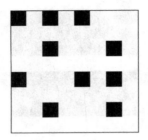

|tə| |təˈwɔːd| |təˈwɔːdz|

preposition, conjunction & adverb

Noting motion in the direction of. Noting location in reference to another place. Noting the person or thing affected by an action. As regards. Identifying or connecting subjects' relationships with each other. Noting that which concerns or is likely to affect another in the future. Forming the infinitive of the verb.

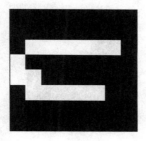

|tʌŋ| |tʌŋz| |ˈlɪŋgwə|

noun

The organ with which animals lick. The organ of speech in humans. The fleshy muscle lying in the floor of the mouth of most vertebrates, sometimes used to catch insects. A language. The common language spoken by a group of tribes whose native languages are different.

t

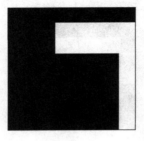

|tuː|

adverb

Over and above. More than enough. Likewise, also.

|ˈtɔːpɪd|

adjective

Numb, motionless. Sluggish, not active. Lethargic.

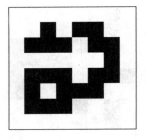

|'tɔːtʃə|

The body inflicts the soul within.

verb [trans.]

To exert pain judiciously. To extract guilt or confessions through the application of pain. To create physical or mental suffering. To vex, excruciate, torment. To be the cause of severe anxiety.

|'taʊə| |'taʊ(ə)rd| |'kɑːs(ə)l| |'fakt(ə)ri|
|'fɔːtrɪs| |'palɪs|

The Gate of Heaven.
The shamans built a pyramid so high
it was caressed by the clouds.
One day they climbed up it, hoping to ascend
to the heavens. On their way up
they were devoured by a curious deity
who was making his way down the steps.
Frantically, the people below hacked away
at the structure but it was too late.
The gods had discovered the world of men
whom they would forever manipulate and torment.

noun

A high building raised above the edifice. A citadel. A tall narrow structure attached to another building or freestanding. A lofty building used as a stronghold or built primarily for defence.

't

A house fortified against attacks often with thick exterior walls, ramparts, battlements, moats, trenches, or anti-siege works. A house or area in a city inhabited by traders from a distant place. A building where goods are manufactured or assembled often by many people and machines. A place where products are fabricated with industrial processes or in very large quantities. A building where the sovereign keeps large quantities of wealth, goods, administrators. A splendid residence. The official abode of a regent, president, bishop, or pontiff.

verb [intrans.]

To soar, fly, rise to great height.

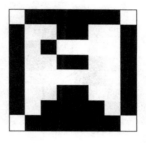

|ˈtaʊn| |ˈsɪti| |ˈtaʊnʃɪp| |səˈsʌɪɪti|

The social complexity within four walls.

noun

A walled collection of houses. A collection of buildings larger than a village. A place having a municipal government. A very large collection of houses and inhabitants. An incorporated municipality. A capital. The inhabitants of a community. A simple or primitive form of local organisation. The aggregate of people living in a community. Those sharing similar customs, habits, language. The union of the many in the general interest, the single will.

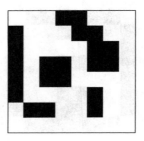

| ˈtrakʃ(ə)n |

noun

The act or state of drawing or pulling over a surface. The power to pull. The available friction of a wheel or foot making contact on the ground.

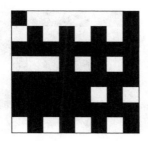

|treɪd| |ˈmɑːkɪt| |ˈməːk(ə)ntʌɪl|

noun

Commerce, traffic. The exchange of goods for other goods or money. The regular time for buying and selling provisions, goods, or livestock. The arena in which commercial transactions are carried out. The state of supply and demand for a particular commodity. An occupation, particular employment. A job requiring training or particular skills.

adjective

Relating to commercial activity.

|trəˈdɪʃ(ə)n| |trəˈdɪʃ(ə)nz|

noun

The oral transmission of accounts without written records. The passing of beliefs and customs from age to age, generation to generation. Long-established and generally accepted methods, rules, æsthetic sensibilities. The body of knowledge of a school of art or literature handed down by predecessors.

|ˈtradʒɪdi| |ˈtradʒɪk|

The Goat Song.

noun & adjective

A play or dramatic work of a sorrowful tone with a fatal or disastrous conclusion. The genre of dramatic art dealing with the grave, calamitous, and unhappy. A dreadful event causing mourning, suffering, distress, destruction.

t

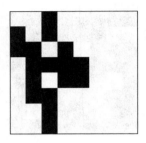

|treɪn|

noun

The part of a king's gown that falls upon the ground. A succession of attendants, servants, followers. A retinue. An orderly company, procession. A series of pack animals or vehicles travelling in the same direction. A trail of gunpowder reaching to the mine.

verb [trans. & intrans.]

To educate, bring up. To rear and modify the behaviour of an animal. To practice or learn a skill, habit. To be taught in such a way.

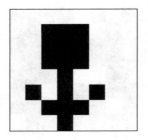

|trəˈdʒɛkt(ə)ri| |ˈvɛktə| |ˈvɛktəz|

The course to be taken by a soul.

noun

The path of a body moving through air or space. The curve described by a projectile's flight. A quantity having direction as well as magnitude. The course of a mathematical entity in a plane relative to another known location.

t

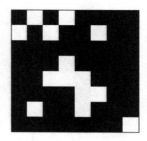

|trans'leɪt| |trans'leɪtɪd|

verb [trans.]

To move from one to the other. To convey. To turn from one language into another. To transmute from one structure to another.

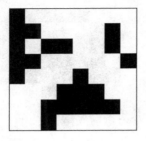

|tranˈspʌɪə|

verb [intrans.]

To pass through pores or cell walls. To give off a watery vapour. To become known through obscure channels, leak out. To prove to be the case. To occur, happen.

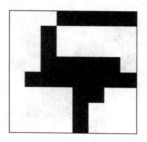

|ˈtrav(ə)l| |ˈtrav(ə)lə| |ˈtrav(ə)ləz| |ˈvɔɪɪdʒ|
|ˈdʒəːni| |riːtʃ| |riːtʃɪŋ| |riːtʃd| |trɪp|

verb [trans. & intrans.]

To pass. To go, move. To take an expedition, esp. of great length. To go to another place by foot, road, ship, airship. To visit many places. To touch with the arm extended. To draw oneself, to attempt to grasp something. To come to arrive at a point in space, place, state. To get as far as. To spread out.

noun

A transit. A passage by sea. A run, short sail between two points. A flight through the air. To go to a place and return to the same point. A wayfarer. One who visits other countries.

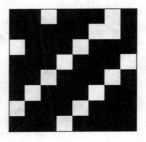

|ˈtrɛtʃ(ə)rəs|

The sign of the Fallen Angel.
(SEE 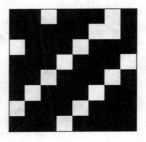 |ˈtɛm(p)tə|.)

adjective

Of people that are faithless, perfidious, guilty of desertion or betrayal, disloyal, traitorous. Of things that are deceptive, untrustworthy, unstable, insecure.

'␣t

|ˈtrʌɪbzman| |ˈtrʌɪbzmən| |trʌɪbz|

The first grouping of men as a whole.
The individual in the bottom left corner
becomes part of a family of families.

noun

A group of people forming a community descended from a single person. A social division based upon family, social, or economic ties, religion. A subdivision of a nation speaking a dialect. A class, group. A primitive group without municipal or national political structures. A person belonging to a traditional society or group.

|trɪk| |rɪˈneɪg|

*The greatest ruse that the Demiurge played on the world
was when he donned a mask and wandered
the earth acting the role of his own adversary.*
(SEE [▨] *|ˈapəsteɪt|.)*

noun

A sly fraud, dexterous artifice. A crafty fraud, stratagem, ruse, wile. A freakish or mischievous act. A skilful demonstration. An illusion.

verb [intrans.]

To denounce, renounce a faith. To recant, break one's word. To go back on a promise, undertaking, contract.

t

|trɒf|

noun

Anything hollowed and open on the longitudinal side. A hollow between two waves or crests. A channel.

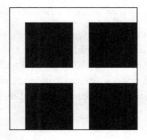

tru:θ		tru:θs		tru:		fakt		fakts
ˈvɛrɪtəb(ə)l		ɪnˈdʒɛnjʊəs		ri:l		rɪˈalɪti		
ˈaktjʊəl		ɪˈrɛfjʊtəb(ə)l						

The accordance of an element to the rule.
The accordance of one rule to another rule.
From this framework the lattice of lived existence is spun.

noun

The contrary of falsehood. The exact correlation between notions
and things. Conformity of words to thoughts. Fidelity, constancy.
Conformity to rule. Rationality, sense within a given framework,
esp. logic, mathematics, religion. Something not supposed or bare-
ly suspected but really done. An indisputable assertion. A proved
thing. A thing that is accepted by all reasonable men. The quality
of existence. The aggregate of the things that underlie phenomena
and appearances. The authentic constitution of a thing rather than
its apparent, external, or illusory characteristics.

t

adjective & adverb

Loyal or faithful to rule, authority, type. Existing naturally in the cosmos; as opposed to potential, possible, theoretical, or virtual. Accurate or exact. According with expectation. Conforming to the laws of nature. Fair, open, guileless, innocent, candid. Honourably straightforward. Incontrovertible, irrefragable. Impossible to deny or disprove.

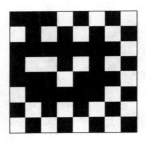

traɪ		trʌɪd		trʌɪɪŋ		ɪkˈspɛrɪm(ə)nt
ɪkˈspɛrɪm(ə)ntz		ɪkˈspɛrɪˈmɛnt(ə)l				
əˈtɛm(p)tɪd		ʌndəˈteɪk(ə)n				

verb [trans. & intrans.]

To engage in, make an effort. To endeavour to accomplish. To venture, speculate. To commit oneself to an enterprise, commitment. To test, examine, bring before a judicial tribune. To see if a thing is suitable, desirable, effective. To determine the stability of a precarious thing. To put to the proof.

noun

A trial to discover uncertain or unknown effects, qualities, rules. A scientific investigation to discover something unknown, test a hypothesis, rule out spurious conjectures. A tentative.

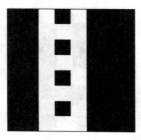

$$|\,{}^{\mathrm{l}}\mathrm{t}\Lambda\mathrm{n}(\mathrm{\partial})\mathrm{l}\,|\ \ |\,{}^{\mathrm{l}}\mathrm{t}\Lambda\mathrm{n}(\mathrm{\partial})\mathrm{l}z\,|$$

*From the simple burial mound evolved more
and more complex structures to convey the living
and the dead to the realm of the underworld.*

noun

A conductor, passage from one place to another. A subterranean path, way, under a mountain, river, sea. An artificial structure conveying one below the earth.

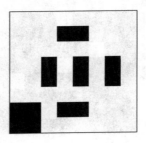

|'twenti|

Five sets of two plus the block representing ten.
(SEE 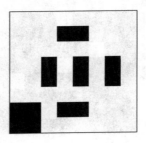 *|'θə:ti|.)*

cardinal number

The natural number following nineteen and preceding twenty-one. Twice ten. A score. It is the number of total digits on the human body, making it suitable for vigesimal counting.

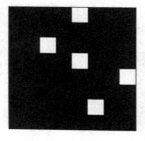

| ˈtwʌɪlʌɪt |

The history or judgement of the gods.
The time before the end of the world.

noun

The dubious or faint light appearing before sunrise and after sunset. The obscure light. From sunset to true dark. The refractions and glances of the sun's light upon the upper atmosphere. The presence of the sun inferred but not actual. The condition after full development, the state of decline before oblivion.

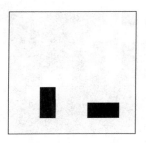

|tuː| |pɛː|

The former of life.
That which came after just one.
The mother and father.

cardinal number

One and one. The natural number following one and preceding three. The symbol of dualism; good and evil, night and day, male and female, life and death.

noun

A duo of things considered, used, displayed together. A couple.

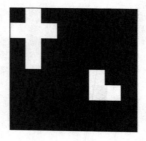

|ʌnˈbɛːrəb(ə)l|

adjective

Unendurable, intolerable.

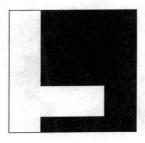

|ʌnˈbrəʊk(ə)n|

adjective

Whole, intact, not fractured. Not interrupted. Contiguous, uniform. Not violated. Not subdued, not weakened. Not impaired, functioning correctly. Not tamed.

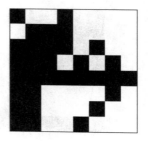

|ʌnkəˈmjuːnɪkətɪv| |ˈkwʌɪət| |ˈwɪspə| |ˈwɪspəd|
|ˈwɪspəɪŋ| |ˈfəːtɪvli| |ˈtasɪtəːn|

adjective & adverb

Still, free from disturbance. Making little sound. Absent of com-
motion, discord, uproar. Tranquil by nature, placid, gentle. Peace-
able, not turbulent. Inactive. Escaping notice, secretive, private,
confidential, clandestine, hidden. Done with stealth, hoping to
avoid observation. Unwilling to talk or impart information. An ac-
tion of speaking under one's breath. Habitually silent, disinclined
to conversation, saying little.

verb [intrans.]

To speak with a low voice into someone's ear. To not engage the
throat in speech and modulate only the passage of the breath.

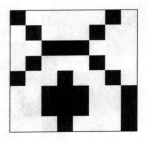

|ˈənˈkɑnʃəsnəs|

noun

The state of being mentally unaware. Lying in the realms of dreams. Being alive yet unresponsive to stimuli. The mental thought processes, memory, knowledge, actions not governed by the person, inaccessible to the waking self.

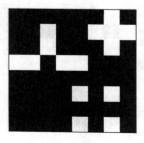

|ʌnkənˈtroʊləbəl|

adjective

Not subject to a higher authority. That cannot be restrained. Beyond the power of man, nature, or deity.

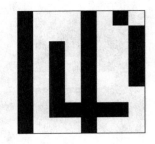

|ʌnkʊkd|

past participle adjective

Not prepared for consumption. Raw. Of food, esp. meat or fish, not heated. Not having been subjected to fire, barely warmed. Being in a state in which the proteins have not been fixed.

|ˈʌndə| |ˌəndərˈlī| |ˈəndərˈlaɪɪŋ|

preposition

Beneath or below. At a lower level than. In a state of subjection to, pupilage to. Below an amount or quality. For less than.

verb [trans.]

Of rock, soil, or structures lying or situated below something. Supporting a cause, belief, method, idea. Underpinning.

|ʌndəˈɡraʊnd|

The sign of all that is unseen by the Sun
or the grace of the Supreme Being.

adjective

The subterranean space. Found below the surface of the earth. Dwelling in the underworld. Not situated on surface, hidden, embedded.

|ʌndɪˈvʌɪdɪd|

past participle adjective

Unbroken, whole, not parted. Devoted to one object. Not divided by dissension, disagreement. Existing on a single plane.

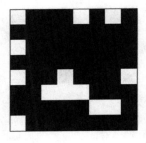

|ʌnˈiːz| |ʌnˈizinəs| |ʌnˈiːzi|

noun & adjective

Discomfort. Anxiety or discontent. Troubled.

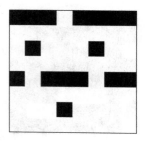

|ʌnˈfɔːtʃ(ə)nətli|

A miracle of iniquitous coincidence.
The concurrent disintegration of more than two parts.

adverb

Unhappily, without good luck.

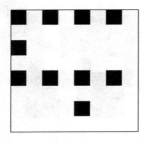

|ʌnɪnˈhabɪtɪd|

A place where no human foot has yet to tread
may yet reveal the footsteps of other beings.
The sign of realms best left untouched.

past participle adjective

Having no dwellers. Not populated. Bereft of permanent human presence.

ˈj

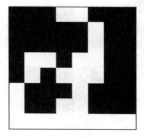

|ˈjuːnɪti|

noun

The state of being one, not separate. The condition of being single. Oneness. The quality of being one in mind, opinion, purpose, action. Harmonious. A thing of complex parts forming a cohesive and well-structured whole.

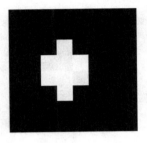

|ˈjuːnɪvɜːs| |ˈkɒzmɒs| |ˈkɒzmɪk|

The totality. A fragile improbability.
(SEE 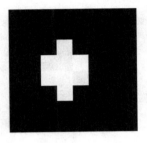 |θɔːt|.)

noun

Everything that physically exists, the entirety of space and time considered as a whole. The earth, the heavens, the whole world of creation. The material and immaterial realms combined. Everything that may be observed or reasonably expected to exist.

adjective

Distinct from the earth. Related to the realm of space and vacuum. Characteristic of the vast scale of the totality. Of the timescales and distances between stars, galaxies, and voids.

|ʌnˈnəʊn| |ˈˈɪnkənˈsivəbli| |ɪndɪˈskrʌɪbəb(ə)l|
|ʌnˈʃʊə| |ˈɪnkɒmprɪˈhɛnsɪb(ə)|

adjective & noun

Not familiar. Not reckoned or understood. Beyond ken. Not famous. That which does not admit description. Indefinite, vague. Trans-cending in qualities to be adequately communicated; good, beautiful, virtuous, repugnant, malodorous, etc. Not to be fully understood. Beyond the reach of the intellect, unfathomable. Unintelligible. Insecure, liable to mishap, danger. Marked or characterised by uncertainty, unreliability, untrustworthiness. Lacking confidence in the self.

adverb

In an unbelievable degree. Extraordinarily, extremely.

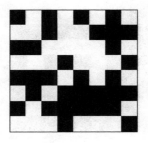

|ʌnˈlɛs|

conjunction

Except, if not, supposing not.

|ʌnˈmeɪd| |ɑːtɪˈfɪʃ(ə)l| |ʌnˈɔːθli| |ʌnˈkani|

That which is not formed of nature strikes the eye and mind forcefully.
Its divergence from the norm repels and disgusts us
at the same time as it seduces. For behind the seductions of the form lies
the inveigling intelligence that designed them.

adjective

Made by art not by nature. Contrived, compassed, formed by an intelligence. Factitious, feigned, fictitious. Artful, contrived with skill. Not belonging to the hand of man or nature, supernatural, mysterious, disturbing. Of the uncomfortably strange or unfamiliar, weird.

|ʌnˈmʌltɪplʌɪ|

The potential universes and dimensions as yet unreleased.

adjective

Not becoming more numerous. Single, unique. Not having repro-
duced, replicated, procreated. Not having been added to.

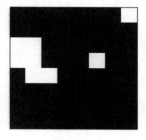

|ʌnˈnatʃ(ə)r(ə)l|

adjective

Contrary to the laws of physics, nature. Affected, stilted. Abnormal, monstrous. At variance with moral standards, wicked, excessively cruel, depraved. At variance to what is expected or usual. Of persons acting unfeelingly, acting outside of the dictates of nature, acting as if directed by a supernatural agency.

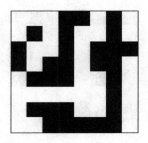

|ʌnˈplɛz(ə)nt|

adjective

Not delighting, displeasing. Causing unhappiness or revulsion.
Unamiable, unfriendly, inconsiderate, rude.

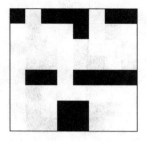

|ʌnˈriːdəb(ə)l|

adjective

Illegible through careless or damaged writing. Too dull or poorly conceived to read. Inaccessible, unfathomable. Difficult to discern or interpret.

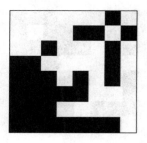

|ʌnˈʃrɪŋkɪŋ|

adjective

Not recoiling, not shunning danger or pain. Not drawing back, un-yielding, firm. Fearless, unhesitating.

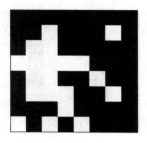

|ʌnˈteɪk(ə)n|

adjective

Not taken by force, not made prisoner, uncaptured. Of a city, region not occupied by an enemy. Of an action not put into effect. Of an object unused, virginal.

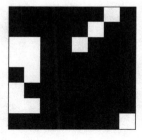

|ʌnˈtɛstɪd|

The lightning ready to strike the juvenile branch.

adjective

Of a person, thing as yet unproven. Not subjected to examination, experiment. Not having been made to withstand assault, hardship, suffering.

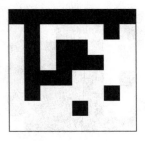

|ənˈtɪl| |tɪl|

*The freefall of ideas, things, and events up to
encountering the jutting occurrence.*

preposition & conjunction

Up to the time that, the point or degree when. To the place that. As
far as. Before a specified time.

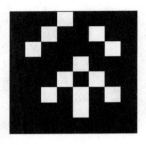

|ʌnˈjuːʒʊəl|

That which the arrow of intent rarely stumbles upon.

adjective

Not common, not frequent, rare. Exceptional. Interesting for being different than others.

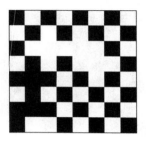

|ʌnˈwɪlɪŋ| |ˈhɛzɪt(ə)nt| |ˈhɛzɪteɪt|

adjective

Of persons or beings not inclined or ready, averse, reluctant, loath to do a thing. Not eager. Irresolute, undecided. Unsure, tentative. Slow in speaking, stammering.

verb [intrans.]

To be doubtful, to delay, make pause. To be reluctant to do something.

|ʌp| |əˈbʌv| |lɪft|

For all time Man has pined to the heavens,
all that lies over his head coming to represent the unattainable,
the divine, the immaterial, the Absolute.

adverb

Aloft, on high, not down. To or toward a point higher in space, over the head, toward the sky. Rising from the ground at 90° and moving away from the earth. So as to raise a thing from a place where it was placed, lying. To a higher level, greater quality. At a higher level than.

preposition

From a lower position in space to a higher one. In the space delineated over a thing. Overhead. Vertically on high. At a higher level than.

verb [trans.]

To raise from the ground. To elevate, heave, hold high. To raise and move to another place. To raise in price, amount, mood, spirit, or quality.

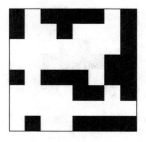

|ˈəːdʒ(ə)nt| |ˈərdʒəntli|

adjective & adverb

Pressing, impelling. Calling for immediate action or attention.

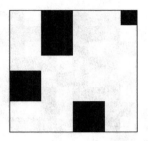

$$\left| \Lambda s \right|$$

pronoun [first-person pl.]

Used by the speaker to refer to themselves plus one or more others.

j

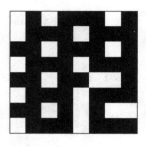

|juːz| |juːzd|

verb [trans.]

To employ for a certain purpose. To take hold, deploy a thing to achieve a purpose, result. To become familiar with an instrument, custom, exercise through habit. To become accustomed. Of an action or state performed repeatedly in the past.

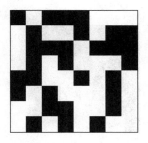

|ˈjuːslɪs| |ɪnˈɛfɪˈkeɪʃəs|

adjective

Answering no purpose, having no end. Destitute of desirable qualities, serving no profitable purpose. Inutile. Destitute of competence, of inadequate ability. Of a remedy, action that lacks efficacy, does not achieve its intention.

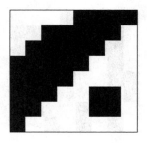

|veɪn|

adjective & noun

Devoid of real use, value. Fruitless, futile, unavailing. Having an excessively high opinion of one's attainment, qualities, virtues. Delighting in attracting the attention of others.

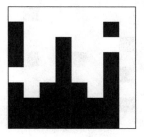

|'vali|

The space between two high points is the most fecund.
It is also the safest, for mountains are exposed places,
exposed to the elements and to the attention of watchers.

noun

A low ground. A hollow between hills. An extensive region between
high grounds usually having a river flowing along its bottom.

ᴵv

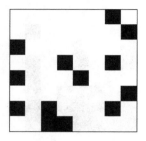

|ˈvɛːris| |ˈvɛːrɪd|

verb [intrans.]

To undergo change, pass from one state to another. To adapt to different circumstances. To differ in size, amount, degree, or characteristics.

|vɔːlt| |ˈbeɪsm(ə)nt| |krɪpt| |ˈkatəkuːm|

A space within the ground is also a space within the psyche,
within the self.
(SEE *|θrəʊt|;* *|ˈstʌmək|.)*

noun

The lowest, fundamental portion of a structure. The level of a build-
ing sunk below the ground. A continued arch. A cellar, cave, cavern.
An arched space under a church used for ecclesiastical purposes. A
chamber beneath a church or graveyard used for burials. A subterra-
nean gallery with recesses excavated in the side for tombs. A complex
of many passages covering a large subterranean area filled with many
chambers of relics, tombs, statuary, and objects of unknown use.

$$|\text{'viːɪk(ə)l}|$$

The basket that unknowingly carries the cosmos as a speck.

noun

A room or building used to convey people from one place to another. That in which any thing is carried, esp. carriage, boat, airship. A substance carrying another dissolved within it. A means of transmission, a material embodiment of a nonmaterial thing.

|vɪˈlɒsɪti|

noun

Rapidity. Speed, quickness of motion. Speed together with direction, vector quantity.

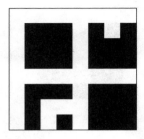

|ˈvɛnəreɪt|

To view as abstract and pure something flawed and physical,
something wormed.

verb [trans.]

To revere. To treat with awe. To see something as exalted, hallow,
or sacred.

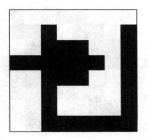

$|ˈvəːn(ə)l|$

adjective

Belonging to the season of spring. Having the mildness and fresh-
ness of spring. Youthful.

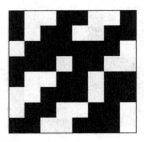

|ˈvɛri|

adverb

In a great degree, eminently, largely. With a superlative to express a description without qualification.

adjective

To note things emphatically. True, real. Of an extreme point in time or space. With no addition or contribution from anything else.

V

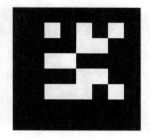

|vʌɪˈbreɪʃ(ə)n| |vʌɪˈbreɪʃ(ə)nz| |ˈmjuːzɪk| |sweɪ|

The universe from top to bottom resonates
with the hum of the low particles,
the roar of the electrons, and the crescendo of the planets
revolving upon their giant glass spheres.

noun

An oscillation. A quiver, tremor. The rapid or reciprocating rhythm
of an elastic entity by which sound is produced. The art of com-
bining vocal or instrumental sounds to produce beauty of form,
harmony, expression. The language and speech of instruments,
sounds, sonorous tones. The encoded documents of this language.
The action of a pendulum swinging to and fro. A rhythmical
movement from side to side. The control or influence exerted by
a person or event.

|vɔɪd| |vɔɪdz|

Peering out at the dark heavens, we perceive
that the cosmos is not uniform.
Between vast clusters of galaxies
lie unimaginable cavities of emptiness.
Yet these empty halls are as naught
in comparison to the great stretches
of nothing that make up ourselves.
For everything solid to our touch
is made of the tiniest particles, as far apart
from each other as we are from the divine mind.

noun

Completely empty space. An emptiness felt by the loss of something real or imagined.

|vɒlˈkeɪnəʊ| |ˈvʌlkənʌɪz| |vɒlˈkanɪk|

noun

A burning mountain. A place where the division between hell and earth is slighted. A conical hill or mountain from the centre of which steam, gases, ash, rock, lava, and molten material may be periodically ejected.

| ˈwɒf(ə)l |

The symbol of memory.
The Europeans fill each pocket with a material substance—
honey, chocolate, sugar, salt, etc.—to mark a point
in a mnemonic codex. Sometimes they are presented as unique objects
denoting a particular symbol or idea. Often they will be
laid out in vast grids of information rising from floor to ceiling.

noun

A small battercake made in a hot iron and eaten with butter, molasses, or jam. A traditional foodstuff printed in squares and subdivided by a grid into a pattern of smaller squares. The honeycomb weave pattern of a cake.

|weɪt| |weɪtɪŋ| |weɪtɪd|

The dark mass lies in ambush.

verb [intrans.]

To stay in expectation. To delay action or departure until an appointed hour, expected occurrence, signal. To remain in readiness for some purpose. To lay in ambush of an enemy. To be dealt with later. To be eager to do something or for something to occur. To pay servile or submissive attendance.

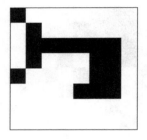

|wɔːk| |wɔːkŋ| |peɪs| |peɪsd|

To move in space is a holy act.
In animals this is carried out through lowly movement:
prowling, slithering, pattering. In man it is
a noble action carried out with a proud and haughty gait.

verb [trans. & intrans.]

To ambulate. To travel with either foot maintaining contact with the earth. To move at a regular slow pace. To move with a regular step, esp. as an expression of anxiety, concentration. To measure a distance with one's stride. To advance in a steady manner, march, dance. To travel along a route or road by foot. To make an excursion for pleasure. To journey, go about. To guide another, to accompany another.

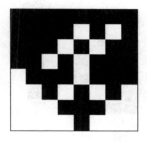

|wɒnt| |wɒntɪd|

The impression of absence upon that which is present.

verb [trans. & intrans.]

To be lacking or missing something. To not exist, be forthcoming. To have a desire to possess or do something. To wish for something or someone. To require, need.

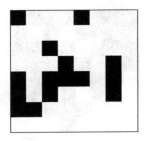

|wɔːn| |wɔːnd| |wɔːnŋ|

verb [reporting]

To caution against fault or danger, to give previous notice of danger or ill. To put a person on their guard. To give due notice with regard to neglect of duty or incorrect decisions, actions, beliefs.

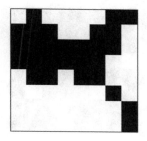

|ˈwɛːri|

*A crevasse may be traversed by a bridge of ice
made of the previous year's snowfall.*

adjective

Timorously prudent, cautious, scrupulous. Given to caution,
habitually on one's guard against danger, mistake.

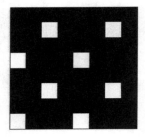

|wɒz| |wər| |biːn|

verb

The past tense of 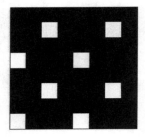 |biː|. To have existed or to have taken place in the world of fact. To have existed or to take have taken place in the world of fiction. To have occurred, existed, happened. To have entered or remained in existence.

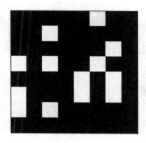

|wɒʃ|

verb [trans. & intrans.]

To clean by ablution. To pass water over something. To clean with water, soap, or detergent. To remove stains, smells, dyes, imperfections from a textile, surface. For water to carry a person, thing along. For a river, stream, sea, ocean to lap, break against a thing. To flow over someone or something.

noun

An act of cleansing. A thin coat of colour or distemper over a wall. A movement of a wave upon a shore. The sound of a surge of water.

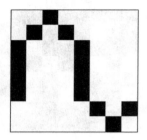

|weɪv| |weɪvz| |ˈəʊʃ(ə)n| |siː| |siːz|

noun

The water as opposed to the land. The vast continuous body of salt-water covering the greater part of the earth's surface. That which surrounds the land masses. The architecture of water. A long body of liquid raised into an arch. Water raised above the level surface, water driven into inequalities. A movement in a body of liquid whereby a portion rises above normal levels and moves as a ridge along the surface. The depression or trough between two crests breaking upon the shore. A pulse, vibration moving through a medium. An undulation.

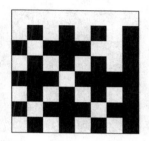

|weɪ| |weɪz| |əˈweɪ|

noun

The road one travels. The method, manner that we walk upon it.
A habit in life. Manner, respect. A particular respect, aspect of
something.

adverb

Absent. Toward or into nonexistence. Not close, at a distance from
a particular point. At a specified distance. At a specified distant
time. From side to side, from one conceptual side to another, off to
the side, no longer attended. Toward a lower level, downward.

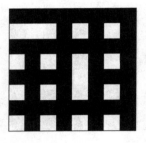

|wiː|

pronoun [first-person pl.]

The plural of 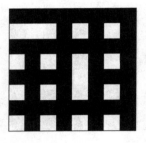 |ʌɪ|. Used by the speaker to refer to themselves and one or more others.

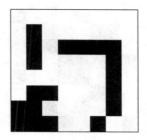

|wiːk| |ˈwiːknɪs| |ˈvʌln(ə)rəb(ə)l| |prəʊn|

The gaps in the armour wherein sunlight and blades may penetrate.

adjective

Lacking vigour, unable to perform physical feats. Feeble, not strong. Of too sensitive a constitution. Infirm, not healthy. Liable to break or fall apart. Soft, pliant, not stiff. Lacking intensity in magnitude, dim, quiet. Susceptible to wounds. Susceptible to disease, harm. Open to nonphysical injury, emotional torment, slights, criticisms. Open to attack, plunder, or destruction by hostile forces. Lying flat, not erect. Resting open, not curled, armoured, or protected.

noun

An infirmity of character, a failing. A self-indulgence, guilty pleasure. A lever by which one's enemies may manipulate and eventually destroy you.

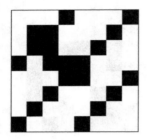

|ˈwɛðə| |ˈklʌɪmət| |ˈmiːtɪərəˈläjikəl|

noun

The state of the air with respect to heat, cold; dryness, wetness; calm, turbulence. The condition of the atmosphere at a time and place described through sunshine, clouds, rains, pleasant breezes, violent stabs of lightning, swathes of snow, desiccating patches. These states applied to a region over a period of time. The general atmospheric conditions of a region throughout the year. The variation of temperature and humidity over many years. The science of atmosphere. The art of prophesising the winds and vapours. The augurs of sunshine.

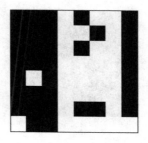

|wiːk| |wiːks|

The darkness and light interwoven with seven items of time.

noun

Seven nights and seven days. The cycle of a calendar from the day of rest till the next. The period in which, according to legend, the earth was born and all the plants and animals fruited.

|weɪt| |ˈhɛvi| |ˈhevəlē| |ˈgravɪti| |gravɪˈteɪʃ(ə)n|
|ˈprɛʃə| |ˈʌɪzək ˈn(y)oōtn|

*The ultimate influence that makes the mass seek
to burrow deeper and deeper into itself.
It falls and falls into its core until it ignites in an inferno
of fusion and burns a hole in the fabric,
trailing cinders upon the floor of the Creator's workshop.*

noun

The quantity measured by balance. The mass of a body exerting
a downward force. The ponderability of material substances. The
force exerted by a mass attracted to another mass. The ultimate
influence, authority. The distortion in the fabric of space-time
made by a large mass causing objects to accelerate towards each
other. The tendency to move towards the centre. The falling of a
body to earth. The force of attraction exerted by every particle in
the universe upon every other. The act or state of pressing, crush-
ing. The distress of being crushed materially and immaterially.

|ˈʌɪzək ˈn(y)oōtn| (1642–1727 CE), English mathematician and physicist. The author of the laws of mass, mechanics, and planetary motions. His work in mathematics included the binomial theorem and differential calculus. Also a secret Socinian sympathiser and great scholar of the Hermetic arts.

adjective & adverb

Ponderous, tending toward the centre of the earth. Not light. Difficult to move. Thick or substantial. Wanting activity, dull, lazy.

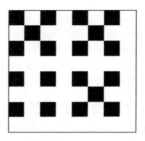

|wɛl|

adverb

Skillfully, properly. In a satisfactory manner. In a kind way, not ill or wicked. Accurately, not amiss, not erroneously. Not insufficiently, not defectively.

noun

A spring, fountain, source. A shaft sunk into the earth from which water may be drawn.

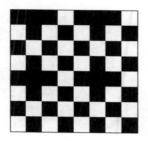

|wɒt| |wɒtˈɛvə|

pronoun, adjective & adverb

That which, that part, when specifying a thing derived from a whole. Which part that is derived from a whole. Interrogating, asking for specific information. Asking for specifying information. Something that is in one's mind indefinitely. Having one nature or the other. Anything, be it what it will. Used to emphasise a lack of restriction in referring to any thing, amount, quality.

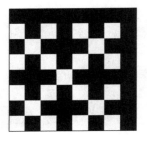

|wɛn| |wɛnˈɛvə|

adverb

At the time that. At what time. Which time, in what circumstances.
After the time specified. The time during which a thing may occur.
On whatever occasion. At any time that, every time that, as often as.

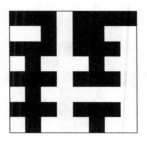

|wʌɪl| |wʌɪlst| |ˈdjʊərɪŋ|

conjunction & adverb

At the same time as, concurrently as another thing is occurring. In the period that. Used to indicate a contrast, whereas.

preposition

Through the course, period of time. Indicating a period of continuous development. At a particular point in the course of. In the course of time, in the time of.

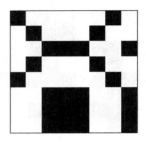

|ˈwɔːlpuːl| |ˈmeɪlstrəm| |ˈvɔːtɛks|

The black hole in the fabric of the ocean. The Great Attractor.

noun

A place where water moves circularly and draws whatever may stray close down into its centre. A part of a river or sea where upon meeting some channel, obstruction, or together with currents, wind, tides creates large violent and dangerous eddies. A rotary movement of cosmic matter around a centre or axis, a body of such matter carried around in a rapid circular motion. A destructive agency that swallows and consumes. A famed entity off the coast of Norway in the Arctic Ocean that sucks in and destroys all vessels within a wide radius.

|wʌɪt|

The absence of darkness.

adjective & noun

The colour of snow, milk. The reflection of most of the wavelengths of light visible to the human eye. Of a surface that is very reflective yet not metallic or sheened. The pure light of the sun, stars, moon. The spectrum filled. The visible part of the eyeball. The glaze upon the eyes of the blind, seers, and the most terrible sybils.

h

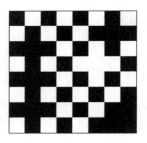

|huː| |huːz|

pronoun & adjective

What or which persons, people. To introduce a clause giving further information. Belonging to or associated with which persons. Of whom or which the clause previously mentioned.

|WʌI|

What lies beyond our realm?
Is it others wondering what lies beyond theirs?

adverb

For what reason or purpose. How so. What circumstances have caused this, what is the causal link before this one. With a negative form to make or agree to a suggestion. On the account of, for which a thing is such. The reason for which.

|wɪk|

noun

The substance around which is formed the wax, tallow, fat of a candle or torch. The taper immersed in oil and grease that maintains a flame. The capillary agent in a candle, lamp. The agent of light.

|wʌɪf| |wʌɪvz| |ˈhʌzbənd| |ˈhʌzbəndz|

Two souls labouring in the material world.

noun

A woman considered in relation to whom she is married. A man considered in relation to whom he is married to. A person of either gender united in marriage. One who is wed to a cause, thing, idea, profession. A person of humble origins engaged in the sale of some commodity compounded to their name, esp. apple, ale, fish.

|wʌɪld|

The spirit of the flame knows no right or wrong.
It is governed by its nature, being beyond good and evil.

adjective

Not tame, not domesticated. Savage and uncivilized. As living in nature, without influence of man. Unrestrained, uncontrolled. Growing without cultivation. Turbulent, tempestuous, disagreeable in temperament as the thunder and wind.

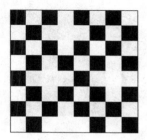

|wɪl| |wʊd| |wɪlɪŋ| |ʌɪd|

verb [trans. & modal]

To desire a thing to be, or be done. To be resolved to have or possess. To command or direct oneself or another. To express the future tense, that should arrive, come to be. To express inevitable occurrences, it must be, thou shall. To express characteristics, ability, having the power or properties to behave in such a manner. To express expectation or speculation doubt about something in the present.

noun

Choice, determination. The faculty by which a person decides or initiates action.

past participle adjective

Ready, eager. Disposed to consent, comply. Disposed to do what is required or asked.

|ˈwɪndəʊ| |ˈvɪtriːn|

The artificial membrane.
The magic wall that cannot be seen yet encases
men within or without it.
(SEE 🔳 *|ɑːtɪˈfɪʃ(ə)l|.)*

noun

The aperture in a building, vessel, carriage whereby light and air are able to enter. An opening in a wall or roof allowing people to see out. An orifice in a structure; sometimes fitted with a pane of glass, plastic, or other translucent material. A glass showcase for containing and displaying specimens, exotic goods, and materials, works of art, relics, historical artefacts, merchandise, or immaterial substances, vapours. A translucent cage raised upon a pedestal esp. in museums.

|ˈwɪntə| |ˈwɪntəz|

The season of Hephaistos, the adversary of Summer.
When life has fled the mortal realm and buried itself under
snow and frosted earth, lying in wait to spring forth once more.
(SEE [image] *|ˈsʌmə|.)*

noun

The coldest season of the Northern Hemisphere. From the brumal solstice to the vernal equinox. The time when hearths burn bright, stories are told, and legends are remembered.

|wʌɪp|

The clearing of knowledge and physical memory.
To make as new.
(SEE |ˈnɒlɪdʒ|.)

verb [trans.]

To cleanse by rubbing with something soft. To remove dirt or mois-
ture from the a surface. To strike off gently. To clear away. To remove
magnetic information from an object, to degauss, esp. ship.

|wɪʃ| |wɪʃz|

The idealised form or state, existing beyond
a small window of potentiality.

verb [intrans.]

To have a strong desire, to long. To hope for a thing not easily attainable. To be disposed, inclined. To silently invoke a hope or desire. To invoke supernatural agency, prayer, occult powers, to perform an action or grant a desire.

noun

A longing desire. A desire expressed. A plea or request of supernatural agencies.

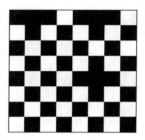

|wɪð| |əˈkʌmpənid| |əˈkʌmpəni|

preposition

Together, in the company of. Possessing features, characteristics. In appendage, noting concomitance. In mutual dealing, relation to. Affected by a state or condition, esp. child, disease. Indicating conflict.

verb [trans.]

To go together. To go jointly. To be present or occur at the same time. To be concurrent.

|wɪð'stand|

The island in the advancing tide.

verb [trans.]

To resist, gainstand. To oppose. To maintain one's position, offer resistance, fail to yield. To resist the attraction, influence of some persuasive power.

|'wɪtnɪs| |'wɪtnɪsd|

The orifice into rapacious memory.

verb [trans.]

To testify, attest to. To perceive an event, person, thing. To have knowledge of an occurrence, happening from personal experience.

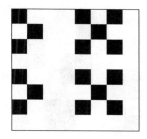

|ˈwʌndə| |ˈwʌndəd|

verb [intrans.]

To be struck with admiration. To be pleased or astonished. To be surprised. To marvel. To be curious, desire knowledge of something.

noun

A feeling of awe. Astonishment mixed with surprise and admiration. An object that creates astonishment. A marvel, prodigy. A strange thing, unexpected or unusual event.

|wəːd| |wəːdz|

The rational immanence of the universal structure.

noun

The first act, intention. The notes or phrase of speech. A part of language, distinct and having meaning in and of itself. A set of characters in writing separated from others by a space. A place-holder for a definite or indefinite meaning. An aural and textual signifier of concepts, things, events. A short discourse. Dispute, argument. News or gossip. Information relayed or spread out.

|wɜːld| |əːθ| |grʌɪnd|

*The XXI Major Arcanum. The globe that contains
all as she spins. She draws the mountains flat, fills the valleys deep,
constantly striving to become a perfect sphere.*

noun

The land, the seas, the air, and all beings who inhabit them all. The terraqueous globe. A system of beings here in this existence on other planes, or on other celestial bodies. The planet on which we live, the third planet from the Sun. A system of thought, group of beings, group of countries, time in history. The current abode of man. The living land as opposed to the realms before birth and after death. The secular realm. The world on which we dwell as opposed to the sea. The soil that is cultivated. The uppermost surface of dirt. The substance of the land. The bottom of the sky. A limited or defined region of land, country. The land about a specific place or building. The bottom or lowest part of anything. The land below the oceans where certain cities are preserved.

w

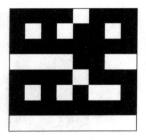

|wəːs| |wəːst|

The sign of things going amiss.
The particles slipping out of place.
(SEE 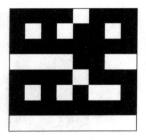 *|dɪˈkeɪz|.)*

adjective

The comparative or superlative of 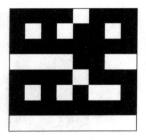 |ˈiːvɪl|. More reprehensible, wicked, cruel, or ill-conditioned. More inferior, defective. More unpleasant, unwelcome. More diseased, sickened. More undesirable qualities. Most inferior, defective. Most unpleasant, unwelcome. Most diseased, sickened. Having the most undesirable qualities.

|wə:θ|

adjective

Equal in price to, equal in value to. Sufficiently good, important
to deserve an action. Deserving of. Suitable or not for a course of
action.

noun

Equivalent value to something under consideration. Price, value.
Excellence, virtue. Importance.

|rɛn(t)ʃ| |rɛn(t)ʃd|

The pivot performing its action.

verb [trans.]

To pull by violence. To wrest, force. To grab, twist, contort something. To perform violence with a pivot or fulcrum. To use the laws of nature for ferocious action.

|jɪə| |jɪəz|

*The many days and nights fold into a pattern
of experience and forgetfulness.*

noun

The time for a planet to make one revolution around its star. The distance travelled by the Earth in one orbit of the sun. Three hundred and sixty five days. A period of calendar time calculated by the sun, the moon, or other events, phenomena. Twelve lunar months. The longest period of time meaningfully held in the imagination. The period from one date until its next occurrence. The quantified age or lifetime of a person, animal, being, thing.

|ˈjɛləʊ|

*The colour of the violent sun. The colour of sulphur
and all those associated with its odour.*

adjective & noun

The colour between green and orange. A bright blaring colour, as
of gold, the yolk of an egg, the centre of a flower. The colour of
faded paper and diseased skin. The colour of Saturn.

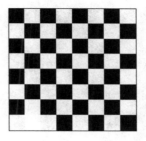

|jɛt|

adverb & conjunction

Nevertheless, notwithstanding, in spite of that. After all. Still, that state remains still. Even. Hitherto, up until the present time. At the present time. From now into the future.

j

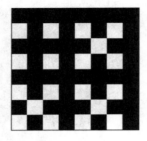

|juː| |jɔːˈsɛlf|

The other entity that we address.
A thing outside of ourselves that we suspect may also be conscious.

pronoun [second-person sing. & pl.]

Used to refer to the person or people that the speaker is addressing.
To speak of a person in general circumstances. Used reflexively of
those being addressed.

|jʌŋ|

All about us in the earth, in the wind,
in the waters, and in the fire, particles of matter swirl in potentiality.
They await that moment when they will encounter
thought and then immediately coalesce into structures such as people,
flowers, donkeys, plastic, volcanoes, glass, shoes.

adjective

New. Having only just come into existence. Being at the first part of life, not old. Vigorous. Immature or ignorant. Having enthusiasm and optimism.